Jan Gossart

AND THE INVENTION OF NETHERLANDISH ANTIQUITY

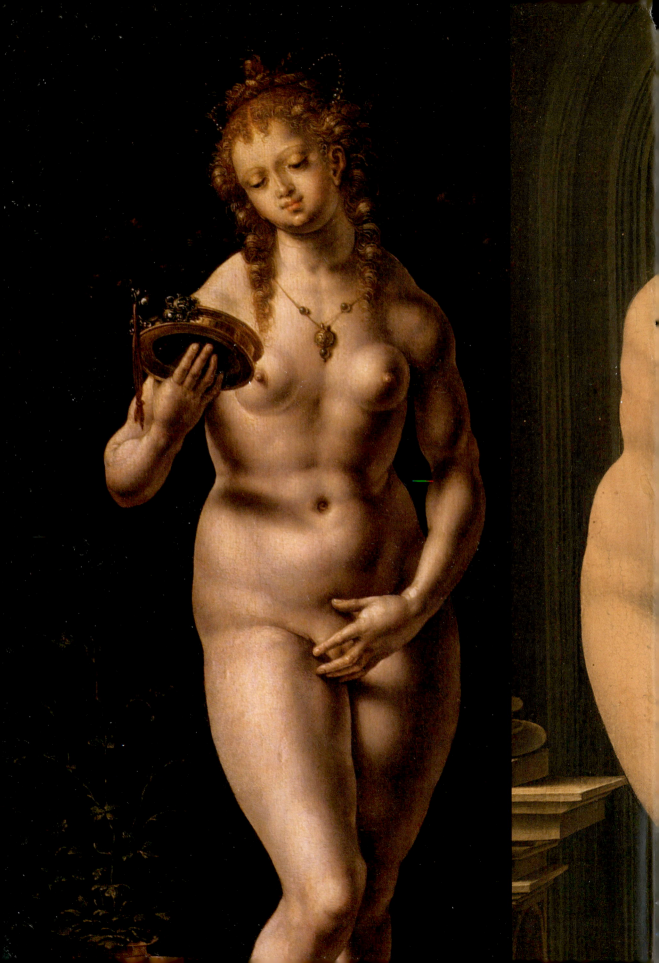

Jan Gossart

AND THE INVENTION
OF NETHERLANDISH
ANTIQUITY

MARISA ANNE BASS

PRINCETON UNIVERSITY PRESS
PRINCETON AND OXFORD

Published by Princeton University Press,
41 William Street, Princeton,
New Jersey 08540
In the United Kingdom: Princeton
University Press, 6 Oxford Street,
Woodstock, Oxfordshire OX20 1TW
press.princeton.edu

Jacket illustrations (front and back): Details
of Jan Gossart, *Danaë*, 1527. Oil on panel,
113.5 × 95 cm. © Bildarchiv Preussischer
Kulturbesitz / Alte Pinakothek, Bayerische
Staatsgemäldesammlungen, Munich / Art
Resource, NY
Illustrations in front matter: p. i, detail of
fig. 77; p. ii, detail of fig. 1; pp. ii–iii, detail
of fig. 77; pp. iv–v, detail of fig. 17; pp. vi–
vii, detail of fig. 30

LIBRARY OF CONGRESS CATALOGING-IN-
PUBLICATION DATA
Bass, Marisa, 1981- author.
Jan Gossart and the invention of
Netherlandish antiquity / Marisa Anne Bass.
pages cm
Includes bibliographical references and
index.
ISBN 978-0-691-16999-6 (hardcover : alk.
paper) 1. Gossaert, Jan, approximately
1478-approximately 1532—Criticism and
interpretation. 2. Mythology, Classical,
in art. 3. History in art. 4. Netherlands—
Historiography—History—16th century.
5. Netherlands—Intellectual life—16th
century. I. Title.
ND673.G65B37 2016
759.9493—dc23
2015021400

British Library Cataloging-in-Publication
Data is available

Publication of this book has been aided by
a grant from the Millard Meiss Publication
Fund of the College Art Association
MM

Designed by Jo Ellen Ackerman /
Bessas & Ackerman
This book has been composed in
Adobe Garamond Pro and Quay Sans
Printed on acid-free paper. ∞
Printed in China
10 9 8 7 6 5 4 3 2 1

TO MY PARENTS,
WITH LOVE

CONTENTS

Acknowledgments viii
Introduction 1

CHAPTER 1
The Embodied Past 7

CHAPTER 2
Land 45

CHAPTER 3
Lineage 75

CHAPTER 4
Legacy 115

Epilogue 145

Notes 155
Bibliography 183
Index 203
Illustration Credits 213

ACKNOWLEDGMENTS

That I felt an immediate kinship with Gossart's mythological subjects—one that goes beyond their insistent blond curls—will surprise no one who has known me a long time. I came to the study of the sixteenth-century Netherlands with a desire to understand the unique ways that art and intellectual culture intersected in a region so small, yet marked in its early history by such momentous political, religious, and cultural upheaval. This book is my first major foray in pursuit of that question.

Ever since I first sat down to discuss Gossart over Turkish coffee with my adviser and friend Hugo van der Velden, at the close of my first year at Harvard University, his warm support, insistence on historical depth, and critique as sharp as Ockham's razor have been a constant guide. I owe an immeasurable debt to him, and sincere thanks to Mia You for tolerating so many dinner conversations about Batavians and obscure Netherlandish humanists. I am most grateful as well for advice and inspiration from other colleagues then at Harvard: Frank Fehrenbach, Jeffrey Hamburger, Ewa Lajer-Burchart, Jennifer Roberts, James Hankins, and especially Joseph Koerner, whose insights enriched my writing in its final stages.

Several fellowships and institutions supported my research and nourished this project. Joseph Connors offered me the luxury of a semester spent reading everything from Suetonius to Paolo Giovio in the original at the Villa I Tatti, a setting made still more welcoming by his wife Françoise, and where I met the inimitable Paul Barolsky, to whom I owe Balzac and whatever wit and humor enlivens these pages. I thank Elizabeth Cropper and the Center for Advanced Study of the Visual Arts for supporting my first year of research abroad in the Netherlands, and the Metropolitan Museum of Art for supporting the second. A special thanks goes to Maryan Ainsworth, together with Nadine Orenstein and Stijn Alsteens, at the Metropolitan Museum for their perspicacity in organizing the seminal retrospective on Gossart that opened in 2010, which has deepened my own work and all future scholarship on the artist. A Mellon postdoctoral fellowship at Columbia University allowed me the space to begin revising and the opportunity for conversation with wonderful colleagues including Michael Cole and David Freedberg. A generous grant from the Millard Meiss Publication Fund also supported this book in its production stage. Finally, the students at Washington University in St. Louis helped to inspire me with their questions and enthusiasm, and all my fellow members of the art history department, Bill Wallace in particular, offered warm support as well.

I might never have stumbled down the strange path that led to this book without the stimulating courses of Susanna Braund and Christopher Wood during my early years at Yale University, let alone without the Latin skills that Diana Smith first fostered during my studies long ago. All translations in this book, unless otherwise noted, are indeed my own. I am immensely grateful to Jan Piet Filedt Kok for taking me on as an intern at the Rijksmuseum, for introducing me to the wonders of the RKD and the collections in the Netherlands, and for all his kindness ever since. I also want to express gratitude to Matt Kavaler for his patience, friendship, and honest critique that helped to make this book better than it would otherwise have been. Among the many other scholars, curators, librarians, and archivists who provided assistance, dialogue, and encouragement as this project developed, I owe particular thanks to Dagmar Eichberger, Larry Silver, Ilja Veldman, Jeroen Stumpel, Maximilian Martens, Stefan Kemperdick, Peter van den Brink, Til-Holger Borchert, Jos Koldeweij, Eric Jan Sluijter, Krista de Jonge, Walter Melion, Mark Pegg, Ariane Mensger, Stephanie Schrader, Orlanda Lie, Michiel Verweij, Huib Uil, Peter Priester, Michel Oosterbosch, and the staff of the Special Collections library at the University of Amsterdam, my second home abroad. I offer additional thanks to Lauren Lepow for her attentive editing, and to my anonymous readers for their valuable comments.

Without my editor Michelle Komie at Princeton University Press, who showed enthusiasm for this project from our very first conversation, this volume would not exist at all. For their support over the years when it came to fruition, I thank Matt Jolly, Denise Gill, Wallace DeWitt, Marshall Kibbey, C. J. Alvarez, Ilona van Tuinen, Ittai Weinryb, Jennifer Sliwka, Prudence Peiffer, and Jonathan Winer. Most of all, I cannot express how much it meant—during long sojourns in windy Zeeland, wintry Amsterdam, or the desolate Midwest, to know that I had the love of my parents, my sister Jenny, my adorable Boucher, and the amazing, wise, and witty Emily Lodish, Regan White, Ariel Bowman, and Jessica Cohen, who remind me every day that there is more to life than writing a book. As Robert Browning said, the best is yet to be.

ter sluys

VLAENDEREN

Crüninge

ZVIITBEVELAND

Stuuesat Soes voste

Beeclandt

Thüno va borsele

Elkerck borselle

moster

Zou

Vlissinge
WALCHER

welsinge

Cloet

persickdame

Toster landt

WOLFARDIICK

de viete

tcasteel

crüninge

ujs ter doest

Suijt

west

oost

aernm he

Weele

Cats

NOORTBEVELAND

bischercke

Middelborch

S. michiel

Emelisse

Welle

Mietc

Goesinck

Campe

pekinge

Soke

hamerste

Veere

Zuipkercke

Conkercke

Ziericzee

SCHOVWEN

Borch

avveldame

Belle

Reuisse

xefscouwe

Maeste

Eeuijat

INTRODUCTION

Behold what the narrative encompassed in these little
 tomes reveals
Of a land, which the swelling sea everywhere surrounds.
If you census this place, it will be but a small corner of the
 large world,
No distant milestone marks the boundary of its shores.
Yet there are many delights within such a trifling stretch
That would charm and move you in miraculous ways.

JASON PRATENSIS IN JAN REYGERSBERGH,
The Chronicle of Zeeland, 1551[1]

The early modern Low Countries and the image of its history were profoundly shaped by a sense of scale. The region's cultural achievements, and attendant local pride, have always swelled beyond the limits of its small geographical domain. The learned doctor Jason Pratensis was no exception. He perceived his narrow corner of the world as an epicenter of intellectual life, and he rejoiced at the publication of the first humanist chronicle devoted to the history of Zeeland, the Netherlandish province he called home. The dedicatory poem that Pratensis penned in its honor extols Zeeland's venerable narrative as surpassing even the humble volume that contains it. Any province so ancient, and still so vibrant today, could never again be dismissed as a minor outpost on the global seas.

Pratensis was among several Netherlandish scholars of the early sixteenth century who employed the rhetoric of cultural richness to praise their native land. They sought to cultivate a renaissance on local soil, an ambition they shared with contemporary Netherlandish artists and patrons. To foster a local renaissance was to revive a region's distinctive past for the sake of nourishing learning and culture in its present. Beginning in the fifteenth century, as cities and regions throughout Europe pursued this goal for themselves, they drew on rediscovered historical texts and local archaeological finds.[2] They engaged in the writing of their own history.[3] As Pratensis well understood, the pulling together of bits and pieces from the past was a creative endeavor, which required not only documented evidence but also vivid description and no small amount of invention.

How that pursuit manifested itself in the early sixteenth-century Low Countries is the subject of the present book. Central to its argument is a rejection of the long-held understanding of this period in Netherlandish art and intellectual history as defined by revelatory encounters with Italy and the rediscovered antiquities of Rome. Classical rhetoric, antique forms, and antiquarian pursuits did not seep into northern Europe passively and inevitably, like silt water after a deluge. On the contrary, it was the conscious effort to generate a flourishing culture in the north, a deliberate challenge to Rome's hegemonic claim to its Roman past and intellectual legacy.

My main protagonist is the artist Jan Gossart (c. 1478–1532), also known as Mabuse, who introduced mythological painting as an independent genre in the art of the Low Countries. With great ingenuity, Gossart took up the task of equaling (and so challenging) Rome's monumental ancient buildings and life-size sculptures. His mythological works invested his patrons with surrogate ancient monuments of their own that realized in full color and on grand scale a classical revival on local shores. Gossart was thus one of the very first Netherlandish artists to actively contribute to local historiography through the visual arts, a phenomenon that the Dutch scholar Henri van de Waal explored in his magisterial study of *geschied-uitbeelding*, or "the imaging of history," in the early modern Netherlands.[4]

Gossart's project also aligns with the emergence of the mythological genre across Europe during the early modern period, which was always attended by claims to wit and erudition, and motivated by the yearning for sensual engagement with the past. The genre lent itself to appropriation in regions peripheral to Rome—whether northern Italy, Germany, or the Netherlands—where it gave tangible presence to the revival of antiquity.[5] In his 1508 dialogue praising the city of Wittenberg, the German humanist Andreas Meinhardi described the palace of the elector Frederick the Wise brimming over with mythological pictures, asserting that their presence was the very index of cultural efflorescence.[6] Meinhardi's dialogue is one of the earliest references to mythological images in northern Europe, and dates only a few years prior to Gossart's own forays into the genre.

Yet despite the significance of Gossart's achievement to the larger history of art in northern Europe, the story of his contribution has never been fully told or appreciated. Already in the later sixteenth century, Gossart was recognized for another unprecedented body of work that has confused the understanding of his mythological oeuvre. He is renowned as the first Netherlandish artist to draw the antiquities of Rome, a project he undertook in dialogue with his greatest patron, Philip of Burgundy (1465–1524), who was then admiral of the Netherlands. They traveled to Italy together in early 1509 and spent four months in Rome, affording Gossart the chance to study not only architectural monuments like the Colosseum but also large-scale ancient sculpture.

The presumption of causality between the two pillars of Gossart's fame—his Roman drawings and his mythological paintings—has resulted in a profound misunderstanding of his engagement with antiquity. The misunderstanding dates back as early as 1567, when the Italian merchant Ludovico Guicciardini in his *Description of the Low Countries* declared that Gossart was "the first to bring from Italy to this country [the Netherlands] the art of painting *historie* and *poesie* with nude figures."[7] A year later, the great Italian biographer Giorgio Vasari duly echoed the same assertion in the 1568 edition of his famous *Lives of the Artists*, thus canonizing Gossart's alleged debt to the south.[8] Even Karel van Mander, the great early biographer of the Netherlandish artists, fell in line and iterated this same statement in his *Lives of the Illustrious Netherlandish and German Painters* (1604), though his own account of Gossart's life does not bear out Guicciardini's claim.[9]

Despite their inherent Italian bias, Guicciardini's words continue to resound throughout modern scholarship on Gossart. The notion that Gossart's Roman sojourn was the primary impetus for his turn to mythological painting has become a commonplace, upheld regardless of the fact that the first documented work he produced in the mythological genre dates a full seven years after his return from Italy.

The catalogue to the 1902 exhibition of "Flemish Primitives" in Bruges inaugurated the modern study of Gossart's oeuvre by declaring that upon his return from Italy, Gossart "was seemingly so captivated by the Renaissance that he left behind all the traditions of his own school," namely, the school of the early fifteenth-century Netherlandish painters like Jan van Eyck and Rogier van der Weyden.[10] Yet the works attributed to Gossart on display in the exhibition itself included only one mythological subject, while the others were portraits and religious pictures very much in the local tradition.[11]

Although Gossart's supposed breach with his early Netherlandish predecessors was hardly affirmed by his oeuvre, it became the basis for interpreting his artistic development and personal character.[12] In the resulting narrative, Gossart's trip to Italy marked his departure from local tradition and his eager embrace of the models of classical antiquity. Gossart was even championed as a pioneer among the "Romanists," a term coined in early twentieth-century scholarship to describe Netherlandish

artists caught up in the "epidemic" of a renaissance closely associated with the rediscovery of Roman antiquity and a slavish devotion to its models.[13]

In more recent years, Gossart has experienced a renaissance of his own, encompassing important inquiry into the historical context of his works and a quiet revolt against the Italocentrism that defined his prior scholarly reception.[14] New research has shed light on the artist's working methods,[15] on his courtly milieu in the Low Countries,[16] and on his embrace of a stylistic plurality encompassing both antique forms and the flamboyant Gothic style of architectural ornament *en vogue* in the early sixteenth-century Low Countries.[17] Despite monographic studies that have persisted in privileging Gossart's southern travels in their analysis of his career, there has been an increasing acknowledgment that Italian models never compelled Gossart to abandon his artistic inheritance from early Netherlandish painting.[18] Yet even so, the understanding of Gossart's mythological paintings in particular continues to be informed by their presumed position relative to Italy.

This book sets out to rehabilitate Gossart's mythological works in the milieu of their original creation by investigating not only the artist's intimate courtly environs but also his place within the intellectual culture of the early sixteenth-century Low Countries. It contends that Gossart participated in a local renaissance—the revival of an alternative "Netherlandish" antiquity—through his antiquarian engagement with Eyckian painting, his selective use of Italian and ancient models, and his involvement in the recovery of the region's ancient history. In this respect, Gossart's mythological paintings offer a paradigmatic example of a much larger historical phenomenon. Gossart's revival of the past was localized and specific, yet also runs parallel to similar local renascences that emerged across the early modern period, both within other intellectual circles in the Netherlands and elsewhere in Europe.[19]

I avoid the categorization of Gossart as a "Northern Renaissance" artist because such modern terminology problematically implies that the Renaissance was a period bifurcated between the poles of south and north, between Italy and everywhere else.[20] Underlying this label is a false confidence in the idea of the "Renaissance" itself as a fixed and stable entity that was translated to northern Europe wholesale after its initial southern flowering, and that resulted in a definitive break with local medieval tradition.[21]

Considering the early modern period instead as one in which the pursuit of a "renaissance" was being constantly redefined and reappropriated in a variety of locales, and for differing purposes, allows us to approach Gossart's paintings on their own terms. The artist's experience on Roman soil and knowledge of Italian models left an indelible mark on his subsequent oeuvre, but it should be stressed once again that he did not produce his mythological works under a spell of influence. Gossart's contribution to the campaign for a local revival of antiquity was a singular experiment, which developed out of a transitional moment in the history of Netherlandish art, and in the larger political, religious, and cultural history of the Low Countries.

Hence my inquiry ultimately extends beyond the understanding of a few paintings, and of the artist who produced them, to revive the world of erudition that Gossart inhabited, that of Jason Pratensis and his colleagues. The sixteenth-century Netherlands was a breeding ground for active scholarship well beyond the patriarchal figure of Desiderius Erasmus, who is too often treated as the sole spokesperson for what was a diverse and eccentric humanist circle.[22] Erasmus achieved great fame and notoriety across Europe through the wide circulation in print of works like his revised edition of the New Testament, and his endeavor to recover Christian history certainly exerted a stronger force among early sixteenth-century humanists in the Low Countries than the concern for the local pagan past. The many other Netherlandish scholars who took up the latter concern, and whom I introduce throughout the subsequent pages, did not share in Erasmus's international reputation. Most of their writings have never been translated and, in some cases, have been almost entirely forgotten. Nonetheless, their contributions—just as much as Gossart's mythological paintings—were seminal to the invention of Netherlandish antiquity.

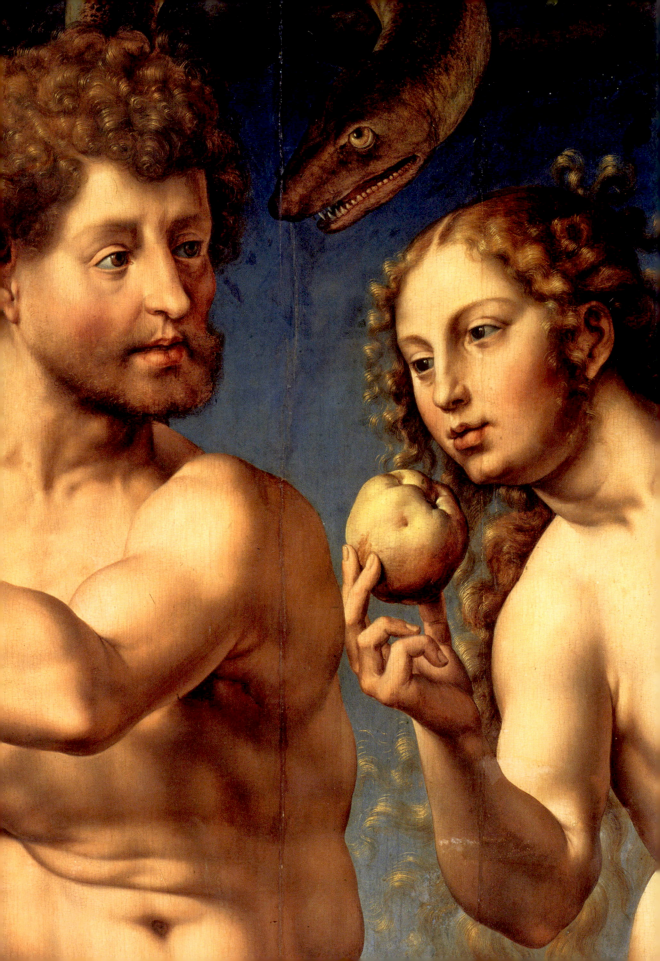

THE EMBODIED PAST

Gossart was obsessed with bodies, and with the representation of bodies in space. His most iconic works, whether mythological or religious in subject, all explore the extreme juxtaposition of enlivened figures within realms of cool stone architecture or intricate foliate ornament. Even his portraits set against monochrome backgrounds present their figures emerging, sometimes as if breaching the boundaries of their frames.

Of course, great swaths of Renaissance painting, from the crucified Christ in the illusory chapel of Masaccio's *Trinity* to Michelangelo's nudes writhing within the imagined architecture of the Sistine Chapel ceiling, were born from this same passion. The impulse to master the representation of the human body within convincing perspectival space finds clear and early statement in Italian Renaissance art theory, notably in Leon Battista Alberti's seminal 1435 treatise *On Painting*.[1] Alberti's notion of *historia*—his elegant prescription for the enlivenment of pictorial narrative—depended on the artful portrayal of bodies moving and conveying emotion as if within a three-dimensional world. When the sixteenth-century Italian Ludovico Guicciardini characterized Gossart's mythological works, he referred to them as *historie* with nude figures, drawing on the discourse of his native Italy.[2]

Yet Gossart's mythological paintings are not pictures designed to convey the progression of historical narrative.

His figures express themselves in ways that are confusing and strangely exaggerated. Whether through their physical contortions or their hyperdimensionality, Gossart's subjects resist the confines of belonging in any one narrative moment. Their embodiment effects instead an aggressive transgression of time and space in which the body of the viewer is physically implicated. Gossart's works demand that the viewer's body become the medium through which the represented body is known and experienced.[3]

Like most Netherlandish artists of his generation and those preceding him, Gossart left not a word of comment on his approach to image making, so this book reconstructs his story through his paintings themselves and through the voices of those with whom he collaborated.[4] Gossart's mythological paintings express their fulfillment of a desire, on the part of his patrons, to engage in a sensual and embodied interaction with figures from the ancient past. These works functioned at once as surrogate antiquities and living beings that could exert an impact in the realm of the present. The starting point for understanding the impact of his mythological images within the early sixteenth century is to delve into the hothouse of elite patronage, intellectual endeavor, and artistic tradition in the Netherlands that nourished the artist's imagination.

THE MIRROR AND THE PEDESTAL

Gossart's *Venus*, dating circa 1521 to the midpoint of the artist's career, and measuring just under two feet high, has a dramatic presence that belies its small size (fig. 1).[5] The goddess stands nude except for a headdress strung with pearls and a necklace that provocatively charts the position of her breasts and navel. An eerie blackness sets off her pale body. She gazes into a mirror and touches herself, a gesture all the more titillating given the androgynous muscularity of her body. The goddess tips her right foot off the edge of her pedestal like an enlivened statue, a movement that tantalizes the viewer with the promise of greater intimacy. Yet even while posing, Venus feigns absorption in her own visage, as if oblivious to any onlooker. The goddess is a precious object, on display together with the other precious objects at her feet, but she is also a sentient subject.

The playful duplicity of Gossart's picture recalls two central foundation myths of artistic creation, both recounted in the *Metamorphoses* of the ancient poet Ovid. The first is the story of Narcissus, the youth who became transfixed by love for his own reflection in a pool of water.[6] The Italian theorist Alberti famously declared Narcissus the founder of painting because he embodied the painter's desire to mirror the natural world.[7] The second myth evoked by Gossart's painting is that of Pygmalion, who fell in love with his sculpture of an ideal woman and prayed to Venus that his creation might be brought to life.[8] By answering Pygmalion's supplication and uniting him with his beloved, Venus fulfilled the ambition of the sculptor to transform inanimate material into living flesh.

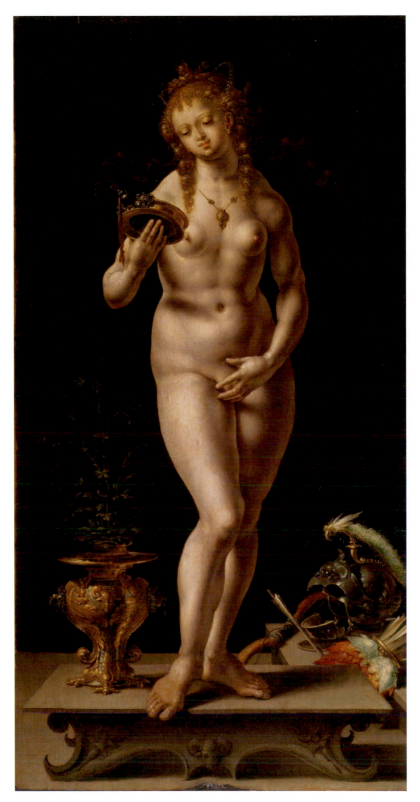

Fig. 1. Jan Gossart, *Venus*, 1521. Oil on panel, 59 × 29.9 cm. Pinacoteca dell' Accademia dei Concordi, Rovigo.

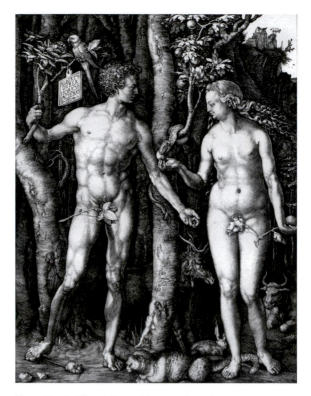

Fig. 2. Albrecht Dürer, *Adam and Eve*, 1504. Engraving, 24.9 × 19.1 cm.
British Museum, London.

At the center of both myths is a figuration of a desiring self: Narcissus enamored of his own image, Pygmalion of his own creation. In Gossart's *Venus*, the presence of the artist is likewise everywhere felt. What motivated his desire to simultaneously embody painting as mirror reflection and sculpture as enlivened form? Through what lens did he engage with these myths of artistic origin as he pursued his own paradigm of the represented nude body? Inquiry into the diverse visual sources that inspired Gossart's *Venus* reveals unequivocally that Italy provided only one of several key points of reference for Gossart's innovative embodiment of antiquity.

The 1504 engraving *Adam and Eve* by the German Renaissance artist Albrecht Dürer was the most immediate precedent for Gossart's project, and its impression upon his *Venus* is unmistakable (fig. 2). Dürer's *Adam and Eve*, which achieved swift and wide-ranging impact through its circulation as a print, represents the foundational moment when the classically proportioned body entered the history of northern European art.[9] These bodies, informed by ancient models and enlivened within the narrative of mankind's fall, occupy an evident place in history. Dürer's couple stands in a prelapsarian moment of purity just before the act of original sin, their heads in perfect profile, their shapely forms frontal but not touching, pushed forward into view by the lush darkness of the forest behind them.[10] Not only is Gossart's circa

Fig. 3. Jan Gossart, *Adam and Eve*, c. 1510. Oil on panel, 56.5 × 37 cm. Museo Thyssen-Bornemisza, Madrid.

1510 *Adam and Eve*—his first independent painting of full-length nudes—an emulative copy of Dürer's engraving (fig. 3), but his *Venus* of a decade later still strongly recalls the muscular body and strong frontality of Dürer's Eve.[11] Gossart built his understanding of the body directly upon the foundations of a fellow northern artist, and did so even after he had been to Rome and seen the city's monumental ancient sculptures firsthand.

Even more important than the formal relation to Dürer's print is what Gossart does with the nude body in relation to historical time. Gossart's Venus, unlike Dürer's Adam and Eve, stands outside any narrative moment, literally toeing the boundary between past and present. Take the objects at Venus's feet—the bow, quiver of arrows, and glistening helmet—items that allude to her son Cupid and her lover

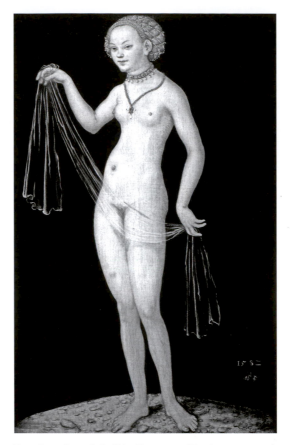

Fig. 4. Lucas Cranach the Elder, *Venus*, 1532. Oil and tempera on red
beechwood, 37.7 × 24.5 cm. Städel Museum, Frankfurt am Main.

Mars. More than anything, they look like props scattered in an artist's studio, which
might be employed to stage a painting of Mars, Venus, and Cupid, but which have
yet to be assembled into an actual narrative composition. The ambiguous back-
ground and the goddess's Renaissance headdress, as in the mythological paintings of
Gossart's significant German contemporaries Lucas Cranach the Elder and Hans
Baldung Grien, make possible the illusion that this is not a goddess of distant
antiquity but a woman engaging the viewer in the living flesh (fig. 4).[12]

The miniature collectibles gathered at Venus's pedestal are indeed the props that
Gossart had at his disposal, as they represent the body of artistic knowledge that he
brought to bear not only in this work but in all his mythological paintings. The
fantastical helmet with its florid plume recalls Gossart's studies of sculpted ancient
armor during his trip to Rome. In his wonderfully enlivened drawing of the famous
bronze *Spinario*, a statue then as now displayed in the Palazzo dei Conservatori,
Gossart includes flanking studies of Roman footwear and two ornate helmets adorned
with rams' heads—an animal associated with bellicose Mars (fig. 5).[13] Gossart depicts

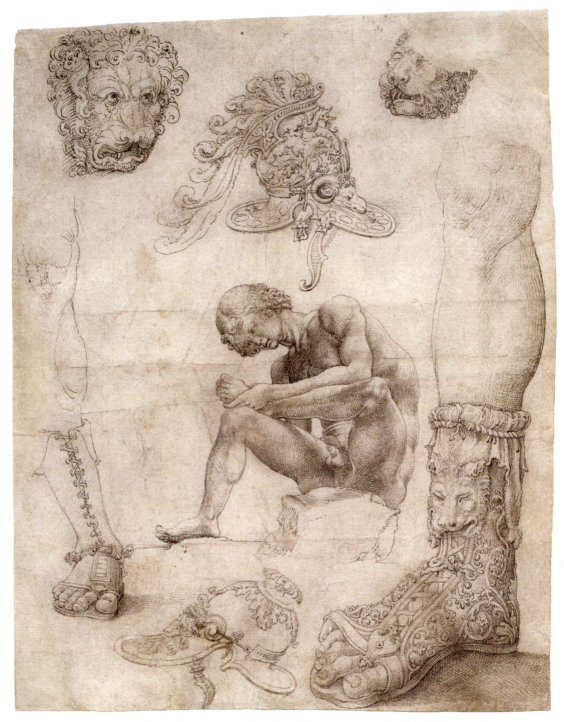

Fig. 5. Jan Gossart, Study sheet with *Spinario*, c. 1509. Pen and gray-brown ink, 26.3 × 20.5 cm. Universiteitsbibliotheek, Leiden.

these same rams' heads on the vase and pedestal in his *Venus*. Like Gossart's paintings themselves, exotic helmets were desirable collectibles among elite sixteenth-century patrons in the Netherlands, for whom they served as emblems of ancient heroism; Gossart's patron Philip had one such object in his own collection, described in the inventory as "a small steel helmet [crafted] in the ancient manner."[14]

However, the helmet in Gossart's *Venus* has a wider valence even beyond its classical associations. The artist's attention to the subtlety of the gleaming surfaces of the helmet and gilt vase reveals a quietly virtuosic display of skill at depicting reflections. We have already seen this painterly achievement linked to Narcissus as founder of the art in Alberti's *On Painting*. Yet whether Gossart would have known the Italian theorist's work is uncertain. Among the early sixteenth-century libraries documented in the Low Countries, only one exemplar of Alberti's writings—his treatise *On Architecture*—appears in the late 1525 inventory of Willem Heda, a local scholar who wrote one of the two biographies of Gossart's patron Philip, and who owned a splendid house on the Groenplaats in Antwerp adorned on its facade with classicizing ornament.[15] But Heda was precocious in this regard, and there is no documented evidence that Gossart's patrons themselves owned works of Italian art theory.

Alberti aside, the notion that reflective surfaces were emblematic of painterly skill had entered into local artistic discourse already with Jan van Eyck, Gossart's greatest predecessor among fifteenth-century Netherlandish painters.[16] Van Eyck was himself mythologized by Renaissance historiographers in both the Netherlands and Italy as the founder of oil painting, and he enjoyed a prestigious place in the minds of sixteenth-century patrons and artists alike.[17] To witness van Eyck's skill at painting reflection, one has only to look at the gleaming armor of St. George in his splendid *Van der Paele Madonna*, which encompasses in its minuscule mirror reflections not only the nearby Virgin and Child but also the artist himself working busily at his easel: an acknowledgment that virtuosic painting always reflects back on its creator (fig. 6).[18] Inasmuch as Gossart looked to Albrecht Dürer and saw an artist who seemed to single-handedly herald the German Renaissance, he would have found in van Eyck a Netherlandish precursor whose miraculous painterly achievements seemed to have emerged ex nihilo, and who thus offered a model for Gossart's own dramatic intervention of mythological painting in the art of the Low Countries.

It was also Jan van Eyck who created the most distinguished forebears to Gossart's nude bodies on a monumental scale. Van Eyck's life-size figures of Adam and Eve situated in the outer wings of the *Ghent Altarpiece* had already long asserted the place of the nude body in the history of Netherlandish art (fig. 7).[19] Stepping out from their darkened niches—proclaiming their corporeal reality through wrinkles, natural curves, and visible facial and body hair—van Eyck's first couple enters into continuity with the world of their local audience. As Adam's foot extends provocatively beyond the edge of the frame, seen from below as he emerges into the space above the heads of the painting's viewers, his physical presence is inescapable (fig. 8). It is the same kind of provoca-

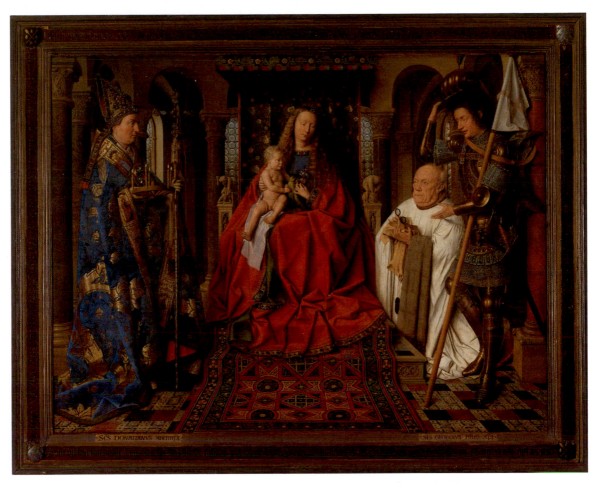

Fig. 6. Jan van Eyck, *The Madonna with Canon van der Paele*, 1436. Oil on panel, 122 × 157 cm. Groeninge Museum, Musea Brugge, Bruges.

tion, on a much smaller scale, that Gossart effects with his teasing *Venus* and her foot dangling off the edge of the pedestal in the painting's foreground.

Van Eyck's first couple do not have the classical bodies of Dürer's Adam and Eve, but they were equally significant to Gossart's painterly interest in enlivened sculpture and his refined technique of handling the oil medium.[20] The Ghent chronicler Marcus van Vaernewijck explicitly lists Gossart among the admirers of the work in his 1568 account of the altarpiece's history.[21] Van Eyck's portrayal of Adam and Eve as sculptures brought to life—and his larger interest in painted sculpture throughout his oeuvre—provided Gossart with a counterpart to the Pygmalion myth within local artistic tradition, much as van Eyck's mirror reflections did with the myth of Narcissus.[22]

Besides his mythological works, the only other nude subjects that Gossart depicted repeatedly throughout his career were Adam and Eve, the embodied representatives not only of biblical history but also of Eyckian legacy. Gossart's large-scale *Adam and Eve* in

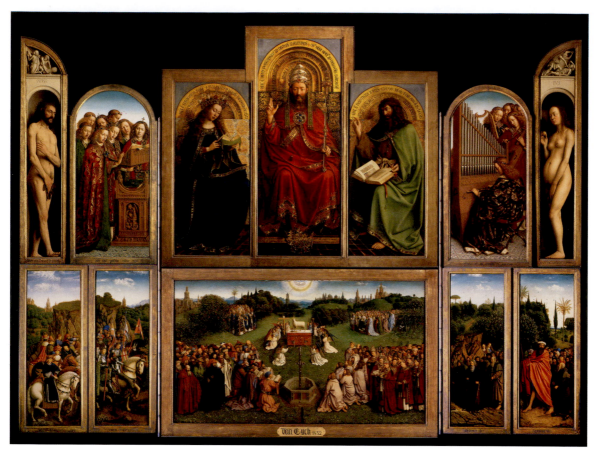

Fig. 7. Jan van Eyck, *Ghent Altarpiece*, c. 1425–35. Oil on panel, 350 × 223 cm. Cathedral of St. Bavo, Ghent.

Berlin reveals how the sixteenth-century artist nonetheless made the subject very much his own, twisting their bodies in a display of postlapsarian carnality and profound instability (fig. 9).[23] Gossart's Adam does not merely tip his foot beyond the frame; he seems about to fall out of the picture entirely. Falling into sin becomes a physical movement into the viewer's realm, implying yet another collapse of time between the era of man's primordial origins and the present day.[24] Gossart also depicted two nude dwarfs as Adam and Eve in a lost painting that once hung in the library of the Netherlandish regent Margaret of Austria, which must have constituted an even more subversive approach to this visual tradition.[25] Regardless of the historical narrative that Gossart tackles, whether derived from the Old Testament or from classical myth, his maneuverings of the body in space disrupt the temporal distance between the viewer and the painting in a manner as provocative as it is unsettling.

Along these same lines, a lost work by van Eyck depicting a nude woman emerging from the bath provides the last crucial link between the project of the fifteenth-century artist and Gossart's mythological oeuvre, his *Venus* in particular. We know

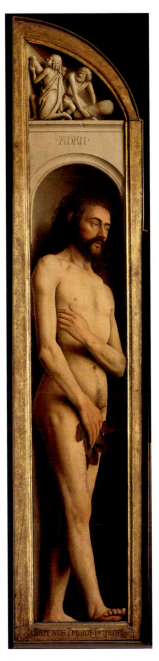

Fig. 8. Jan van Eyck, *Ghent Altarpiece* (detail), c. 1425–35. Oil on panel. Cathedral of St. Bavo, Ghent.

from a description of the panel by the fifteenth-century Neapolitan humanist Bartolomeo Fazio that van Eyck depicted an illusionistic mirror in the picture such that the viewer could delightfully survey the female form both from the front and from behind.[26] By virtue of the mirror's reflection, in other words, the woman's body came alive as a three-dimensional form. Gossart's *Venus*, which depicts the goddess at her toilette as if she too might have just stepped out of the bath, thus descends from the models of earlier Netherlandish painting not only in its technique but even in its particular subject.

Indeed, the representation of bathers was the one major arena—prior to the introduction of mythological subjects, and outside of biblical figures like Adam and Eve—in which northern artists from van Eyck to Dürer exercised their interest in the nude body.[27] In part, this interest derived from the numerous public bathhouses in northern Europe and their prominence as cultural institutions in the region.[28] A Netherlandish medical treatise from 1514, which catalogues the hygienic benefits of bathing, represents the bathhouse as a space of communal pleasure and benefit; a woodcut illustration from the treatise shows the purposeful range of bodies, from the young men and women courting nude in the tub to an old servant woman with sagging breasts (fig. 10).[29]

Southern European visitors were as taken with northern bathhouses as they were with Eyckian painting. In the early fifteenth century, the Spanish journeyman Pero Tafur visited van Eyck's hometown of Bruges and expressed astonishment at the custom of men and women bathing together.[30] In 1416, when the Italian humanist Poggio Bracciolini paused from hunting manuscripts in German monasteries to enjoy the baths at Baden-Baden, he was no less amazed at the ease with which men and women mingled in the nude.[31] Standing in the ambulatory above, he could admire the figures from every angle, much as Fazio described van Eyck's painting as offering full view of the woman's body.[32] Confronted with a scene of frolicking nude northerners, the Italian was the one who professed to be overcome with modesty.

Gossart himself composed a scene of female bathers with scattered basins of water, jugs and vessels displayed in the background (fig. 11).[33] Squared for transfer, this

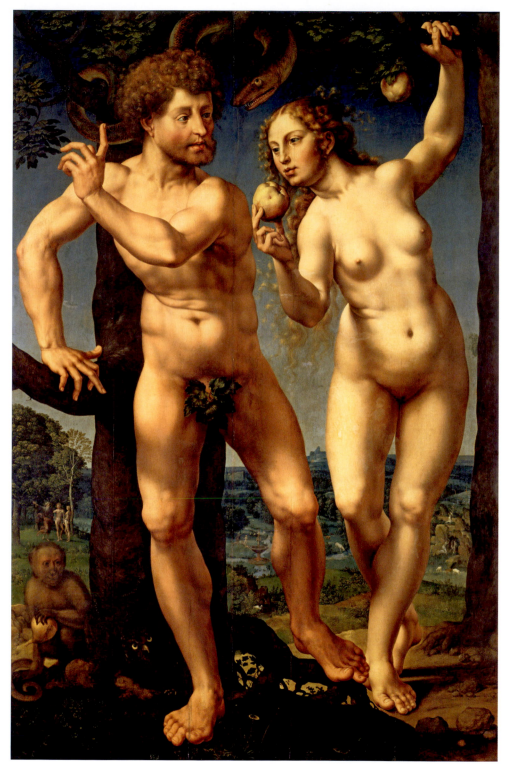

Fig. 9. Jan Gossart, *Adam and Eve*, c. 1525. Oil on panel, 172.2 × 115.8 cm. Gemäldegalerie, Staatliche Museen. Berlin.

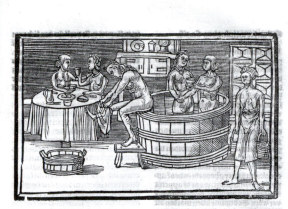

Fig. 10. Bathhouse scene from Magninus Mediolanensis, *Tregement der ghesontheyt*, 1514. Woodcut. Bijzondere Collecties, Amsterdam.

drawing may have served as a design for a wall painting in the palace of one of his patrons.[34] Within such a context, Gossart's bathers would have elided contemporary practice with the realm of the artist's studio, placing the nude body at the intersection of the real and the ideal. Within the composition, Gossart employs the bathhouse as a resonant space, a platform from which to demonstrate not only his virtuosic ability to depict the body from all angles but also his expansive art-historical knowledge. The *Spinario* that he studied in Rome inspired the hunched woman seated on the far left, and Italian Renaissance prints likely prompted Gossart's conception of several other figures.[35] The prominent woman in the foreground combing her hair as she gazes into a mirror is Gossart's *Venus*, now divorced from a mythological context and brought fully into everyday life. If the goddess's mythological identity mollified, or at least helped to justify, her sensual embodied representation in the painting, here only the female bather's coy preoccupation with her reflection mediates her otherwise direct confrontation with the viewer.

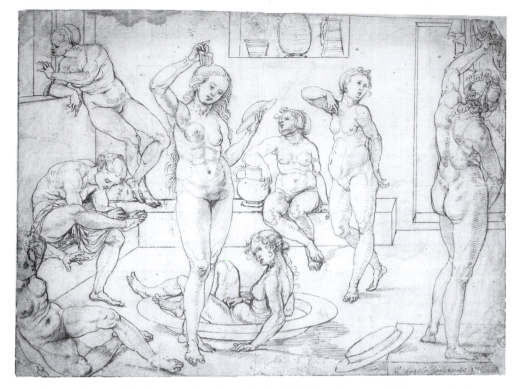

Fig. 11. Jan Gossart, *Women's Bath*, c. 1520–25. Pen and brown ink over black chalk, 38 × 50.3 cm. British Museum, London.

We have seen that Gossart drew not only on his study of ancient sculpture but also on the models of the nude body offered by his fellow northerners Dürer and van Eyck. His sophisticated engagement with these models depended in no small part on his patrons, who granted him the time as well as the privileged access to study such precious works of art. A particularly striking example of Gossart's elite position, and the knowledge it afforded him of local artistry and also of the much wider visual field, appears in *Venus* as well. Tucked behind the goddess's pedestal, Cupid's single drawn arrow and colorful feathered quiver might well evoke the distant New World, "discovered" in Gossart's lifetime and understood foremost through the exotic objects that traveled across the Atlantic to European collections. In 1519, some of the earliest of these objects were sent by Hernán Cortés from Mexico to the Netherlandish court, including weapons and featherwork artifacts representative of New World artistic practice.[36] When Dürer saw these objects in Brussels the following year, he marveled that they were wondrous beyond description.[37]

Gossart's patron Philip was among the few early sixteenth-century noblemen in the Low Countries who came to own such objects. Featherwork of "blue, white, red, and yellow pigments" is listed in his palace inventory, and it is tempting to imagine the feathered quiver in Gossart's *Venus* as his response to these foreign works, made from the material of living creatures, as counterparts to his own embodied approach

to the medium of painting.[38] Cupid's arrow and quiver might even double for Gossart's brush and palette, evoking the parallel between making love and making art, between New World wonders and his own painterly achievements. If we take the objects at Venus's feet as representing the tools of Gossart's artistry, we have to recognize not only the exclusive and intimate realm in which he worked but also Gossart's role in reflecting back on his patrons their own wealth, knowledge, and refinement. By affording Gossart access to the treasures of their noble collections, by supporting his travel to Italy and intensive study of his fellow northern artists, his patrons affirmed their own lineage and ambitions in the courtly realm.

A CAREER AT COURT

Gossart's radical assertion of mythological painting as a genre within the art of Low Countries, and his distinctive approach to the genre, depended foundationally on the traditions of the Burgundian court. His primary patron, Philip of Burgundy, was the last bastard son of the great Duke of Burgundy Philip the Good (1396–1467), under whose rule the Burgundian Netherlands had constituted by far the wealthiest power in all Europe. Philip the Good and his successor Charles the Bold had modeled a degree of courtly splendor and rich artistic patronage that Philip of Burgundy and his fellow early sixteenth-century noblemen desired to perpetuate.[39] The knightly order of the Golden Fleece that Philip the Good had founded in 1430 continued as a strong political and ideological institution for Gossart's commissioners.[40] The gleam of costly gold vessels and tapestries, which illuminated the chambers of the fifteenth-century Burgundian court, was a largesse beyond the reach of a bastard son like Philip of Burgundy, but the highest elite of the Netherlands still devoted tremendous resources to these modes of display.[41]

During the years that Gossart produced his mythological works, the political landscape of the Netherlands was on the cusp of a significant change. At the time Gossart was born, Maximilian I of Austria had just become ruler of the Burgundian Netherlands through his marriage to Charles the Bold's only daughter, Mary of Burgundy, in 1477.[42] Maximilian remained in power several years before relinquishing the position to his son and successor, Philip the Fair, who ruled briefly in his wake.[43] When Philip died prematurely in 1506, Maximilian appointed his daughter, Margaret of Austria (1480–1530), as acting regent in the Low Countries.

It was Margaret who presided during the ambassadorial mission to Italy in 1509 on which Gossart accompanied his patron Philip. Margaret, deeply committed to the traditions of the Burgundian court in which she was raised, pursued visual continuity with her Burgundian predecessors even while also participating in the budding local interest in antiquity. The seminal burial chapel that Margaret commissioned for herself, her husband Philibert of Savoy, and her mother-in-law at Brou represents a pinnacle of her vast and trend-conscious patronage.[44] Maximilian went on to become

Holy Roman emperor, working to extend the reach of his own Habsburg dynasty across Europe through war and political negotiation, while simultaneously expressing those ambitions through art.[45] He also ensured that Margaret cared for the upbringing of Philip's son, the young prince Charles, who would succeed Maximilian both in the Netherlands and within the widening Habsburg realm.

In 1530, just two years before Gossart died, Charles V was crowned Holy Roman emperor and ascended to unprecedented power as an international ruler, building upon the efforts of his grandfather Maximilian. From this moment onward, the art and rhetoric of political power in the Low Countries began to shift significantly to comply with the new position of the Netherlands within the larger Habsburg domain.[46] Burgundian visual tradition was never by any means banished, but over the ensuing decades of the sixteenth century, there was a sure and gradual embrace of a triumphant classicism declaring the region's ties to Roman imperial history and to Europe at large.

Gossart rode the crests just before this sea of transition. His engagement with antiquity under Philip's patronage—and, as we will see, even his unprecedented mythological nudes—still cleaved to a regional notion of the historical past, one that also had Burgundian roots. His career benefited from spanning the last decades in which the desire for Burgundian opulence forcefully persisted. And, in many ways, Gossart's documented activities exemplified what it had long meant to be a court artist in the Burgundian Low Countries. He not only enjoyed permanent employment from the highest members of the Netherlandish nobility but also worked closely with his patrons to create images that served their particular courtly needs. He produced designs for the tomb monuments of Charles V's sister Isabella of Austria and for his own Philip of Burgundy. He restored paintings for Margaret of Austria and, on Philip's behalf, advised on the design of a choir screen for Utrecht Cathedral.[47] When the exiled king of Denmark Christian II found refuge in the Low Countries, Gossart painted a portrait of his children (fig. 12).[48] The gallery of noble faces that confront us from his many portraits alone attests to his courtly success (fig. 13).

Even Gossart's major works for religious foundations stemmed from individuals with close ties to the inner Burgundian circle. He received the commission for his early *Adoration of the Kings*, which hung in the chapel of Our Lady at St. Adrian's Abbey in Geraardsbergen, from a friend of Philip of Burgundy, the Lord of Boelare Daniel van Boechout (fig. 14).[49] Gossart's most famous and monumental painting— the now-lost altarpiece created for the Premonstratensian Abbey of Middelburg in the province of Zeeland—was commissioned by the abbot Maximilian of Burgundy, nephew to Philip.[50] Situated in Zeeland's then-bustling capital port city, where innumerable travelers and noble embassies made landing, the altarpiece would have announced the resplendence of the Burgundian Netherlands to any visitor who saw it. Albrecht Dürer himself made a special pilgrimage to that work in 1520, though he wrote curtly in his diary that "it was better in painting than in design."[51] One can

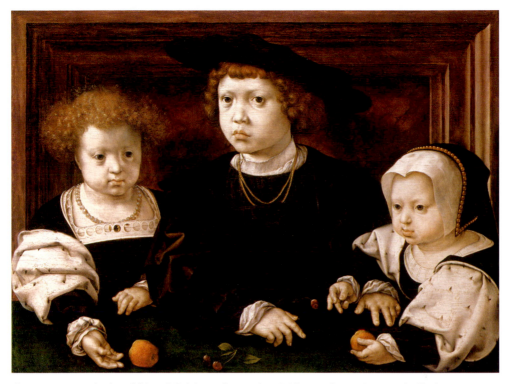

Fig. 12. Jan Gossart, *The Three Children of Christian II of Denmark*, 1526. Oil on panel, 34 × 36 cm. Royal Collection, Windsor Castle.

only wonder what Dürer would have said about Gossart's mythological works, inspired in part by the German artist's own designs in print.

To characterize Gossart as a court artist is not to deny that he may have run a workshop engaged in serially producing paintings for a broader market.[52] His numerous depictions of the Virgin and Child, many of which exist in multiple copies of varying quality, surely would have appealed beyond the court to urban and merchant buyers. But it was his embrace by the Burgundian court that launched his career, and it was the court that fostered the environment for his greatest artistic innovation. That is to say, the court provided the platform from which Gossart could launch his unprecedented mythological nudes, and a context in which his patrons could appreciate not only the erotic appeal but also the complex historical resonance of his works.

The documented owners of Gossart's mythological paintings also belonged to a small Burgundian circle. As we will explore in the next chapter, Philip of Burgundy was the patron who helped to cultivate Gossart's mythological inventions. What attracted Philip to the young artist is unknown; Gossart's career seems to have begun in the city of Antwerp, and perhaps the nobleman encountered him there.[53] Regardless, from their trip to Rome until his death, Philip provided Gossart a secure home base at his court. As discussed in chapter 3, Philip also helped to promote Gossart's

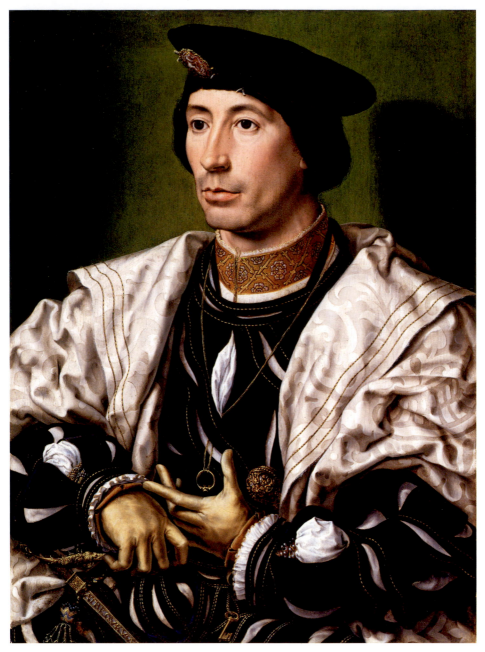

Fig. 13. Jan Gossart, *Portrait of a Nobleman*, c. 1528–30. Oil on panel, 56 × 42.5 cm. Gemäldegalerie, Staatliche Museen. Berlin.

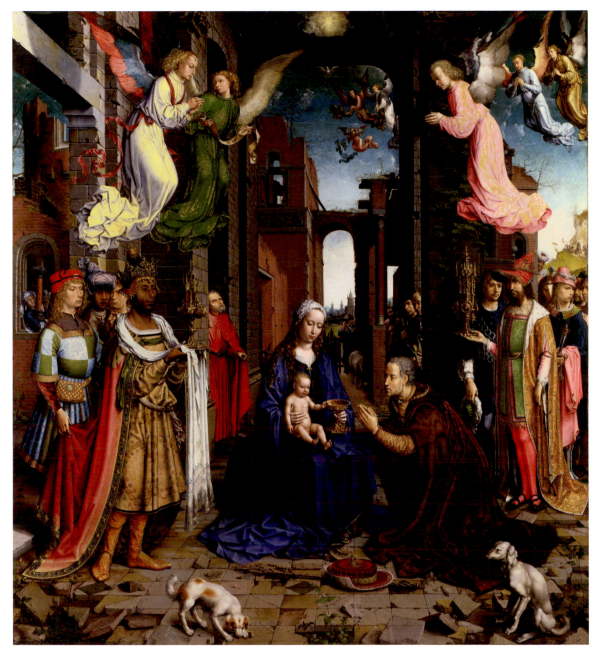

Fig. 14. Jan Gossart, *Adoration of the Kings*, c. 1510–15. Oil on panel, 177.2 × 161.8 cm. National Gallery, London.

mythological works by offering them as gifts to prominent figures like Margaret of Austria. Two close colleagues and friends of Philip—Count Henry of Nassau, Lord of Breda and knight of the Golden Fleece, and Philip of Cleves, Lord of Ravenstein—also owned monumental mythological paintings by the artist. Perhaps there were some urban patrons of Gossart's mythological works; nor is it impossible that a few of the humanists closely associated with the court owned works by Gossart as well. The inventory of the aforementioned scholar Willem Heda lists "a painting of a naked woman" in his collection, though the panel's authorship is not recorded, and Heda himself—who held numerous positions in the church and as a political official in the Habsburg administration—may have been a minor nobleman.[54] In short, the court remained the primary locus for Gossart's mythological works throughout his lifetime.

Yet the patronage structure in which Gossart operated is only one part of the story. As we have already seen, Gossart channeled the legacy of Burgundy through his ability to emulate—with greater skill than any of his artistic contemporaries—the paintings of Jan van Eyck. Like Gossart after him, van Eyck had garnered the adulation of the fifteenth-century elite and Duke Philip the Good himself.[55] His career spanned the glory days of the Burgundian court, and his art was bound up in its ideals. Granted, the duke took more interest in commissioning costly works of inherent material value, like the previously mentioned precious vessels and tapestries, than he did in the far less expensive genre of panel painting.[56] But for the members of the early sixteenth-century nobility for whom Gossart worked, van Eyck's paintings were intimately associated with the world of their fifteenth-century precursors. Van Eyck's detailed renderings of luscious vestments, costly marbles, shimmering gold-smith work, and uncannily lifelike portraits represented a window into a recent yet still distant past that Gossart had the ability to revive.

EYCKIAN REVIVAL

During the first decades of the sixteenth century, the desire to perpetuate Eyckian tradition was a larger motivating factor in Netherlandish art and collecting. Copies and interpretations after the works of van Eyck and other early fifteenth-century masters were produced steadily during Gossart's lifetime. One of Gossart's most successful contemporaries, Quentin Massys, active in the busy commercial metropolis of Antwerp, evoked fifteenth-century Netherlandish painting repeatedly in his works and especially in his devotional images.[57] Even Massys's *Moneylender and His Wife* includes a convex mirror in the foreground that recalls the play on reflection in van Eyck's art (fig. 15).[58] In particular, it evokes the famous convex mirror in van Eyck's lost painting of a woman at her bath and the mirror in the background of his *Arnolfini Portrait*, which not only invites the viewer into the picture's splendidly detailed interior but also reveals a pictorial self-awareness of the world beyond the frame (fig. 16).[59]

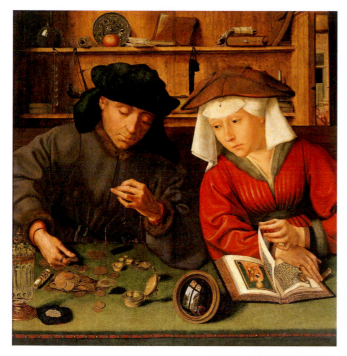

Fig. 15. Quentin Massys, *The Moneylender and His Wife*, 1514. Oil on panel, 70.5 × 67 cm. Musée du Louvre, Paris.

Fig. 16. Jan van Eyck, *The Arnolfini Portrait*, 1434. Oil on panel, 82.2 × 60 cm. National Gallery, London.

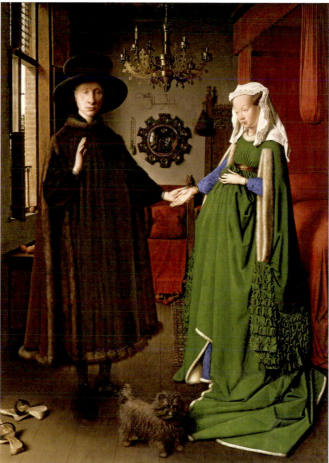

The *Arnolfini Portrait* itself was one of the great gems in Margaret of Austria's early sixteenth-century collection, where it is inventoried with a pair of wings adorned with the coat of arms of the donor who presented it to Margaret.[60] The added wings not only asserted the identity of their giver but must also have been intended to ensure the precious work's continued protection. Margaret's court artist Bernard van Orley, one of Gossart's most important contemporaries, also engaged with earlier Netherlandish tradition in both his paintings and the remarkable designs for tapestries for which he is most famous, and did so even while incorporating into his art a knowledge of Albrecht Dürer's prints and Italian Renaissance models.[61] In van Orley's case, it was the interests of his courtly patrons that motivated him to fathom the depths of the local artistic past, and the same was true for Gossart as well.

A handful of devotional paintings long attributed to Gossart follow van Eyck's compositions and might be cautiously described as "copies," though—as will become evident—that term obscures the creative interpretation and reimagining that underlie them.[62] The attribution of these works to the artist has not gone unchallenged, and doubts have been expressed in recent scholarship about the extent of Gossart's debt to his great precursor.[63] In my view, the question of authorship in these few instances in no way diminishes the significance of early Netherlandish painting to Gossart's artistic endeavor as a whole. The model of van Eyck has already proven central to Gossart's project of mythological painting in terms of both his painterly technique and his approach to enlivening the nude body within the pictorial realm. Surveying Gossart's religious works and portraits reveals that his relentless pursuit of embodiment and the representation of space—in a manner redolent of Eyckian tradition—was indeed a constant throughout his oeuvre.

In Gossart's remarkable *St. Luke Drawing the Virgin*, created for the altar of the painter's guild in Mechelen sometime circa 1515, he found a platform for asserting his particular contribution to local tradition (fig. 17).[64] St. Luke was the patron saint of Netherlandish artists, the apostolic founder of painting in the region, and there was a long practice of guilds commissioning altarpieces that represented him. The most significant fifteenth-century prototype was Rogier van der Weyden's *St. Luke Drawing the Virgin*, which itself derives its composition from van Eyck's *Rolin Madonna* and thus reveals a double origin both in the saint himself and in the founding father of Netherlandish painting (fig. 18).[65] Gossart looks back to van der Weyden's model in positioning the humble Virgin and saint in the foreground, with a deep expansive background behind them.

At the same time, the realm that Gossart's St. Luke and Virgin occupy is entirely new. The saint's act of capturing the true likeness of the Virgin Mary is inextricably bound up in Gossart's act of enshrining the figures within an architectural world of colored marbles, gilt bronze, elaborate capitals, and coffered ceilings that alludes both to the models of antiquity and perhaps even to elements of the *Tempietto* (c. 1502) in Rome, designed by the Italian Renaissance architect Donato

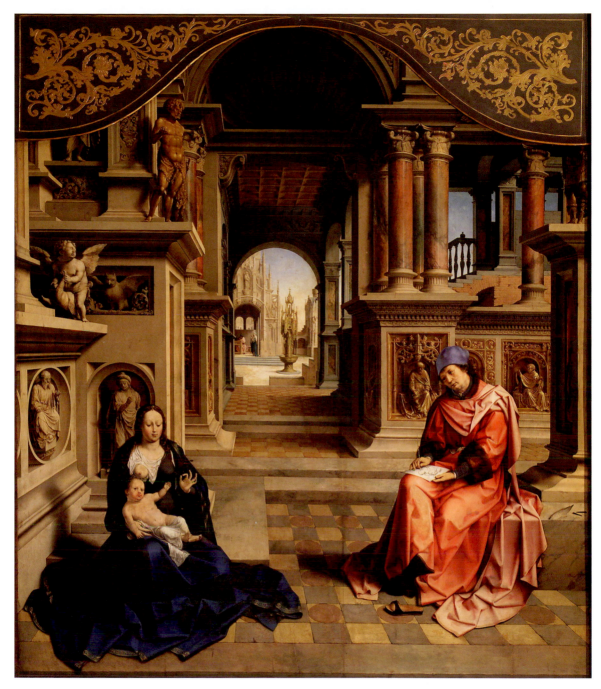

Fig. 17. Jan Gossart, *St. Luke Drawing the Virgin*, c. 1515. Oil on panel, 230 × 205 cm. Národní Galerie, Prague.

Bramante.[66] Here is the new repertoire of architectural and ornamental forms to which Netherlandish artists, as descendants of St. Luke, could now lay claim. The receding perspective lines converge on a resplendent Gothic fountain in the distance, beside which St. Luke and the Virgin appear yet again.[67] It is through this highly constructed space that Gossart invites us to imagine the Holy Mother's eternal presence, and to appreciate his skill in making them present before our eyes.

The Mechelen altarpiece attests that after studying the antiquities and sites of Rome, Gossart did not forsake his local roots. He returned home to conduct a rigorous inquiry into his native visual tradition, mastering the enlivened painterly techniques of his early Netherlandish forefathers and mingling them with his newly acquired knowledge from Italy. Gossart's aforementioned *Adoration of the Kings* (see fig. 14) is another seminal manifestation of these interests, painted on the foundation of works by his fifteenth-century predecessor Hugo van der Goes.[68] The strong sense

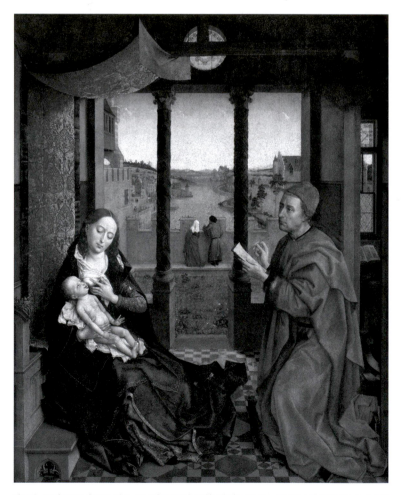

Fig. 18. Rogier van der Weyden, *St. Luke Drawing the Virgin*, c. 1435–40. Oil and tempera on panel, 137.5 × 110.8 cm. Museum of Fine Arts, Boston.

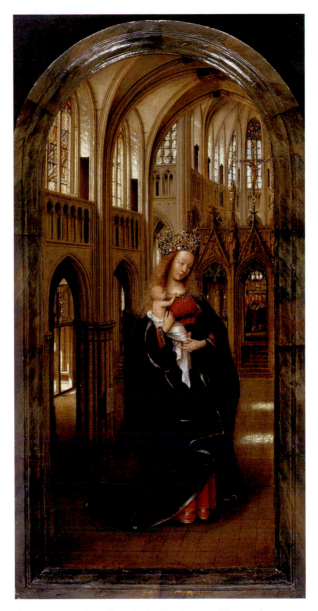

Fig. 19. Jan van Eyck, *Madonna in the Church*, c. 1425. Oil on panel, 32 × 14 cm. Gemäldegalerie, Staatliche Museen. Berlin.

of receding space in the *Adoration*, coupled with the attention to the minute details of costume, physiognomy, and the ornate golden vessels being offered as gifts to the Christ Child all align with the models of earlier Netherlandish painting.

Consideration of van Eyck's precious *Madonna in the Church* alongside Gossart's early work provides another example of his dialogue with his local artistic inheritance (fig. 19).[69] Van Eyck's small panel must once have formed part of a devotional diptych with an accompanying image of a donor in its right wing. The enshrined interior of the Gothic cathedral was understood within a long northern medieval tradition as symbolic

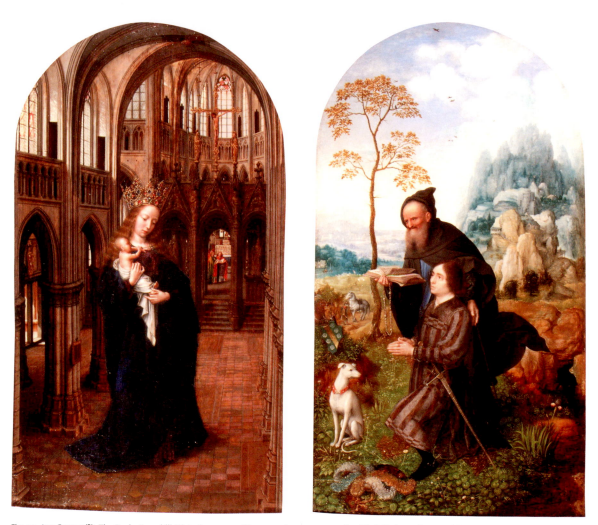

Fig. 20. Jan Gossart(?), *The Doria-Pamphilj Diptych*, 1510–15. Oil on panel, 40.2 × 22 cm (each). Galleria Doria Pamphilj, Rome.

of the body of the Virgin Mary, the ecclesiastical mother. Van Eyck's painting renders this metaphor as actuality by showing the Virgin engaged in an intimate moment with the Christ Child, yet simultaneously standing larger than life within the church interior, the tip of her delicate jeweled crown reaching almost to the clerestory. The play of sun and shadow on the church floor at once recalls the Virgin's purity—her Immaculate Conception was as pristine as light penetrating through glass—and also makes the space seem that much more believable as a world into which the viewer can enter. The tangible realm of the Gothic interior proffers the Virgin's body as a real presence, inviting the donor praying before the panel to imagine that she is really there.[70]

Van Eyck's *Madonna in the Church* was emulated by a handful of artists around the turn of the century including Massys and perhaps Gossart himself in the so-called *Doria-Pamphilj Diptych*, though the attribution of the painting has been questioned

(fig. 20).[71] Regardless, the contemporary interest in this particular work by van Eyck resonates with the detailed execution and format of Gossart's *Malvagna Triptych* from circa 1513 (fig. 21).[72] In each panel of this precious triptych, measuring just over one foot high, Gossart envelops his divine subjects in a canopy of glistening flamboyant Gothic ornament, the new and popular stylistic mode of the early sixteenth-century Netherlands.[73] Gossart boasts his mastery of the local style by making each canopy slightly distinct in its patterning, while at the same time unifying the triptych as a convincing whole. The architectural embrace of the saintly bodies evokes the same conception of the Virgin as ecclesiastical mother and employs the same compositional strategy as van Eyck's example, but also renders the work unmistakably contemporary.

In the *Malvagna Triptych* Gossart also already begins to play with the boundary between viewer and picture as he did in his later mythological painting *Venus*. Far more insistently than her counterpart in van Eyck's *Madonna*, Gossart's Virgin inhabits the very foreground of the picture, the liminal point between image and viewer. Among her coterie of frolicking musical angels, a few even tantalize by dangling their little feet off the edge of the frame, as if to emphasize their pronounced proximity. It is no coincidence that Gossart inscribed his signature in this very active zone of the painting, along the step just below the Virgin's feet, as if to mark the site where his creative agency is most assertively present.

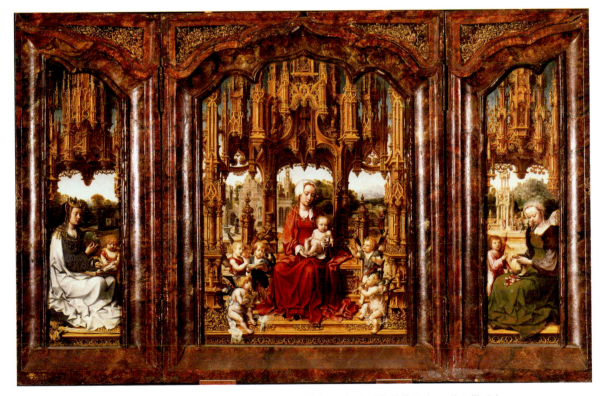

Fig. 21. Jan Gossart, *Malvagna Triptych*, 1513–15. Oil on panel, 45 × 18 cm. Galleria Regionale della Sicilia, Palazzo Abatellis, Palermo.

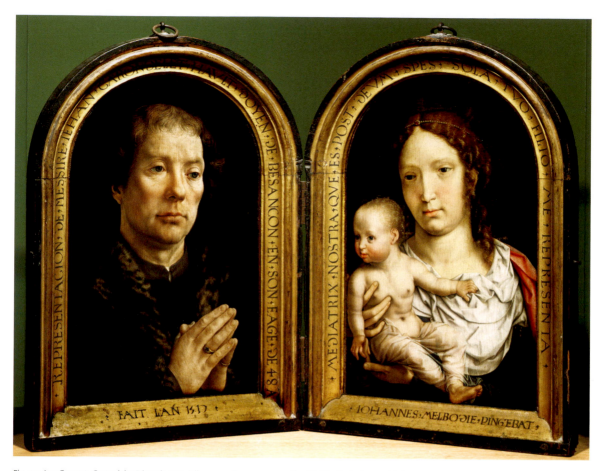

Fig. 22. Jan Gossart, *Carondelet Diptych*, 1517. Oil on panel, 42.5 × 27 cm (each). Musée du Louvre, Paris.

Gossart's portraits likewise demonstrate his historically conscious approach to the models of his Netherlandish predecessors. While the costume of the unidentified nobleman in his Berlin portrait is wholly contemporary, his three-quarter pose, the insistent rendering of his sartorial finery, the Burgundian motto inscribed on his sword, and the vivid portrayal of his face—even down to the stubble of his moustache—all align Gossart's likeness with those of Burgundian courtiers from the previous century (see fig. 13).[74] Even the wonderful gilt fish that seems to come alive and bite the sitter's right pinky recalls the fifteenth-century practice of augmenting portraits with additional markers of identity, not only mottos but also personal pictorial emblems. Neither the identity of the sitter nor the significance of the fish has been discovered, but even in anonymity the painting reflects an early sixteenth-century courtly realm indebted to fifteenth-century tradition.

Along similar lines, the *Carondelet Diptych* that Gossart created in 1517 harkens back to the format of early fifteenth-century models in rendering the connection

between saintly mother and donor inescapably immediate (fig. 22).[75] Jan II Carondelet, a prominent Burgundian official who nonetheless lacked the true noble lineage of many of his colleagues, patronized Gossart—the eminent court artist du jour—in part as a way to link himself more closely to the courtly milieu. Within the interior, Carondelet's praying hands and the Virgin's presentation of the Christ Child push so far forward that the devotional encounter almost seems to happen in the space between the two panels, in the real three-dimensional world; indeed, the diptych was likely displayed open only at a partial angle to heighten the effect of their emergence from the picture plane.[76] The word "representation" that Gossart inscribed around each of the interior frames even seems to pronounce emphatically that the act of re-presenting, or making present again, is really what his art is all about.[77] This re-presentation applies both to his living portrayal of the Virgin and her supplicant and also, on another level, to Gossart's virtuosic evocation of the pictorial past. Gossart is underscoring the idea that his paintings not only collapse historical time between subject and viewer but also merge tradition and innovation.

Carondelet's use of visual association with the fifteenth-century Netherlands also manifests itself in other commissions. *St. Donatian*—a panel formerly attributed to Gossart and now more plausibly given to Jan Cornelisz. Vermeyen—was painted for Carondelet circa 1525–30 to memorialize his office as canon of St. Donatian's Church in Bruges (fig. 23).[78] The panel formed part of a diptych or a triptych that included an extant portrait of Carondelet in his canon's robes (fig. 24).[79] Modeled on the depiction of the saint and donor in van Eyck's *Van der Paele Madonna*—a painting that then hung in St. Donatian's Church—the commission further indicates how central van Eyck remained to the early sixteenth-century imagination and conceptions of local identity. Facing the image of St. Donatian from his accompanying portrait, Carondelet entered into dialogue with a history of artistic patronage as well as a distinguished ecclesiastical lineage.

Any doubt as to Gossart's emulation of van Eyck is finally dismissed by a painting that represents his most direct engagement with local tradition. Gossart performs a more self-conscious revival of the Eyckian past in his *Deesis* (c. 1525–30) than he ever undertakes in relation to the models of Roman antiquity (fig. 25).[80] Gossart followed the figures of his distinguished predecessor in one-to-one ratio, skillfully capturing the depiction of precious gems and gold embroidery, and the lifelike portrayal of the body for which van Eyck was known. One has only to look at the stunning pearls casting their soft shadows against Christ's robe, or the vibrancy of John the Baptist's gesticulating hands.

At the same time, Gossart historicizes the figures of the *Deesis* by placing them once again within flamboyant Gothic arches, marking out his work as distinct from its model.[81] This framing device may well have served to integrate the painting into its intended setting; it has been proposed that the *Deesis* was created for Margaret of Austria's burial chapel in Brou, composed predominantly in a Renaissance Gothic mode.[82] Yet the very notion of reframing and reintegrating the most famous work of

art from the previous century signals a perceived distance from the moment of its original creation. This temporal awareness did not by any means preclude the devotional function of the *Deesis*, but it points to a simultaneous appreciation for van Eyck's art as part of the local historical record.[83] When Marcus van Vaernewijck pays homage to the *Ghent Altarpiece* in his 1568 *Mirror of Netherlandish Antiquity*, he not only lists Gossart among the admirers of the work but also treats van Eyck's famous painting itself as an "antiquity" worthy of preservation.[84]

Vaernewijck's historization of the *Ghent Altarpiece* is already anticipated in Gossart's oeuvre. For Gossart, to paint in the Eyckian manner was to work in what might be called an antiquarian style, one that involved the excavation not of ancient stones but of the pictorial world of the recent Netherlandish past.[85] Through his superior mastery of Eyckian technique, Gossart ensured his success among the Netherlandish nobility and distinguished himself from his artistic contemporaries just as much as through his knowledge acquired in Italy. His engagement with van Eyck did not precede but was instead part and parcel of his revival of antiquity. While many subsequent artists in the Netherlands would go on to paint mythological images, Gossart alone approached classical subject matter with a visual vocabulary and technical virtuosity grounded in earlier Netherlandish tradition.

Fig. 23. Jan Cornelisz. Vermeyen(?), *St. Donatian*, c. 1525/30. Oil on panel, 43 × 35 cm, Musée des Beaux-Arts, Tournai.

Fig. 24. Jan Cornelisz. Vermeyen(?), attributed to Jan Gossart, *Portrait of Jan II Carondelet*, c. 1525/30. Oil on panel, 43.2 × 34.3 cm, The Nelson-Atkins Museum of Art, Kansas City, William Rockhill Nelson Trust.

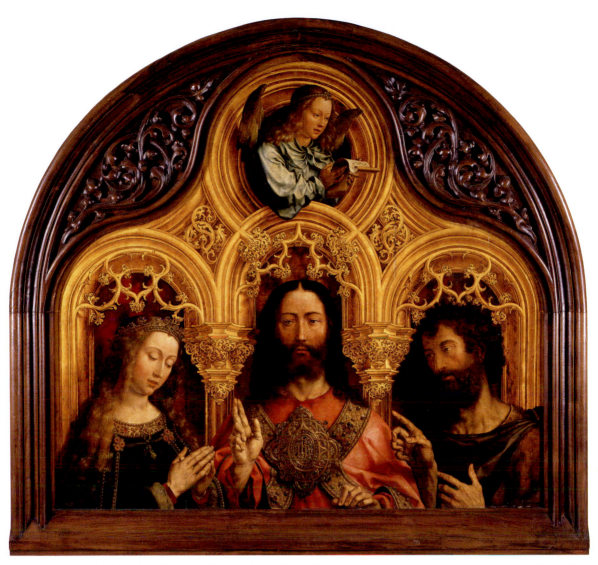

Fig. 25. Jan Gossart, *Virgin Mary, Christ Blessing, and St. John the Baptist (Deesis)*, 1525–30. Oil on paper attached to panel, 122 × 133 cm. Museo del Prado, Madrid.

Yet while reviving the Burgundian past through stylistic means served Gossart's local patrons in perpetuating one aspect of their past, it was not enough to claim a local renaissance rooted in antiquity. Gossart's patrons distinguished themselves from their fifteenth-century Burgundian predecessors precisely in their desire to showcase a knowledge of their classical pedigree based on historical evidence, and to affirm that knowledge through collecting practices and permanent artistic commissions. What catalyzed this new interest among the Netherlandish nobility?

The scholarly circles in the early sixteenth-century Low Countries provide the answer. In order to achieve their artistic aims, Gossart and his patrons recruited local humanists who were busy excavating ancient texts and interpreting archaeological sites in the region, and the ruminations of these humanists rubbed off. Rather than bringing Italy to the Netherlands, it was the aspiration—expressed by these scholars—to make the Netherlands a worthy rival to Italy that girded Gossart in the achievement of his ultimate innovation and provided the impetus for his patrons to embrace the figures of their ancient past.

A NEW LATIUM

Sometime prior to 1530, the Netherlandish humanist Gerard Geldenhouwer laid eyes upon one of the most coveted historical sources discovered in his lifetime. In the collection of his German colleague Conrad Peutinger, Geldenhouwer studied firsthand a medieval copy after an ancient road map charting the entire Roman Empire across eleven sheets of parchment and measuring almost seven meters long.[86] At the center of this map, Geldenhouwer would have seen Rome itself, depicted larger than any other city and personified as a seated ruler holding the orb of the world, surrounded by roads leading outward like the spokes of a wheel toward the far reaches of Persia, Spain, and Britain (fig. 26).

When recalling Peutinger's map in his later writings, Geldenhouwer reveals that his own interests lay in a location on the extremity of the Roman Empire (fig. 27). There nestled between two rivers was inscribed the Latin name for Geldenhouwer's birthplace, *Noviomagi*, or Nijmegen, near a site labeled "the camp of Hercules" that the humanist identified with the local town of Gorcum.[87] Although in the grand scheme of Peutinger's map, both were only minor outposts, diminutive in size and importance compared to the Roman capital, the region of Geldenhouwer's birth was for him the very heart of his historical inquiry and a source of immense pride. In a poem from the same treatise, Geldenhouwer extols his native city as unrivaled by ancient Greece, as worthy of praise as Rome itself: "O Nijmegen, with whom no other place on earth contends, a grove has wreathed round you with aged oak trees. A river equal to the Helicon surrounds you, along with nourishing fountains that shining Apollo loves."[88]

Gerard Geldenhouwer (1483–1542) was the most important humanist collaborator with Gossart, and served as both secretary and biographer to the artist's patron Philip.[89]

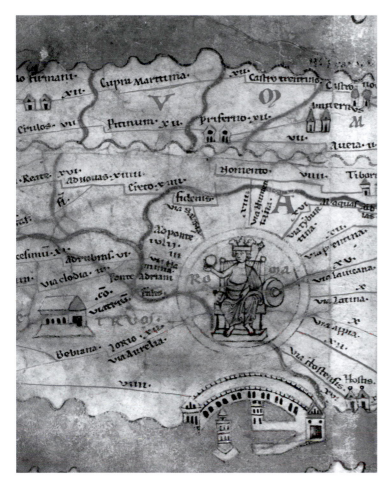

Fig. 26. *Tabula Peutingeriana* (detail), c. 1200.
Österreichische Nationalbibliothek, Vienna.

Fig. 27. *Tabula Peutingeriana* (detail), c. 1200.
Österreichische Nationalbibliothek, Vienna.

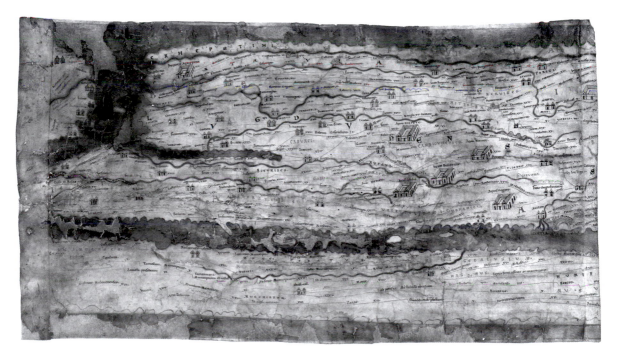

The tension between Rome and Nijmegen, center and periphery, that underlies Gelden-houwer's pursuit of classical revival was as central to Gossart's project as it was to the longer history of humanist endeavor in the Netherlands. Already in the fifteenth century, the Netherlandish humanist Rudolph Agricola—the scholarly counterpart to Jan van Eyck—was the first to express the desire that his native shores might one day surpass Italy in civilization and learning. The Low Countries were called "lower Ger-many" (*Germania inferioris*) in ancient textual sources, and it is for this reason that Agricola proclaims the region's promise under that name:

> We will liberate ourselves from the disgrace that now surrounds us; they will cease to call us barbaric and illiterate and dumb and whatever else that might be considered even more uncivilized. I hope that our *Germania* will then be so learned and literate that not even Latium itself will be more Latinate.[90]

Agricola evokes the epic model of Virgil's *Aeneid* to describe a nation poised between past and future. He aspires for the Low Countries to become a new Latium, like the region that Aeneas colonized as founder of the Roman Empire, a place where the ideals of classical culture could flourish anew.[91]

When his fellow countryman Petrus Montanus echoed Agricola's words at the end of his 1504 *Adage in Praise of the Germans*, the promise of Latium was beginning to seem more real.[92] The great Netherlandish humanist Desiderius Erasmus was quickly establishing an international reputation as a leading scholar. Erasmus's Trilingual College at the University of Leuven, which he helped found in 1517 as a site for rigorous study of Latin, Greek, and Hebrew, not only attracted eminent intellectuals from across Europe but helped to cultivate an ever-growing circle of distinguished Netherlandish humanists, including Geldenhouwer himself. By 1530, Charles V's ascent as Holy Roman emperor had been matched by the ascendance of intellectual culture in the Low Countries, which Agricola had prophesied in his first call to arms.[93]

Geldenhouwer's pride in the antiquity of his hometown of Nijmegen was directly connected to his belief that the Netherlands could challenge Italy in cultural achievement. For Geldenhouwer and other local humanists, evidence that the Low Countries constituted a region rich in ancient history underscored their contempo-rary pursuit of classical revival in arts and letters. A distinguished *local* past would allow them to assert both their independence from, and unique scholarly contribu-tion to, the humanist movement in Europe at large.

In the service of advancing their own historical agenda, Netherlandish human-ists naturally looked to their Italian counterparts for examples of how to undertake antiquarian study.[94] The scholar Matthaeus Herbenus, for instance, signals his knowledge of the Italian historiographers Flavio Biondo and Leonardo Bruni in the introduction to his 1485 treatise *On Maastricht Restored*, a celebration of his home-

town in the Low Countries. However, Herbenus employs their models to his own end. He does not celebrate the edifices of Rome and Florence; instead, he lauds the Romanesque churches within Maastricht's walls as ancient monuments and traces the city's foundation back to Julius Caesar.[95] Even though Herbenus follows the rhetorical outlines laid out by Italian historians, he does so in praise of his own country. Imitation of form equates not with passive reception but instead with the active writing of history.

The competitive dialogue between Netherlandish scholars and their colleagues in Italy intensified in the years preceding Gossart's turn to mythological painting. A particularly relevant case is Geldenhouwer's close friend and fellow humanist Martin Dorp. In 1508, Dorp wrote the conclusion to a play by the Roman author Plautus titled *The Pot of Gold*, which had survived from antiquity only as a fragment.[96] In his proposed conclusion, he strove to capture Plautus's original style as a model for Latin students, who then performed the entire play under his direction in Leuven that same year.[97]

Dorp's colleagues extolled his contribution to humanist education in the Low Countries. His friend Jan Becker of Borssele proclaimed: "Henceforth you will be for me like that painter, wished for already long ago. With that little brush of yours, you were able to restore that most infamous Venus of Apelles, which had been mutilated in her nether regions. You did what nobody else had dared to do."[98] By invoking the famous statue of the ancient artist Apelles, Jan Becker praises Dorp for having carried out that archetypal humanist operation: the restoration of the past and its revival in the present.[99] Not surprisingly, when Dorp made the unfortunate discovery soon thereafter that the distinguished Italian scholar Antonio Urceo had previously written an ending for Plautus's play, he was eager to defend the originality of his work:

> Let nobody think perchance that I desired to contend for glory: pitting youth against old age, Holland against Italy, the philosopher against the poet. This work of mine did not fail to please some very learned men, since they made their vote of approval both through numerous letters and by performing it in the most celebrated towns.[100]

Although Dorp did not set out to trounce his Italian colleague, he insinuates that he may have done just that. In the competitive revival of antiquity, Holland and Italy were now tied, one to one.

Herbenus's praise for the antiquity of Maastricht and Dorp's restoration of Plautus strongly parallel Gossart's approach to visual models in his mythological paintings. Gossart naturally drew on the firsthand knowledge he acquired in Italy and other intermediary Italian sources, but the goal was always in the end to produce paintings that would stand for the revival of antiquity in his own land and contribute to the larger project underway in the circle of patrons and humanists with whom he

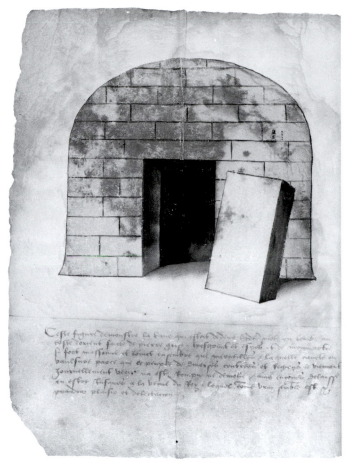

Fig. 28. Entrance to tomb outside Brussels, c. 1507. Österreichische Nationalbibliothek, Vienna.

collaborated. In building upon the foundations of Eyckian tradition in his mythological works, Gossart created images that proclaimed their local origins in their very appearance and material makeup; even if they depicted classical subjects and classicizing architecture, his inventions were still fundamentally part of Netherlandish antiquity and could not be claimed by anyone else. More than once, Geldenhouwer evokes the overused trope of humanistic writing and hails Gossart as "a second Apelles."[101] What he really means is that the artist—as Jan Becker declared to Dorp—had done what nobody else dared to do: forge new ground in the restoration of the ancient past on Netherlandish soil.

It was from this perspective that Geldenhouwer and his fellow humanists roused Gossart's courtly circle to engage with the revival of antiquity. Beyond his interest in the history of his hometown of Nijmegen, Geldenhouwer was also a pioneer in antiquarian study of the region at large. He published the first treatise

exclusively devoted to the Batavians, the ancient inhabitants of the Low Countries who had been newly rediscovered in the writings of Cornelius Tacitus and other Roman authors. We will see in the following chapters that he actively pursued knowledge of the region's ancient boundaries as well as its character and virtues. In doing so, Geldenhouwer made a significant intellectual impact not only in the early sixteenth century but also long thereafter.[102]

The flurry of interest in the Batavians and the quest for evidence of this ancient population's former presence in the region was also concurrent with new archaeological finds in the Netherlands. Early excavations outside Leiden and Brussels garnered the attention of Emperor Maximilian of Austria, who had already engaged in various antiquarian undertakings in Germany and may have helped to encourage such pursuits in the Low Countries.[103] During his 1508 visit to Leiden, Maximilian received as gifts antiquities discovered at the site of Roomburg, including ancient coins, two bronze lions, and a small bronze statue of Minerva.[104] A tomb outside Brussels discovered one year earlier in 1507 also attracted Maximilian's interest, and a manuscript account of its finding, associated with the local humanist Jean Lemaire de Belges, not only illustrates the tomb's entrance but also refers to the "pleasure and delectation" that Maximilian took in visiting the site together with the many other "people from diverse countries and regions who came everyday to see it" (fig. 28).[105] As the next chapter reveals, both Geldenhouwer and Gossart's patron Philip of Burgundy would become involved in their own archaeological investigation just a few years later.

The understanding of what constituted Netherlandish antiquity in Gossart's circle has already proven to encompass the paintings of Jan van Eyck, but it was also inflected by the melding of Burgundian tradition with the newfound awareness of Batavian ancestry, and with the humanist enterprise of Geldenhouwer and his colleagues. It was this evolving conception of local history that captured the interest of Gossart's noble patrons and spurred them to commission works of art that could fill in where the local archaeological record was lacking to affirm their own ancient past and participation in a local renaissance.

LAND

Land was the foundation of any claim to a historical past, and yet the land of the Low Countries was especially resistant to historiographical reconstruction. The local humanists in Gossart's milieu sought to recover the ancient geography of the Netherlands as it existed during Roman times, but in doing so, they faced not only a relative dearth of archaeological evidence but also the vagaries of the region's fluid and ever-changing boundaries, caught in a perennial skirmish with the tides.

Gossart's earliest known mythological painting emerged out of the discussions and debates surrounding this very question (fig. 29).[1] Signed prominently in Latin "Jan Gossart painted this" and dated to 1516, the painting has been heralded as the first monumental depiction of classical nudes in the history of Netherlandish art. No less significant than the bodies themselves is the setting that frames them, with its equally unprecedented revival of ancient architectural forms. These two aspects of the work have secured its essential place in scholarship tracing the emergence of the antique mode in the sixteenth-century Low Countries. Yet more important than questions of style and artistic models is what actually motivated Gossart to develop his unique pictorial strategy toward the embodiment of the past, both in this image and in all his subsequent mythological works.

Gossart's painting will prove to mark the beginning of the local antiquarian project that the artist, his patron,

and several humanist interlocutors sought to champion in their home province of Zeeland, a stretch of land where the sea is constantly brushing elbows with the shores. Not only has Gossart designed the architecture and implied space of the picture to evoke the past and present topography of that watery province; he has also endowed the figures themselves with polysemous identities. Through the interaction between Neptune and the goddess at his side—long identified simply as Amphitrite—the artist embodies both the prowess of his patron and the fertile region of Zeeland itself.[2]

BEYOND ROME

Two gods stand poised on a stone pedestal. Their sculpted bodies, fixed like marble statues within their resplendent architectural surrounds, are not carved of cold stone but ripple with muscle and breath. A halo of stubble prickles the male god's cheeks and chin, and curls of hair adorn his massive chest. A conch shell strung precariously around his hips with a leafy vine covers, but also accentuates, his formidable manhood: a preposterous display of false modesty. The goddess wears no such covering and yet she blushes, inclining her blue eyes toward her lover's face, and parting her lips ever so slightly to reveal her two front teeth. The god wraps his arm around her protectively, taking hold of her hand with a gesture of decorum and resting his mighty thumb on her white fingers. The goddess reciprocates, reaching her arm behind the god's back and closing the circle around her body.

Gossart's 1516 painting was the product of a close collaboration among him, his patron, and a court humanist, which seems almost a stereotype of Renaissance artistic production, yet represents a working relationship largely unprecedented in the art of the Netherlands prior to that point. The painting was commissioned and inspired by the admiral of the Netherlands Philip of Burgundy, whose name and personal motto, *A plus sera* ("There will be more"), appear in the work's upper right corner.[3] According to Willem Heda, Philip "exercised painting and drawing in his free time and was skilled in both, and was the best judge of sculptures," a description that emphasizes the nobleman's discerning eye for art.[4] In addition, Philip's newly employed secretary, the humanist Gerard Geldenhouwer, almost surely played a crucial role in guiding the painting's conception.[5] There is much evidence to suggest that Geldenhouwer's antiquarian pursuits at court and beyond fed the imaginations of artist and patron alike.

Gossart's relationship with Philip began early in his career with their storied trip to Italy. Between late fall of 1508 and the spring of 1509, Philip led an ambassadorial mission to the papal court of Pope Julius II and asked the artist to accompany him.[6] The embassy traveled through northern Italy and arrived in Rome in January 1509. According to Geldenhouwer's posthumous biography of Philip, the admiral's audience with Julius II extended beyond diplomatic parlance to a discussion of ancient art and architecture. Allegedly the pope was so impressed with Philip's knowledge that he gifted

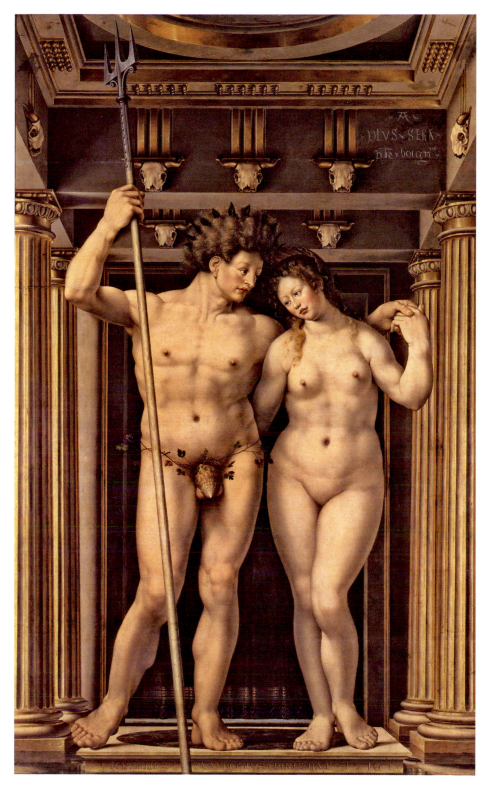

Fig. 29. Jan Gossart, *Neptune and Zeelandia*, 1516. Oil on panel, 188 × 124 cm. Gemäldegalerie, Staatliche Museen. Berlin.

the northerner with two ancient busts, which Geldenhouwer identifies as portraits of Julius Caesar and the Roman emperor Hadrian.[7] If this story is true, the busts would have been among the earliest Roman antiquities ever owned by a Netherlandish patron.

Still more unprecedented, however, were the drawings that Gossart produced during this brief sojourn, the first known studies after Roman antiquities by an artist from the Low Countries.[8] Gossart must have made many more drawings than the four sheets that survive today, but in themselves the extant examples represent his diverse interests, captured in a meticulous style characteristic of his Netherlandish training. He drew great architectural structures like the Colosseum (fig. 30).[9] He scrutinized the design of ancient armor and classicizing ornament on statues and monuments, as evinced by the collected studies on his *Spinario* sheet (see fig. 5). And he sketched monumental figural sculptures, carefully observing the poses and musculature of their bodies (figs. 31–32).[10]

While Gossart was surely not the first Netherlandish artist to visit Rome, his arrival coincided with a momentous period of antiquarian endeavor in the city, where

Fig. 30. Jan Gossart, *View of the Colosseum Seen from the West*, c. 1509. Pen and brown ink over black chalk, 20.2 × 26.8 cm. Kupferstichkabinett, Staatliche Museum, Berlin.

Fig. 31. Jan Gossart, *Apollo Citharoedus of the Casa Sassi*, 1509. Pen and brown ink, over black chalk, 30.8 × 17.7 cm. Galleria dell'Accademia, Venice.

the famous ancient sculpture of the Laocoön had been unearthed less than three years earlier, and where Julius II himself had just installed the Belvedere courtyard in the Vatican palace to showcase newly rediscovered works from antiquity.[11] Yet Geldenhouwer reports that Gossart did not create these studies solely on his own initiative but at Philip's strong behest: "Nothing in Rome delighted Philip more than those sacred monuments of antiquity, which he commissioned the most famous painter Jan Gossart of Mabuse to depict for him."[12]

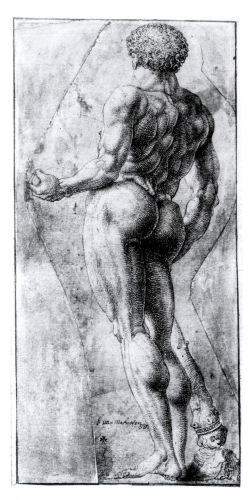

Fig. 32. Jan Gossart, *Hercules of the Forum Boarium*, c. 1509.
Pen and ink, 22.6 × 10.7 cm. Location unknown.

Scholars have often cited this passage as evidence that Rome provided the main impetus for Philip's subsequent commission of works like Gossart's 1516 painting, but to do so is to take Geldenhouwer's statement out of context. By the time he wrote and published the biography in 1529, Geldenhouwer's open conversion to Lutheranism meant that his account of the Roman sojourn was informed as much by his religious convictions as by the memory of his deceased patron.[13] Immediately after his mention of Gossart's drawings, Geldenhouwer proceeds to pit Philip's admiration for "the sacred monuments of antiquity" and the citizens of venerable Roman descent against the disgust he felt toward the immoral ecclesiastics at the Vatican. Geldenhouwer writes that Philip saw cardinals stick out their tongues and make obscene gestures at the members of his embassy so as to insinuate that all northerners were simple folk.[14] Whether or not this corresponds to what Philip actually experienced, the rhetoric and intentionality of the passage as a whole—the contrast Geldenhouwer establishes between the wickedness of present-day Rome and the purity of its classical past—should alert us to the inadvisability of treating the biography as a straightforward historical document.[15] When Geldenhouwer concludes his account of the embassy by reiterating the language of his earlier reference to Gossart's drawings—"In short, nothing in Rome pleased Philip except the sky and sun, stones and timbers, and those Roman citizens"—it becomes clear the humanist is principally concerned to emphasize that Philip admired only those aspects of Rome true to its ancient origins and untarnished by Catholic corruption; his passing reference to Philip's commission provides merely one example in this vein.[16]

The surviving drawings themselves offer a more objective means by which to consider the mutual project of artist and patron, and to appreciate the appeal of such works as personal records of their shared visit. In Gossart's drawing of the Colosseum, the seeming eagerness of his pen, the desire to render every detail of the monument before him, extends not only to the building's tiered columns but also to its crumbling stones, sprouting weeds, and the surrounding terrain that seems in danger of engulfing its very foundations. The artist captures the experience of viewing the past across the gulf of temporal distance. Both the high level of finish and the inscription in the sheet's upper right corner, which identifies the artist in the third person and in a contemporary hand that is not Gossart's own, suggest that drawings such as this

one came to serve their patron more as mementos of the Roman experience—collector's items that Philip could show and discuss at his court—than as the active vehicles for Gossart's creation of a new kind of painting.[17] It is significant that upon returning home from Italy, Gossart did not make immediate use of these drawings as visual models but instead began a productive dialogue with the painterly tradition of his early Netherlandish predecessors; his *Malvagna Triptych* and *Adoration of the Kings* have already offered crucial examples of this early endeavor (see fig. 14, fig. 21).

Even when Gossart finally produced the painting known as *Neptune and Amphitrite*—seven years after his visit to Rome—his use of Italian models is hardly emphatic. Any recollection of specific monuments is folded subtly into the fabric of his own composition. Gossart does not explicitly quote a single Roman building, nor does he adhere strictly to ancient precepts. Examples include the wholly unclassical capitals of the surrounding columns and the arrangement of the triglyphs in the entablature, which are situated above the bucrania rather than adjacent to them as properly illustrated in the 1511 edition of the ancient Roman Vitruvius's treatise *On Architecture*.[18] While boasting his knowledge of antiquity and inventive approach to architectural form, Gossart simultaneously avoids any overt or site-specific reference to the antiquity of the eternal city. Gossart is here constructing an alternative antiquity out of forms suggestive of—yet distinct from—the canon of ancient architecture.

At the same time, within this eccentric architectural space, Gossart situates two figures still firmly grounded in northern artistic tradition. Gossart recalls again the archetypal precedent of Dürer's *Adam and Eve* (see fig. 2), disrupting the prelapsarian purity of the engraving's composition—its two figures inclined toward one another but not touching—through the sensual embrace of Neptune and his consort.[19] Past scholarship has often cited a circa 1510 engraving of Mars and Venus by the Italian artist Jacopo de' Barbari as the other immediate point of reference for Gossart's painting, owing to a single mention of de' Barbari in Geldenhouwer's biography of Philip.[20] Yet it seems more likely that de' Barbari, who was not especially adept at portraying the figure, was himself engaging with Dürer's *Adam and Eve* in designing his *Mars and Venus*, and that the affinity between the Italian's print and the pose of Gossart's figures is the result of their shared dialogue with that model. Jacopo de' Barbari's importance to Gossart ultimately seems overstated in light of the visual evidence, as is perhaps his perceived influence on early sixteenth-century art in Germany and the Netherlands at large.

Once again, equal to if not more significant than Dürer's example is that of Gossart's forefather Jan van Eyck, whose legacy superseded the allure of Italy in the early sixteenth-century Low Countries. Gossart unquestionably looks back to the figures of Adam and Eve from van Eyck's *Ghent Altarpiece* (see fig. 7) in depicting his deities with blushing cheeks and conspicuous body hair, the signs of living bodies rather than lifeless stone.[21] These details are the hallmarks of an Eyckian tradition of painterly enlivenment and would have resonated as such with Philip and his fellow

members of the Netherlandish court. Even Gossart's imaginative play with ancient architectural forms could be seen in parallel to van Eyck's creative engagement with Romanesque architecture; in paintings like van Eyck's *Van der Paele Madonna* (see fig. 6), the Romanesque setting connotes an "antique" space at a historical remove from the artist's own fifteenth-century context, much as the architecture in Gossart's painting marks out the temporal distance between the depicted gods and their sixteenth-century viewers.[22]

That Gossart should have followed local painterly tradition to any degree may seem surprising given the work's overtly classical subject, but his choice relates directly to the context of its creation. After their southern journey, both the artist and his patron returned to make their home in Zeeland, a Netherlandish province that was especially important to Philip's duties as admiral.[23] Geldenhouwer reports in his biography that Philip "presided over the matters pertaining to the profit of all Zeeland and its mariners with no less care than he gave to his own home."[24] Geldenhouwer's statement is not mere hyperbole, for as we will see, Zeeland's shores were as crucial to Netherlandish trade and diplomacy as to the recognition of the region's ancient history. Understanding Philip's particular devotion to the shores of Zeeland, and Geldenhouwer's own involvement at his court, brings us closer to the unique motivations underlying Gossart's composition.

THE CHARMS OF ZEELAND

In September of 1517, Cuthbert Tunstall wrote to his friend Desiderius Erasmus in a ghastly mood. Tunstall had just spent two months in Zeeland as English ambassador to the Netherlandish prince Charles V, who was preparing to set out from the province to claim his hereditary right to the kingdom of Spain.[25] Tunstall and his fellow ambassadors had been forced to stay put until favorable winds allowed the prince to set sail. With trenchant prose, the Englishman describes the place in which he had been obliged to linger so unwillingly: "I with my household am returned from Zeeland barely safe and sound, after such a severe trouncing from the foul and absolutely pestilential stink of the air in those parts that many days' fasting has not yet quite driven off the fever that it gave me!"[26] After likening Zeeland's waters to the black and bitter Styx itself,[27] Tunstall recounts venturing out for a walk, only to be foiled by hundreds of ditches and a road that "if wetted by a drop of rain is stickier than any birdlime and clings to your feet."[28] He observes that were it not for the dikes holding back the sea, "the monsters of the deep" would wreak havoc upon the region's idle and inebrious inhabitants.[29] Not even the good harvests and harbors of Zeeland's isles could redeem the province in his estimation.

However genuine Tunstall's discomfort, the ostentatiousness of his complaints signals that his letter was a clever and timely literary exercise; it is the very opposite of a *laus patriae*, or praise of country, a genre Netherlandish humanists had only just

Fig. 33. Jacob van Deventer, *Map of Zeeland*, c. 1570. Colored engraving. Bijzondere Collecties, Amsterdam.

begun to apply to their homeland.[30] Tunstall must have known that one of the earliest and most important contributions to the genre in the Low Countries was Erasmus's own adage *A Batavian Ear* (1508), in which the latter extols his native Holland for the fertility of its pastures, its navigable rivers, and its many pleasant towns.[31]

While Erasmus would have recognized the irony of Tunstall's letter, he would also have conceded that its description was, albeit exaggerated, not altogether unjust.[32] More so than Holland or any other Netherlandish province, Zeeland embodied simultaneously both the great prosperity and the potential destruction that resulted from the land's proximity to the ocean, which in turn defined the Low Countries as a whole.[33] As Jacob van Deventer's map of the province reveals, Zeeland was little more than a loose assemblage of islands during the sixteenth century, dangerously prone to flooding but also an important center of international trade because of its coastal position (fig. 33).[34] In Anton van den Wijngaerde's sixteenth-century panoramic drawing of Walcheren—the island where Tunstall and Charles V's entourage spent most of their time—the harbor town of Veere appears as an isolated outpost of civilization on a body of land dwarfed by the surrounding waters and cut through with canals and rivulets, which must indeed have made for adventurous walking (fig. 34).[35]

Netherlandish humanists themselves did not shrink from using the trope of Zeeland's inhospitable shores in their writing. The playwright Jacob Zovitius, a

Fig. 34. Anton van den Wijngaerde, *Panorama of Walcheren*, 1550. Pen and watercolor on paper. Museum Plantin-Moretus, Antwerp.

Fig. 35. *Expostulatio*, from Jacob Zovitius, *Ruth*, 1533. Bijzondere Collecties, Amsterdam.

native of the Zeeland town of Zierikzee, vented his frustration over the enduring threats to the province in a lengthy acrostic poem of 1533 (fig. 35): "O Neptune, earth-shaker who has flooded Zeeland twice over, what region hereafter will want you as its ruler?"[36] The scholar Cornelius Aurelius, a close and important contemporary of Geldenhouwer, composed a now-lost *Dialogue between Vesta and Neptune on the Subject of Flooding* that could only have expressed the same pressing hope for concord between land and sea.[37] Gossart's own brother, Nicasius, was commissioned by the city of Middelburg around 1529 to produce designs for a new and improved harbor, a reminder of just how real and present concerns were about ensuring the security of Zeeland's shores.[38]

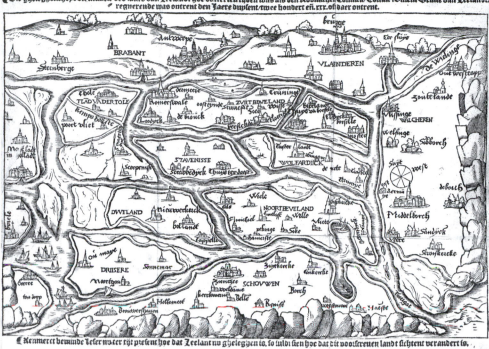

Fig. 36. *Map of Zeeland c. 1230*, from Jan Reygersbergh, *Dye cronijcke van Zeelandt*, 1551. Woodcut. Bijzondere Collecties, Amsterdam.

In his 1551 *Chronicle of Zeeland*—the first published chronicle devoted to the province—Jan Reygersbergh explains that his writing was necessitated by the volatility of the region, which had endured "so many strange events and wonders of inundation and high floods," and which had suffered such great losses as a result.[39] This physical devastation left Reygersbergh all the more determined to preserve not only the events of the past, but the very land on which those events had taken place.[40] To emphasize the point, the volume includes a historical map showing Zeeland as it was three centuries earlier, circa 1230, with an accompanying inscription urging the viewer to marvel at how radically the province had been transformed by time (fig. 36).[41]

Philip settled in this waterlogged province not only to preside over its shores and commerce but also eager to renovate his newly inherited palace located at West-Souburg on the isle of Walcheren, the farthest outlying of all Zeeland's islands.[42] Given what we have learned about the region's terrain, this renovation project would have been inflected with an added urgency. Geldenhouwer goes out of his way in Philip's biography to assert that he spared no expense as he oversaw the project. Philip "moved so familiarly among craftsmen, architects, sculptors and painters that he was thought to be one of them," and Gossart was among "the painters and

architects of the first quality" whom Philip summoned to the task of realizing his ambitions of courtly splendor and sophistication.[43] Although neither the castle on Walcheren nor its archival records are extant, we can confidently surmise that Philip's palace at Souburg was the original location of the artist's 1516 painting.

Zeeland was also the setting for Geldenhouwer's entry into Philip's service, several years after Gossart but under circumstances no less exceptional than the southern travels shared by artist and patron. The event that precipitated his appointment is recorded in the humanist's first published work, the subject of which should immediately draw our attention. Geldenhouwer's short 1514 *A Letter on Zeeland* was the first treatise wholly devoted to the history and geography of the Netherlandish province, and was published together with Martin Dorp's edition of Plautus discussed in the previous chapter.[44] In the text, Geldenhouwer—in marked contrast to Tunstall—effusively celebrates Zeeland's thriving commerce and wealth of humanist learning, citing its bustling ports and the many esteemed scholars nurtured on its soil.[45] He praises the farmland, the palaces and temples, the quick-witted inhabitants, and the ample harvests of pure wheat and the whitest salt. Not least, he touts the newly documented antiquity of Walcheren, the island that the admiral then called home:

> The lord Philip of Burgundy, commander of the Ocean, has persuaded me that the name "Wallachria" derives from "Gallia," with the G transformed into a W. This very year Philip found at Westkapelle a marble stone inscribed with the name of Hercules in most ancient letters, which means either that Hercules once landed there or that Zeeland was held to be sacred to Hercules. And in my judgment, that is not far off.[46]

The stone altar, which still survives today, is inscribed with a dedication to the god Hercules Magusanus and, as Geldenhouwer eagerly observed, provides unassailable evidence of ancient cult worship in the region.[47] Still more crucially, the inscription was the first of its kind ever found in Zeeland and one of the earliest to be discovered in the Netherlands as a whole (fig. 37). Likely through Philip's instigation, it was enshrined soon after its discovery in a wall of the church at Westkapelle, the westernmost point on Walcheren; Philip's own palace at West-Souburg lay less than twenty kilometers away, just down Walcheren's southern coastline (fig. 38).[48] Within the church, the stone offered a retrospective of local history, as the medieval saint Willibrord was said to have smashed a pagan idol worshiped on the site and thereby to have converted the inhabitants to Christianity.[49]

For Philip, a patron whose interest in antiquity had already been fueled by his trip to Italy, the finding of this inscription must have been exhilarating. While Gossart's drawings of Roman monuments had provided Philip with a record of Italy's past, this altar dedicated to Hercules—sprung from Netherlandish soil—offered something that the drawings could not: a testament to the ancient history of his

Fig. 37. Altar dedicated to Hercules Magusa-
nus. Zeeuws Museum, Middelburg.

Fig. 38. Jacob van Deventer, *Map of Zeeland*
(detail), c. 1570. Colored engraving. Bijzon-
dere Collecties, Amsterdam.

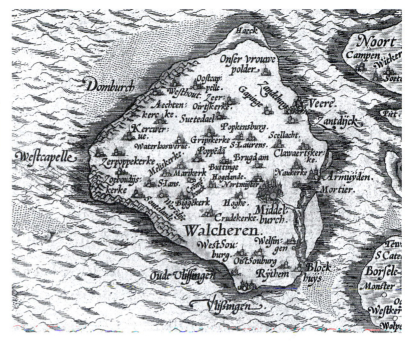

native land. That the altar was dedicated to Hercules made the historical resonance
even greater, as the hero had long figured in literature on the mythical origins of the
Burgundian house.[50] Just a few years earlier during the 1511 winter festival in Brussels,
Philip had showed a nascent interest in cultivating his heroic lineage by sculpting a
monumental Hercules snowman, as the city's poet Jan Smeken records.[51] Yet whereas
a sculpture of snow was only an ephemeral monument, Philip—by means of long-
enduring stone—could now assert his own ancient lineage not only through literary
tradition but also through archaeological evidence. All this meant that Philip sud-
denly had much to discuss with a budding scholar like Geldenhouwer.

Not long after the humanist gained entrance into the admiral's intimate milieu,
he began to work alongside Gossart in realizing the antiquarian ambitions of their
patron. In his 1516 pamphlet on the funeral of King Ferdinand of Aragon, Gelden-
houwer recounts how Philip aided and encouraged Gossart in his design of a chariot
for the solemn procession, which was adorned with "the effigies of nude *genii*" as well
as a panoply of military arms and insignia.[52] Geldenhouwer refers to Gossart as "the
Apelles of our age" and honors Philip as "his one and only patron, who in this project
(as in all things) is superhuman in his inventiveness."[53] An emphasis on the impor-
tance of linking the ancient Roman past to the Netherlandish present frames the
entire narrative. In his dedication to Ferdinand's grandson, Charles V, Geldenhouwer
stresses how the funerary rites bestowed on Caesar and Emperor Augustus—the
"pious institutions" of Charles's forefathers—were perpetuated in the 1516 ceremony.[54]
At the same time, in the treatise's concluding paragraph, Geldenhouwer expresses the

challenge he faced when recounting an event still steeped in "barbarous vocabulary" and Burgundian trappings through the medium of Latin prose.[55] Gossart's spirited nude figures were also engaged in a balancing act between the ancient past writ large and the local traditions of the Burgundian court for which his works were created. This is surely another reason that Geldenhouwer is so eager to single out the novel contributions of Gossart and Philip to the funerary project.[56]

Even more telling is Geldenhouwer's poem on the art of painting, written just one year earlier in 1515 and dedicated to "the magnificent hero Philip of Burgundy, commander of the sea."[57] The poem lists among the myriad subjects that the painter might portray with his brush the various loves of the gods, great deeds of men, and elements of the natural world, including the element over which Philip, as admiral, had sway: "the waves of the ocean and the furious winds, the realms of trident-bearing Neptune, and the court of Tethys."[58] By alluding to the famous episode in the first book of Virgil's *Aeneid*[59] when the sea god calmed the waves and drove off the winds, Geldenhouwer insinuates Philip into the realm of epic, with its epochal struggle between war and peace. And as the poem's final lines attest, the admiral's command also extended beyond the turbulent ocean to more calm and cultured domains: "Because you, illustrious Philip, bestow worthy gifts on the painters of our time, we have written you a few little verses in praise of art."[60] Geldenhouwer's intimate familiarity with the ambitions of Gossart and his patron is here unmistakable.

Gossart's 1516 painting may well have been the first mythological work produced under Philip's auspices; at the very least, it is the earliest of them to survive today. The image would seem to represent a culminating moment in the discussions among Gossart, Geldenhouwer, and their mutual patron. From those initial travels through Italy to the finding of Zeeland's first ancient inscription, the ambition to revive the ancient past on Netherlandish shores had quickly come to define the intellectual and artistic pursuits at Philip's court.

THE ELUSIVE AMPHITRITE

Past interpretations of Gossart's painting, beyond the question of its visual precedents and presumed debt to Italian models, have hinged almost exclusively on the figure of the marine god Neptune and his presumed relation to Philip himself. Neptune has been understood to allude to Philip's admiralship and to his title "commander of the sea," a parallel that Geldenhouwer's poem honoring the admiral already suggested.[61] The sensual portrayal of Neptune's nude body has also been aligned with the bachelor Philip's amorous proclivities and infamous relations with the opposite sex. In 1516, the year of the painting, Philip was scolded openly at the meeting of the Order of the Golden Fleece for being "much too fond of chasing women and inclined to cheat at games."[62]

One of the primary functions of Gossart's monumental work was without question as a potent erotic image. The molluscan specimen accenting the god's

genitals, the goddess's hand that disappears behind her lover's back and seems to have found rest upon his muscular buttock, the latent tension in their stillness—all these elements would have engaged Philip as the painting's owner in a playful awareness of his own physical desire.[63] Even the burgundy curtain that Gossart depicts behind the figures recalls the way sensual images of nudes were displayed in Philip's other palace at Wijk bij Duurstede; a blue-and-yellow curtain hung there over a large painting of a nude Venus and Cupid, which—when it was pulled back—would have engaged Philip still further in a furtive and titillating encounter with the deities.[64]

Yet while the association between Philip and the sea god in Gossart's painting surely constituted one aspect of its reception at the admiral's court, the intentionality of the work cannot be explained solely in terms of its patron, any more than it can be construed as the inevitable product of his sojourn in Rome.[65] If the figure of Neptune stands for Philip himself, then the goddess at his side must have a corresponding role as well, beyond serving as an affirmation of the admiral's virility. Gossart depicts the two deities hand in hand, side by side on the same pedestal. He clearly grants them equal prominence in the composition. Neptune's neglected consort thus warrants some attention of her own.

According to the myth, Amphitrite was a Nereid who shunned Neptune's advances and fled to the ends of the world.[66] Neptune sent a dolphin in pursuit, who brought her back to the sea god, and she eventually acquiesced in his desires. The couple then celebrated their marriage surrounded by the full glory of their watery kingdom. Neptune and Amphitrite are thus most often portrayed together on a chariot drawn by hippocampi, accompanied by the trusty dolphin as well as a host of Tritons, Nereids, and other sea creatures. Such iconography had been employed in ancient Greek temples devoted to the couple, famously at Corinth and at Tenos, and it recurs from antiquity onward, eventually attaining canonical status in the 1571 illustrated edition of Vincenzo Cartari's *Images of the Gods* (figs. 39–40).[67]

An immediate example for Gossart and Philip—one they would readily have encountered during their travels through Italy—was Jacopo Ripanda's fresco in Rome's Palazzo dei Conservatori (c. 1505–7), which includes a portrayal of Neptune and Amphitrite riding on a dolphin in the foreground of a Roman naval victory (fig. 41).[68] Ripanda's deities are nude from the waist up and embrace each other fondly, as do the figures in Gossart's later painting, though the arrangment of the embrace itself differs significantly between the two works. It seems undeniable that Gossart saw the fresco and kept its model in mind, particularly as he employed it quite directly one year later in his painting *Hercules and Deianira* (see fig. 53).

However, it is also important to recognize the ways in which Gossart's 1516 painting deviates from Ripanda and from the iconography of Neptune and Amphitrite in general. Rather than riding the open seas, the two deities as depicted by the Netherlandish artist stand alone, enshrined in a shallow architectural space. The dolphin that securely identifies Ripanda's couple is absent, as are the chariot, sea

Fig. 39. *Neptune and Amphitrite*, 315–25. From ancient Cirta. Mosaic. Musée du Louvre, Paris.

Fig. 41. Jacopo Ripanda, Neptune and Amphitrite (detail), from *Battaglia navale, Sala di Annibale*, 1505–7. Fresco. Palazzo dei Conservatori, Musei Capitolini, Rome.

Fig. 40. *Neptune and Amphitrite*, from Vincenzo Cartari, *Le imagini de i dei de gli antichi*, 1571. Houghton Library, Cambridge (Mass.).

horses, and host of marine nymphs that are otherwise usually included in depictions of the pair. Apart from the laurel crowns worn by the gods, which might seem to be the vestiges of a recent triumph, Gossart has banished all narrative detail from the painting.[69] The lovers' oceanic accessories are pared down to the trident in the god's hand, the conch he wears, and the scalloped shell that adorns the goddess's hair like a bonnet, and which serves as her sole defining attribute. Ripanda's image of Neptune and Amphitrite likely provided a starting point for the conception of Gossart's painting, but neither the artist nor the patron may have intended the couple's identities to be quite so stable.

It was not until the late sixteenth century that Neptune and Amphitrite became a popular subject in the art of the Netherlands, particularly in the dominant seaport of Antwerp. The Antwerp secretary Cornelius Grapheus already conveyed the local image of the city as a maritime power in his 1527 poem "Antwerp speaks," in which he describes Neptune and his oceanic entourage bringing fortune to the city and its merchants.[70] The local artist Frans Francken the Younger would later paint no fewer

Fig. 42. Frans Francken the Younger, *The Triumph of Neptune and Amphitrite.* Oil on copper on wood, 23.5 × 30.9 cm. Cleveland Museum of Art, Cleveland, Gift of Mrs. Noah L. Butkin.

than twenty versions on this very theme, each with a boisterous cast of sea beings (fig. 42).[71] During the triumphal entries into the city, Neptune and other aqueous deities surfaced frequently, but even less so than in Francken's crowded paintings, the sea god and his bride were seldom isolated or privileged amidst the hubbub of these processions. Often they shared the stage with the likes of Oceanus, Nereus, Triton, or a retinue of watery nymphs.[72]

Local deities usurped the traditional marine gods on several occasions as well, introducing a new degree of visual ambiguity. In the 1549 entry of Prince Philip II into Antwerp, the same Cornelius Grapheus described the triumphant pairing of the personified city and her spouse the river Scheldt.[73] During this procession, the *Triumphal Arch of the English Nation* was crowned by another such couple: a bearded god with a trident and a goddess in a white gown, riding together in a shell-shaped chariot drawn by hippocampi (figs. 43–44). The published account of the festivities describes this group as "four large statues or carved sculptures, each twelve feet high, which can be identified as an image of Oceanus Britannicus (the English sea), an image of Britannia (England), and the images of two Tritons, or sea horses."[74] Yet were these figures to be encountered in isolation—without the explanatory text—

Fig. 43. *Triumphal Arch of the English Nation* from Cornelius Grapheus, *De seer wonderlijcke, schoone, triumphelijcke incompst van de hooghmogenden Prince Philips, Prince van Spaignen*, 1549. Bijzondere Collecties, Amsterdam.

Fig. 44. *Triumphal Arch of the English Nation* (detail) from Cornelius Grapheus, *De seer wonderlijcke, schoone, triumphelijcke incompst van de hooghmogenden Prince Philips, Prince van Spaignen*, 1549. Bijzondere Collecties, Amsterdam.

Fig. 45. Benvenuto Cellini, *Salt Cellar*, 1540–44. Gold, enamel, and ebony, 26 × 33.5 cm. Kunsthistorisches Museum, Vienna.

they might seem to be not Oceanus Britannicus and Britannia, but rather Neptune and Amphitrite.

Another commentator on Philip's II procession, the Spanish humanist Juan Calvete de Estrella, expressed this very confusion regarding a similar arch erected by the Genoese, adorned by a female figure with a dolphin and anchor at her side. Estrella identified her equivocally as representing either "the grandeur of the sea, Amphritrite, wife of the god Neptune, or the very rich seafaring city of Genoa itself."[75] Estrella's comment suggests that on the basis of iconography alone, a regional depiction was easily conflated with yet another iteration of a well-known myth.

It is not difficult to surmise why the local deities on the English and Genovese arches so closely resemble the universal gods of the seas. Presumably the designers called the iconography of Neptune and Amphitrite to mind when conceiving how they might depict the union of Britain and its surrounding waters, or Genoa as a seaport. After all, no real visual tradition existed for either subject. For the designer of the English arch in particular, drawing on the essential form of an existing mythological couple (Neptune and Amphitrite), and the triumphal connotations that they carried with them, resulted in an image of a new mythological pair who specifically embodied Britain's identity as a formidable maritime power. A myth of the sea was thus transformed into the myth of a nation.[76]

More so than many of her fellow aqueous divinities, Amphitrite was a slippery character whose figural proximity to Neptune was readily appropriated. Her significance paled in comparison to her husband's, as his countless infidelities undermined not only her spousal status but also her authority as joint ruler of the seas. Boccaccio explains in his *Genealogy of the Pagan Gods* that Neptune "had a wife by the name of Amphitrite and a bounteous number of children, though they were born of many different women."[77] In the ancient Greek sanctuaries of Neptune and Amphitrite, the male god was the focus of cultic devotion while his wife played only an ancillary role.[78] On Roman sarcophagi depicting marine triumphs, Amphitrite was displaced by the other Nereids or by the ocean-born Venus.[79] In classical and Renaissance literature, Amphitrite was often taken as a stock personification of the sea, as in the opening lines of Ovid's *Metamorphoses*,[80] or in the *Mythologies* of Natale Conti (1567), who writes, "She's supposed to be Neptune's wife because she represents water, but what Amphitrite really represents is the body and internal composition of all the moisture that either encircles the earth or is contained inside it."[81]

Without the recognizable trappings of Neptune's entourage, Amphitrite remained amorphous and, in the eyes of at least one Renaissance artist, profoundly uninspiring. The great Italian sculptor Benvenuto Cellini, when describing the genesis of his famous saltcellar, recounts that his patron Cardinal Ippolito d'Este had consulted two learned men on possible iconographies for the salt (fig. 45).[82] Having heard the proposals of these "virtuosos," as the artist mockingly calls them, Cellini went on to dismiss both options on the grounds that no matter how erudite a humanist's prescription, it hardly guaranteed a beautiful visual product.[83] The artist explains the superiority of his own invention as follows:

> Messer Gabbriello suggested that I should model an Amphitrite, the wife of Neptune, together with those Tritons of the sea, and many other things that are beautiful to say, but not to make. I have made an oval form, and on this form, in keeping with how the Sea shows itself to embrace the Land, I made two figures well over a palm big, in a sitting posture, entering into each other with their legs, just as one sees certain long branches of the sea entering the land.[84]

Cellini chooses a subject tailored to the functional specificity of the object itself. The artist represents the geographical intersection of land and sea by means of which salt—the very substance contained by a saltcellar—is actually produced. The gilt basin in which the salt would have been placed is situated at the point where the couple's legs and sensuous nude bodies intertwine, their fecundity underscored by Land's unmistakable gesture of squirting milk from her breast. The resonance and appeal of the couple's entwining bodies would have made the saltcellar all the more engaging as a conversation piece in the elite courtly milieu for which it was made. Cellini's unique creation embodies the double meaning of the Latin word *sal* as both

"salt" and "wit," stimulating visual inquiry and clever interpretive discourse in a way that a mere straightforward representation of Neptune and Amphitrite's marriage would never have allowed.[85]

Gossart's painting was likewise commissioned by a noble patron and destined for display in the courtly realm, so it is little surprise that the work shares a close affinity with Cellini's saltcellar. Gossart's deities do not announce their identities through a copious display of attendants and oceanic accoutrements. Instead, they command attention—as do Cellini's counterparts—through the sensuality and refinement of their bodies. Just as the meeting of legs atop Cellini's salt evokes the intersection of earth and sea, the union between Gossart's deities also harbors meaning, particularly as regards the goddess at Neptune's side. Like Cellini's fertile nymph or the triumphant figure of Britannia, Gossart's goddess might well be understood to represent not a body of water but instead a watery body of land.

AN ANCIENT ISLE REDISCOVERED

The perfect symmetry of the embrace between Neptune and his lover constitutes the organizing principle of Gossart's painting. Gossart thrice echoes its shape in the surrounding architecture: in the ocular opening above the gods' heads, in the circle of pebbled green marble on the pedestal below their feet, and, finally, in the painting's most subtle yet spectacular detail: the glasslike pool of water that encircles the pedestal itself and ripples gently against the surrounding columns (fig. 46). The water extends behind the pedestal and below the tassels of the burgundy curtain in the background, where it resolves into a slender band of brilliant blue, revealing that just beyond the temple's threshold lies the open ocean.

Gossart and Geldenhouwer may have been aware that Greek sanctuaries dedicated to marine gods were invariably located near the sea, on an isthmus or an island.[86] The looming statues that these temples housed were not just generic deities; they were also guardians of the specific shores on which they stood. The pool of water at the feet of the gods in Gossart's painting is thus anything but an ancillary detail; it

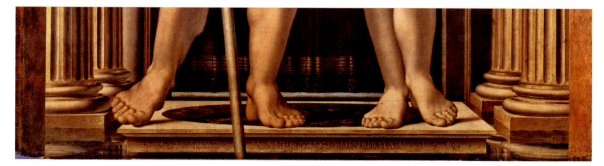

Fig. 46. Jan Gossart, *Neptune and Zeelandia* (detail), 1516. Oil on panel, 188 × 124 cm. Gemäldegalerie, Staatliche Museen. Berlin.

has an implied source and locality. The deities are standing in a temple situated as if on the edge of the land with water stretching out behind them. The isolation of the figures is emphasized by the building's close confines and by the pedestal on which they are standing, which is itself evocative of an island in the midst of the sea.

We know that Philip commissioned Gossart's painting while living at his palace on the isle of Walcheren in Zeeland, and that he did so just two years after the discovery of the ancient Hercules inscription washed up on the shores of that island's westernmost point, where the land stops and the open sea begins. Given that the province was Philip's residence and his governing domain, as well as the place where Gossart's work was most probably displayed, it is difficult to imagine that the intended location could have been elsewhere. In effect, the painting situates an ancient temple on the shores of Zeeland itself.

This localized setting also has implications for the two gods who inhabit it. As already noted, Gossart establishes a deliberate affinity between the bodies of the deities and their physical surroundings. The parallel between the shape of Neptune's tender embrace and the shape of the waters encircling the pedestal below implies that the goddess whom he shields is herself like a body of land enveloped by and bound to the sea god's natural element. For Philip to imagine himself in the guise of Gossart's Neptune, standing in the littoral realm of Zeeland, meant assuming not only the posture of virile lover but also the role of devoted guardian to his watery homeland. Far more than a general embodiment of sea, the blushing goddess gazing up at Neptune adoringly with her bright blue eyes might seem to embody the region under Philip's charge, the site of his palace and his newly discovered ancient lineage. She might seem to be not Amphitrite but "Zeelandia": the sensual personification of the place where land and sea meet.

What does it mean to consider Gossart's painting as *Neptune and Zeelandia* rather than *Neptune and Amphitrite*? It need not induce a quest after Zeelandia's iconography in earlier Netherlandish art, as that quest would prove fruitless. Nor need it imply that the intention of Gossart as artist, or Philip as the painting's commissioner, was for the goddess to have a single invariable meaning. However, there is no question that the painting, by virtue of its original display in Philip's palace on Walcheren, performed an imaginative reconstruction of the past. Gossart has invented a temple honoring two deities who serve as perpetual protectors of Zeeland's embattled shores. He has employed the illusive medium of painting to posit an architectural monument in three dimensions, an ancient site uniquely belonging to the most aqueous province of the Netherlands. So in the endeavor to recover the conversations that might have happened around Gossart's painting, it bears considering whether Philip—as the ambitious patron he was—saw in his companion goddess someone more specific and familiar than the vast and anonymous ocean.

In later centuries, the province of Zeeland would prove receptive to personification. In 1641, the local humanists Petrus Stratenus and Cornelis Boey published a

Fig. 47. Title page from Petrus Stratenus and Cornelius Boey, *Venus Zelanda*, 1641. Bijzondere Collecties, Amsterdam.

collection of verse entitled *The Venus of Zeeland*, which takes the province as the setting for their imaginary love affairs with two beautiful women.[87] On the title page of the volume, designed by an anonymous artist, the sensual Venus of Zeeland herself is depicted just off the province's coastline, seated in the scallop shell from which she was born (fig. 47).[88] Cornelis Boey, leaving no doubt that the goddess of love emerged from the waves along his native shores, devoted a poem to this very theme, which hails "the newborn Venus, burning in the frigid midst of Zeeland's sea," as she "raises her joyous head from the icy stream and recognizes the waters of her fatherland."[89]

It is no coincidence that the earliest precedents for Boey's humanist praise of his homeland are to be found in Gossart's learned circle and in the works of his artistic contemporaries. In addition to Geldenhouwer's 1514 *Letter on Zeeland*, the trope of Zeeland as a *locus amoenus* appears in the writings of the Zeeland humanist Hadrianus

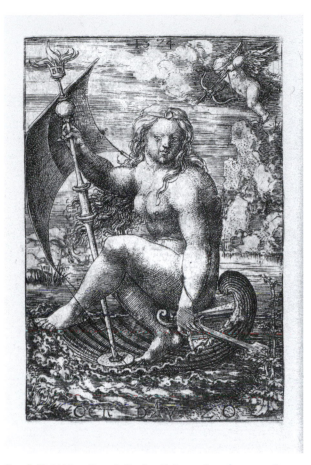

Fig. 48. Dirck Vellert, *Venus Sailing in a Shell*, 1524. Engraving, 7.3 × 4.8 cm.
Rijksmuseum, Amsterdam, Rijksprentenkabinet.

Barlandus, a scholarly contemporary and close colleague of Geldenhouwer. Barlandus describes the province as a pleasure garden where it was "the greatest delight to study, to promenade, or to exchange intimacies with a companion," in short, a place worthy of Venus herself.[90] The title page of Stratenus and Boey's 1641 volume descends directly from a small 1524 engraving by Gossart's contemporary Dirck Vellert, *Venus Sailing in a Shell* (fig. 48).[91] The goddess in Gossart's 1516 painting wears as her only attribute a scallop-shell bonnet, the same kind of shell in which Vellert's *Venus* has set sail.

Yet the primary importance of considering the connection between Zeeland and Gossart's painting lies in the revelation of the work's meaning and function within the artist's intimate intellectual milieu. By ensconcing Neptune and his paramour within a classical temple—seemingly situated in the province itself—the image asserts the

Fig. 49. *The Island of Utopia*, attributed to Ambrosius Holbein, from Thomas More, *Libellus vere aureus nec minus salutaris quam festivus de optimo reip. statu, deque nova insula Utopia*, 1516. Woodcut. Houghton Library, Cambridge (Mass.).

region's ancient past, building upon the evidence of Philip's archaeological find and on Geldenhouwer's analysis of Walcheren's ancient history in his *Letter on Zeeland*.

Fundamental to Philip and Geldenhouwer's shared interest in the antiquity of the province was the recent discovery that Roman writers such as Julius Caesar, Pliny the Elder, and Tacitus had long ago described the Netherlands as a body of land surrounded on all sides by water.[92] The so-called island of Batavia—generally understood to be located between the branches of the Rhine and to border the ocean on its western front—had already captured the contemporary imagination by the time Gossart created his monumental painting of 1516. Venus herself was evoked explicitly as mother of the Batavian isle,[93] while another writer envisioned Mercury and Apollo looking down from the clouds on its shores, prophesying that the land would one day abound in fruits, gold, and milk and would teem with the most industrious citizens.[94]

The very notion of a waterbound nation as an ideal locus of culture and virtue was explored that same year in Thomas More's immensely popular *Utopia*, a work that he composed while traveling through the Netherlands.[95] Geldenhouwer himself even helped see to press the volume's accompanying woodcut of the Utopian isle (fig. 49).[96]

Beyond imaginative descriptions, the geography of the Batavian isle as described in ancient sources proved difficult to align directly with the present-day Netherlandish provinces. Geldenhouwer was one of several contemporary scholars engaged in active dispute over this very question, and attempts to describe and chart the precise limits of the Batavian territory would continue for decades thereafter.[97] The details aside, it is important to recognize why Zeeland figured prominently in the early stages of debate. No matter how many historical maps of Batavia might be drawn—notably, Geldenhouwer himself commissioned the first—the difficulty of aligning past and present boundaries still remained.[98] Sixteenth-century Zeeland, however, was itself a collection of islands and already closely mirrored the presumed topography of Batavia and its northern surrounds.[99] A look back at Jacob van Deventer's map confirms this striking affinity (see fig. 33). Cornelius Aurelius even refers explicitly to Walcheren as marking the outer periphery of the Batavian territory, and as the point where the branches of the Rhine reach the ocean.[100] Indeed, the proliferation of writings on Zeeland's history following on the heels of Geldenhouwer's 1514 treatise indicates the extent to which the province gripped the contemporary historical imagination.[101]

The reception of Gossart's painting was thus doubtless informed by the notion that the geography of Zeeland offered a crucial point of reference for the ancient history of the Netherlands as a whole. The island-like pedestal on which Gossart's deities are standing may even have evoked this topographical association between the contemporary province and the ancient Batavian isle and thereby roused further discussion among the visitors to Philip's palace. Not only by virtue of its classical subject but also in its very design, Gossart's painting could not but have stirred to mind the newfound fascination with local antiquity.

Above all, Gossart's painting contributed to the antiquarian project underway at the admiral's court and in the early sixteenth-century Low Countries by serving as a surrogate monument that brought ancient history to life. Given that the province of Zeeland had been so transformed by centuries of floods and had little in the way of a visible historical record, Gossart's work offered a glimpse of a regional past that was otherwise scarcely in evidence. The ancient inscription that Philip had discovered on the island of Walcheren, although of great historical significance, hardly gave much pleasure to the eyes.

The most impressive ancient structure known in the sixteenth-century Low Countries was itself a testament to the vagaries of the local historical record. The submerged castle of Brittenburg was seen only on the rare occasions when the waves receded enough to reveal its fundaments off the coastline.[102] First recorded in the

Fig. 50. The ruins of the castle of Brittenburg, from Ludovico Guicciardini, *Descrittione di tutti i Paesi Bassi*, 1581. Bijzondere Collecties, Amsterdam.

latter half of the fifteenth century, the castle's sightings became an immense source of fascination and a site of archaeological activity, including an excavation commanded by Philip's fellow nobleman Jan II of Wassenaer in 1520.[103] A later engraving seen to press by the Netherlandish cartographer Abraham Ortelius reveals the desire to elevate Brittenburg to the status of an ancient monument on par with those discovered in Italy (fig. 50).[104]

In fact, the Brittenburg ruins were associated with the deranged Roman emperor Caligula, who, according to Suetonius's biography, built a tower on the northern shores across from Britain so as to launch his conquest of the isle, and ordered his Roman soldiers to gather conch shells at the water's edge as spoils of battle.[105] The Zeeland doctor Reinier Snoy, another contemporary of Geldenhouwer and fellow historian of Batavia, alludes to this story when he dismisses those who seek to deny the antiquity of the Netherlands and its long history of withstanding the waves. These disbelievers, Snoy writes, "are driven by nothing other than the fickleness of fancy: if I were to banish them to the shores of their native sea so that they might gather conchs, will they not hold in admiration the sandy stones protecting the island against the ocean, by which the sea itself is held in its seat?"[106] Considered in relation to Gossart's painting, the comical conch that protrudes from the god's waist might even be a playful allusion

to this Neptune's indigenous origins, his trident hewn from crude wood and iron, his spoils not glistening gold but the shells of the sea.

For Philip as a patron, having experienced Rome's wealth of antiquity firsthand, it must have been difficult to escape the awareness of what his own native Netherlands lacked, and he clearly grasped the potential of Gossart's art to fill this gap. Unlike the artist's depiction of the Roman Colosseum as a building ravaged by time, or the ruins of Brittenburg buried beneath the waves, Gossart's 1516 painting portrays an antiquity that is resplendent and perfectly intact, the local past brought to life in the present through the deities at its center with their sensual and animated bodies. The painting's subtlety and complexity are the true marks of its success. Gossart created not an overt allegorical representation but rather an image that mediates between antiquity and the present, between Batavia and Zeeland, between functioning as an embodiment of history and a delectable image of mythological nudes. This is true regardless of whether the original viewers of Gossart's painting saw it as *Neptune and Zeelandia* or instead as only *Neptune and Amphitrite*. For the initiated, the painting asserted Zeeland's place within the annals of Netherlandish antiquity and affirmed Philip's role as lover, admiral, and restorer of his homeland's venerable history. For anyone else who saw it, it was still a work without precedent in the art of the Low Countries, which signaled that Netherlandish artists and patrons too had the knowledge and acumen to engage with classical antiquity.

In Philip's palace on the island of Walcheren, Gossart's 1516 painting gave visual form to the revival of the past on local shores and heralded a new era of greater peace, prosperity, and cultural achievement in the Low Countries. To recognize that the province of Zeeland, and the meeting of land and sea, lie at the very foundation of Gossart's earliest extant mythological image is to realize that the ambition of the artist who painted it, and of Philip and Geldenhouwer as his interlocutors, was not to follow in the footsteps of Italy but to claim an ancient lineage of their own.

CHAPTER 3

LINEAGE

To pursue one's lineage implies a desire to understand the history sedimented in the body as a point of origin. Genealogy endeavors to reconstruct a line of descent by tracing the scrapes and scars left by the past.[1] In the project to recover the local antiquity of the Netherlands, land alone was not enough. There also needed to be bodies, ancestral inhabitants who had left signs of having lived, fought, and died there.

The rediscovery of the Batavian isle fed the genealogical imaginations of Gossart's noble patrons no less than it inspired the pens of local humanists. The bellicose Batavians, the island's tribal dwellers, proved a natural complement to the existing narrative of Trojan heroes to whom the Burgundians had long traced their ancient ancestry. The Batavians were quickly woven into the historiography of the Low Countries from the early sixteenth century onward, and their deeds and character reconstituted through ancient literary and archaeological remains. Where the visual evidence fell short, the artist and the forger put their skills to work, and both patrons and scholars in the Netherlands were complicit in their ruses.

Antiquity (as object rather than concept) was also meant to take the form of a physical entity that one could collect, display, and hold in one's hand. Objects too have a lineage, whether real or perceived, and tangible contact with them feeds the longing that the fragmented body of

the past might become whole again.[2] While Gossart's *Neptune and Zeelandia* served as a surrogate architectural monument with local foundations, his small-scale mythological paintings functioned as surrogates for antique collectibles. They did so in dialogue with other new sculptural genres that emerged in the Netherlands at the same moment, and for parallel reasons: the portrait bust, medals, and small-scale sculpted nudes.

This assemblage of objects is approached here from two interrelated angles: first, in terms of the ways these works embody and reinforce the genealogical narratives of their patrons; and second, through a consideration of how they assert—via a chain of material and formal associations—their origins in a distant past. Gossart's *Hercules and Deianira* (see fig. 53), the earliest of his extant small-scale paintings, proves the most paradigmatic example of a work that performs this double role.

A GALLERY OF ANCESTORS

Having gained new knowledge of his ancient past, Philip soon found himself compelled to defend his rights as a noble of Burgundian lineage. In the latter months of 1516, Philip had agreed at the request of Charles V to leave behind his admiralship and court in Zeeland—the very context for which Gossart's *Neptune and Zeelandia* was produced—in order to become bishop of Utrecht and to transfer his residence to the bishop's palace at Wijk bij Duurstede.[3] Already in February 1516, Pope Leo X had given his permission for Philip to enter the priesthood and, by extension, to become a candidate for the position. Yet as Philip's second biographer, Willem Heda, points out, the nobleman "was never raised for the church profession but occupied himself far more with arms and literary pursuits."[4] Reluctant by inclination to accept the appointment, he felt all the more so when Charles demanded yet another concession: that Philip resign his membership in the highest institution of the Netherlandish nobility, the Order of the Golden Fleece.[5]

Charles argued that an oath of chivalry was incompatible with the dignity of a bishop's seat, but Philip's ancestry spoke in opposition; his own father, the Duke of Burgundy Philip the Good, had been the order's founder.[6] On the basis of this hereditary claim, Philip refused for months to relinquish the gold collar of his knighthood, up to the point of receiving threatening letters from Charles himself.[7] Not until the 1519 chapter meeting of the order in Barcelona was the matter finally resolved. Philip's coat of arms was hung in the choir of the Barcelona cathedral only as a retrospective marker of his former status, and he would never again take part in the ceremonies so closely associated with his familial name.[8] A letter dated April 5, 1520, written by Philip to Laurent de Blioul, greffier of the order, finally confirms his begrudging return of the collar.[9]

The question of Philip's place within Burgundian tradition framed both the proceedings and the immediate response to his triumphal entry into Utrecht in May

1517. Philip's secretary Gerard Geldenhouwer wrote a treatise commemorating his patron's inauguration that received a rare commendatory preface from none other than Desiderius Erasmus, and which describes the procession from the city walls to the palace at Wijk bij Duurstede, through streets filled with garlands, flowering wreaths, and villagers shouting, "Long live Lord Philip, brother of David, best of patrons! May he live long! May he live happily!"[10] The invocation of Philip's deceased brother David of Burgundy, an elder son of Philip the Good who had likewise served as bishop of Utrecht, was surely meant to convince the new appointee that here too he was becoming part of a Burgundian legacy, even if it meant relinquishing one embodiment of that legacy for another.[11]

A pamphlet published in Deventer on the occasion of Philip's appointment duly compared his acceptance of spiritual duties in place of the fleeting pleasures of courtly life to Hercules's fabled choice between virtue and vice.[12] In the dedication to Philip of his 1517 treatise *The Complaint of Peace*, Erasmus reminded the new bishop that he now shouldered not only the responsibility of preventing war but also the dual challenge of living up to the Burgundian models established by his brother and father.[13] Erasmus recognized that Philip's role as bishop was as much about political duties and familial ties as it was about ecclesiastical office.

At his new palace outside Utrecht, Philip responded to his change in situation by turning once again to the possibilities afforded by Gossart's art. Geldenhouwer employs the rhetoric of renovation to describe his patron's activities in these years: "Philip made the ancient palace at Wijk bij Duurstede more perfect with new edifices; he adorned it with such pictures, sculptures, and terracotta works, the likes of which I would hardly believe to exist to Italy itself."[14] Geldenhouwer's competitive stance toward Italy suggests a continuity in ambition between the creation of Gossart's *Neptune and Zeelandia* and the artistic commissions that Philip would pursue in Utrecht. At the same time, however, through his renovations to the palace where his brother David of Burgundy had once lived, Philip took up Erasmus's charge to build upon the memory of his esteemed predecessor. The inventory of the Wijk bij Duurstede residence made after Philip's death confirms that he continued to treasure several ecclesiastical vessels and garments once belonging to David—material manifestations of his fraternal inheritance—even as he pursued a new conception of his venerable lineage and patronly ambitions.[15]

With his ousting from the Order of the Golden Fleece still fresh in mind, Philip devised as one of his first projects a room that powerfully asserted his sense of historical and political belonging. The "terracotta works" that Geldenhouwer mentions in Philip's biography align with an exceptional series of sculpted busts at Wijk bij Duurstede. The portrait bust as a sculptural category, perhaps more than any other, connoted a direct and immediate link to the art of antiquity. While painted portrait series representing noble and monastic lineage already enjoyed a long tradition in the Netherlands, and full-length sculpted portraits of the nobility adorned the exteriors

of town halls from Bruges to Zeeland, there was no precedent in the Low Countries for a private series of portrait busts, and this innovation on Philip's part should be considered in close dialogue both with Gossart's project of mythological painting and with larger pan-European artistic interests.[16]

The terracotta bust in particular was a genre transmitted from Italy, which gained popularity in northern Europe in the early sixteenth century through the works of itinerant Italian sculptors like Guido Mazzoni and Pietro Torrigiani, but as is evident from the series at Wijk bij Duurstede, northern patrons like Philip quickly appropriated the form for their own aims.[17] The major precedent for Philip's series in northern Europe, albeit in a different context and medium, was the series of bronze busts of Roman emperors commissioned circa 1509 by the emperor Maximilian I for his own tomb in Innsbruck, Germany.[18] The sculptor Jörg Muskat, who created the busts, consulted ancient Roman coins in his depiction of the imperial likenesses, representing as accurately as possible Maximilian's extended imperial lineage. Muskat also produced bronze busts of Maximilian himself and members of his family that may have formed part of another series.[19] Margaret of Austria, Maximilian's daughter, likewise had marble portrait busts of herself and her deceased husband Philibert of Savoy in her library at Mechelen, created by her court sculptor Conrad Meit, as well as a terracotta bust of Mary Tudor displayed in the same room that manifested the diplomatic ties between the Netherlands and England.[20]

As testimony to the significance of Philip's own portrait series, a 1520 letter written by Geldenhouwer to his friend and fellow humanist Frans Cranevelt proves especially significant. Geldenhouwer refers to his own intellectual endeavors—he is studying Greek and curious for a report about the archaeological findings at the old castle in his hometown of Nijmegen—but complains that the duties of court consume all his time. Nonetheless, the centerpiece of his letter is an effusive report on his patron's newly installed sculptures and Gossart's role in their creation, which he clearly considers worthy of Cranevelt's interest:

> Jan Gossart has adorned a room here in the palace. For its magnitude, I believe there is nothing more beautiful in the world, whether you see the painting, or look at the living statues of the ancient emperors. You should come here from Bruges to see it; the journey is scarcely one day beyond Nijmegen! Prince Henry of Nassau recently came from Holland for just this reason, as did many other nobles and important men.[21]

Geldenhouwer describes a splendid painted chamber adorned with imperial portraits. In the 1524 inventory of Wijk bij Duurstede, the series is recorded as follows: "In a small painted room, fourteen terracotta busts, polychromed, set into niches high in the wall."[22] In a later inventory of the palace from 1529, dating to after Philip's death, only thirteen busts remained in the niches; one of them, representing

Fig. 51. Bust of Charles V, c. 1520. Terracotta with polychromy, 51 × 63 cm. Gruuthusemuseum, Bruges.

Jan II of Carondelet—fellow Burgundian courtier and patron of Gossart—had been sent to Carondelet on his personal request.[23] There is also a separate reference in 1529 to "another bust of Bishop Philip made of terracotta," though it is not clear that Philip's portrait belonged to the series; the earlier inventory indicates that his bust was displayed instead in the palace oratory.[24]

Juxtaposed with the inventory records, Geldenhouwer's concerns in his letter to Cranevelt are revealed to be those of a humanist and not an art historian. This portion of the letter constitutes Geldenhouwer's *petitio* to Cranevelt following the standard structure for Renaissance epistolary address; he is urging Cranevelt to visit him in Utrecht through the enticement of viewing Gossart and Philip's latest artistic endeavor. While Geldenhouwer records elsewhere in his private notes that a French sculptor named Claude de Chartres received the commission for the busts in 1518, here he does not bother to attribute their creation to the sculptor's hand.[25] Nor does Geldenhouwer specify Gossart's precise role, though it seems most plausible that the artist executed not only the painting of the chamber itself but also the polychromy of the portraits. Terracotta busts produced in the sixteenth-century Netherlands and surrounding northern countries were almost always polychromed; thus Geldenhouwer's praise of these sculpted figures as "living statues" may reflect his admiration for Gossart's veristic skills at enlivening clay with blushing cheeks and softly modeled skin (fig. 51).[26]

Yet given that we know the busts at Wijk bij Duurstede included the likeness of Carondelet—and thus potentially other contemporary personages—Geldenhouwer's reference to "the living statues of the ancient emperors" also has to be taken as more rhetorical than documentary. Cranevelt would not be faulted if he had imagined, on the basis of Geldenhouwer's description, that the busts represented the twelve Caesars from the famous biographies of the Roman writer Suetonius, a manifestation of direct imperial line akin to what Maximilian I commissioned for his tomb at Innsbruck. In reality, however, the series must have mingled past and present personages in a more complex visual program, one tailored to Philip's specific antiquarian interests and courtly circle.[27] If Geldenhouwer played a role in conceiving the chamber's renovation, he may have signaled to Philip a passage from another ancient writer, Pliny the Elder, who describes in his *Natural History* how ancestral halls were once adorned with "portraits modeled in wax, each in its own niche," such that they would make deceased family members eternally present.[28] Pliny's description may have inspired not only the specific mode of display for Philip's terracotta busts but also the notion of ancient lineage itself as living on through sculpted likeness.

Of all Geldenhouwer's references to Gossart in his extant writings, the passage from his letter to Cranevelt is perhaps the most revealing. By ascribing sole agency to Gossart in the "adorning" of the palace chamber, regardless of the collaborative efforts that underlay its creation, Geldenhouwer positions the artist as a recognized and distinguished participant within his antiquarian circle. Gossart's ability to reanimate the ancient past under the guise of a regional present, and within a legacy of noble Burgundian patronage, parallels Geldenhouwer's own historical and literary projects. Gossart did not simply depict classical subjects; he had the ability to transform those subjects into living monuments that were at once authentic Netherlandish creations and powerful assertions of local antiquity. Standing in this room at Wijk bij Duurstede, Philip, Henry of Nassau, and his fellow noble visitors would have come face-to-face with their own enlivened ancestry.

GIANTS OF HISTORY

A painting of "Hercules with Deianira, nude figures of considerable size," caught the eye of Italian courtier Antonio de Beatis during his visit to Brussels on 30 July 1517.[29] Beatis encountered the nudes at Henry of Nassau's sumptuous palace in Brussels, along with other curious marvels including an enormous bed onto which Henry's inebriated guests tumbled after long banquets and a painting full of "diverse bizarre details" that was none other than Hieronymus Bosch's famous *Garden of Earthly Delights* (fig. 52).[30]

The population of "men and women, both black and white, engaged in various actions and poses" that Beatis observed in Bosch's enigmatic painting must have struck the southerner as remarkable in juxtaposition not only with the mythological

bodies of Hercules and Deianira but also with the alleged antics of Henry's court. As Beatis discovered, Italian Renaissance artists could hardly claim preeminence in their engagement with the painted nude. Indeed, Beatis's travels in days to come left him no less astonished by Jan van Eyck's wondrously vivid depiction of the nude Adam and Eve in the *Ghent Altarpiece*.[31] Yet particularly the central panel of Bosch's painting, which Beatis labors to describe—an entanglement of figures suspended in a realm that is neither heaven nor hell, at once fantastical and uncannily real—reveals a Netherlandish fascination with the body not merely as abstract ideal but also as embodiment of the messiness of lived experience.

A 1567 inventory of Henry's palace, describing his *Hercules and Deianira* as "a large painting of a giant and a giantess," makes clear that Beatis's reference to figures of considerable size (*di bona statura*) should be taken seriously.[32] No such large-scale work survives today. However, a diminutive *Hercules and Deianira* has come down to us— measuring just over one foot high—and prominently dated along its lower edge to the same year as Beatis's account (fig. 53).[33] It is not known who commissioned this smaller work, but there is little doubt that Gossart was the artist responsible for painting both it and the lost picture that once hung in Brussels. Having only just created his unprecedented 1516 painting for Philip's palace at Souburg, Gossart did not yet have any followers among his Netherlandish colleagues in the production of mythological works. Nor is it surprising that Henry of Nassau possessed one of the artist's mythological works as early as in 1517. His close acquaintance with Philip, already documented prior to Geldenhouwer's 1520 letter, would have afforded him ready access.[34]

Fig. 52. Hieronymus Bosch, *Garden of Earthly Delights*, 1500–1505. Oil on panel, 220 × 390 cm. Museo del Prado, Madrid.

Fig. 53. Jan Gossart, *Hercules and Deianira*, 1517. Oil on panel, 37 × 27 cm. Barber Institute of Fine Arts, Birmingham.

Gossart's surviving *Hercules and Deianira* demonstrates yet again how his works situated the mythological body within the discursive and embodied practices of the Netherlandish court. The painting reveals that the artist began to work on a smaller scale at the same time as he undertook the project of large-scale mythological painting, or very shortly thereafter. The interaction of bodies is markedly more intricate and tactile than that seen in *Neptune and Zeelandia*. The lovers have gotten themselves into a tantalizing bind. Deianira has gracefully woven her legs between the hero's muscular thighs, in and out around his calves, and under the back of his knee. Her right foot has come to rest on the floor below, crisscrossing behind her husband's with perfect symmetry. As Hercules reaches his arm around Deianira's supple waist, and she around his shoulder, the couple seems poised to embrace completely, to eradicate the last remaining space between them. Yet Hercules and Deianira are also each hiding something behind their backs, objects burdened with implications of their extended history.

That Gossart produced more than one *Hercules and Deianira* is in itself intriguing. Though relatively uncommon as a subject of Renaissance art, the myth as Gossart portrayed it seems to have had particular significance in the early sixteenth-century Netherlands. In the Birmingham painting, Gossart even inscribed the names "Hercules" and "Dyanira" in the shadows between the bucrania above their heads: a direct identification of his subjects found in no other extant mythological painting by the artist.[35]

Gossart's portrayals of Hercules and Deianira also enjoyed greater popularity than any other subject in his mythological oeuvre. In addition to the lost painting for Henry of Nassau's palace and the painting now in Birmingham, there is an early sixteenth-century woodcut inscribed *I[oannis] M[albodius] S[culpsit]* ("Jan Gossart carved this") that depicts Hercules and Deianira surrounded by classical ruins (fig. 54).[36] Like the painting, the woodcut shows the couple in near embrace, their bodies entangled, their gestures highly suggestive of sexual activity. Yet ruined buildings like those in the background of the woodcut appear in none of Gossart's authentic paintings, only in works copied after him, like the extant *Hercules Wrestling with Antaeus* painting, which depicts the hero dramatically overcoming his foe on a receding stage of classicizing columns and arches (fig. 55).[37] It is quite implausible—despite the claim of the print's inscription—that Gossart himself carved its woodblock.[38]

The composition of the Birmingham painting also went into rapid circulation via two other prints. The first is an etching largely faithful to its model, for which Gossart may have been partly responsible, as the artist is known to have experimented with the etching medium (fig. 56).[39] The second is an engraving by Gossart's near contemporary Allaert Claesz. that takes more interpretive license (fig. 57).[40] Claesz. reverses the position of the figures and moves them outdoors, but their entwined nude bodies and the emphatic meeting of their feet in the foreground still derive from Gossart's original. The swift reception evinced by all these prints is remarkable,

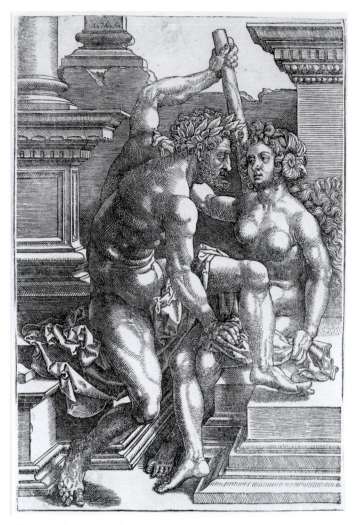

Fig. 54. Jan Gossaert, *Hercules and Deianira*, c. 1520. Woodcut, 25.8 × 17.2 cm. Museum of Fine Arts, Boston.

as none of the artist's other mythological paintings are known to have made an equivalent visual impact, let alone in the reproductive medium.

Gossart's Birmingham painting provides a foundation for considering why his depictions of Hercules and Deianira garnered so much interest. The painting's success lies both in its particular mythological subject and its sophisticated design. A strong organizing principle—present to a lesser extent in the prints—governs the painting's composition and endows the work not only with its intense erotic allure but also with its more subtle resonances.

The artfully entwined pose of Gossart's nudes stands out even within the genre of Renaissance erotic images. Although Gossart seems to have modeled the upper bodies of the Birmingham couple on the aforementioned fresco by Jacopo Ripanda

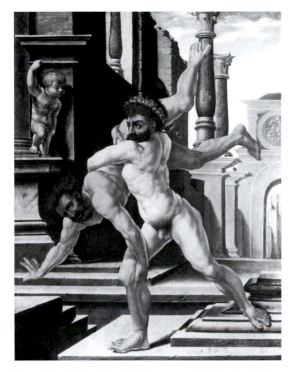

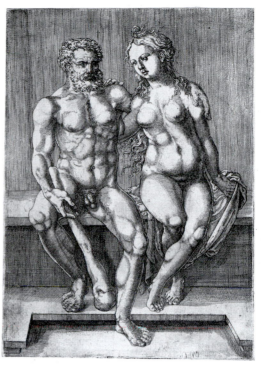

Fig. 55. *Hercules Wrestling with Antaeus*, 1523, after Jan Gossart. Oil on panel, 46 × 35.5 cm. Private collection.

Fig. 56. *Hercules and Deianira*, attributed to Jan Gossart, c. 1520–30. Etching, 19.2 × 14 cm. British Museum, London.

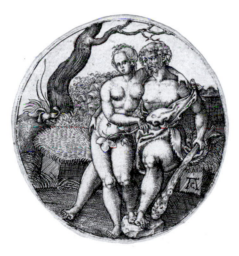

Fig. 57. Allaert Claesz., *Hercules Holding a Club and Embracing Deianira*, c. 1520–30. Engraving, 5.7 cm (diameter). British Museum, London.

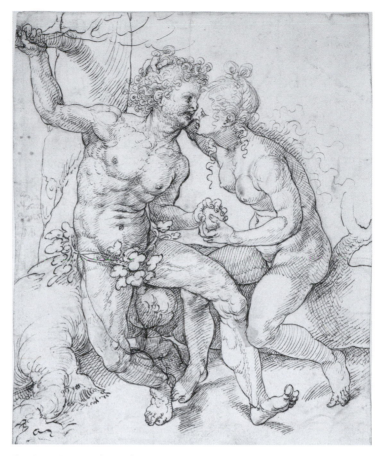

Fig. 58. Jan Gossart, *Adam and Eve*, c. 1520–25. Pen and ink over black chalk, 25.7 × 21 cm. Albertina, Vienna.

(see fig. 41), their lower bodies are truly his own invention.[41] Generally, a single intersection of limbs sufficed to suggest erotic union, as in one of Gossart's own drawings depicting Adam and Eve in a postlapsarian state of entangled desire (fig. 58).[42] In the Birmingham painting, however, Gossart takes this motif to an unprecedented extreme, iterating it so many times over that his couple's legs cease to be a mere indication of physical lust and begin to generate interest in their own right. This is no accident but instead a deliberate exaggeration on the artist's part.[43] There is an insistence to the artifice of these intertwined limbs; their visual appeal lies not only in their enticing sensuality but also in their evident facture. As in Gossart's *Neptune and Zeelandia*, the lovers' highly exaggerated pose points to something particular about the couple's relationship and how the viewer should approach understanding it.

According to classical myth, Deianira was a victory prize.[44] Hercules won her hand in marriage after defeating his rival suitor Achelous in a fierce contest. Soon after, the newlywed couple set off for the hero's homeland, but they were thwarted by

a dangerous, rushing river. Hercules entrusted a centaur named Nessus with ferrying Deianira across the waters, but when the deceitful creature took his bride captive and fled, the hero was forced into combat. Hercules swiftly pursued his enemy, shooting down the centaur with a poisoned arrow and boldly swimming the river to rescue the girl. The Roman poet Ovid lingers in his account of the hero's actions at the river's edge, describing how Hercules plunged fearlessly into the rushing waters while still burdened with his quiver and lion's skin.[45] Although Nessus ultimately fell by the hero's arrow, the vengeful centaur with his dying breath gave his bloodied cloak to Deianira, telling her of its powers to revive a waning love. Years later, when Deianira heard a rumor that Hercules had fallen for another woman, she desperately sent him the cloak. Overcome by the poisoned garment, the agonized hero threw himself on a funeral pyre and died. Deianira, riddled with guilt, committed suicide.

Perhaps the most famous Renaissance depiction of the couple's fateful encounter is a painting by the Italian artist Antonio Pollaiuolo, *Hercules, Nessus and Deianira* (c. 1470) (fig. 59).[46] Taking the climactic scene of crossing as his subject, Pollaiuolo emphasizes the hero's steady aim, the churning river, and the swift movement of the narrative across its waters. He even includes a minute but clearly identifiable depiction of Florence in the background, associating the greatest hero of antiquity with the strength and might of his native city.[47] An ekphrasis composed by the ancient writer Philostratus on an imagined painting depicting Deianira's rescue may have inspired Pollaiuolo in his choice of this particular episode.[48]

Fig. 59. Antonio Pollaiuolo, *Hercules and Deianira*, c. 1475–80. Oil on panel transferred to canvas, 54.6 × 79.2 cm. Yale University Art Gallery, New Haven, University Purchase from James Jackson Jarves.

Yet in contrast to Pollaiuolo's dramatic action scene with its vast landscape and rushing river, Gossart's Birmingham painting removes Hercules and Deianira from the setting and temporality of narrative. The austere stone walls in the background offer no hint of the larger context and focus all attention on the entwined figures that they surround. The shallow space pushes the bodies outward toward the threshold of the painting, where a ledge marks with its cracks and fissures the boundary between the ancient past and the present moment attested by the date at their feet. By suggesting that the space separating object and viewer can be breached, Gossart invites an intensely palpable engagement with his subjects.[49] This arrangement evokes the grisaille niches on the exterior of early Netherlandish altarpieces inhabited by fictive sculptural bodies often painted as if coming alive, not unlike the effect that the polychromed portrait busts, displayed in niches at Wijk bij Duurstede, would have conveyed in three dimensions.[50] Gossart's painting thus anticipates a viewer accustomed to local visual strategies who, upon recognizing the figures as Hercules and Deianira, could reconstruct the plot and uncover its present-day implications by engaging with the rhetoric of the couple's animated bodies.

Although at first glance the lovers seem wholly lost in their embrace, the attributes they hold tell another story. The white cloak caught up under Deianira's thighs is the only detail that refers directly to the myth. Although it curiously shows no trace of the centaur's blood, Gossart clearly specifies that it is the garment in question, rendering its gold-embroidered collar with careful detail. The cloak in Deianira's hand is situated in symmetrical opposition to the gnarled club Hercules clutches at his side. Gossart emphasizes the club's rustic craftsmanship: its knotted wood, makeshift metal frame, and menacing spikes. The weapon could be taken as a metonym for the physical prowess of the hero whom Deianira's gift made frail, but such serious implications in no way detract from the humorous and erotic suggestiveness of the oversized staff, which so clearly stands in for his thinly veiled manhood. If Hercules were to stand up and attempt to wield this impressive club, it would be preposterously large, almost two-thirds the height of his body.

The club thus calls to mind the tense boundary between the hero's active life and his pursuit of love. An interesting comparison can be made with a circa 1590 engraving after a design by Hendrick Goltzius, in which the hero turns his back on the club and quiver lying in the foreground and embraces Deianira on a makeshift bed cushioned by the skin of the Nemean lion (fig. 60).[51] The defeat of Nessus appears in the distance, while the text below the image describes the couple's marital bliss: "After the wrestling-match between Hercules and Naupactian Achelous, after the fraud of Nessus and after the Lernean arrow, now Alcmena's happy son holds Deianira in his embrace, and impassioned, he gives her grateful kisses on the marriage bed."[52] Whereas in Goltzius's print Hercules has clearly abandoned fighting for foreplay, Gossart's painting is more unresolved. With one hand embracing his lover and the other holding the shaft of his weapon, Gossart's Hercules is shown to be caught in the tension between love and war.

Fig. 60. Jacob Matham after Hendrick Goltzius, *Hercules and Deianira*, from *The Loves of the Gods*, c. 1590. Engraving. 28 × 19.5 cm. British Museum, London.

The sculpted relief below Gossart's figures underscores this implicit conflict. Three scenes depicting the labors of Hercules are readily visible: from left to right, the frieze includes the episodes of the hero wrestling Antaeus, battling the Hydra, and supporting the globe in place of Atlas (fig. 61). The segment of the frieze obscured in the shadows beneath the couple's legs has been identified as showing Hercules wearing the skin of the Nemean lion and Hercules cleaning the Augean stables, but Gossart clearly portrays these scenes—quite difficult to make out—as lesser in importance than the other three historiated reliefs.[53]

The inclusion of the Hydra is especially relevant, as Hercules used the toxic blood of this serpent to poison the arrow with which he killed Nessus, and which in turn poisoned the cloak now in Deianira's hand. By rhyming the Hydra's multiple heads with the spikes of the hero's club, Gossart seems to encourage the viewer to pursue this sort of associative link between the picture and the mythical narrative

Fig. 61. Jan Gossart, *Hercules and Deianira* (detail), 1517. Oil on panel, 37 × 27 cm. Barber Institute of Fine Arts, Birmingham.

Fig. 62. Jan Gossart, *Hercules and Deianira* (detail), 1517. Oil on panel, 37 × 27 cm. Barber Institute of Fine Arts, Birmingham.

(fig. 62). Similarly, the way in which Deianira lifts the white cloak like a curtain over the final scene of the frieze seems more than nervous fidgeting. It could well remind the viewer that Hercules, the same hero who took the weight of the world on his shoulders, was ultimately crushed by the hand of a jealous woman. An epigram by the sixteenth-century Netherlandish poet Janus Secundus speaks to the irony of such a powerful figure's being overwhelmed by love: "On an image of Hercules carrying Cupid on his back, and succumbing under the load. He who once held lightly the weight of the heavens now finds little Love a heavy burden on his shoulders.[54] It is uncertain whether Secundus is describing a real image or simply imagining a picture of Cupid riding piggyback, but the tone that he takes in these verses—at once playful and admonitory—aligns closely with the mixed messages in Gossart's *Hercules and Deianira.*

Taken as a whole, the frieze Gossart has depicted resembles an ancient Roman sarcophagus, a *spolium* integrated into the surrounding architecture. The labors of Hercules were a fairly common subject for sarcophagi, and a few surviving examples—including the *Savelli Sarcophagus* that Gossart may have seen in Rome—even divide the individual scenes by columns as they appear in the painting (fig. 63).[55] However, even if Gossart's frieze was inspired by a Roman monument, it does not reproduce any specific model directly. All the ancient Hercules sarcophagi follow one of a handful of standardized sequences for the labors, to which Gossart does not adhere; nor do his scenes follow the chronology of the hero's life as given in Apollodorus or the other established textual sources on the twelve labors.[56] Rather than keeping to a linear narrative, the artist has selected particular episodes for their relevance to his own painting and highlighted them within the frieze according to his own pictorial intentions.

Taken together, the three prominent scenes in the frieze encompass the principal realms of the world. Antaeus was the son of the earth and derived his strength from the land. The Hydra was a serpent of the water who inhabited the swamps of Lerna. The burden that Hercules bore in Atlas's stead was to hold the heavens on his shoulders. A striking parallel is to be found in Ovid's *Heroides*, a collection of imaginary letters between lovers very familiar in Gossart's courtly milieu.[57] In Ovid's letter from Deianira to Hercules, she condemns her husband for pursuing romantic affairs over the concerns of his worldly domain:

> To you is owing peace upon the earth, to you safety on the seas; you have filled with worthy deeds both abodes of the sun. The heaven that is to bear, you yourself once bore; Hercules bent to the load of the stars when Atlas was their stay. What have you gained but to spread the knowledge of your wretched shame, if a final act of baseness blots your former deeds?[58]

Even if Gossart's frieze was not inspired by this exact passage, his sculpted scenes provide a similar retrospective on the hero's global conquests and expose the

Fig. 63. *Savelli Sarcophagus.* Museo Torlonia, Rome.

gap between the hero's bellicose past and amorous present. Notably, this theme becomes even more explicit in the aforementioned woodcut *Hercules and Deianira* after Gossart's design, in which the hero straddles his lover in a sexualized rendition of territorial conquest, evoking through his stance, laurel crown, and strong profile the iconography of a triumphant Roman emperor (see fig. 54).[59]

The image of Hercules as world ruler was very much on the minds of the Netherlandish nobility in 1517 when Gossart's Birmingham painting was made. As mentioned in the previous chapter, Charles V sailed that year from the Low Countries to Spain to claim his newly inherited kingdom. In anticipation of the journey, Charles had debuted his new Herculean *devise* at the 1516 meeting of the Order of the Golden Fleece.[60] It was the last of these ceremonies that Philip attended, and one at which Henry of Nassau, fellow knight of the order, was also present.

Displayed at the ceremony was an image of two pillars standing in the sea together with the motto *Plus Ultra,* "Still Further," a reference to the mythical columns erected by Hercules at the Straits of Gibraltar and an embodiment of the young ruler's imperial ambitions.[61] In an accompanying Latin oration given by Italian humanist Luigi Marliani, the young prince was duly hailed "as a new Hercules and

Atlas," who through his virtue must sustain the burden of the world and learn to understand his own magnitude.[62] Although the image from the 1516 meeting does not survive, a very similar panel from the 1519 chapter meeting in Barcelona gives a sense of its dramatic effect (fig. 64).

Fig. 64. Plus ultra devise, 1519. Barcelona Cathedral, Barcelona.

The origin of Charles's *devise* illuminates the historical valence of Gossart's painting. For the conception of the motto, Charles and his counselors looked to a fifteenth-century vernacular text central to the culture of the Burgundian court and still popular during the early sixteenth century: Raoul Lefèvre's *Compendium of Trojan Histories* (c. 1464).[63] Lefèvre, who served as Philip the Good's chaplain and wrote the *Compendium* at the duke's request, posits an ancient ancestry for the Burgundian nobility by combining biblical, mythological, and historical narratives, from the labors of Hercules to the epic of ancient Troy.[64] In particular, Lefèvre's account of Hercules's conquest of kingdoms and beautiful ladies prefigures Gossart's painting by firmly establishing the myth of Hercules and Deianira within the local historical tradition of the Netherlands.

Lefèvre imagines Hercules and Deianira engaged in *gracieuse devises* ("graceful exchanges") of courtly romance.[65] In a lengthy passage, the author describes Hercules admiring the lovely Deianira from his window, while she sits in the garden dreaming of him. The chiasmus of the scene becomes explicit in its final lines, when the lovers are interrupted by the encroaching threat of Achelous. Lefèvre writes:

> As she [Deianira] was thinking about Hercules and Hercules was thinking about her, news came that Achelous was coming to besiege the city by land and sea, and their minds were so distracted that Hercules ceased to gaze at Deianira and the maiden ceased to think of Hercules.[66]

This exchange of mutual desire is remarkably close to Gossart's own entwined composition. Like Lefèvre, Gossart presents the couple simultaneously as subject and object; however absorbed in the intimate passions of their union, they are not immune to the external force of the worldly realm. Inasmuch as Gossart's image stimulates a desire on the part of its viewers to emulate the couple's passionate embrace, it also reveals the necessity of putting up defenses. This negotiation between the bedroom and the battlefield, explicit throughout Lefèvre's narrative, also crucially underlies the chiastic structure of Gossart's composition.

It is no coincidence that the sole depictions of Hercules and Deianira in Netherlandish art to predate Gossart's painting are based on Lefèvre's text and were

Fig. 65. *Wedding of Hercules and Deianira*, Tournai Workshop, c. 1513. Tapestry. Metropolitan Museum of Art, New York, Gift of Mrs. Daniel Guggenheim.

Fig. 66. *Hercules and Deianira* from Raoul Lefèvre, *Compendium*, 1470s. Koninkijke Bibliotheek, the Hague.

produced for the courtly realm. Tapestry series showing the life of Hercules, including the episode of his marriage to Deianira, were still being woven in Tournai in the early sixteenth century and shipped off to noble patrons (fig. 65).[67] Henry of Nassau himself, the owner of Gossart's lost painting, acquired for his collection a fifteenth-century illuminated manuscript of Lefèvre's *Compendium* (fig. 66).[68] The story of Hercules and Deianira is presented in Henry's manuscript—according to a pictorial convention common in illuminations from this period—as a progression of multiple scenes set within a single landscape. While the fully clothed couple in these images and the narrative compositions they inhabit bear little resemblance to Gossart's far more complex painting of sensual nudes, both the tapestries and Henry's manuscript testify that the sixteenth-century conception of Hercules and Deianira was still very much grounded in fifteenth-century Burgundian heritage.

HERCULES BATAVUS

Yet even as the imagined lineage established in Lefèvre's text endured in its appeal, the desire for a more tangible connection between Hercules and the Low Countries was also beginning to emerge. Sometime shortly prior to 1506, Willem Heda composed a genealogical treatise honoring Charles V's grandfather Maximilian of Austria.[69] Although never published, the text survives in its original presentation copy, written in Roman capitals and with a title page framed by a subtle drawing

of a triumphal arch (fig. 67). Relying once again on the tradition of Lefèvre's *Compendium*, Heda devotes an entire chapter to Hercules and his noble deeds. Yet the humanist proves unsatisfied merely to iterate Burgundian literary tradition. After recalling the columns that Hercules erected in Spain, Heda purports to remind Maximilian of another Herculean monument within his realm:

> Likewise it is well known in our time that at the boundary of the Cimbri, who are the inhabitants of your province of Zeeland, a huge stone is seen with an effigy of Hercules. Under the effigy is written, "sacred to the god Hercules."[70]

We have absolutely no record of such a "huge stone" in Zeeland at this early date. Heda cannot have meant the Hercules altar that Philip of Burgundy later found in the province: his treatise predates Philip's 1514 discovery; moreover, Heda clearly refers to an actual effigy of the hero.[71] Perhaps Heda was applying interpretive license to a statement made by the ancient writer Tacitus that Hercules visited not only the shores of Spain but also those of the Netherlandish provinces.[72] In later years, Heda would document actual ancient inscriptions that had been found near the city of Utrecht; he had an unquestionable interest in the archaeological record and a yearning for affirmation of the ancient past in his native land, so much so that he felt compelled to concoct his own evidence.[73]

The blurring of lines between historical pursuit and forgery—one of the recurring themes in the Renaissance approach to the past and its search for origins—is documented in the Netherlands well beyond Heda's treatise.[74] The most remarkable example from the early sixteenth century was an authentic Roman inscription discovered not far from Leiden and then appropriated, perhaps by one of the humanists in Gossart's circle, with the addition of the spurious phrase "The Batavian people, friends and brothers of the Roman emperors." Geldenhouwer elides the original inscription with the invented one when recording the text in his 1530 treatise *Batavian History*.[75] A surviving eighteenth-century brick inscribed with the "friends and brothers" text may be molded from the actual sixteenth-century forgery; the ancient stone itself is extant and shows no sign of adulteration, despite Geldenhouwer's conflation of their inscriptions (figs. 68–69). Whatever form the invented evidence originally took, the motivation behind it is clear. The forger gave voice to a simple archaeological find, transforming it into an expression of Roman esteem for the Batavian people, and by extension for the distinguished ancient ancestry of the Low Countries.

Geldenhouwer, as we have seen, was consumed with the project of substantiating local antiquity, particularly as it concerned the history of Batavia. Along with his interest in the topography of the ancient isle, he became fascinated with the character and physical qualities of the Batavians as described in ancient sources. The Batavian people were famed above all for their bravery in battle and loyal service as soldiers in the Roman legions. Already in the 1514 publication that contains Geldenhouwer's

DD·NN·MAXIMILIANO·CAES·
AVG·GERMANIC·PANNONIC·
DALMATIC·ET·PHILIP·EIVS·F·
BVRGVND·BELGIC·FRISIO·PRI
CIPIB·INVICTISS·VVILHEL·HEDA
ALFENVS·GENETHLIACVM·DD·

ONSVEVERE
maiores noſtri Maxi
miliane Caſar. Au
guſte: primogenita
eorum (quæ ad uitæ
uſum producebātur
diis protectoribus tā
q̃ ſacra offerre: ut reſiduum his bene iu
uantibus uberiori fœnore fœlicius prodi
ret. Sic Baccho uuas: fruges cereri: & ipſi
Pomonæ fructus oblatos legimus. Nec ea
conſuetudo penitus aboleuit: cūm pri
mas uuaſ & alias matureſcentes fruges ſū

Fig. 67. Title page of Willem Heda, *Genethliacum*, c. 1506. Universiteitsbibliotheek, Utrecht.

Letter on Zeeland, there is a list of epithets excerpted from Tacitus and hailing the Batavians as "fierce, savage, full of life," "comrades of the Roman Empire," and "ancient victors of many wars."[76] Geldenhouwer himself declared in his 1520 treatise *Lucubration on the Batavian Isle* that the island "produces the most beautiful men and women," and that the men in particular were "strong and tall, always the most ready and apt to undertake the perils of war."[77] By creative association, when the printer of Geldenhouwer's *Batavian History* sought an illustration for the book's title page, he reused a depiction of Adam and Eve after the Fall, showing a virile Adam with an animal skin hanging over his groin and Eve wearing her hair tied up prettily in classical fashion (fig. 70).[78] Because there was no existing repertoire of Batavian iconography from which to draw, the printer's appropriation was a logical and evocative choice for an image of primitive existence, though one perhaps not entirely aligned with Geldenhouwer's agenda of ennobling the ancient tribe.[79]

More significant than their physical traits, however, was the Batavian custom of worshipping Hercules as a patron deity, a historical fact on which Geldenhouwer and other local scholars eagerly capitalized.[80] Even the humanist Jean Lemaire de Belges, employed at Margaret of Austria's court and greatly indebted to fifteenth-century Burgundian tradition in the writing of his vernacular history, *Illustrations of Gaul and Singularities of Troy* (c. 1511–13), includes a proud reference to the local cult of Hercules: "The princes of great influence in those times were named Hercules, for whom—as Cornelius Tacitus testifies—the Germans in perpetual memory of him would, when marching into battle, sing songs and chants of his marvelous and terrible deeds in their native language."[81]

Geldenhouwer notably translated a few relevant chapters from Lemaire de Belges's history into Latin and included them in his own treatise *Batavian History*.[82] Geldenhouwer, however, augments Lemaire's description of ancient Herculean temples along the Rhine by referring back to the stone that Philip of Burgundy had

Fig. 68. Inscription found at Roomburg. Kasteel Duivenvoorde, Voorschoten.

Fig. 69. Gens Batavorum inscription. Rijksmuseum van Oudheden, Leiden.

HISTORIA BA
TAVICA, CVM APPENDICE DE VETVSTISSIMA
Nobilitate, Regibus, ac Gestis Germanorum.
Rhapsodo Gerardo Nouiomago.
*
Locorum declaratio, in calce addita, ubi hacte
nus ab aliquibus cæcutitum.

Argentorati, apud Chr. Aegen.

Fig. 70. Title page, from Gerard Geldenhouwer, *Historica Batavica*, 1530. Bijzondere Collecties, Amsterdam.

found on the island of Walcheren in 1514: "In Zeeland as well, not far from Middelburg, in a site that they now call Westkapelle, there was once a cult [to Hercules], which the monuments of antiquity, preserved in the church at that place, clearly indicate."[83] This reference, less than two decades after the stone's discovery, is remarkable in that it shows Geldenhouwer actively updating the Burgundian historical record with real archaeological evidence, just as Heda had attempted in his genealogical treatise for Maximilian I.

Geldenhouwer's efforts to link Burgundian and Batavian heroism also extended to literary remains. Sometime in the early 1510s, while perusing an old manuscript in the library of Leuven University, Geldenhouwer had discovered an epitaph honoring a Batavian soldier named Soranus, which he believed to have been written by the emperor Hadrian himself.[84] Geldenhouwer was so taken with the verses as evidence

of the admiration shown to his ancestors that he included it in both treatises he later published on the history of Batavia (fig. 71). Speaking in the first person, Soranus declares in the epitaph:

> I am he who was once most famed on Pannonian shores,
> out of a thousand Batavian men, the foremost in bravery.
> With Hadrian as judge, I could cross the wide waters
> of the deep Danube wearing all my armor,
> and while an arrow shot from my bow hung in the air
> and fell, I fixed and broke it with another arrow.
> I, whom neither Roman nor barbarian, neither soldier with spear,
> nor Parthus with bow, was ever able to conquer:
> Here I lie, here I have consecrated my deeds with a memorial stone.
> Let it be seen whether anyone after me will match my deeds.
> I set my own example, I the first who carried out such feats.[85]

The skill of swimming in full armor, of which Soranus boasts, was among the virtues for which Batavian soldiers received particular praise in the ancient histories of Tacitus, as well as from Renaissance writers familiar with his works; Aeneas Silvius Piccolomini, for instance, refers in his popular fifteenth-century *Commentaries* to an "island in the Rhine that was long ago settled by the Batavians, warlike men so strong

Fig. 71. Epitaph of Soranus the Batavian, from Gerard Geldenhouwer, *Historica Batavica*, 1530. Bijzondere Collecties, Amsterdam.

they could swim the Rhine in full armor."[86] Yet the combined prowess in swimming and archery described in the epitaph above is especially remarkable, as it suggests a strong affinity between Soranus and his Herculean forebear, the hero to whom the Batavians paid homage. The very episode in which Hercules performed these same feats both on land and in water likewise took place on the banks of a perilous river and is a story by now familiar: the hero's mythical rescue of Deianira.

Given the prominence of Hercules and Deianira in the historiography of the Netherlands, the association between Soranus and Hercules must have resonated with Geldenhouwer as a powerful historical connection. Nor would the significance of the chiastic relation between Burgundian and Batavian history have been lost on Geldenhouwer's contemporaries. The Batavians had entered into local parlance almost immediately and became familiar even to those outside elite humanist circles. In 1517—the same year to which Gossart's *Hercules and Deianira* dates—the humanist Cornelius Aurelius published his monumental and immensely successful *Chronicle of Holland, Zeeland, and Friesland* (also known as the *Divisiekroniek*), which offers a vernacular account of the entire history of the Netherlands from man's biblical origins to the reign of Charles V.[87] In addition to charting the great deeds of the Roman emperors, Burgundian dukes, and the noblest Netherlandish families, Aurelius also includes extended discussion of the Batavians, offering effusive praise for their strength and superior abilities on the battlefield.[88] He even affirmed the military activities of the ancient tribe and documented their former presence in the region by including the first published illustration of a Netherlandish archaeological find, a tile inscribed with the abbreviation for "the army of Lower Germany" (fig. 72).[89] Here is a powerful example of an ancient object being used to substantiate the reconstruction of the local past, and a foresighted one in its use of the print medium as a means of dissemination. As indicated by the evidence of use and marginal notations in the surviving first editions of Aurelius's *Chronicle*, the passages concerning Batavia and local antiquity were the most eagerly read of the book's many chapters, presumably because they offered the latest and most exciting historical information.[90]

In the intimate realm of court, this kind of historical inquiry must have been especially fervent. Geldenhouwer relates that Philip spent evenings at his palace reading and discoursing on poetry, sacred letters, and above all ancient history.[91] The humanist's correspondence with his friend Cranevelt documents that he was actively requesting books to support his patron's literary pursuits, including works hot off the press like Erasmus's latest edition of the New Testament.[92] Geldenhouwer describes the engagement with historical texts in particular as a shared experience at court, recounting that he was called upon to give voice to the stories of the past by reading classical sources aloud to Philip. Given Geldenhouwer's own interests, those sources surely included excerpts from ancient writers like Tacitus describing the Batavians and their watery homeland. Philip's newly renovated dining room at Wijk bij Duurstede included three large painting panels showing nude men engaged in

Fig. 72. Tile from Germania Inferioris, from Cornelius Aurelius, *De cronycke van Hollandt, Zeelandt ende Vrieslant*, 1517. Woodcut. Bijzondere Collecties, Amsterdam.

combat, in all likelihood a depiction of the labors of Hercules, which may well have stimulated Philip's guests to draw parallels interconnecting mythical history, the Batavian past, and the courtly and political affairs of the day.[93]

So as to assert the importance of ancient ancestry in the present context, Geldenhouwer and Cornelius Aurelius had already begun to refer to themselves as "Batavians" and to praise their patrons under this same designation.[94] Both humanists would proceed to revise the genealogy of the noble families of the Netherlands, including the Egmonds and the Wassenaers, by tracing their lineage back to the greatest Batavian heroes.[95] The rebellious uprising of the province of Guelders that erupted during these same years provided fertile ground for associating local noblemen with the Batavian war heroes of the past.[96] Located in the eastern part of the Netherlands, Guelders was a particular threat to nobles with land holdings in Holland and Brabant, including the Egmonds and Henry of Nassau himself, who together with Philip was actively endeavoring to subdue the rebels. In a 1516 letter

lauding Henry's success in the war against Guelders, Aurelius asserts the nobleman's heroic descent by hailing Henry as nothing less than "the glory of our Batavia."[97]

Hercules may have been the most ubiquitous hero of antiquity and of Renaissance courts across Europe, but in the context of the early sixteenth-century Netherlands, his legacy acquired specific meaning, providing a bridge between the ancient Batavians and the Burgundian nobility. We do not know the composition of Henry of Nassau's large painting of Hercules and Deianira, but by virtue of its subject alone, it is clear that the lost work confronted its owner not only with the challenge of negotiating between war and peace—the pleasures of love and the glorious perils of heroism—but also with a compelling union of mythical and historical lineage. If Gossart's small surviving rendition of the couple has allowed us to reconstruct the resonance of the myth, it can also finally invite consideration of how scale itself impacted the reception of Gossart's mythological works.

UT PICTURA NON POESIS

Gossart's *Hercules and Deianira* and his other diminutive mythological pictures innovate in combining the intimacy of private devotional images—like his own *Malvagna Triptych* and the works produced by his fifteenth-century predecessors—with the new antiquarian appetite for small figurines, coins, and medals. We have already seen how Gossart's *Venus* traces its lineage back to the precious art of Jan van Eyck (see fig. 1). While past scholarship has generally treated Gossart's small-scale works as either explicitly erotic or cautiously moralizing in their treatment of classical subject matter, it is their objectness as much as their actual subjects that endowed these paintings with an irresistible allure and allowed them to operate in a middle ground between those two poles.[98] Not simply pictures hung on a wall, they were things to be held, given as gifts, and shared with friends. They were activated in the present moment by intimate handling, circulation, and conversation. A painting of "lovemaking" listed in the inventory of Philip's palace at Wijk bij Duurstede is even described as having its own little box, indicative as much of its lascivious subject as of the possibility that it could be taken from place to place, and easily guarded for private viewing.[99]

Whatever the compositional relation between Henry of Nassau's monumental *Hercules and Deianira* and Gossart's small extant picture in Birmingham, it is worth considering the implications of Antonio de Beatis's sighting of the lost painting in 1517. As Cuthbert's loathsome sojourn in Zeeland has already documented, that year marked Charles V's imminent departure for Spain and meant that diplomats from across Europe as well as the local Netherlandish nobility had assembled in strong force.[100] It must have been on this occasion that many noblemen encountered Gossart's new mythological paintings for the first time. Perhaps one of Henry of Nassau's colleagues saw his *Hercules and Deianira* in Brussels and was so taken with the work that he commissioned Gossart to paint him a small version, or else

received it as a gift from Henry or Philip. Technological examination of the panel has revealed that it is painted thinly and with loose brushwork, suggesting perhaps that it was a rush order, which Gossart had to finish with some haste.[101] In its intimate scale, the Birmingham painting was not only faster to produce but also a portable object that would have allowed Gossart's work to move within a wider sphere of exchange.

In this regard, Gossart's diminutive mythological picture paralleled the function of the collectible antiquities, as well as Renaissance surrogates for such ancient objects, documented in the possession of Philip and his other contemporary Netherlandish patrons. Classical coins, which were by nature designed to circulate, allowed their owners to share in a mutual appreciation of the classical past, both in the contemporary moment and with an awareness of the many hands through which they had passed over time.[102] Philip's numismatic collection of over one hundred coins, both silver and copper, is described pointedly in the Wijk bij Duurstede inventory as "old coins from antiquity," leaving no doubt as to the venerable origins of the collector's trove.[103] Nor was Philip alone in this interest. Having viewed the coins in the possession of the Mechelen humanist Jerome van Busleyden, his English colleague Thomas More was inspired to reciprocate by composing epigrams praising the collection; More himself was also known to send coins as gifts to friends.[104]

Renaissance portrait medals—modern counterparts to ancient coins—were likewise exchanged as personal presents and collectibles. The creation of such medals in the Netherlands reached new heights of artistry and erudition during the decades spanned by Gossart's career, in response to both larger pan-European trends and local humanist enterprise.[105] The two most prominent commissions in the early sixteenth-century Low Countries were the 1519 medal for Erasmus created by Quentin Massys and an anonymous medallion of the Netherlandish pope Adrian VI produced around 1522.[106] The record of Erasmus's correspondence concerning his medal exemplifies the custom, practiced both by his fellow humanists and by courtiers, of sending these objects together with letters to friends and colleagues. The portrait medal made present and tangible the connection between giver and recipient and affirmed—through its inherent mobility—the larger network to which they belonged. Although Gossart's primary patron, Philip of Burgundy, never commissioned such a medal, the jetons (*rekenpenningen*) minted during his tenure as bishop of Utrecht—with his profile on the front and a *festine lente* motif on the reverse—circulated in similar fashion,[107] and Philip's grandnephew Adolph of Burgundy took advantage of the medium with a spectacular commission a few years later (see fig. 91).

Especially notable among the new practitioners of medal making in the Low Countries was the poet Janus Secundus, who—in addition to penning his many epigrams—sculpted portraits of court officials and local scholars like Frans Cranevelt.[108] In a 1533 letter to the Netherlandish painter Jan van Scorel, Secundus demonstrates how portrait medals allowed for exchanges concerning artistry as well as

friendship. Referring to a medal depicting Jan II Carondelet, Secundus writes, "I am sending you the effigy of the archbishop of Palermo, which I sculpted in these last days, so that you may see whether I have made any progress. I ask that you judge it honestly."[109] Secundus's query testifies to a desire to excel in an antiquarian medium that he himself was instrumental in introducing within the Low Countries, as well as to the fact that sculptors and painters in the courtly ambit worked in collaboration. Secundus goes on in the same letter to ask whether Scorel might put in a good word for him with Henry of Nassau, a patron with whom the latter was already on familiar terms.[110] In his endeavor to establish himself as a contributor to the local renaissance in his native land, it is no coincidence that Secundus was courting both Carondelet and Henry of Nassau, two established patrons of Gossart's works.

Small figural sculptures—another emergent category of object in Netherlandish art of the early sixteenth century—parallel Gossart's mythological project even more closely. Gossart's contemporary Conrad Meit—the same sculptor who carved the aforementioned marble busts depicting Margaret of Austria and her husband—produced numerous such statuettes in wood, bronze, and alabaster from his position as court artist in Mechelen.[111] Gossart was certainly acquainted with Meit, as he stayed at the sculptor's house during a visit to Mechelen in 1523 when he was called there to restore works in Margaret's collection.[112] Perhaps, like Secundus and Scorel, Meit and Gossart shared a dialogue as they endeavored to innovate in their respective media. Meit is also the sole sculptor whom Geldenhouwer singles out amongst the great practitioners of the liberal arts, a list that the humanist compiled in his manuscript notes for an unrealized history of the early sixteenth-century Netherlands.[113]

Meit began creating his small statuettes of nude figures around 1510, a date closely contemporaneous with that of Gossart's first mythological paintings. His *Adam and Eve*—composed of two separate wooden figures, each barely ten inches high—could be turned around and viewed from all sides, caressed in their owners' hands, and posed in different positions (fig. 73).[114] Meit's *Judith with the Head of Holofernes* comments on its own status as a pseudo-antique through the way that Judith displays the prize of her conquest atop a classical column; the head is presented as a treasured object akin to that of the nude figure herself, who stands atop a base incised with the artist's own signature (fig. 74).[115] Judith's sensual body is evocative not only in its scale but also its very materiality; alabaster's white color and translucence associated it with both the marble of antiquity and the carnality of living flesh.

A sensitivity to the impact and meaning of materials is evident throughout Meit's oeuvre. His *Mars and Venus* entices no less through the smooth and glistening patina of bronze, a medium that had a direct ancient pedigree (fig. 75).[116] A few ancient bronze statuettes were circulating in the Low Countries at the time, at least some of which traced their provenance to local soil. In addition to the small statue of Minerva discovered in 1508 at the ancient site of Roomburg, Margaret of Austria's inventory suggestively records her ownership of "a small nude youth, made of metal,

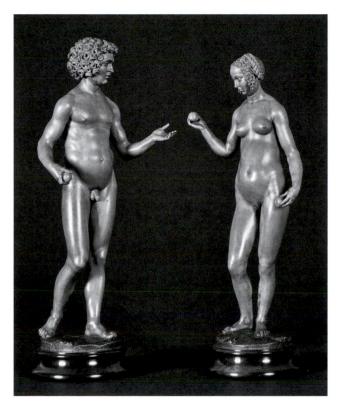

Fig. 73. Conrad Meit, *Adam and Eve*, 1510. Boxwood, 36 cm (Adam); 37 cm (Eve).
Schloßmuseum Friedenstein, Gotha.

and very ancient" that may have been a representation of Hercules.[117] Dating circa
1515–20, Meit's *Mars and Venus* shares a further affinity with the blatant nudity and
provocative couplings found in Gossart's own mythological images. The curly-haired
god and his lover—with her parted hair, narrow shoulders, and ample hips—even
resemble the figure types of Gossart's *Hercules and Deianira*.

Like Gossart, Meit was quite singular in his engagement with the classical nude
in the early sixteenth-century Netherlands, which makes all the more plausible that the
two artists engaged in a mutual and emulative exchange between sculpture and
painting.[118] Gossart and Meit were fulfilling the same desire on the part of their courtly
patrons, the same impulse to possess the past as a tangible reality. Although neither
Meit's sculptures nor Gossart's paintings could ever be mistaken for antiquities, they
were designed—through their scale and material associations—to rhyme compellingly
with ancient artefacts. While this point may be more evident in the case of Meit's
statuettes, it was no less true in the case of Gossart's diminutive mythologies.

Not long after his appointment as bishop of Utrecht, Philip gifted Gossart's
Hermaphroditus and Salmacis—very close in its dimensions to the Birmingham

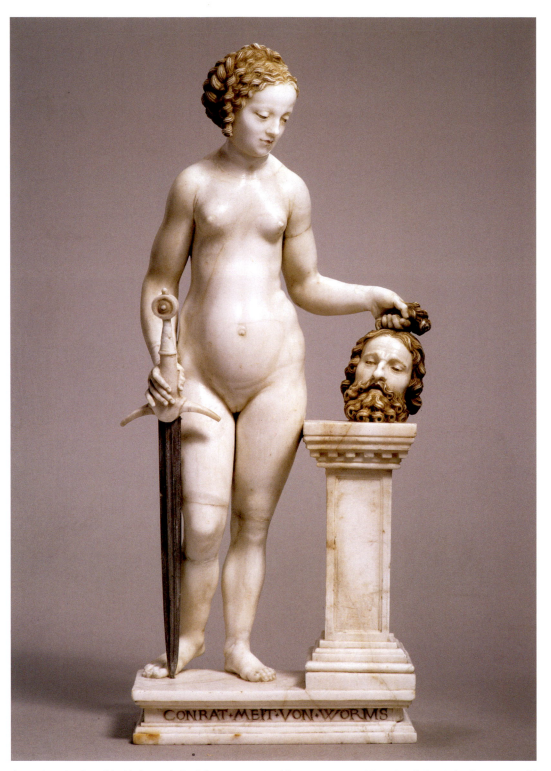

Fig. 74. Conrad Meit, *Judith with the Head of Holofernes*, c. 1525–28. Alabaster, 29.5 × 13.1 × 6.6 cm. Bayerisches Nationalmuseum, Munich.

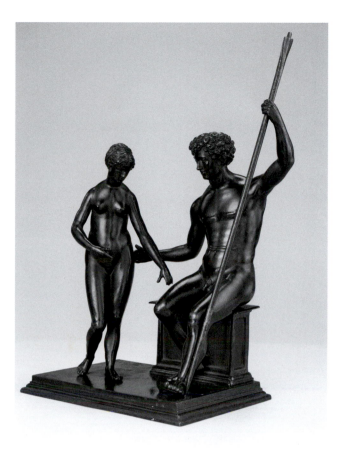

Fig. 75. Conrad Meit, *Mars and Venus*, c. 1515–20. Bronze, 34.3 cm (Mars); 23.6 cm (Venus). Germanisches Nationalmuseum, Nuremberg.

Hercules and Deianira—to Margaret of Austria (fig. 76).[119] The painting depicts the water nymph Salmacis venting her lust on Hermaphroditus, a beautiful youth who had innocently come to swim in her lake. The small size of Gossart's picture invites close study of the naked struggle in the foreground, complete with its clever figural allusion to the ancient Apollo sculpture that Gossart had drawn in Rome (see fig. 31). No less intriguing is the background detail of the gods answering Salmacis's plea for perpetual union with Hermaphroditus and transforming the pair into a single hermaphroditic body, a metamorphosis that—as the pathetic tree stump beside them suggests—leads to a loss of reproductive potency.[120] Gossart employs the motif of intersecting limbs already encountered in his *Hercules and Deianira*, but here the couple's relationship is more fraught, their physical struggle conveying through body language the inequality of their desire.

It is telling that Margaret kept Gossart's *Hermaphroditus and Salmacis* in the contemplative space of her private study along with other types of collectibles already

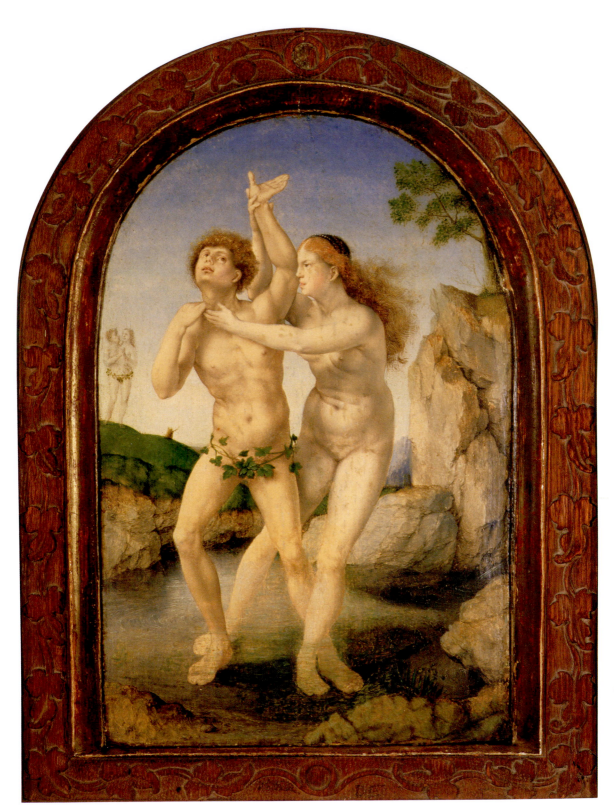

Fig. 76. Jan Gossart, *Hermaphroditus and Salmacis*, c. 1517. Oil on panel, 33 × 22 cm. Museum Boijmans van Beuningen, Rotterdam.

mentioned, such as medals and bronze statuettes.[121] Directly following the entry on Gossart's painting, her inventory records "two figures of Adam and Eve in the nude, of gilt metal, and well crafted," a description that recalls the figurines of Conrad Meit.[122] The juxtaposition of the Adam and Eve statuettes with Gossart's painting may even have provoked Margaret to engage in a kind of *paragone* debate on the relative merits of painting and sculpture as media through which the classical body could be reenlivened.[123]

The inventory entry on Gossart's *Hermaphroditus and Salmacis* itself sheds light on the painting's flexible design as an object. The work is described as having had two frames, the first painted in faux marble and the second gilded, with an accompanying inscription along its lower edge, the text of which is unfortunately not recorded.[124] The physicality of Gossart's *Hermaphroditus and Salmacis*, the evocation of sculptural materials—stone and gilt metal—in its framing apparatus, reveals that the composition's entangled bodies were also bound within the illusion of interlocking media. The painting sates the powerful desire for possession of curious things. If we recall Gossart's *Venus* (see fig. 1), which presents the goddess at her toilette as one among a meta-collection of precious objects spanning in their allusions from ancient Rome to the New World, the desirability of the artist's *Hermaphroditus and Salmacis* within the gift exchange between Philip and Margaret betokened an intimate conversation about the collecting of art and the representation of the body itself.

Another of Gossart's small mythological paintings provides a means to reconstruct how the framing elements of *Hermaphroditus and Salamacis* would have functioned. Gossart's 1521 *Venus and Amor* preserves an original double frame nearly identical in construction to that described in Margaret's inventory (fig. 77).[125] The outer rim of the frame is inscribed with a witty verse, spoken by Venus to Cupid: "Shameless son, you who are inclined to torment men and gods, you do not even spare your own mother; cease, lest you be destroyed."[126] This playful chastisement recalls the language of Lucian's dialogue between Venus and Cupid, one of those that Erasmus had translated into Latin and which Geldenhouwer's humanist colleague Hadrianus Barlandus published in 1512.[127] The dialogues were extremely popular as school texts because they not only introduced simple Latin phrasing but also facilitated a knowledge of mythological subjects tempered by lessons in Christian morality.[128]

However, far more important than the text itself is the fact that the outer frame of Gossart's *Venus and Amor* is detachable. The viewer could therefore physically manipulate the painting, enjoying it either with or without the accompanying inscription. The painting's very construction necessitates the act of holding the painting in one's hand and engaging in dialogue with it. This aspect of Gossart's *Venus and Amor* recalls, as frequently noted, a passage from Geldenhouwer's biography describing Philip's renovations to Souburg, in which he recounts that his patron "had versifiers who decorated pictures and buildings with poems, so that he could display each picture as both speaking and silent." [129] Although Geldenhouwer clearly alludes to the Horatian dictum *ut pictura poesis*, meant to suggest that both painting and poetry similarly aspired to the

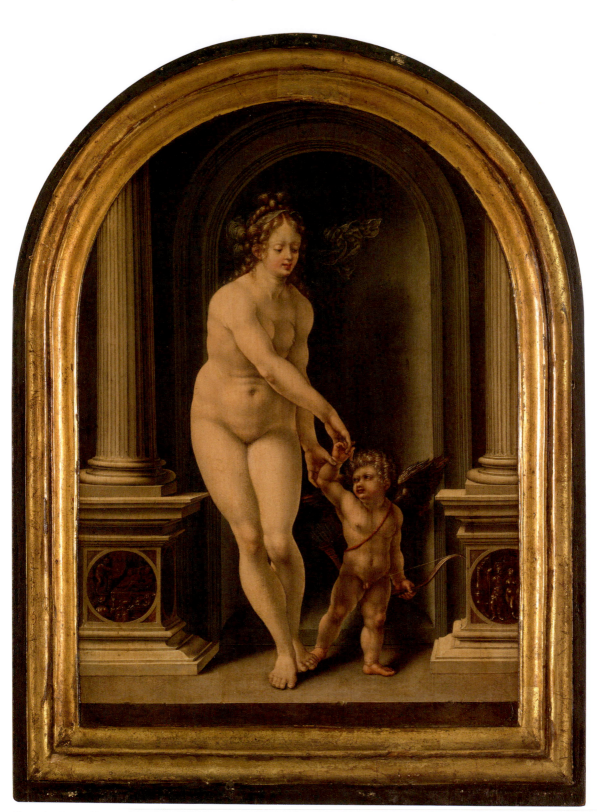

Fig. 77. Jan Gossart, *Venus and Amor*, 1521. Oil on panel, 32 × 24 cm. Musées Royaux des Beaux-Arts, Brussels.

imitation of nature, he also acknowledges that works in Philip's residence—like Gossart's *Venus and Amor*—did not *always* speak. Philip's pictures could be brought into dialogue with text if so desired, but they could also stand alone.[130]

Appending inscriptions to works of art, furniture, and the walls of palace chambers seems in itself to have been fairly common practice at the early sixteenth-century courts of the Netherlands. The inventory of Philip's palace at Wijk bij Duurstede lists a bed and table described as "speaking" (*loquitur*) that had belonged to his predecessor as bishop, Frederick of Baden.[131] Jerome van Busleyden likewise wrote several verses to accompany items in his collection ranging from paintings, wall murals, and stained glass, to a table and mirror that come alive and address their viewers.[132] In Desiderius Erasmus's 1522 colloquy *The Godly Feast*, every object or work of art in the garden of the villa where the dialogue takes place is accompanied by an epigram, which provides the occasion for a lively discussion between friends.[133] Erasmus may even have had Busleyden's mansion in mind when composing the text.[134]

Yet whereas a humanist like Erasmus ultimately believed that the written word was a more compelling means of communication than images, Philip's court operated according to a different model. The very fact that the inscribed frame of Gossart's *Venus and Amor* could be removed is an indication of the primacy afforded to the visual. In fact, the message of the text on the outer frame is already inherent in the composition through the two roundels to either side of the figures, which are painted to look like sculpted bronze, and scaled to the size of the coins and medals whose low-relief surfaces they evoke. These roundels, like the historiated relief in Gossart's *Hercules and Deianira*, expand upon the movements of the composition's central bodies. Both scenes, one depicting Vulcan exposing the adultery of Venus and Mars, and the other showing Venus and Mars in warm embrace, evince Cupid's interventions in his mother's love life. Venus's twisted torso and emphatic grip on the arm of her filial archer convey the tense and sensual struggle between them, her physical chastisement of Cupid for his deeds. The rhetoric of Gossart's bodies conveys the painting's essential meaning, with or without the text.

The removable frame on Gossart's *Venus and Amor* affirms unequivocally that his mythological paintings were anything but illustrations of a single narrative or overarching message. Gossart's *Hercules and Deianira* may or may not have had an original frame inscribed with verse, but in the end, such a verse could only have represented one out of the spectrum of interpretations that the painting might incite. The work offers itself as tangible link between ancient heroes and its contemporary courtly viewers, a pleasurable invitation to intimate engagement, but also as a material creation directly descended from the objects and collecting practices of the classical past.

At the same time, however, Gossart's provocative little pictures were born into a shifting world, in which the religious debates of the Protestant Reformation, as discussed in the next chapter, brought perilous consequences for images and their progenitors. Gossart's small *Virgin and Child*, dated to circa 1527, demonstrates how

Fig. 78. Jan Gossart, *Virgin and Child*, 1527. Oil on panel, 30.7 × 24.3 cm. National Gallery, London.

his art equivocally toed the line in reviving the ancient past so palpably within a fraught Christian present (fig. 78).[135] The figures and format of this religious work come uncannily close to his representation of mythological deities, its shape and dimensions almost identical to those of the *Venus and Amor* from a few years earlier. A backdrop of cold stone pushes the articulated interaction between mother and child into our space just as assertively, and Christ's dynamic nude body stretches outward like a heroic infant Hercules, ready to strangle the legendary serpents who crept into his crib. Christ even looks up toward the Latin word "serpentis" above his head in an inscription describing how the Virgin's seed will trample the snake and, by extension, the sins of mankind. A winged putto's head bursts from the stool below the Virgin's feet, echoing the child's outstretched arms and the promise of heavenly salvation. This entanglement of Christian and ancient history became the productive problem with which Gossart grappled in his last great mythological painting.

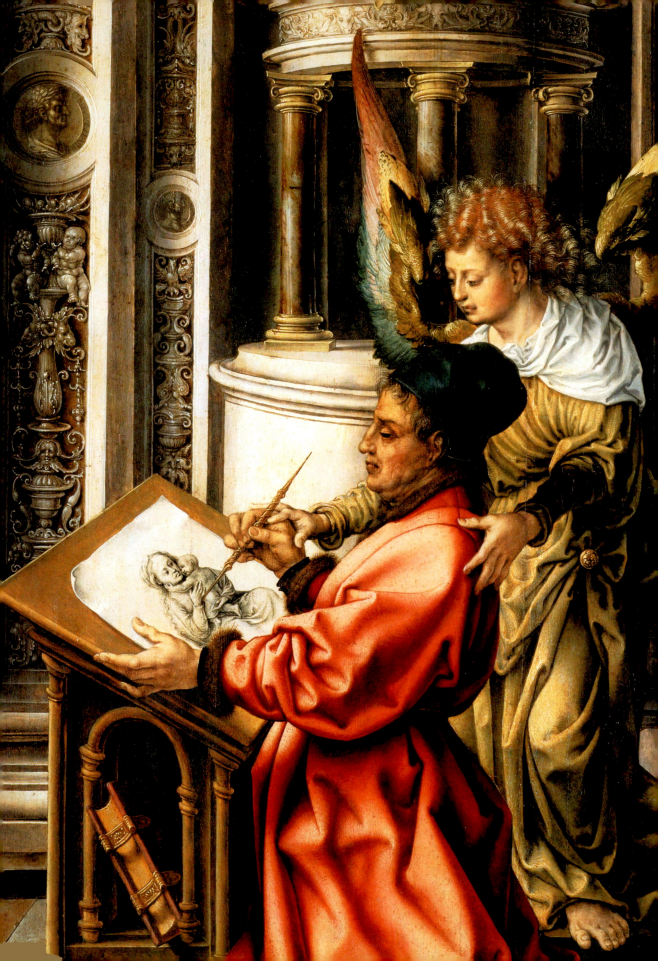

LEGACY

A concern for legacy motivated the invention of Netherlandish antiquity above all else. The endeavor to recover knowledge of ancient geography and ancestry, and to embody that venerable history through artistic commissions, implied an overarching hope that such efforts would prove lasting and impactful. This is exactly what Rudolph Agricola meant when he looked back to the past with prospective ambitions for the future, wishing that the Low Countries might one day be as Latinate as Latium itself.[1]

Yet the circumstances that gave rise to Gossart's visual contributions to this local renaissance were particularly difficult to sustain. As we have seen, his art required the nurturing of a sentient patron like Philip of Burgundy, eager to engage his court artist in intimate dialogue with humanists like Geldenhouwer. For such a focused antiquarian project to have a wider impact, other members of the local community had to take an interest as well, hence Philip's calculated gift of Gossart's *Hermaphroditus and Salmacis* to Margaret of Austria, or Geldenhouwer's letter to Cranevelt urging him to come see the portrait busts newly adorning the halls of his patron's castle.[2]

So what happened to Gossart's production of mythological pictures after Philip of Burgundy's death in 1524, and during the last decade of the artist's life, when the Protestant Reformation began to exert its force in the Low Countries? Heightened debate about the use and function of images in

Detail of Fig. 82

the Netherlands reached its first peak during the later 1520s, spurred by radical icono-clastic responses to Martin Luther's reform movement in Germany, and by an intensi-fied turn in Netherlandish scholarship toward questions of religion and moral deco-rum. While the impact of the Reformation on German artists was far swifter and more immediate than on their Netherlandish counterparts—not until the 1560s did icono-clasm leave its most devastating scars on the Low Countries—sensual images of classical nudes already became targets of critique.[3]

Gossart's 1527 *Danaë*—his last extant mythological painting—is thus in many ways his most remarkable (fig. 79). Not only does it predate paintings of the same myth by Correggio, Titian, and other Italian artists; its very subject cuts to the heart of questions surrounding the power of images. This picture, born into a climate of Reformation, is the only surviving mythological painting by Gossart to postdate Philip's death. We know with certainty neither who commissioned it nor where it originally hung, though I will argue that Philip's grandnephew Adolph of Burgundy was its most plausible patron. Ventured here is an attempt to understand how Gossart employed his *Danaë* to champion the legacy of the renaissance in which he participated, and to uphold the union of classical antiquity and Netherlandish tradition fundamental to his artistic career.

THE DILEMMA OF DANAË

Danaë's womb, according to the winding trajectory of classical myth, was the origin of artistic invention. When Danaë's father locked her in a tower to preserve her virginity, hoping to nullify a prophecy that his daughter's child would one day kill him, he failed to account for the ingenuity of the gods. Jupiter, ruler of the heavens, transformed himself into a shower of golden rain, descended through the ceiling of Danaë's prison, and made love to her. Perseus, the child of their union, became the hero who slew the monstrous Medusa, the Gorgon the very sight of whom could turn a living man into stone. From the blood of Medusa's severed body sprang the winged horse Pegasus, who flew to Mount Helicon, dug his hoof into the earth, and brought forth the inspiring stream that flowed ever after from the mountain abode of the Muses.

Gossart's *Danaë* assertively dramatizes its own material origins. As Danaë lifts the luscious swath of blue fabric draped across her thighs and welcomes the god's descending bounty, Gossart figures the womb concealed beneath those heavy folds, the mythical point of inception for all artistic inspiration and, by extension, for his painting itself. Danaë's upturned eyes, blushing cheeks, quivering lips, and the revelation of her perfectly sculpted breast not only manifest her carnal desire but also already anticipate the narrative outcome of the union at the painting's center.

Past scholarship on Gossart's *Danaë* has offered two vastly different interpreta-tions of the painting, neither of which has proven conclusive, but which together have the merit of signaling the picture's unorthodoxy.[4] For decades, there was almost

Fig. 79. Jan Gossart, *Danaë*, 1527. Oil on panel, 113.5 × 95 cm. Alte Pinakothek, Bayerische Staatsgemäldesammlungen, Munich.

unanimous consensus that Gossart's work adhered to an obscure medieval tradition, in which the myth was understood to prefigure the Immaculate Conception.[5] Medieval illustrations in this tradition show Danaë chastely clothed in her tower, receiving Jupiter as a heavenly beam of light.[6] Gossart's painting was likewise said to offer a model image of chastity because Danaë is depicted wearing a blue robe and a gold diadem, and humbly seated on the floor like the Virgin Mary, not unlike Gossart's representation of the Madonna in his Prague *St. Luke Drawing the Virgin* (see fig. 17).

More recently, scholars have rejected the understanding of Gossart's painting as an embodiment of pure chastity and have acknowledged that the image might be just as prurient as the later Italian representations of the myth.[7] Danaë's bared legs, loosening thighs, and willing gesture of drawing open the folds of her robe are not at all characteristic of the Virgin. In later Renaissance paintings like those by Titian and Tintoretto, Jupiter's golden shower was often transformed into coins, alluding to the most carnal kind of commerce.[8] This emphasis on the exchange of Danaë's body for money only escalated as each sixteenth-century artist vied to surpass his predecessor with ever-wittier visual play upon the theme of cupidity. In a particularly brilliant 1603 painting by Hendrick Goltzius, the coins represent payment not only to Danaë but also to the creator of the image itself, the gold (*golt* in Dutch) a pun on the artist's own name (fig. 80).[9] The suggestion of prostitution is heightened in all these examples by the inclusion of intermediary figures—whether Cupid, a maidservant, or an aged procuress—who transform the act of lovemaking between Jupiter and Danaë into a transactional spectacle.

The interpretation of Danaë as an image of chastity violated, if not an outright prostitute, can be traced to an infamous scene from a work by the ancient Roman writer Terence, whose writings were well known in the Netherlands and were frequently taught in local Latin schools.[10] In his play *The Eunuch*, a painting depicting the Danaë myth hangs on the wall of a private chamber where a virgin girl is resting after her bath. A young man, who has disguised himself as a eunuch to gain access to the chamber, gazes upon the image of Danaë and becomes so wholly enraptured that he is incited to emulate Jupiter and rape the maiden. For St. Augustine and other later Christian commentators, the causal relation between the painting in Terence's play and the youth's act of sexual aggression was a warning against the dangerous power of images.[11]

Erasmus alludes to this episode from Terence in his dialogue the *Ciceronian*, composed the same year to which Gossart's *Danaë* dates, and published in 1528. The humanist writes disapprovingly, "In paintings, Jupiter coming down through the roof into Danaë's lap holds captive our eyes much more than Gabriel announcing the heavenly conception of the holy Virgin; Ganymede snatched up by the eagle delights us more ardently than Christ ascending into heaven."[12] The message is clear: the mythological image is both a dangerous distraction and entirely out of place in a Christian context. Slightly later, the Amsterdam humanist Alardus Amstelredamus

Fig. 80. Hendrick Goltzius, *The Sleeping Danaë Being Prepared to Receive Jupiter*, 1603. Oil on canvas, 173.3 × 200 cm. Los Angeles County Museum of Art, Los Angeles. Gift of the Ahmanson Foundation.

would gloss a line from one of Erasmus's early pastoral poems, "My eyes saw it, my heart burst into flame," with the negative example of Danaë, offering a lengthy explication of the dangerous link between sight and physical desire.[13] An epigram by the sixteenth-century Netherlandish poet Nicolaus Grudius, written to accompany a painting of Danaë, offers a similar admonition: "If Jupiter dallied with Danaë as an image of gold, you too should learn to fear the guiles of the gold at which you gaze."[14] In a 1519 poem praising Hadrianus Barlandus's treatise *On the Noblemen of Holland*, his colleague Corneille van Coukercken contrasts Barlandus as serious historian with the sort of frivolous writer who sings of "the furtive loves of Jove, so that he might send drops of ruddy golden metal—damages to virginity—through the roof-tiles into Danaë's lap."[15] Barlandus himself remarked in his 1530 commentary on Terence, and in reference to the painting of Danaë, "We see many works of this kind today in the homes of wealthy men and courtiers, more than those depicting the powerful deeds of Christ."[16] While echoing Erasmus, Barlandus's statement also calls to mind Gossart's

own courtly milieu; as a close friend of Geldenhouwer and a native of Zeeland, Barlandus may even have known the artist's mythological paintings firsthand.

In light of this dominant textual tradition, it might seem that the erotic appeal of Gossart's picture requires some qualification. It has been posited that the work was accompanied by an inscription on its frame casting Danaë as an embodiment of female corruption.[17] The underlying assumption behind such a suggestion is that no matter how sensual, the northern nude could never entirely escape negative moralizing implications.[18] Yet simply positing the presence of a text appended to the frame cannot resolve the painting's inherent complexities. Gossart's mythological works, as we saw in the previous chapter, support diverse modes of interaction and interpretation on the part of their viewers regardless of the inscriptions attached to them. The question is not how we should seek to justify the eroticism of Gossart's *Danaë* but rather how we should understand the ways that the painting anticipates its own situated viewing. In other words, how might the work have engaged viewers both in its historical context and in its specific site of display?

First, Gossart's *Danaë* eschews the obvious categories and deliberately treads the boundary between pagan and Christian, ancient and modern. Rather than evincing creative retreat, many works of art produced during the first decade of the Reformation reveal surprising experimentation in response to the mounting questions surrounding the place of classical models and the nude body in a Christian context.[19] As we have already seen, Erasmus's diatribe against the pollution of paganism reverberated in the circles of his fellow Netherlandish humanists. Yet Gossart addresses this objection in his art through confrontation rather than avoidance, suggesting that his patrons not only were open to this kind of artistic response but, indeed, may even have encouraged it.

If we compare the artist's *Danaë* to his Prado *Virgin and Child* of the same approximate date—both female figures framed by a classical backdrop, clothed resplendently in satin and pearls and blushing as they expose their perked breasts—it is difficult to imagine that the artist was not thinking consciously at the interstices of ancient and Christian paradigms (fig. 81).[20] The assertive carnality of Gossart's *Virgin and Child* seems to go beyond the mere embodiment of the Word made flesh.[21] As the Christ Child stands on the book in the Virgin's lap, its pages fluttering at the gentle touch of her fingers, Gossart entices us simultaneously with Christ's sensual embrace of his mother and the strange rhyming of his rotund belly with the dimpled apple in his hand. Mankind's pagan and postlapsarian histories are eminently tangible even in the presence of the Redeemer.

Such visual experiments are all the more remarkable given Gossart's contemporary context. As the reform movement began to take hold in the Netherlands during the tumultuous 1520s, and met immediate backlash from its opponents, images and their makers were caught in the crossfire. The treatises of Martin Luther, as well as those of radical Reformers and iconoclasts like Andreas Karlstadt, were already

Fig. 81. Jan Gossart, *Virgin and Child*, c. 1527. Oil on panel, 63 × 50 cm. Museo del Prado, Madrid.

catalogued among the regular lists of banned books, an indication of their wide circulation.[22] Iconoclastic outbreaks are recorded throughout the provinces beginning in 1525.[23] Procedures against alleged Lutheran activity affected both artists and intellectuals in Gossart's immediate milieu, including prominent figures like the Antwerp humanist Cornelius Grapheus and the painter and tapestry designer Bernard van Orley, official court artist to the regent Margaret of Austria.[24] Van Orley was among a group of several Netherlandish artists who were discovered to have hosted and attended secret Lutheran sermons, and who were publicly tried in May 1527.[25] Given the prominence of the trial and the individuals involved, it seems likely that Gossart would have been aware of the proceedings. At the very least, the artist must have felt the impact of the growing fissures in belief among the members of his intimate circle.

Significantly, Gossart's closest humanist collaborator, Gerard Geldenhouwer, was very much consumed by the reform movement. After Philip's death, Geldenhouwer journeyed to Wittenberg in 1525, where he met Karlstadt and several other Lutherans and conceived a strong desire to convert.[26] Geldenhouwer wrote a letter to Philip's grandnephew Adolph of Burgundy in November 1526, reporting on his experience and claiming—whether truely or not—that it was his former patron, Adolph's own relative, who had encouraged him to undertake the trip.[27] Perhaps Geldenhouwer was hoping for Adolph's sympathy given that the exiled king of Denmark Christian II, who had converted to Lutheranism in 1524, was residing at Adolph's palace in Zeeland that same year.[28] Regardless, it is telling that by the end of the decade, Geldenhouwer had permanently left the Netherlands for Germany, where he took up a professorship at the Lutheran university in Marburg and remained until his death.

That Gossart himself was drawn into the growing Reformation debate about images seems evident from his *St. Luke Drawing the Virgin*, now in Vienna, plausibly dated to the early 1520s (fig. 82).[29] Gossart's composition adheres to the Eastern Orthodox version of the legend of St. Luke, in which the saint did not capture the Virgin's portrait from life but instead through a heavenly vision. In this respect, his Vienna painting differs not only from previous representations in Netherlandish art but also from his own earlier altarpiece depicting the same subject (see fig. 17). By portraying the Virgin in a celestial cloud surrounded by frolicking putti, and by showing an angel directly guiding the artist's hand, Gossart emphasizes—in accordance with the Eastern tradition—that Luke's drawing occurs directly under divine auspices. Moreover, the juxtaposition of this Marian vision with the statue of Moses prominently displayed on a pedestal in the background asserts that the Mosaic law of the Old Testament, which forbids graven images, has no bearing in the New Testament context of the present. St. Luke, as patron saint of Netherlandish artists, not only captures the Virgin's true likeness by means of angelic intervention but also legitimates Gossart's own creative endeavor. The artist's revival of the more obscure

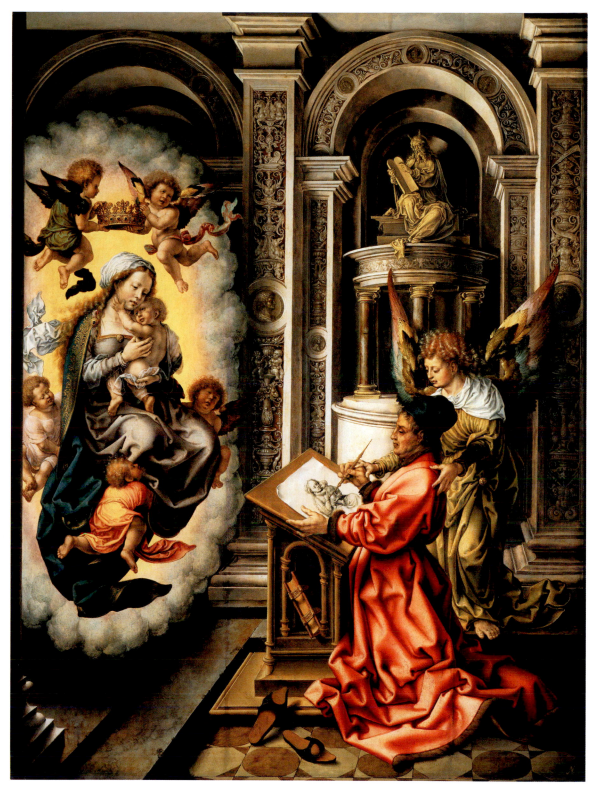

Fig. 82. Jan Gossart, *St. Luke Drawing the Virgin*, 1520–22. Oil on oak panel, 110 × 82 cm. Kunsthistorisches Museum, Vienna.

Eastern version of the St. Luke legend may indicate collaborative input from one of his humanist colleagues, but regardless it shows a desire to seek out a historically grounded argument against the condemnation of images. Nor does Gossart, in seeking to convey that message, shirk from the kind of meaningful play that visual images allow. The cherubic putto floating behind the Virgin Mary's back, scantily dressed in a diaphanous robe, pivots his lower body toward the viewer to fully reveal his genitalia. Safely within the confines of a heavenly vision and justifiable as a reminder of Christ's mortal incarnation, such an indiscretion is beyond reproof.

If the Reformation context inflected Gossart's approach to apostolic history and the local St. Luke tradition, it bears asking whether his *Danaë*—and his very choice to depict one of mythology's most controversial visual subjects—also attests to his deliberate engagement with the image debate. *Danaë* is in many ways the most conservative among his surviving mythological paintings in the concealment of its subject's full nudity, but that by no means belies its boldness.

As already observed, Gossart's painting sits no more comfortably among depictions of Danaë violated than it does among those that evoke the Virgin's Immaculate Conception. Unlike Titian, Tintoretto, Goltzius, and almost all subsequent artists, Gossart does not represent Jupiter's shower as gold coins or offer any overt reference to prostitution. He thus avoids any allusion to the plot and moral problematics of Terence's play. In place of coins, Gossart depicts individual drops of rain falling into Danaë's lap and emphasizes the heavenly otherness of the raindrops through his use of medium. Gossart created Jupiter's shower with a mixture of real gold leaf and shell gold applied to the panel's surface. This real gold gathers heavily along the folds of Danaë's robe and dramatically catches the light.

Although this expensive addition to Gossart's painting surely appealed to its original patron as a reflection of wealth and elite status, the resulting dialogue between precious material and artistic imitation is equally significant. Jupiter's shower stands in vivid contrast to Gossart's skillful use of yellow paint to create the impression of glistening gold in the surrounding architecture, in Danaë's diadem, and in the tassels on the cushion (or cushions) that form her seat.

In this regard, Gossart once again followed in the illusionistic tradition of van Eyck, showcasing his ability to re-create any precious substance from jewels to colored marbles.[30] The flamboyant Gothic arches framing Gossart's *Deesis* (see fig. 25) are also executed in gold leaf, an index of its commissioner's prestige that affords opportunity for comparison between the architecture of the heavenly kingdom— represented through the material of gold itself—and Gossart's illusive rendition of the gold accoutrements adorning the figures from van Eyck's original *Ghent Altarpiece* (see fig. 7). Through this play on materiality, Gossart demonstrates his excavation of Eyckian painterly tradition and the antiquarian status of his mythological paintings in reviving both the aura of the fifteenth-century Netherlands and the region's far more ancient history.

Within Gossart's *Danaë*, the juxtaposition of his painterly skill with Jupiter's shower of real gold makes a further claim, calling attention not only to Gossart's talents but also to the presence of a divine agent whose generative union with Danaë itself constitutes a work of artifice.[31] There are two creators at play here: Gossart himself and the celestial figure of Jupiter, whose golden shower is generative not of painterly illusion but of an actual birth. The descending bounty of real gold works in tandem with Gossart's compositional design to focus attention on the positive moment of Danaë's impregnation. There are no mediating servants or cupids like those present in the later Italian depictions of the myth. Gossart represents Danaë's union with the deity descending into her chamber as a direct heavenly encounter not unlike the divine vision of the Virgin Mary experienced by St. Luke in the artist's painting now in Vienna. Danaë's intimate moment of lovemaking is shared only with the painting's viewers. The surrounding semicircular space—a shape itself associated with virginity—seems to open receptively before us, as if to invite our exclusive entrance into a space that Danaë's father had intended to be inviolable.[32]

Gossart stays true to the original myth in showing Danaë imprisoned high above the rest of the city, whose many other magnificent buildings can be seen through the window in the background.[33] Between the columns of her chamber, an imagined city exemplifying the full architectural vocabulary of Gossart's Netherlands—classical arcades, flamboyant Gothic canopies, medieval brick steeples—situates the isolated moment of Danaë's impregnation within the discourse of local artistic tradition. This view far surpasses the disinterested treatment of setting by an Italian artist like Correggio, who in his *Danaë* only gestures to her predicament with a single structure visible in the distance (fig. 83). By emphasizing Danaë's isolation, Gossart also reminds us that were it not for her imprisonment, Jupiter would never have needed to create the golden shower as an artful disguise, a means to penetrate the structure that enclosed her. Ovid even suggests in his *Amores* that the god was motivated foremost by the challenge of the conquest itself: "If a bronze tower had never held Danaë, then Jupiter would never have made Danaë a mother."[34]

However, even as Gossart's *Danaë* lures us with the same vision that spurred Jupiter's desire, the painting also situates its viewer in the opposite role, as the physical recipient of the god's advances. Judging from our awareness of the ledge below Danaë's feet and our view into the domed ceiling above, the painting posits an intended eye level that is quite low and essentially at the point of Danaë's womb, thereby focusing attention on the site of contact between the divine and the human realm.[35] A 1504 treatise *On Sculpture* by the Italian humanist Pomponius Gauricus—edited and republished in Antwerp in 1528 by the humanist Cornelis Grapheus—explores the allure of this compositional construct in theoretical terms.[36] Gauricus uses an image of Danaë to exemplify the meaningful use of perspective in art, describing how it could allow for "three ways of viewing" the same work: "When you looked at the picture straight on, you would see the girl desirous and astonished.

Fig. 83. Correggio, *Danaë*, 1530. Oil on canvas, 158 × 189 cm. Galleria Borghese, Rome.

When you looked upwards, you would think that Jupiter was about to descend from the clouds as a rain shower, and when you looked down, you would wonder at the multitude of gold spread across Danaë's nether regions."[37] For Gauricus and Gossart, Danaë's myth appealed as a pictorial subject in part because it allowed for interactive role play, an opportunity to multiply the viewer's perspective on the narrative.

If Gossart's painting favors one angle over the other, it is certainly that of Danaë as recipient. Technical examination has revealed a careful perspectival construction in the preparatory underdrawing, which is designed to emphasize viewing the image from below and to draw the eye toward the receding point located at the center of Danaë's body.[38] Other details within the painting play to the advantage of this intended perspective. Looking upwards to the very summit of the picture, the viewer encounters an ornamental putto's head surrounded by scrolling vines, which are beginning to sprout leaves and come alive. We have seen Gossart use this motif elsewhere, for instance, in his small *Virgin and Child* also dating to 1527, where it signaled a hope of divine salvation (see fig. 78). Yet the putto's specific placement within this larger painting has a more tangible significance as a proleptic allusion to the fruits of the coupling between Jupiter and Danaë. The vines curling outward

Fig. 84. Jan Gossart, *Danaë* (detail), 1527. Oil on panel, 113.5 × 95 cm. Bayerische Staatsgemäldesammlungen, Alte Pinakothek, Munich.

toward the surrounding architecture suggest that the entire space—the space of Gossart's pictorial invention—is born from the union at the painting's center. The ornament aligns along the vertical axis not only with the god's heavenly shower of gold and with Danaë's lap, but also with Gossart's signature along the painting's lower edge. Danaë's womb, already linked via mythological history to the birth of Perseus, the slaying of Medusa, and the origins of the Castalian font of the Muses, thus also becomes the divine point of origin for Gossart's art.

The centrality of the womb finds its ultimate expression in the artist's portrayal of Danaë's posture (fig. 84). It has been postulated that Gossart based the positioning of his figure on an antique gem or coin depicting Danaë, but although we know Philip had some such objects in his collection, the link is impossible to verify.[39] The manner in which Danaë holds her body, however, bears close relation to a far more immediate and familiar model from the realm of everyday experience, specifically from the experience of motherhood.

Gossart's representation of Danaë's seated pose mirrors almost exactly the position that Renaissance women in northern Europe took when giving birth. As illustrated in the popular treatise for midwives composed by Eucharius Rösslin and

first published in Germany in 1513, women generally birthed their infants while sitting on a low stool (fig. 85).[40] The Dutch translation of Rösslin's treatise illustrates the stool specially designed for this use, its angle and proximity to the ground even parallel in form to the strange cushion, or pile of cushions, on which Gossart's Danaë is seated (fig. 86).[41] It is difficult to imagine that contemporary viewers would have failed to recognize the association between Danaë's positioning and the act of birthing.

Danaë's upright pose is all the more notable since subsequent Renaissance artists almost always portrayed her reclining on a bed as if ready for lovemaking, an association that Gossart's painting subtly mediates. The lush pink pillows with their sizable tassels may well evoke the context of a bedchamber; they even resemble those propping up the sexual partners in the infamous erotic series *I Modi*, whose publication had precipitated a great scandal in Italy just a few years earlier (fig. 87).[42] The closest comparison to Gossart's unusual choice of posture is a passage from the Italian writer Francesco Colonna's sprawling romance *Hypnerotomachia Poliphili* (1499), which treats Danaë as an emblem of fertility by describing her seated on a bench of green jasper, a stone that aided in childbirth.[43] It is clear from Colonna's description

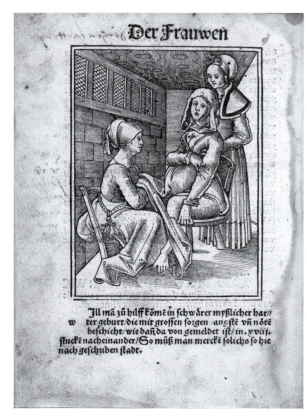

Fig. 85. Title page illustration of a woman giving birth, from Eucharius Rösslin, *Der swangern Frauwen und Hebamen Rosegarten*, 1513. Woodcut. Francis A. Countway Library of Medicine, Boston.

Fig. 86. Birthing stool, from Eucharius Rösslin, *Den Roseghaert vanden Bevruchten Vrouwen*, 1528. Woodcut. Bijzondere Collecties, Amsterdam.

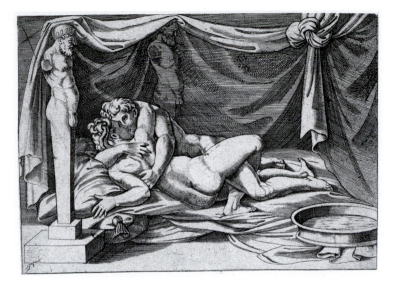

Fig. 87. Marcantonio Raimondi, *A Nude Couple Embracing*, from *I Modi*, c. 1510–20. Engraving, 13.2 x 18.5 cm. British Museum, London.

that Danaë's future pregnancy in no way diminished her sensual allure. Even medieval objects like *Schreinmadonna*, sculptures of the Virgin that open to reveal their interiors, invited the viewer's simultaneous erotic and devotional engagement with Mary's womb.[44] By alluding to both the bedroom and the birthing chamber, Gossart does not cancel out Danaë's amorous charge but adeptly straddles ancient and Christian tradition.

Once again, Gossart's carefully orchestrated composition, and its proleptic collapse of narrative time, pushes against the traditional reading of Danaë as a corrupt prostitute, and of her likeness as necessarily corruptive for its viewers. As his Danaë succumbs to Jupiter's shower, she is also already preparing for the future, for the moment when her child Perseus will be born. The viewer of the painting is situated together with Danaë as recipient of Jupiter's bounty and, by extension, of Gossart's enlivening art. The immediacy of engaging with Danaë's body that the painting's composition establishes, the affinity between her pose and the embodied practices of sixteenth-century women, conflates viewer and subject in a manner even more dramatic than in any of Gossart's earlier mythological paintings.

Bypassing the mire of Christian moralizing tradition, Gossart shifts focus to the pregnant body at the center of the narrative, and to the question of the relation between divine and human agency that was central to the Reformation debate over the response to images. The generative potential of Danaë's womb affirms a link between past and future fundamental to both Gossart's revival of early Netherlandish painting and his own artistic legacy. If the union between Danaë and Jupiter is a

godly act, which not only results in the birth of Perseus but also generates his painting itself, then the power of the image can be understood only as one of positive creation. It thus remains to consider who might have commissioned this daring picture, and in what corner of the Netherlandish courtly and intellectual ambit it would have been positively received.

A RETURN TO ZEELAND

On 7 April 1524, three years before the date inscribed on Gossart's *Danaë*, his foremost patron, Philip of Burgundy, passed away and was buried in the parish church of St. John the Baptist at Wijk bij Duurstede, beside the grave of his brother David of Burgundy.[45] Gossart and court secretary Gerard Geldenhouwer joined together to create a funerary monument that would honor the nobleman for whom they had worked so many years.

As artist and scholar well understood, Philip's proudest achievements were not his frustrated attempts to curb the war with the province of Guelders but were instead the occupations of peace. Philip's restoration of his residences at Souburg and at Wijk bij Duurstede had produced—through the collaboration of Gossart and Geldenhouwer—two of the greatest Renaissance palaces in the Netherlands. Although the tomb monument they designed does not survive, Geldenhouwer preserved the accompanying epitaph by publishing the verses on the last folio of his 1529 biography of Philip:

> To the excellent leader, the most clement lord Philip of Burgundy, son of the duke of Burgundy Philip the Good, bishop of Utrecht, patron of Jan Gossart and Gerard Geldenhouwer, who erected this monument in his blessed memory. Whoever you are who approaches this tomb sees a lover of peace and an expert in war, whose soul rests above the stars. He, while victory still had yet to conquer unjust enemies, was ordered to yield to death and passed away. He repaired ruined palaces with splendid refinement. He waged battles, but that was no fault of his own. A treacherous citizen incited them, a treacherous magistrate nourished them, and in so doing counsels the destruction of the fatherland.[46]

The text of the epitaph combines a retrospective of Philip's endeavors with a prospective warning about how the ongoing war threatened not only his legacy but also the stability of the Netherlands as a whole. It emphasizes that Philip participated in the Guelders campaign against his will and through "no fault of his own." We can speculate that Gossart designed the physical monument to reflect his patron's far more eager engagement with the peaceable arts and, specifically, with the models of antiquity. In doing so, the artist would have perpetuated the memory of the antiquarian endeavors in which he and Philip had together taken part.

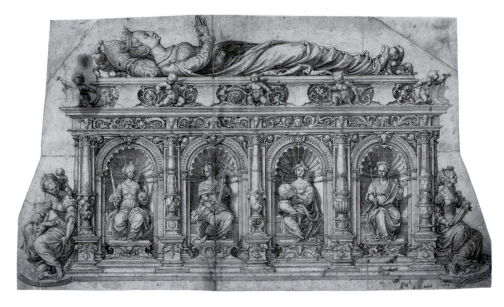

Fig. 88. Jan Gossart, design for the tomb of Isabella of Austria, c. 1526. Pen and brown ink, brush and gray ink, 27.4 × 47 cm. Kupferstichkabinett, Staatliche Museum, Berlin.

Gossart's surviving drawing for the tomb of Queen Isabella of Austria, composed of classicizing columns, nude putti, bucrania, and female personifications of the virtues, offers the best parallel for the kind of ornament that might have adorned Philip's memorial (fig. 88).[47] Such an ornate monument would have been costly to produce— perhaps prohibitively so—as even King Christian II of Denmark seems to have rejected Gossart's design for Isabella's tomb in favor of a less elaborate memorial to his deceased wife.[48] Nonetheless, if the monument erected to Philip employed any semblance of the antique mode, it would have been both a fitting testament to its dedicatee and also a prescient work in the larger history of Netherlandish funerary sculpture.[49]

While in the subsequent years Gossart had no shortage of commissions for portraits and devotional images, the demand for his mythological paintings seems to have diminished. With the exception of a painting of Hercules—now lost, but recorded in Ipolito Michaeli's Antwerp inventory as dated 1530—Gossart's *Danaë* is the only mythological work documented as postdating Philip's death.[50] Some pictures with mythological subjects are listed—without attribution—in the 1528 inventory of Philip's fellow nobleman Philip of Cleves, but assuming that Gossart was responsible for painting them, it is more likely that he did so while his primary patron was still alive, prior to 1524. Within the inventory, two works—one depicting Mars and Venus; the other, a "beautiful girl disrobing"—are explicitly said to "have come from the deceased lord of Utrecht," indicating that they were originally Philip's commissions.[51]

Gossart's *Danaë* surfaces for the first time only in an inventory of the Prague Kunstkammer from 1621, so it is impossible to determine its original owner with

certainty.[52] It is even rather difficult to imagine who—after Philip's death—would have stepped in to command such a major work. The absence of the painting in the surviving inventories of Gossart's now-familiar patrons like Margaret of Austria, Henry of Nassau, and Philip of Cleves would seem to point in a new direction. By far the best candidate, albeit on the basis of circumstantial evidence, is the nobleman Adolph of Burgundy.

Adolph's familial and official ties to Philip of Burgundy support the argument for his interest in Gossart's work and in continuing the tradition of his great-uncle's court. When Philip was appointed bishop of Utrecht in 1517, Adolph became admiral of the Netherlands in his place.[53] Like Philip before him, Adolph exercised his office as admiral from the island of Walcheren. He resided in a palace called Sandenberg, long since destroyed but originally situated just outside the town of Veere, as recorded in Anton van den Wijngaerde's panorama (fig. 89).[54] Unfortunately, no inventory of Sandenberg's holdings survives, as nearly all related archival material has been lost.[55]

There are nonetheless significant indicators that Adolph's ambitions, like those of his great-uncle, well exceeded the limits of his provincial post. We will see that he cultivated a creative and intellectual milieu in Zeeland closely, and perhaps deliberately, aligned with that of his predecessor. Adolph must have been among the frequent visitors to Philip's palace at Souburg, where he could have admired Gossart's *Neptune and Zeelandia* firsthand and become acquainted with the budding interest in the local antiquity of his native province. Adolph's documented patronage of artists and scholars alike thus warrants closer consideration.

Fig. 89. Anton van den Wijngaerde, *Panorama of Walcheren* (detail), 1550. Pen and watercolor on paper. Museum Plantin-Moretus, Antwerp.

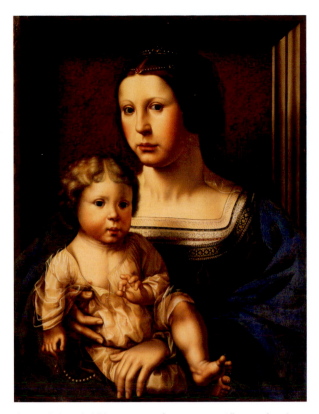

Fig. 90. *Virgin and Child*, c. 1522, copy after Jan Gossart. Oil on panel, 43.8 × 33 cm. Metropolitan Museum of Art, New York. Gift of J. Pierpont Morgan, 1917.

The most frequently cited record of Adolph's engagement with Gossart is found in Karel van Mander's biography of the artist. Van Mander writes that Adolph employed Gossart at his court and commissioned him to paint a portrait of his wife, Anna van Bergen, and one of her sons in the guise of the Virgin and Child.[56] This description has long been associated with a frequently copied composition by the artist, which indeed bears the traces of Anna's features (fig. 90).[57]

Less well known is a portrait medal of Adolph struck in 1532, which attests to the admiral's pride in his own image and engagement with an antiquarian medium still relatively new to the Low Countries. The medal captures Adolph's dignified likeness as a bearded nobleman with a lush fur-lined cloak and, around his neck, the collar of the Golden Fleece, the knightly order to which he was elected in 1515 (fig. 91).[58] Adolph may have felt a particular appreciation for metalworking, as a beautifully incised copper plaque commemorating the site at which his heart was buried also survives today in St. Martin's Church in Beveren, a small town just outside of Antwerp where Adolph had a lordship.[59]

Adolph's portrait medal itself was created to commemorate a specific event in his life. Its reverse depicts a fleet of ships vanishing promisingly into the distance,

riding a churning sea and guided by a beaming star in the sky above. As the surrounding Latin inscription declares, "Where God will lead us by this favorable star is where we must go." In 1527, Adolph had outfitted two vessels for a voyage of discovery to claim the island of Cozumel, located just off the coast of Mexico in the New World.[60] Charles V had gifted the island to the admiral in 1520, and Adolph—who may have been inspired by the exotic featherwork objects in the collections of Philip and Margaret of Austria—was eager to capitalize on his rightful claim and expand his territory from the islands of Zeeland to the shores of the New World.[61] Unfortunately for Adolph, his men lacked the navigational acumen to carry out the transatlantic crossing, and the Spanish ultimately claimed the island in his place.

In addition to his artistic commissions, Adolph also fostered close connections with local humanists, again perhaps with the model of his great-uncle in mind. He employed Geldenhouwer's colleague and fellow Batavian historian Reinier Snoy as his personal physician, and the scholar Jan Becker as tutor to his sons.[62] He took an active interest in the Veere guilds of rhetoricians, groups comprising learned artists and writers who organized all manner of performances and festivities for the town.[63] Erasmus dedicated *A Handbook on Good Manners for Children* to Adolph's eldest son, Hendrik.[64] Barlandus honored the admiral himself with a biography of the great duke of Burgundy Charles the Bold, in which the humanist compares the nuptial celebrations of Charles and Margaret of York to the infamous banquets of Antony and Cleopatra and the Roman emperor Heliogabolus, boasting that even the feasts of antiquity were no match for those of the Burgundian rulers.[65] A shipment of 150 vats of French wine destined for Adolph's court in 1524, but confiscated en route at the port of Middelburg, may suggest that the admiral sought to equal the lavishness of his Burgundian precessors with his own dinner parties.[66]

Fig. 91. Portrait medal of Adolph of Burgundy, 1532 Bibliothèque Royale de Belgique, Brussels.

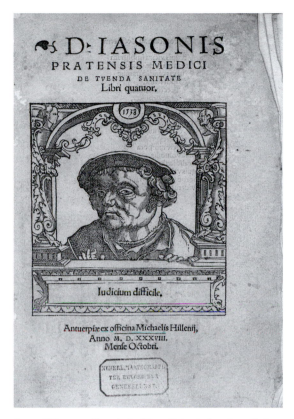

Fig. 92. Title page with portrait of Jason Pratensis, from Jason Pratensis, *De tuenda sanitate*, 1538. Bijzondere Collecties, Amsterdam.

Yet a far more vivid window into the habits and intellectual pursuits of Adolph's court derives from one especially remarkable humanist who served him, the doctor Jason Pratensis (1486–1558).[67] Born to a medical family in Zeeland's prominent town of Zierikzee, Pratensis published numerous pioneering treatises on topics including reproductive health, sterility, and mental illness and was a prominent citizen of his local province, yet his writings are scarcely known today and have never been considered in art-historical literature. Pratensis left a stunning visual document of his character in a woodcut portrait on the title page of his 1538 treatise *On Maintaining Good Health* (fig. 92).[68] Pratensis peers out knowingly from a window framed by ornate classicizing columns and rests his hand on a ledge inscribed with the words "judgment is difficult," a motto fitting to his profession. Given that few early sixteenth-century humanists in the Netherlands commissioned portraits in reproductive media, with the notable exception of Desiderius Erasmus, the woodcut is a first indication that Pratensis was sensitive to the potentiality of visual images.[69]

In a passage on good dining practices in the same treatise graced by his portrait, Pratensis recalls the experience of sharing a table with Adolph of Burgundy, a scene characterized as much by the flow of wine as by the flow of erudite conversation:

My patron Adolph of Burgundy was not unaccustomed, of his own accord, to summon several learned men to his table. After we were all sated from the meal (as much as nature required), he would engage us in charming and pleasurable discourse either on an especially delightful subject of philosophy or some other discipline.[70]

The language of Pratensis's description, with its emphasis on pleasure and delight, is a reminder that in the realm of the Renaissance court, there was nothing more desirable than the mutual fulfillment of mind and body. Erasmus's colloquy *The Godly Feast*, with its imagined description of learned friends discoursing together on the scriptures and works of art, represents the ideal embodiment of this pursuit, an ideal that Pratensis extends to the lived experience of Adolph's court in Zeeland.[71] Geldenhouwer had already characterized Philip's court in similar terms.[72] In such a setting, it is easy to imagine works like Gossart's *Hercules and Deianira* and his other small mythological pictures being passed between hands and sparking conversation (see figs. 1, 53, 76, 77). Of course, Pratensis writes in an effusive mode typical of humanist descriptions of patrons and their courts, and his subject may not always have lived up to such a high standard in his prandial habits. The regent of the Netherlands Mary of Hungary, successor to Margaret of Austria, mused in 1532 that Adolph was "a good conversationalist before dinner, but after dinner, was entirely out of sorts," implying that he was inclined to excessive indulgence.[73]

Pratensis explains in his introduction that at the time of writing *On Maintaining Good Health*, he had just entered the service of Adolph's son Maximilian of Burgundy.[74] Thus his reference to the admiral as "my patron" in the passage above is retrospective, attesting that he had already come to know the family years prior to 1538. He also mentions treating Adolph's wife, Anna van Bergen, for arthritis and praises her virtue and fertility as a mother; indeed, she gave birth to three sons and three daughters.[75] "A good tree bears good fruits," Pratensis declares in admiration, a motto that would have fittingly accompanied Gossart's portrait of Anna and her rosy-cheeked progeny (see fig. 90). Pratensis's own adopted Latin name derives from the word *pratis*, which means a verdant field or meadow: an epithet well suited to a doctor of reproductive medicine and one who lived to the ripe age of seventy-two. His colleague Hadrianus Cordatus even praised him as a second Nestor, the great elderly warrior of Homeric epic.[76]

In addition to his medical practice, Pratensis's writings reveal his tandem interests in poetry and arts, which makes them all the more resonant in reconstructing the context for a painting like Gossart's *Danaë*. The humanist doctor was already on close terms with Gerard Geldenhouwer as early as 1515, as evinced by his verse contributions to the latter's volume *Eight Satires*.[77] Significantly, it was in this volume that Geldenhouwer published his poem honoring Philip of Burgundy as a patron who cultivates anew the ancient art of painting.[78] In Pratensis's own collection of

poems *An Orchard of Songs of Youth*, published in 1530 but written—as the title suggests—during his younger years, he draws on classical mythology to trope on the subject of chaste love.[79] In one poem, he summons the ancient Muses to his native Zierikzee to help his friend find a bride; in another, titled "Venus Armed with a Girdle," the goddess addresses her imagined viewers directly: "Raise your eyes, beholder, nor should you stand still. I am a goddess! My girdle will burn you with its blazing flame."[80]

Most significantly, Pratensis's treatise *On Maintaining Good Health* provides the only other extant description of an artistic commission that we can attribute to Adolph with certainty, beyond van Mander's reference to Gossart's portrait of his wife and child and the surviving 1522 portrait medal. The description surfaces, of all places, amidst discussion of the salutary benefits attributed to various fish, from which Pratensis breaks off in an exuberant aside to describe the heroic feats of his patron:

> When the divine Adoph of Burgundy, Lord of Beveren and Veere, restored the demolished dams in Duiveland against floods and the mad waves of the rabid sea, the fishermen from Brouwershaven (a town that was also under the lord's sovereignty) presented his highness with a swordfish captured in the British ocean. The most illustrious hero commissioned a portrait of the fish carved from wood, which he had suspended so that it would be on display in the entrance hall of his palace at Sandenberg.[81]

Pratensis recalls the aftermath of a particularly disastrous flood that ravaged the coastline of the Netherlands in 1530.[82] Reygersbergh's 1551 *Chronicle of Zeeland,* for which Pratensis wrote a dedicatory poem, refers not only to the flood itself but also to the gifting of the swordfish, attesting that the wooden sculpture was still on view at Sandenberg twenty years after its installation.[83] The sculpture would have reflected the skill of its maker in capturing the creature's "portrait" but also—in its preservation of a natural specimen through art—would have paralleled Adolph's own endeavors to restore his native Zeeland by means of human engineering.[84] According to Pliny the Elder, whom Pratensis explicitly cites in his text, the swordfish was a creature that itself revealed the mighty powers of nature through the formidable spear on its snout, and thus its sculpted counterpart also embodied Adolph's ability to subdue the forces of the natural world.[85]

The dialogue inherent in Adolph's commission between divine nature and human artifice is highly suggestive that the admiral encouraged some semblance of an art-theoretical discourse at his court. The carved swordfish would have been an exceptional work of art, without comparison to any extant or documented sculpture in the Netherlands during this period. Not only a tangible memory of local history, it was also a testament to Netherlandish artistry that aligns with the Eyckian tradition of art's emulative competition with nature's craft. In all these respects, Adolph seems

precisely the kind of patron who might have desired one of Gossart's very last mythological works for his own collection. Sandenberg—like Philip's palace at Souburg before it—may even have been the setting for conversations in which the artist participated about the legacy of Philip's antiquarian pursuits in Zeeland, and the future of mythological painting in the Netherlands at large.

Adolph's ownership of Gossart's *Danaë* remains only a best guess, but we cannot yet leave behind Jason Pratensis, whose writings on female medicine still remain to be explored. The converging of artistic and natural creation in the receptive body at the center of Gossart's painting, its direct allusion to birthing, and its celebration of art's potentiality in the face of Reformation debate—all find remarkable parallels in the humanist's most significant and original writings.

THE PREGNANT BODY

In 1524, Pratensis launched his career with the publication of his treatise *On the Womb*, the first of his many works to address pregnancy, copulation, and the promotion of female health. In this work as well as his later writings, Pratensis proves delightfully eccentric, sprinkling his pragmatic advice with witty and provocative musings. He cites ancient medical authorities like Galen alongside verses from the love poetry of Ovid and other Roman authors.[86] He includes colorful anecdotes from antiquity, such as the story—later illustrated in a 1596 treatise by the Antwerp cartographer Abraham Ortelius—of the ancient German tribes who fostered bravery in their children by launching newborn babies into the rushing Rhine; those who managed to stay atop the fathers' shields were marked out for future careers as successful warriors (fig. 93).[87] Such allusions suggest that Pratensis understood the female body as inextricable from local history and culture.

One of the most surprising digressions in *On the Womb* is a prolonged passage railing against the Lutheran presence within the Netherlands, which Pratensis perceives as an almost inexorable pestilence.[88] His discussion of this topic appears amidst a subsection explaining, quite practically, the important role of the husband in supporting a pregnant wife, and prescribing that a married man should endeavor to calm his wife's fears and offer her solace so that when the time of birth arrived, no shaky nerves would hinder a happy outcome. It is here that he pauses to address the mounting religious conflict in the region, explaining, "as this is not the place for a declamation, it is much better to give an aside and then hasten my thoughts back to the matters at hand." Over the course of the next two pages, Pratensis explains that he has prayed for "a better state of mind on the Lutherans," but still cannot help but dwell on his grave concerns over the movement's destructive force:

> That most beautiful concord between students and teachers, subjects and prelates,
> monks and priors is destroyed, and that harmony of once unanimous brothers,

INFANTIA.

GERMANI modò editum infantem (clypeo impo-
fitum habet epigramma Græcum) tefte Ariftotele
8.Politicor.atque Galeno,& adhuc ab vtero calen-
tem,ad fluuium deferunt: ibíque feu candens fer-
rum in trigidum humorem mergendo, fimul de naturæ rigore
periculum faciunt,fimul corpus roborant. Quippe fi citra no-
xam id tolerauerit,& propriæ naturæ robur oftendit,& nouum
prætereaxobur ex frigidæ commercio comparat.Vt rectè Clau-
dianus: *nafcentes explorat gurgite Rhenus*.Nugæ funt,& ab huius
gentis genio alieniffima , quæ Iulianus Imp. & Nonnus Pa-
nopolita,item Nazianzenus tradunt;huius nempe immergen-
di in fluuio morem effe , vt impuri lecti à cafti coniugij fobo-
lem difcernat:nempe vt quos fluuius abripit, impuro lecto fa-
tos , quos verò in fumma aqua fufpendit, laudabili coniugio
procreatos doceat . A paruulis duriciei ftudere, Cæfar tradit.
Puerum protinus haftile tenerum vibrare,fcribit Seneca. Nudi
iuuenes,quibus id ludicrum eft, inter gladios fe atque infeftas
frameas faltu iaciunt, tefte Tacito . In pueritia nudos agere,
etiam in maximo frigore, fatentur Pomponius & idem Ta-
citus.

Fig. 93. Infancy (*Infantia*), from Abraham Ortelius, *Aurei saeculi imago*,
1596. Engraving. Bijzondere Collecties, Amsterdam.

now estranged from their studies, devolves into stridencies, factions, and belliger-
ent uproars. And the monarch of the Christian republic trembles as much at this
pestilent dogma as from the pressure of its most violent battering ram.[89]

What is especially striking about this passage is the way that Pratensis employs
pregancy and marriage as metaphors for the unfolding of contemporary events.
Having just discussed the importance of the bond between husband and wife, he
now emphasizes how Reformation conflict has produced discord in relationships
between colleagues who once engaged in mutual learning and devotion. He also
describes his own mind as pregnant with worry, and goes on to express the hope that
Charles V as patriarch of the region will manage to curtail the incipient violence.
Pratensis concludes by taking comfort that at least his native Zierikzee remains
immune from Lutheran activity, but if he had written these comments a few years
later, he might have said otherwise.[90] In 1527, the same year to which Gossart's *Danaë*
dates, Zeeland's local officials began to take harsher action in response to the move-
ment's growing presence, as signaled by the first local pamphlets published against

Reformers and prominent trials of local inhabitants, including Pratensis's humanist colleague Hadrianus Cordatus.[91]

That Pratensis's interest in pregnancy went well beyond the mere desire for birthing healthy children—and extended metaphorically to a salutary concern for the collective body of his homeland—also manifests in more positive terms. In his 1551 dedicatory poem for Reygersbergh's *Chronicle of Zeeland*, Pratensis declares that his province "vies with the foremost places in its fertility," not only because of its clear air and bountiful trees but also in the genius (*ingenium*) of its inhabitants, a description that aligns closely with the spirit of Gossart's *Neptune and Zeelandia* and its visual embodiment of the region.[92] Pratensis's medical successor in Zierikzee, the doctor Levinius Lemnius, continued this tradition in his own writings when he claimed hyperbolically that laurel trees twenty feet high were growing on Zeeland's shores, implying that it was home to Apollo and the ancient Muses.[93] A commendatory letter included at the end of Pratensis's *On the Womb*, written by his friend the humanist schoolmaster Willem Zagarus, who was also a citizen of Zierikzee, declares the treatise itself to be endowed with generative promise:

> O honored Jason, all of us will owe a debt to you, we married men who are
> good lovers of good wives, for whose children—even those not yet born—you
> too will care with wisdom. Now not only your Cornelia but all of Zeeland will
> gladly sing, "My Jason did not fetch the Golden Fleece, but rises as an even
> brighter honor from the medical arena." Farewell, and bring forth this your
> offspring for the benefit of many other births.[94]

Zagarus aligns Pratensis with the legendary hero Jason, whose quest for the Golden Fleece was a central myth of the Netherlandish nobility and the eponymous knightly order. Zagarus suggests that all of Zeeland will burgeon under the doctor's learned care, and that the province in turn will sing the doctor's praises.

Although little of Zagarus's own writing survives, his close contact with humanists in Gossart's milieu, including Geldenhouwer, Barlandus, Cranevelt, and the Zierikzee playwright Jacob Zovitius, suggest that he was very much a participant in local intellectual culture.[95] A tantalizing description from Dominicus Lampsonius's 1565 biography of Lambert Lombard—Gossart's younger artistic contemporary— refers to Zagarus as a lover of drawing and a scholar extremely knowledgeable in classical art theory.[96] By quoting effusively from Pliny the Elder's *Natural History*— the most important source on ancient art for Renaissance readers—Zagarus allegedly inspired Lombard with his learning to such an extent that the artist was seized by a desire to study Greek and Latin himself.[97]

Zagarus and Pratensis may well have shared a friendly dialogue on ancient art and contemporary artistic developments in the Low Countries. Discussion of images surfaces throughout Pratensis's writings, and reading his works chronologically

reveals a clear evolution in his views on the subject. One topic that especially interested Pratensis was the way images entered the body and became active within the mind. In a chapter titled "On Loving" from his late treatise *On Diseases of the Mind*, published in 1549, Pratensis provides a long excursus in which he draws on the work of the fifteenth-century Italian humanist Marsilio Ficino, whose name he explicitly cites, to describe how the mind "receives images, as well as figures of extrinsic bodies and objects, through the organ of the senses."[98]

The physiological link between the womb and the imagination, two powerful and fertile loci within the human body, receives the most extended treatment in Pratensis's works. From the second-century writer Soranus to Leon Battista Alberti's fifteenth-century treatise *On Architecture*, the notion of the impressible womb—that a child might be born beautiful or deformed depending on the images taken in through the mother's eyes—had been a recurrent source of fear and fascination and remained so for sixteenth-century writers well beyond Pratensis himself.[99]

The notion of the mind's receptivity proves fundamental already in a chapter from Pratensis's 1524 *On the Womb*, which addresses how likeness occurs between parent and child, and the potential role of sight in transforming a woman's fetus. Pratensis concludes his chapter in *On the Womb* by advising that "in nuptial chambers where the sweetest sports of Venus are exercised and where a couple strives with silent offices to produce the most beautiful child, images of extraordinary charm are to be depicted, so that the beauty of the design might descend into the womb, at least to the extent that art can be emulated."[100] Pratensis not only acknowledges that life can in fact imitate art such that an aesthetically pleasing painting might result—through the power of the imagination—in the birth of a charming and beautiful child; he also offers this belief as practical advice to married couples on the kind of pictures they should display in their bedrooms.

While Pratensis is explicit on the potential function of images in *On the Womb*, he is vague on the nature of the works he prescribes, saying only that they should be of "extraordinary charm." Whether motivated by comments from his readers or by his own concerns as an author, Pratensis proves much more emphatic on the same point a few years later, in his 1531 treatise *How to Prevent Sterility*:

> Nobody flees from pictures, which are bold incitements of the libido. They seem most talkative, and their silent discourse often penetrates deeply and shoots forth sharper pricks all the way down to the marrow, more so than anything else. There is a well-known story of a young man who left the marks of his lust on a statue of Venus. Tiberius is also said to have had his bedroom sketched with pictures even more lascivious (which the books of Elephantis described). And it is handed down in letters that horses have neighed at painted horses. Therefore, since the birth of a child should be sought by all means, and since a birth comes about only through lovemaking between a man and a woman, I do

not think it absurd—so far as Christian religion allows and a regard for decency permits—that these pictures and other things thought to be useful should be called upon as an aid.[101]

Here Pratensis engages with artistic paradigms in a manner both self-conscious and demonstrative of his classical knowledge. He refers to a story told by Pliny the Elder of how the ancient painter Apelles, in order to demonstrate his skills of imitation, made a picture of a horse to which real horses responded by neighing.[102] He also alludes to the statue of Venus by the ancient sculptor Praxiteles, which infamously incited one male admirer to lock himself in her temple at Knidos and attempt to make love to her.[103] He even recalls the Roman emperor Tiberius's display of titillating pictures inspired by the erotic writings of a female ancient Greek author named Elephantis, which discoursed on the merits of various different sex positions.[104]

Yet what makes this passage remarkable is how Pratensis puts his ancient references to use. The stories of Praxiteles's Venus and Tiberius's erotic pictures might easily be glossed as negative examples of dangerously licentious art. Yet Pratensis asserts on the authority of classical tradition that sensual images do indeed have a place in the homes of contemporary married couples who are eager to produce children. Although he is careful to qualify his statement by referencing the Christian context for which he is writing, and the importance of maintaining decency in the marital chamber, his conclusion is nonetheless anything but orthodox.

In championing the positive power of erotic images, Pratensis proves outright radical when read against the comments of his colleagues writing in the Netherlands at this same moment, specifically Erasmus and fellow scholar Juan Luis Vives. Both Vives and Erasmus are unequivocal in condemning the presence of alluring paintings in private houses precisely because of their impact on viewers. In Vives's 1529 treatise *On the Office of Marriage*, he points to the dangers of hearing and sight in their potential to infect the body: "Corruption can penetrate to the soul through both senses. Apply these precautions to your house so that everything will be closed off to filth and obscenity."[105] Erasmus's comments in his 1526 treatise *The Institution of Christian Matrimony* are even more relevant. Not only was Erasmus's work published just one year prior to the creation of Gossart's *Danaë*, but Pratensis himself undoubtedly read it. His own line referring to the Venus statue is quoted verbatim from a passage in Erasmus's text, in which Praxiteles's Venus is employed as a negative example:

> Just as dirty talk has no place in the family circle, neither have licentious pictures. A silent painting can be very eloquent and work its way stealthily into people's consciousness. If there are actual sights that you think will endanger the morals of your sons and daughters, why allow them constantly to be placed before their eyes? *There is a well-known story of a young man who left the marks of his lust on a statue of Venus.*[106]

Pratensis borrowed Erasmus's words so as to make the very opposite argument. He champions images precisely because of their generative powers and refutes Erasmus's appeal to morality in the context of love between married partners. Pratensis's quarrel with Erasmus represents a subtle but deliberate rebuke to the increasing condemnations of images in Reformation debate. At the same time, his comments reveal a nascent visual discourse emerging in response to the contemporary religious climate, and in the same province where Gossart had produced his groundbreaking *Neptune and Zeelandia* only a decade earlier.

Pratensis's assertion that sensual images were appropriate not only for the eyes of men but for both members of a married Christian couple casts a provocative light back on Gossart's painting of *Danaë*, with its focus on the womb and its implication of the viewer's receptiveness to Jupiter's heavenly shower. Little thought has ever been given to the female audience for Gossart's mythological pictures, but of course if one such work hung in Adolph of Burgundy's palace, then his wife, Anna van Bergen—whom Pratensis praised as a paragon of motherhood—surely would have seen it.

It would be far too reductive to conclude that the sole intention of Gossart's *Danaë* was to inspire conjugal relations and promote successful births.[107] However, it is relevant to ask whether reproduction might have been taken—along the lines that Pratensis suggests—as justification for a category of image like mythological painting, the status of which was threatened by the surging moral and religious debate. For a patron like Adolph of Burgundy, owning one of Gossart's mythological works would have been a way to perpetuate his great-uncle Philip's legacy as well as demonstrate his own savvy patronage and engagement with the ancient past. But as the Reformation increasingly gained a foothold in Adolph's province of Zeeland, other arguments in favor of alluring images also may have had appeal.

Given that Pratensis worked closely in the service of Adolph and Anna, the noble couple must have been aware of the doctor's positive views regarding the generative potential of the female body and of images themselves. And given the six children they brought into the world, they may well have welcomed the prescriptions of their local medical expert for displaying inspiring artworks in their bedchamber, as one among a myriad reasons to patronize the region's most prominent artist. It is not entirely fanciful to imagine that Gossart's portrait depicting Anna and her son may even capture the likeness of a child conceived before yet another painting by the artist himself. In such an instance, Gossart's *Danaë* would be the truest testament to the artist's irresistible talents and to that elusive boundary between art and life.

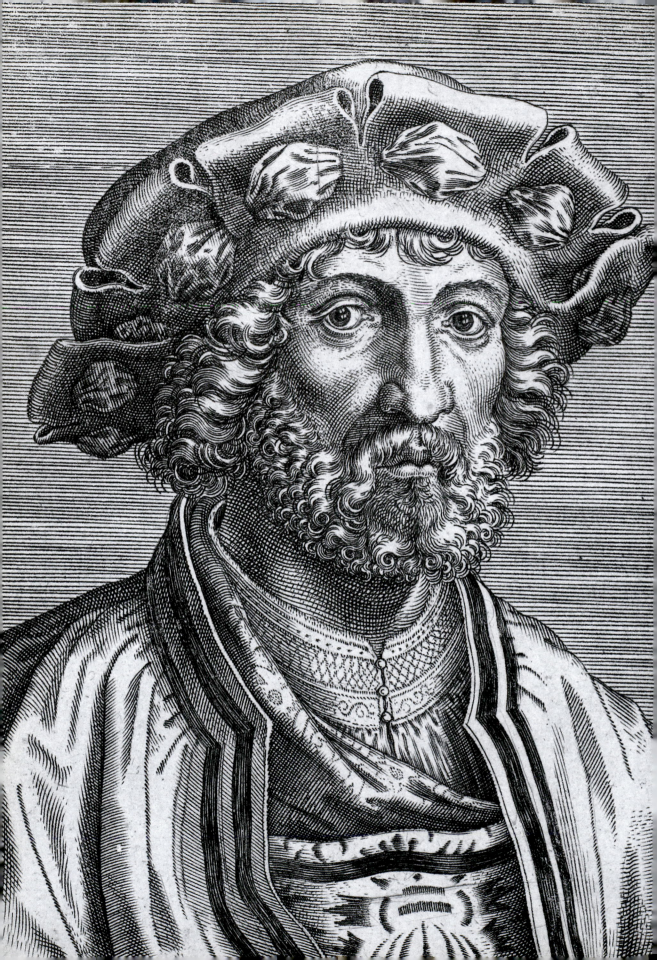

EPILOGUE

What I'm showing you here no master could teach you.
Only Mabuse possessed the secret of giving figures life,
and Mabuse had only one pupil, who happened to be me.
I've had none, and I'm an old man.[1]

MAÎTRE FRENHOFER TO NICOLAS POUSSIN,
from Balzac, *The Unknown Masterpiece*, 1837

This book has argued that Gossart's mythological paintings operated within a closed circuit. First nurtured under Philip of Burgundy's patronage, and inspired by the local recovery of the Batavian past, his works belonged to a privileged audience of humanists and noblemen who had entrée into the intimate realm of the Netherlandish court. The ambition of Gossart's localized revival of antiquity was contained by its own erudition, site-specificity, and dependence on its immediate context of reception. These limitations were not confining; on the contrary, they allowed the artist to experiment and innovate. It is thus no surprise that Gossart remained rooted in the courtly circles of the Low Countries up until his death in 1532, never leaving behind the realm where he had garnered such high esteem.

Gossart's combined engagement with classical forms and the Eyckian idiom, and his powerful ability to enliven the human figure—evinced by his mythological works as well as his portraits and religious paintings—remained all

Detail of Fig. 94

but unrivaled in the Low Countries during his lifetime. This was in no small part because his project was so difficult to replicate, and so dependent on the unique body of knowledge and skill that he possessed. Of course, Gossart's works inspired his fellow artists to some extent. During the last years of his career, printmakers like Dirck Vellert and Lucas van Leyden as well as painters like Jan Cornelisz. Vermeyen and Jan Sanders van Hemessen began to emulate his approach to portraiture, the nude, and antique ornament.[2] Yet these other artists were also responding to market demands that led them in other directions, and only rarely did their works take up mythological themes.

This book has also endeavored to show that Gossart's innovations were the product of a particular moment in time. As the last chapter explored, the Reformation already began to alter the climate surrounding the reception of mythological images in the Netherlands during the last decade of his career. In the years immediately following his death, as the political body of the Low Countries became more international and less tethered to the tightly knit world of Burgundian tradition into which Gossart was born, his project of creating mythological paintings that embodied a locally rooted past was further eclipsed by new pan-European interests. At the mid-sixteenth-century Habsburg court, it was the Venetian artist Titian whom the Netherlandish regent Mary of Hungary and Charles V's son Philip II of Spain commissioned to create mythological works for their palaces. Within the thriving metropolis of Antwerp, artists like Frans Floris became far more emphatic in evoking the models of Roman antiquity and the Italian Renaissance in their representations of the nude body.

Despite frequent scholarly attempts to situate Gossart as a founding father of antiquarian pursuits and mythological imagery in the Low Countries during the later sixteenth century, his afterlife tells a different story. Working backward through Gossart's posthumous legacy in literature and art criticism reveals the extent to which his mythological paintings embodied a singular and fleeting revival of the Netherlandish past.

It has often been overlooked that Gossart found a remarkable nineteenth-century apotheosis in Honoré de Balzac's famous 1837 novella *The Unknown Masterpiece*.[3] The elusive character of Mabuse in Balzac's story, whose name derives from the town, Maubeuge, whence Gossart hailed, stands as progenitor to a dying school of painting. Though long deceased, Mabuse continues to haunt the memory of his only pupil, Master Frenhofer. Only Mabuse, Frenhofer declares, possessed the secret of painting figures that seemed astonishingly alive.[4]

Frenhofer is consumed throughout Balzac's novella with completing what he proclaims his ultimate masterpiece, a painting of a female nude on which he has labored for ten years in blind obsession. Frenhofer's younger colleagues, themselves characters based on the historical figures of Frans Pourbus II and Nicolas Poussin, contrive throughout the story to see the mysterious work themselves. Yet, as they

discover at the novella's close, Frenhofer has overworked his canvas to the point of suffocating the figure with paint, thus reversing the promise of Mabuse's life-giving art and tolling the demise of his mentor's tradition. When Frenhofer finally realizes his failure through his colleagues' eyes, he banishes them from the studio in a fit of rage and proceeds that very night to take his own life. The character of Mabuse in *The Unknown Masterpiece* suggests that Balzac saw in Gossart a figure whose artistic legacy did not transcend its own moment. How did he come to this conception of the Netherlandish artist?

Balzac's early nineteenth-century Paris offered no ready access to viewing Gossart's paintings themselves. The Louvre acquired Gossart's *Carondelet Diptych* only in 1847, and auction records from the first decade of the nineteenth century document just three paintings associated with the artist on the market, one already dubious in attribution and another presumably a much later copy.[5] Balzac took a particular interest in northern European painting, eventually amassing his own collection of works by seventeenth-century Dutch and Flemish masters as well as a few by the sixteenth-century German artists Albrecht Dürer and Hans Holbein.[6] The veristic qualities of Dutch and Flemish painting acquired a cultural valence in early nineteenth-century France as counterpoint to the idealistic modes of romanticism and neoclassicism, which appealed to Balzac's self-perception as a realist writer.[7] After a visit to Dresden's Gemäldegalerie in later years, Balzac wrote that Holbein's work moved him more than Raphael's *Sistine Madonna*.[8] Yet despite hatching plans to visit Flanders with a friend, the Flemish writer Samuel Henry Berthoud, just a few weeks after *The Unknown Masterpiece* went to press for the first time, Balzac seems never to have realized the journey.[9] More likely than not, the novelist never had firsthand knowledge of Gossart's paintings.

What Balzac had was a summary of the life of the artist, based on early sources, set forth in a French reference work: Michaud's *Universal Biography*, which the author conveniently purchased in early spring 1831.[10] Balzac structured *The Unknown Masterpiece* around a genealogy of northern artists for which he required an elder representative. In Michaud's biography of Gossart, Balzac found a master who represented the essential artistic qualities associated with the visual tradition stretching back to van Eyck, but whose engagement with the nude figure also stood in important opposition to Poussin, the youngest artist in the novella, whose historical counterpart escaped Frenhofer's fate and found inspiration in Italy for his representation of classical nudes.[11]

The understanding of Gossart that Balzac inherited had its beginnings in the sixteenth century. The Netherlandish art theorist Dominicus Lampsonius was the first writer to critically address the history of art in the Low Countries and thus the first to place Gossart within a larger chronology.[12] Lampsonius's 1572 *Effigies of Several Celebrated Painters of the Low Countries*, which honors each of its subjects with a portrait and accompanying poem, presents Gossart in a hat broidered with ribbon, a

lustrous cloak, and a richly patterned doublet that distinguishes him as one of the best-dressed figures in Lampsonius's pantheon (fig. 94). In fact, Gossart closely resembles the sumptuously dressed noblemen in his own portraits (see fig. 13). As the artist fixes his gaze on the viewer, he clutches his resplendent robe with a vibrant hand, drawing attention to the regal motif of a crown situated at the center of his breast. Gossart here seems the epitome of a court artist, swathed in success, gesturing both to his prestige and to the kind of exquisite materials he could so adroitly imitate in paint. Yet as Lampsonius explains, the picture is not so straightforward:

> And so you too, Mabuse, are said in our verses
> to have educated your age in drawing.
> Indeed, who else was able to daub lively pigments
> on Apellian pictures in a manner more exquisite to the eye?
> Granted, you yield in skill to others who followed your time,
> but a commander of the brush equal to you will be rare.[13]

On the one hand, Lampsonius lauds Gossart's masterful handling of pigments, affirming the splendor afforded to the artist in his portrait. On the other hand, Lampsonius is equivocal as regards Gossart's influence as an educator. In declaring that the subsequent generation had surpassed Gossart in skill, Lampsonius must primarily mean skill in drawing, since he acknowledges that even future artists will find Gossart's painterly technique difficult to match.[14] Lampsonius's earlier remarks in the aforementioned biography of his beloved Netherlandish master, Lambert Lombard, support this conclusion (fig. 95).[15] Around the same time that Lombard encountered Jason Pratensis's colleague Willem Zagarus in Zeeland, Lampsonius reports that Lombard had sought out Gossart in order to study drawing with the master but felt dissatisfied with what he had learned.[16] Only upon visiting Italy and delving into the works of Italian painters did Lombard claim to have gained a correct understanding of the art.[17] For Lampsonius, Gossart was a brilliant exponent of Netherlandish tradition, not a forerunner in the Italian mode.

Karel van Mander's biography of the artist in his *Lives of the Illustrious Netherlandish and German Painters* (c. 1603) closely accords with the visual and literary portrait provided by Lampsonius. Although van Mander follows Vasari (who in turn followed Guicciardini before him) in stating that Gossart had brought "the correct manner of composing and making pictures full of nudes and all kinds of allegories from Italy to Flanders," the biographer says little else on this point and clearly esteems the artist not for his adaptation of Italian examples but instead for his precise renderings in paint.[18] Van Mander's words of praise for the neatness of the artist's works echo those he employs for prior Netherlandish masters like Jan van Eyck, as does his emphasis on Gossart's beautiful portrayal of draperies and portrait likenesses.[19] Elsewhere in his writings, van Mander upholds Gossart's painted draperies as superior to those of

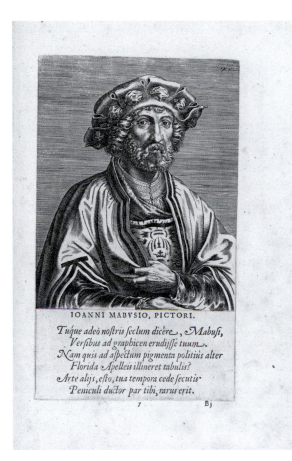

Fig. 94. Portrait of Jan Gossart, from Dominicus Lampsonius, *Pictorum aliquot celebrium Germaniae Inferioris effigies*, 1572. Rijksprentenkabinet, Rijksmuseum, Amsterdam.

Fig. 95. Portrait of Lambert Lombard from Dominicus Lampsonius, *Lamberti Lombardi apud Eburones pictoris celeberrimi vita*, 1565. Engraving. Bibliothèque Royale de Belgique, Brussels.

any other artist, particularly the fine fabrics displayed in his depictions of the Virgin and Child.[20] In the biography itself, van Mander even tells a wonderful anecdote about a visit by Charles V to the court of Gossart's patron Adolph of Burgundy, during which the artist outfitted himself in a paper garment that he had painted with "beautiful damask flowers and handsome ornaments," and which delightfully tricked the eyes of his courtly onlookers.[21] The encyclopedic writers of Balzac's early nineteenth century clung to this anecdote and invariably refer to the costume in their brief entries on the artist; one dictionary from 1804 refers to Gossart under the entry for "damask" itself, as if painter and material had become synonymous.[22]

The only painting of nudes to which van Mander refers in his biography of Gossart is a depiction not of a mythological subject but instead of Adam and Eve, described—without any reference to Italian precedent—as "most beautifully and perfectly executed" and "valued at a high price."[23] Michaud's nineteenth-century biography took from van Mander this account of Gossart's *Adam and Eve*, and Balzac employs it in a riveting passage from *The Unknown Masterpiece*, in which Frenhofer discourses on the ambitions and limits of his master's art.[24]

In downplaying Gossart's ties to Italy, van Mander sets the stage for his life of the Netherlandish artist Jan van Scorel, whom he esteems as the true "lantern bearer" of the sixteenth-century Netherlands.[25] Just as Lampsonius upholds Lombard as leader in the new school of painting, van Mander writes, on the opinion of Frans Floris and other contemporaries, that it was Scorel who illuminated the Low Countries with his understanding of Italian models and served as a "road-builder" for subsequent artists (including, by extension, van Mander's own circle in Haarlem).[26] Just as Lampsonius recalls Lombard's initial study with Gossart, van Mander relates that Scorel had sought out the master early in his career, but that the latter's dissolute ways soon compelled him to seek inspiration elsewhere. In describing Gossart drinking himself into a frenzy and inciting tavern brawls to the point of endangering the life of his pupil, van Mander figures him as anything but a role model for future Netherlandish artists.[27]

For Lampsonius and van Mander, Gossart's ability to convincingly render precious materials, to give life to his painted subjects, and to proffer his eccentricity as a virtue afforded him the exclusive privilege to stand in line with his great predecessors in the Low Countries: artists who likewise found favor at the Burgundian court for their vivid powers of imitation. Their portrait of Gossart as an artist who cleaved to the traditions of the past, mediated through subsequent centuries, was what inspired the role of Mabuse as father of a dying art in Balzac's *The Unknown Masterpiece*, and this representation rings true in relation to Gossart's mythological works and larger career.[28]

Of course, both Lampsonius and van Mander interpreted Gossart's legacy according to their own biases. To have dwelled too extensively on Gossart's southern journey might have undermined their respective portraits of Lombard and Scorel as

Fig. 96. Maarten van Heemskerck, *Self-Portrait in Rome with the Colosseum*, 1553. Oil on panel, 42 × 54 cm. Fitzwilliam Museum, Cambridge.

the great innovators in propagating Italian manner and technique. Yet they were also right to characterize Gossart as an eccentric proponent of local tradition. His dedication to the artistic heritage of the Low Countries—combined with his visual embodiment of local antiquity and ties to the Burgundian court—distinguished him from subsequent Netherlandish artists who made a knowledge of Italy central to their style and formal vocabulary. Although Lombard and Scorel themselves also engaged with local humanists and antiquarian endeavor in the Low Countries, they did so with quite different motivations and predominantly through modes other than mythological painting.[29] Lombard may have contributed to a lost cycle depicting the labors of Hercules, created for the bishropic palace of his early patron Érard de la Marck in Liège, which was perhaps inspired by Gossart's example, but de la Marck died not long after employing the artist at his court and left Lombard to engage with local antiquity primarily through the media of drawing and print.[30]

The first Netherlandish artist after Gossart to fully pursue the mythological genre was Maarten van Heemskerck, whose career is already separated by a significant gulf from that of his predecessor. Heemskerck went to Italy in 1532 and spent four years producing a vast corpus of drawings after ancient monuments and contemporary Italian works of art. Over twenty years later—still eager to assert his knowledge of Roman antiquity—Heemskerck painted a self-portrait that shows him standing proudly before the Colosseum (fig. 96).[31] An equivalent statement is nowhere to be found in Gossart's

oeuvre. Heemskerck's mythological paintings were created in dialogue with local humanists, as were Gossart's works before him, but the later artist's style and insistent quotation of ancient monuments alongside Italian Renaissance models constitute a conscious break with Netherlandish visual tradition of the prior decades.[32]

Beginning around 1540, the mythological genre in the Netherlands increasingly became the province of urban patrons with the rise of the art market in Antwerp and practitioners like the aforementioned Frans Floris, as well as Willem Key, Vincent Sellaer, and Jacob de Backer, whose paintings showcased their knowledge of Italian models in reflection of the interests of their public.[33] These urban buyers had far more awareness of and access to information on Italian Renaissance and classical models than Philip or Gossart's other patrons ever possessed. Within the intellectual community, the landscape had also changed. The great Antwerp cartographer and antiquarian Abraham Ortelius was part of the next generation of humanist scholars in the Low Countries to engage with local antiquity, but he did so within an urban and international circle of interlocutors quite distinct from the courtly context to which Geldenhouwer had belonged.[34]

By the later sixteenth century, the treatment of Gossart's paintings had already begun to parallel that of the works of the great fifteenth-century Netherlandish artists. Around 1540, the Habsburg court began to commission copies after Jan van Eyck's *Ghent Altarpiece* and Rogier van der Weyden's *Lamentation* to fulfill their desire to enfold those early fifteenth-century works within their collections. The Netherlandish artist who produced these copies was Michel Coxcie, whose oeuvre reveals his remarkable ability to emulate different styles, from Raphael to Gossart himself.[35] Sometime prior to 1580 (most likely in the years 1560–65), Coxcie was commissioned to paint wings for Gossart's *St. Luke Drawing the Virgin* now in Prague, which at that time was still housed in Mechelen's cathedral (fig. 97).[36] Coxcie softens and refines his painterly touch in deference to his predecessor's color scheme and fine manner but exercises his own sculptural Raphaelesque style in representing the figures.[37] In essence, Coxcie frames Gossart's original as a historical object worthy of preservation, much as Gossart himself had done in his emulative *Deesis* after van Eyck's *Ghent Altarpiece*.

Gossart's contribution to the local renaissance among his Burgundian patrons and humanist colleagues was innovative in its moment but ultimately short-lived. As it turns out, Balzac got it right. Gossart was really more of an end than a beginning.

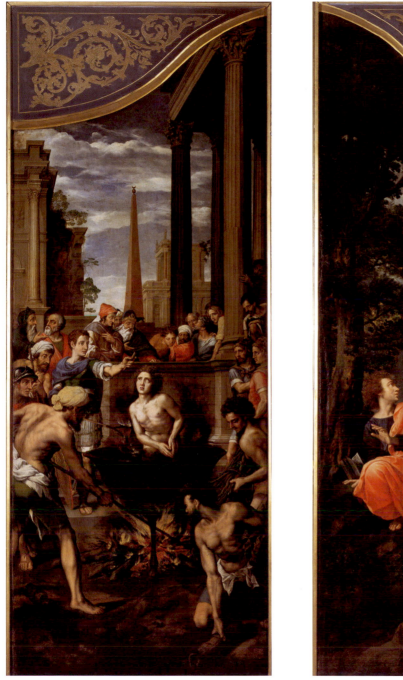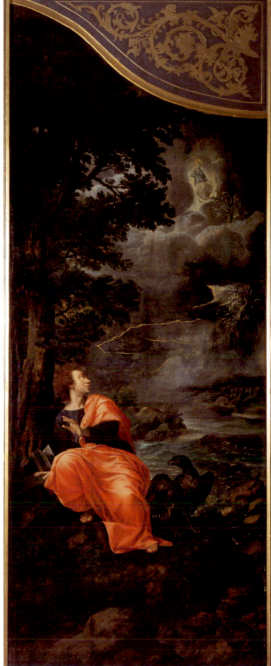

Fig. 97. Michel Coxcie, side wings depicting St. John the Evangelist and St. Matthew, c. 1560–65, from Jan Gossart, *St. Luke Drawing the Virgin* (c. 1515). Oil on panel. Národní Galerie, Prague.

NOTES

INTRODUCTION

1. "En brevibus complexa tomis narratio prodit / Terrae, quam tumidum cingit ubique fretum. / Parvus erit magni, si hanc censes, angulus orbis, / Ipsaque non longus terminat arva lapis. / Sunt tamen in tractu tantillo plurima, quae te / Delectent, miris adficiantque modis." Reygersbergh, *Dye cronijcke*, A4r.

2. For examples ranging from the courts of northern Italy to England, Germany, France, and Hungary, see the recent studies by Vine, *In Defiance of Time*; Wood, *Forgery, Replica, Fiction*; Ott, *Die Entdeckung des Altertums*; Nevola, *Siena*, 147–55; Rowland, *Scarith of Scornello*; Lemerle, *La Renaissance et les antiquités de la Gaule;* Cooper, *Roman Antiquities in Renaissance France*; Farbaky et al., *Matthias Corvinus, the King*; and Farbaky and Waldman, *Italy and Hungary*.

3. On this concept, which is central to the argument of this book, see de Certeau, *The Writing of History*. See also Burke, *The Renaissance Sense of the Past*.

4. Van de Waal, *Drie eeuwen vaderlandsche geschied-uitbeelding*.

5. Northern Italian court artists like Andrea Mantegna, Antico, Correggio, and Dosso Dossi created their mythological works under similar local motivations, not by slavishly importing ideas and inspiration from Rome. See Campbell, *Cabinet of Eros*; Luciano et al., *Antico*; Furlotti and Rebecchini, *The Art of Mantua*; and Fiorenza, *Dosso Dossi*, esp. 161. For an important study of Gossart's most significant counterpart in early sixteenth-century Germany, Lucas Cranach the Elder, in relation to the pursuit of local antiquity in that region, see Bierende, *Lucas Cranach d. Ä. und der deutsche Humanismus*.

6. Meinhardi, *The "Dialogus" of Andreas Meinhardi*, 255–65. For discussion of this dialogue and the paintings it catalogues, see Borggrefe, "Die Bildausstattung des Wittenberger Schlosses."

7. "Giovanni di Mabuge, il quale fu il primo che portò d'Italia in questi paesi l'arte del dipingere historie e poesie con figure nude." Guicciardini, *Descrittione*, 98.

8. "E Giovanni di Mabuse fu quasi il primo che portasse d'Italia in Fiandra il vero modo di fare storie piene di figure ignude e di poesie." Vasari, *Le vite*, 7:584. Vasari's only revision to Guicciardini's original remark is to say that Gossart was "almost the first" ("quasi il primo") rather than simply "the first" to export the nude to his native Netherlands.

9. "Hy heeft Italien en ander Landen besocht en is wel een van de eerste die uyt Italien in Vlaender bracht de rechte wijse van te ordineren en te maken Historien vol naeckte beelden en alderley Poeterijen." Van Mander, *Lives*, 1:160, fol. 225v. See also Melion, *Shaping the Netherlandish Canon*, 118–19, and further discussion in the epilogue to this book.

10. "Gossart accompagna Philippe de Bourgogne en Italie . . . et fut évidemment si captivé par la Renaissance, qu'il laissa là les traditions de son école." Weale, *Exposition des Primitifs Flamands*, xxvi. See also Francis Haskell's discussion of the Bruges exhibition as an argument for national culture, with reference to Gossart, in *History and Its Images*, 431–95, esp. 449.

11. Weale, *Exposition des Primitifs Flamands*, 63, no. 150, 65, no. 154, 68, no. 161, 82, nos. 191–92, 90, no. 221, 91, nos. 224 and 225, 126, no. 330, and 136, no. 370. The only mythological painting (no. 225), *Hercules Wrestling with Antaeus*, is now attributed to one of Gossart's followers (see fig. 55 in this book).

12. "Dans l'oeuvre de Gossart, il y a la manifestation de deux manières réellement distinctes: La première procède immédiatement de toute l'école nationale des primitifs flamands, depuis van Eyck jusqu'à Metsys; le voyage en Italie a déterminé la second: sans discernement, presque sans goût, mal préparé d'ailleurs à cet éblouissement, Mabuse pille, imite, copie les Italiens de Florence et de Rome, laisse le meilleur de son talent se perdre dans ces illusoires tentatives, et revient en Flandre changé de dépouilles demi-grotesques, demi falsifiées, prise sur le plus mauvais de l'art Italian: le néo-antique." Gossart, *Jean Gossart de Maubeuge*, 92.

13. "Voor al de latere romanisten heeft Mabuse het voorwerk gedaan; tevens echter over hun standpunt als het ware reeds heen komende! Het *geheele* proces van het Romanisme weerspiegelt zich reeds in hem op een eigenaardige wijze." Hoogewerff, *Nederlandsche schilders in Italië*, 6, 41–56, esp. 51. Similar views were expressed in the next two monographs on the artist, for which see Weisz, *Jan Gossart*, and Segard, *Jean Gossart dit Mabuse*. Max Friedländer critically observed that the question of a Netherlandish painter's relation to Italy was an all too ubiquitous question, yet did not escape it entirely in his own discussion of Gossart's artistic development. Friedländer, *Early Netherlandish*

Painting, 8:11. For comment on the problems with the term "Romanist," see Hendrikman, "Verknipte interpretatie," 83–89, 227–28.

14. New research began in 1965 with the first retrospective exhibition devoted to the artist (Pauwels, Hoetink, and Herzog, *Jan Gossaert genaamd Mabuse*), and culminated most recently in the 2010 exhibition and catalogue raisonné, organized by the Metropolitan Museum of Art, which greatly expanded the knowledge and scope of his oeuvre (Ainsworth, *Jan Gossart's Renaissance*).

15. Ainsworth, "Observations concerning Gossart's Working Methods."

16. The seminal study of Gossart's patronage remains Sterk, *Philips van Bourgondië*. See also Eichberger, *Leben mit Kunst*; Schrader, "Jan Gossaert's Art of Imitation"; and Schrader, "Gossaert's *Neptune and Amphitrite*."

17. The pioneering article on this topic is Silver, "The 'Gothic' Gossaert." The most significant investigation of the "Renaissance Gothic" has been undertaken by Ethan Matt Kavaler in "Renaissance Gothic in the Netherlands"; "Pictures of Geometry and Narratives of Ornament"; "Gothic as Renaissance"; and *Renaissance Gothic*. See also de Jonge, "Style and Manner in Early Modern Netherlandish Architecture." For important discussion of Gossart's relation to the style of Antwerp Mannerism, see also van den Brink and Martens, *ExtravagAnt*, esp. 41–53.

18. See especially Ariane Mensger's exploration of this topic in "Blick zurück nach vorn"; "Jan van Eyck, 'Belgarum Splendor'"; *Jan Gossaert*, passim; "Jan Gossaert und der niederländische Stilpluralismus."

19. For a few recent and important studies of this phenomenon, see Wouk, "Reclaiming the Antiquities of Gaul"; Neville, "The Land of the Goths and Vandals"; Hoppe; "Northern Gothic, Italian Renaissance and Beyond"; and Hoppe, "Romanik als Antike." For the classic statement of this idea, see Panofsky, *Renaissance and Renascences*.

20. The category "Northern Renaissance Art" is a modern invention. To my knowledge, the first use of this terminology in a book title is Stechow, *Northern Renaissance Art 1400–1600*, though it is perhaps already implied as the category underlying Benesch, *The Art of the Renaissance in Northern Europe*. For further discussion of the problem with this terminology, see especially Wijsman, "Northern Renaissance? Burgundy and Netherlandish Art," and the somewhat biased discussion in Belozerskaya, *Rethinking the Renaissance*, 7–46. For the particularly troubled application of the term to the representation of the nude body in northern European art, see Clark, *The Nude*; Lindquist, *The Meanings of Nudity*, passim; and my review of de Clippel, van Cauteren, and van der Stighelen, *The Nude and the Norm,* in *CAA Reviews* (October 2012): http://www.caareviews.org/reviews/1877.

21. See the eccentric but still valuable discussion in Huizinga, "The Problem of the Renaissance" (first published in Dutch in 1920), and Huizinga, *The Autumn of the Middle Ages* (first published in Dutch in 1919).

22. For thoughtful comment on the tension between Erasmus's international reputation and his local career in the Netherlands, see Jardine, *Erasmus, Man of Letters*, 3–26.

CHAPTER 1
THE EMBODIED PAST

1. Alberti, *On Painting*.

2. Guicciardini, *Descrittione*, 98 (see introduction, n. 7).

3. Merleau-Ponty, *Phenomenology of Perception*; see also the compelling application of Merleau-Ponty's work in Csordas, "Embodiment as a Paradigm for Anthropology," and Csordas, "The Body as Representation and Being-in-the-World," 6–10.

4. On the notion of "pictorial invention" in early Netherlandish painting as a counterpart to written art theory, see especially Marrow, "Artistic Identity in Early Netherlandish Painting."

5. Ainsworth, *Jan Gossart's Renaissance*, 229–32, no. 34.

6. Ovid, *Metamorphoses*, 3.339–508.

7. Alberti, *On Painting*, 62.

8. Ovid, *Metamorphoses*, 10.223–97; see also Stoichita, *The Pygmalion Effect*.

9. Schoch, Menda, and Scherbaum, *Das druckgraphische Werk*, 1:110–13, no. 39, with prior literature. See also Dürer, *Vier Bücher von menschlicher Proportion*, composed primarily between late 1513 and 1515, and the facsimile with modern German translation by Hinz. For a particularly compelling discussion of Dürer's creative process, see Parshall, "Graphic Knowledge."

10. Koerner, *The Moment of Self-Portraiture*, 187–202.

11. Ainsworth, *Jan Gossart's Renaissance*, 114–17, no. 1.

12. For Cranach, see Brinkmann, *Cranach die Ältere*, and for Baldung's nudes, Brinkmann, *Witches' Lust and the Fall of Man*, both with prior literature.

13. Ainsworth, *Jan Gossart's Renaissance*, 383–85, no. 101.

14. "Een stalen huyfken up zijn antyck." Sterk, *Philips van Bourgondië*, 57, 253, fol. XXIXv, and 311n27.

15. "Leo Baptista de re edificatoria." Kathedraalarchief, Antwerp, KAA, *Testamenta Antiqua* 625, no. 61, 41v. I am very grateful to Michel Oosterbosch of the Antwerp Rijksarchief for sharing with me a transcription of Heda's library inventory. For Heda's house and biography, see van Genderen, "Kroniekschrijver, kanunnik en humanist"; van der Horst, "Willem Heda"; van Langendonck, "Het Karbonkelhuis van kanunnik Willem Heda"; de Jonge, "*Anticse wercken*," esp. 28–29. In his 1528 edition of the Italian theorist Pomponius Gauricus's

writings on perspective, the Netherlandish humanist Cornelius Grapheus also makes mention of Alberti. See Gauricus, *De sculptura seu statuaria*, A2v, and Gauricus, *De sculptura (1504)*.

16. On the importance of *reflexy-const* to Netherlandish art theory, see Melion, *Shaping the Netherlandish Canon*, esp. 70–84.

17. Hindriks, "Der 'vlaemsche Apelles.'"

18. De Vos, *Stedelijk Museum voor Schone Kunsten*, 194–233, no. 9.

19. For an overview of van Eyck's career, see Dhanens, *Hubert and Jan van Eyck*; see also Jacobs, *Opening Doors*, 61–84; and on the Adam and Eve figures, see especially Lehmann, "Mit Haut und Haaren."

20. Ainsworth, "Observations concerning Gossart's Working Methods," 83–85.

21. "Meester Jan van Mabeuse, Meester Hughe, ende veel meer andere hebben elck bysonder eenen grooten lof daer af ghegheven." Van Vaernewijck, *Den spieghel der Nederlandscher audtheyt*, 118v.

22. See Preimesberger, "Zu Jan van Eycks Diptychon," though his argument that van Eyck necessarily had a knowledge of classical sources and Italian art theory is overstated.

23. Ainsworth, *Jan Gossart's Renaissance*, 120–22, no. 3.

24. On this point, see also Kavaler, "Gossart's Bodies and Empathy."

25. Eichberger, *Leben mit Kunst*, 130–31n357.

26. Baxandall, "Bartholomaeus Facius on Painting," 102–5.

27. Röver-Kann, *Das Frauenbad*; Müller, "Hans Sebald Behams 'Jungbrunnen' von 1536"; Wood, "The Studio around 1500," 65; Zerner, *Renaissance Art in France*, 217–25; Borggrefe, "Anatomie, Erotik, Dissimulation"; and Nuttall, "Reconsidering the Nude," 305–8. Of course, bathing was part of the culture in Italy and Europe at large. For general discussion, see Wolfthal, *In and out of the Marital Bed*, 121–53; for Italy specifically, see Guérin-Beauvois and Martin, *Bains curatifs et bains hygiéniques*, as well as Pontano, *Baiae*.

28. Tuchen, *Öffentliche Badhäuser in Deutschland*.

29. Mediolanensis, *Tregement der ghesontheyt*. See also van Dam, "*De consideracie des badens.*"

30. Tafur, *Travels and Adventures*, 200.

31. Bracciolini, *De Balneis*. See also Négrier, *Les bains à travers les âges*, 130–46; dall'Oco, "Poggio, Baden e il 'de Balneis'"; and especially Enenkel, "Autobiografie en etnografie."

32. "Ego autem ex deambulatorio omnia conspiciebam: mores, consuetudinem, suavitatem victus, vivendi libertatem ac licentiam contemplatus. Permirum est videre qua simplicitate vivant, qua fide videbant viri uxores suas a peregrinis tangi; non commovebantur, non animum advertebant; omnia in meliorem partem accipiunt." Bracciolini, *De Balneis*, 47. See also Wolfegg, *Venus and Mars*, 44–50, fols. 18v–19, for a drawing of a bathhouse by the Master of the House-

book showing a second-floor ambulatory like the one that Bracciolini describes. A similar ambulatory is also depicted in a fragment from Albrecht Altdorfer's bathhouse wall mural painted c. 1532 for Johann III, Count Palatine of the Rhine in the episcopal palace of Regensburg (Szépművészeti Múzeum, Budapest, inv. no. 3890). See Winzinger, *Albrecht Altdorfer*, 55–56, nos. 80–89.

33. Ainsworth, *Jan Gossart's Renaissance*, 375–77, no. 98.

34. On the tradition of private bathhouses in the Burgundian courtly milieu, see de Jonge, "Estuves et baingneries." Philip of Burgundy's bathing chamber at Wijk bij Duurstede is described in the inventory of his palace, for which see Sterk, *Philips van Bourgondië*, 263, fol. XXXVI. Philip's fellow nobleman Philip of Cleves is documented to have had a mythological painting of Diana and Actaeon in his bathhouse at the palace of Wynendale: "ung grant tableau devant les estuves, de Dyane et Acthéon." Finot, *Inventaire sommaire*, 426. See also Denhaene, "Les collections de Philippe de Clèves," and Olivier, "Philippe de Clèves."

35. Ainsworth, *Jan Gossart's Renaissance*, 375–76. Here and elsewhere, I am grateful to Stijn Alsteens for discussing his thoughts on Gossart's drawings with me.

36. Vandenbroeck, "Amerindian Art and Ornamental Objects"; Shelton, "Cabinets of Transgression," 193–95; Eichberger, "Naturalia and Artefacta," 17–18.

37. Dürer, *Schriftlicher Nachlass*, 1:155, lines 33–50 (27 August 1520).

38. "Twaelf plumaigen van blauw wit root ende geluwe verwen." Sterk, *Philips van Bourgondië*, 227, fol. IXv.

39. A good overview is provided in Marti et al., *Charles the Bold*.

40. For the early chapter meetings of the order, see Gruben, *Les chapitres de la Toison d'Or*.

41. Particularly relevant are Eichberger, *Leben mit Kunst*, and Campbell, *Tapestry in the Renaissance*.

42. For a brief summary of Maximilian's career, see Hollegger, "The Biography of Emperor Maximilian I."

43. Cauchies, *Philippe le Beau*.

44. See *Brou: un monument Européen à l'aube de la Renaissance* (http://editions.monuments-nationaux .fr/en/le-catalogue/bdd/livre/711), and for the documents concerning the commission, Bruchet, *Marguerite d'Autriche*.

45. On Maximilian's patronage, see Michel and Sternath, *Emperor Maximilian I*, and Silver, *Marketing Maximilian*, both with additional literature.

46. See Soly and van de Wiele, *Carolus: Keizer Karel V*.

47. Weidema and Koopstra, *Jan Gossart*, 19–22, nos. 12–15, 28–31, nos. 21–22.

48. Ainsworth, *Jan Gossart's Renaissance*, 272–73, no. 51.

49. Campbell, *The Sixteenth Century Netherlandish Paintings*, 352–83; Ainsworth, *Jan Gossart's Renaissance*, 145–50, no. 8. See also Campbell, "The Patron of Jan Gossaert's 'Adoration of the Kings.'"

50. On the Middelburg altarpiece, see van Dyck, "Jan Gossaerts retabel."

51. "Von dannen fuhr ich gen Mitelburg; do hat in der abtey Johann de Abüs eine grosse taffel gemacht, nit so gut im hauptstreichen als in gemähl." Dürer, *Schriftlicher Nachlass*, 1:162, lines 29–32 (8 December 1520).

52. See Ainsworth, "Gossart in His Artistic Milieu," 20–22.

53. Weidema and Koopstra, *The Documentary Evidence*, 7–8, no. 1.

54. "Een tavereel van een nacte vrou." Kathedraalarchief, Antwerp, KAA, *Testamenta Antiqua 625*, no. 61, 10v. Heda's testament also records that he owned a painting of Lucretia, a diptych of Lucretia and Cleopatra, and various religious works depicting St. Anthony, Mary Magdalene, and others (10r–14r).

55. See Philip the Good's remarkable letter on the life pension he wished to grant to van Eyck, on the premise of engaging the artist "pour certains grans ouvraiges," in Weale, *Hubert and John van Eyck*, xlii–xliii, no. 24 (12 March 1435).

56. Van der Velden, *The Donor's Image*, passim.

57. Silver, *Quinten Massys*, esp. 70–86.

58. Michel, *Catalogue raisonné des peintres du Moyen-Age*, 207–9, no. 2029, and Silver, *Quinten Massys*, 108–9, 136–38, cat. 16, with additional literature.

59. Campbell, *The Fifteenth Century Netherlandish Schools*, 174–211.

60. Ibid., 174. The painting was given to Margaret by the Spanish nobleman Don Diego de Guevera.

61. On van Orley's career and oeuvre, see the excellent summary in Galand, *The Bernard van Orley Group*, esp. 19–129. The *Haneton Triptych* (Musées Royaux des Beaux-Arts de Belgique, Brussels, inv. no. 358) is a particularly rich example of van Orley's engagement with early Netherlandish painting, on which see ibid., 237–61. On van Orley's tapestry designs, see Campbell, *Tapestry in the Renaissance*, 287–377.

62. Panofsky, *Early Netherlandish Painting*, 1:350–56, and van Miegroet, *Gerard David*, 95–141; On the copying of van Eyck's paintings in particular, see Duverger, "Kopieën van het 'Lam-Gods'-retabel"; Silver, "Fountain and Source"; Blacksberg, "The Paintings of the Godhead"; Mensger, "Blick zurück nach vorn."

63. Ainsworth, "Introduction," in *Jan Gossart's Renaissance*, 6, declares among the achievements of her scholarly team that they have "come to terms with Gossart's so-called Eyckian phase and recognized that it has been much overstated in the past."

64. Ainsworth, *Jan Gossart's Renaissance*, 150–54, no. 9.

65. Purtle, *Rogier van der Weyden*.

66. Heringuez, "Bramante's Architecture," 241.

67. Gossart prepared the elaborate composition using ruled vanishing lines. See Kotková and Pokorný, "*St Luke Drawing the Virgin*," 34–35.

68. I am not convinced by the arguments for joint attribution to Gerard David made by Ainsworth, "Gossart in His Artistic Milieu," 13–15, and Ainsworth, *Jan Gossart's Renaissance*, 131–39, no. 6, 148–49, no. 8. See the relevant comments in my review, "*Man, Myth and Sensual Pleasures*." For further refutation, see Campbell, *The Sixteenth Century Netherlandish Paintings*, esp. 369–71.

69. Harbison, "Miracles Happen"; Meiss, "Light as Form," 181; Purtle, *The Marian Paintings of Jan van Eyck*, 144–56.

70. For the concept of producing presence, especially at the junction of the medieval and early modern periods, see Gumbrecht, *Production of Presence*, esp. 21–32.

71. Ainsworth, *Jan Gossart's Renaissance*, 140–45, no. 7a–b; see also Silver, *Quinten Massys*, 75–76, cat. 13, and the example by the Master of 1499 (Koninklijk Museum voor Schone Kunsten, Antwerp) in Hand, Metzger, and Spronk, *Unfolding the Netherlandish Diptych*, 140–49, no. 21.

72. Ainsworth, *Jan Gossart's Renaissance*, 131–39, no. 6.

73. See especially Kavaler, "Renaissance Gothic in the Netherlands."

74. Ainsworth, *Jan Gossart's Renaissance*, 285–87, no. 56.

75. Ibid., 243–49, nos. 39–40. On Carondelet, see Coenen, "Carondelet, Jean II."

76. Van der Velden, "Diptych Altarpieces and the Principle of Dextrality."

77. See also discussion in Sander, "Anmerkungen zu Jan Gossaert."

78. Ainsworth, *Jan Gossart's Renaissance*, 305, fig. 252, with prior literature.

79. See discussion in Dunbar, *German and Netherlandish Paintings*, 228–38.

80. Ainsworth, *Jan Gossart's Renaissance*, 213–17, no. 29.

81. Kavaler, "Renaissance Gothic in the Netherlands."

82. Kavaler, "The Court Style of Brou," and Kavaler, *Renaissance Gothic*, for Margaret's choice of Gothic over classical ornament for her funerary chapel at the monastery of Brou.

83. I allude here to a much-critiqued argument in the final chapter of Belting, *Likeness and Presence*, 458–90. See also Hamburger, "Art History Reviews XI," 43–44.

84. Van Vaernewijck, *Den spieghel der Nederlandscher audtheyt*, esp. 117r–119r. The four chapters immediately preceding Vaernewijck's discussion of the *Ghent Altarpiece* refer to other historical buildings and monuments in Ghent and surrounding areas under the rubric "van veel antiquiteyten deser Nederlanden," building up to van Eyck's painting as the greatest antiquity of all.

85. See especially van de Waal, *Drie eeuwen vaderlandsche geschied-uitbeelding*, esp. 58–59, and also Nagel and Wood, *Anachronic Renaissance*, 278. For the description of van Eyck's works as "fort antique" in the inventory of Margaret of Austria's collection, and the significance of that term, see Eichberger, "Stilplurismus und Internationalität."

86. It is not certain when Geldenhouwer saw the map owned by Peutinger, who lived in Augsburg, but it was most likely in the latter half of the 1520s when he started to establish closer contacts in Germany; see Geldenhouwer, *Collectanea*, 78–82. On the so-called *Tabula Peutingeriana*, see Bosio, *La Tabula Peutingeriana*, and Prontera, *Tabula Peutingeriana*, with prior literature. Peutinger had received the map from its previous owner, the great German humanist Conrad Celtis, and it became an object of enduring interest. The Netherlandish cartographer Abraham Ortelius expended great effort in the latter half of the sixteenth century to recover the map and have it published as a print, a project brought to fruition only after his death in 1598. See Meganck, "Erudite Eyes," 60–64, and also Langereis, *Geschiedenis als ambacht*, 215, for the use of the map by the later Netherlandish historiographer Petrus Scriverius.

87. "Gorichemum, non procul a castris Herculis, una cum pagis aliquot vicinis vetus nomen hodie retinet. Ager enim Herculis dicitur Batavice: 'dat landt van Arkel'. Horum castrorum fit mentio in charta illa vetustissima, quae itinera Romanorum militum ex provinciis nonnullis depicta continet. Hanc mihi ostendi clarissimus vir dominus Conradus Peutingerus, utriusque iuris doctor, patricius ac cancellarius nobilis Augustae Vindelicorum qui secundus a Celte cognomine suo, poeta laureato, patriam suam totamque Germaniam illustrare coepit." Geldenhouwer, *Historische werken*, 142.

88. "O Noviomagum, cui non certaverit ullus / Terrarum locus . . . Te nemus annosae redimitum robore quercus, / Aequans Aonium, cingit, fontesque salubres / Quos adamat Clarius." For the full text of the poem, see Geldenhouwer, *Historische werken*, 140–42. Geldenhouwer adapted the poem from an original version, published as the sixth satire in his *Satyrae octo*, E3v–E4v; also printed in Geldenhouwer, *Collectanea*, 169–71.

89. For the most accurate biography of the humanist, with prior literature, see Geldenhouwer, *Historische werken*, 10–12, and Bietenholz, *Contemporaries of Erasmus*, 2:82–84. See also the still important study by Prinsen, *Gerardus Geldenhauer*.

90. "Vindicemusque nos et ab ignominia, qua nos barbaros indoctosque et elingues et si quid est his incultius esse nos iactitant, exolvamus, futuramque tam doctam atque literatam Germaniam nostram, ut non Latinius vel ipsum sit Latium." Agricola, *Letters*, 68, no. 3.

91. For the ubiquity of the *Aeneid* as political model in the Renaissance, see Quint, *Epic and Empire*.

92. *De laudibus Germanorum* in Geldenhouwer, *Historia Batavica*, 26r–26v. Montanus's adage is preserved only in Geldenhouwer's publication.

93. Ijsewijn, "The Coming of Humanism to the Low Countries," and de Vocht, *Collegium Trilingue*

Lovaniense. On the ideology of Charles V's imperial rule, Tanner, *The Last Descendant of Aeneas*.

94. On the history of antiquarian scholarship in the Renaissance, see Weiss, *The Renaissance Discovery of Classical Antiquity*; Jacks, *The Antiquarian and the Myth of Antiquity*; Barkan, *Unearthing the Past*; Stenhouse, *Reading Inscriptions*; as well as the canonical article by Momigliano, "Ancient History and the Antiquarian." For recent assessment of the latter, see Herklotz, "Arnaldo Momigliano's 'Ancient History and the Antiquarian.'"

95. Herbenus, *De Trajecto instaurato*, 8 and passim. See also Ijsewijn, "The Coming of Humanism to the Low Countries," 254–60.

96. Dorp et al., *Dialogus*.

97. On the history of Dorp's conclusion to Plautus's *The Pot of Gold* and his role in encouraging Latin school drama in the Netherlands, see Creizenach, *Geschichte des Neueren Dramas*, 53–54; de Vocht, *Monumenta Humanistica Lovaniensia*, 326–34; *Tentoonstelling Dirk Martens*, 208–9, no. A308, 275, no. M106; Ijsewijn, "Martinus Dorpius, dialogus (ca. 1508?)," 74–79. For Dorp's biography, see Bietenholz, *Contemporaries of Erasmus*, 1:398–404.

98. "Tu mihi posthac eris pictor ille, iamdiu desyderatus, qui famatissimam illam Apellis Venerem inferiori parte mutilam (id quod nemo ausus est) reficere tuo isto penicillo potueris." Dorp et al., *Dialogus*, E2r.

99. On the dialogue between recovery of the old and assertion of the new in humanist discourse, see the excellent article by Greene, "Resurrecting Rome."

100. "Ne quis forte arbitretur cum illo me voluisse de gloria certare: iuvenem cum sene, Hollandum cum Italo, philosophantem cum poeta . . . utcunque se res habet. Labor hic meus adeo viris aliquot doctissimis non displicuit, ut et crebris litteris et in celeberrimis etiam oppidis actionis calculo comprobaverint." Dorp et al., *Dialogus*, D2v.

101. Geldenhouwer, *Collectanea*, 210 ; Geldenhouwer, *Pompa exequiarum*, 3v: "Nostri saeculis Apellis." Geldenhouwer, *Collectanea*, 235; Geldenhouwer, *Vita clarissimi*, A7v: "Joannem Malbodium, nostrae aetatis . . . Apellem." For further discussion of this epithet in relation to Gossart, see Mensger, "'Nostrae aetatis Apelles.'"

102. Mulier, "De Bataafse mythe opnieuw bekeken"; Schöffer, "The Batavian Myth"; and chaps. 2–3 in this book.

103. On Maximilian's antiquarian activities in Germany, see Wood, "Maximilian I as Archeologist."

104. "Variis antiquitatis monumentis clarus, quae magno numero eruta ante sexagenos amplius annos refossis fundamentis fuerant, in quibus duo leonum ex aere conflata signa, cum Deae Pallados hominibus illis ignoratae simulacro, et nomismata argentae aeneaque Antonini, Neronis, aliorumque complura, quae sibi donate abstulit

Maximilianus Caesar, anno 1508." Junius, *Batavia*, 268–69. This is the first recorded account of these ancient finds' being given to Maximilian. See also Bogaers, "Maar waar zijn de leeuwen van weleer," and, on the Roomburg site: Lems, *Op zoek naar Matilo*; Polak, van Doesburg, and van Kempen, *Op zoek naar het castellum Matilo*; Brandenburgh and Hessing, *Matilo—Rodenburg—Roomburg*. For an extant example of a Minerva statue discovered in the Netherlands, which may be an analogue of the small object Maximilian received, see Brouwer, *De Romeinse tijd in Nederland*, 68–70, no. 27.

105. The illustrated manuscript documenting the tomb and its contents is preserved in the Österreichische Nationalbibliothek, Vienna, MS 3324. The inscription on the relevant folio reads: "Ceste figure demonstres la cave qui estoit dedens ladicte mote ou tombe au costé d'orient faicte de pierre grise tresgrant et espes et de mommartre si fort massonné et joinct ensemble que merveilles, laquelle caveté ou vaulsure parc que le peuple de diverses contrees et regions le viennent journellement veoir, n'a esté rompu ne demolie, ains encoires delaisse en estre jusques à la venus de Roy [Maximilian], lequel comme vray semblable est y prendra plaisir et delectacion" (fol. 9v). Lemaire de Belges, *Des anciennes pompes funeralles*, 98–99. See also Fontaine, "Antiquaires et rites funéraires."

CHAPTER 2
LAND

1. Ainsworth, *Jan Gossart's Renaissance*, 217–21, no. 30. The painting had belonged to English merchant Edward Solly but is not documented prior to 1821. For the history of Solly's collection, see Köhler, "Die Sammlung Solly," and Herrmann, "Peel and Solly."

2. An earlier version of the argument presented in this chapter can be found in my article "Jan Gossaert's *Neptune and Amphitrite* Reconsidered." The title *Neptune and Amphitrite* appears in the original guide to the Berlin collection (Waagen, *Verzeichniss der Gemälde-Sammlung*, 162, no. 130), and in the first catalogue raisonné of the artist (Gossart, *Jean Gossart de Maubeuge*, 67, no. 648). It has remained unchallenged since.

3. "A / plus sera / ph[ilipp]e bourg[og]ne." For Philip's biography, see Sterk, *Philips van Bourgondië,* and also Bietenholz, *Contemporaries of Erasmus*, 1:230–31.

4. "Picturae ac liniamentum per ocium operam dans, utrumque callebat, et de sculpturis optime judicabat." Heda, *Historia episcoporum Trajectensium*, 424.

5. For Geldenhouwer's biography, see chap. 1, n. 89.

6. See Wauters, "Une ambassade flamande," 19–23, and, for archival documents related to the embassy, see Weidema and Koopstra, *Jan Gossart*, 8–11, nos. 2–3. None of these documents mention Gossart, which means that he was truly there on Philip's personal behalf and not as part of the official mission.

7. "Itaque factus est, ut Julius eum summopere amaret, multaque ultro offerret, quae alii ambire solent. At ea animi celsitudine erat, ut nihil a Julio acceperit praeter statuas marmoreas duas, quarum una Julii Caesaris, altera Haelii Hadriani erat." Geldenhouwer, *Collectanea*, 232–33, and Geldenhouwer, *Vita clarissimi*, A6r–A6v. Ancient busts were not unprecedented gifts for a prominent ambassador in Rome to receive. Lorenzo de' Medici also reported that he received two imperial portrait heads from Pope Sixtus IV on an embassy in 1471. See *La Toscana illustrata*, 194: "Del mese di Settembre MCDLXXI. fui eletto Ambasciatore a Roma per l'Incoronazione di Papa Sisto, dove fui molto onorato, e di quindi portai le due Teste di Marmo antiche delle Imagini d'Augusto, et Agrippa, le quali mi donò detto Papa Sisto." It has sometimes been suggested that the marble bust of an emperor documented in the inventory of the nobleman Philip of Cleves might have been one of the two busts from Philip of Burgundy's collection, though this is impossible to confirm. See Finot, *Inventaire sommaire*, 429: "Une teste d'empereur de marble blanc."

8. For summary and prior literature, see Alsteens, "Gossart as a Draftsman," 90–91, and Schrader, "Drawing for Diplomacy."

9. Ainsworth, *Jan Gossart's Renaissance*, 386–87, no. 102.

10. Ibid., 378–82, nos. 99–100.

11. For useful summary and discussion, see Barkan, *Unearthing the Past*, 1–63, and Christian, *Empire without End*, esp. 151–213.

12. "Nihil magis eum Romae delectabat, quam sacra illa vetustatis monumenta, quae per clarissimum pictorem Joannem Gossardum Malbodium dipingenda sibi curavit." Geldenhouwer, *Collectanea*, 233, and Geldenhouwer, *Vita clarissimi*, A6v.

13. See Geldenhouwer, *Collectanea*, 78–82, and Prinsen, *Gerardus Geldenhauer*, 64–97. For the 1526 letter in which Geldenhouwer professed his conversion to Lutheranism, see Cranevelt, *Literae virorum eruditorum*, 545–48, no. 209 (Worms, 13 November 1526). See also further discussion in chap. 4.

14. "Legatione peracta in Brabantiam rediit. Interrogatus, ut placeret Roma, nullum locum magis placere asseverabat, si illa scelerum fex (quos curtisanos vocant) procul isthinc ablegaretur. Cives Romanos, qui veteres nominantur, graves esse viros dicebat. Sacrificorum, episcoporum, cardinalium, pontificis maximi non minus impudentem quam impurum luxum ac fastum ita execrabatur, ut affirmaret se non dubitare quin gentiles et pagani (ut dicimus)

castius innocentiusque vixerint, quam hi, qui nunc Christiano orbi religionis leges praescribunt. Addebat, se vidente, cardinales quosdam primi nominis, dum sacrae reliquiae populo et praecipue Germanis nostris venerande ostenderentur, exertis linguis ac digitis in turpem modum compositis, nostrorum simplicitati insultasse." Geldenhouwer, *Collectanea*, 233, and Geldenhouwer, *Vita clarissimi*, A6v–A7r.

15. The Lutheran agenda undergirding this passage is evident even in Geldenhouwer's word choice, particularly in the derogative use of the word *curtisanos* to refer to the members of the Roman Curia, a usage also found in Martin Luther's own writing. See J. Ramminger, *curtisanus*, in *Neulateinische Wortliste*, www.neulatein.de/words/3/007199.htm.

16. "Nihil ei (ut paucis dicam) Romae placuit, praeter coelum et solum, lapides et ligna, et cives illos Romanos." Geldenhouwer, *Collectanea*, 234, and Geldenhouwer, *Vita clarissimi*, A7r.

17. The inscription on the drawing reads: "Jennin Mabusen eghenen / handt, Contrafetet in Roma / Coloseus." It may be possible to identify the author of this text based on the handwriting. Gossart himself has been ruled out, for which see Ainsworth, *Jan Gossart's Renaissance*, 386n8. A close comparison with Geldenhouwer's autograph manuscript preserved in the Koninklijke Bibliotheek in Brussels, MS II 53, rules him out as well. I am very grateful to James Hankins and especially to Michiel Verweij, curator of manuscripts in Brussels, for consulting with me on this point. I have not been able to compare the inscription to Philip's handwriting, but this certainly warrants investigation.

18. See Kavaler, "Gossart as Architect," 34–35; Heringuez, "L'architecture antique"; Heringuez, "Bramante's Architecture"; and Kik, "Bramante in the North."

19. For Dürer's engraving and its impact on Gossart, see chap. 1.

20. Geldenhouwer, *Collectanea*, 235, and Geldenhouwer, *Vita clarissimi*, A7v (quoted in n. 43 below). For this tradition, see Duverger, "Jacopo de' Barbari en Jan Gossart"; Levenson, "Jacopo de' Barbari," 31–34; Eichberger, *Leben mit Kunst*, 284–88; Ferrari, *Jacopo de' Barbari*, 142–43, no. 26; and Böckem, "Jacopo de' Barbari: Ein Apelles am Fürstenhof?"

21. See chap. 1, and also König, "Gossaerts Neptun und Amphitrite"; Lehmann, "Mit Haut und Haaren," 106–7; Mensger, "Jan van Eyck, 'Belgarum Splendor'"; Seidel, "Nudity as Natural Garment," 214.

22. Hoppe, "Die Antike des Jan van Eyck," and Nagel and Wood, *Anachronic Renaissance*, 147–58. See also chap. 1 for Matthaeus Herbenus's treatment of Romanesque churches as local Netherlandish antiquities.

23. Gossart seems to have been admitted into the local Brotherhood of Our Lady in Middelburg already in 1509, which would suggest that immediately after the trip to Rome, the artist settled conveniently close to the admiral's court in Zeeland and remained so even while accepting commissions from other patrons. See Ainsworth, "Gossart in His Artistic Milieu," 11, and also Weidema and Koopstra, *Jan Gossart*, 12, no. 4, on the tenuous identification of Gossart with the artist "Janin de Waele" mentioned in the register. The original document (cited in Gossart, *Jean Gossart de Maubeuge*, 31n2) can no longer be located.

24. "Praefectus enim ab eo rebus maritimis, et regiarum classium dux consitutus est, in qua praefectura, ea quae ad totius Zelandiae nautarumque commodum spectabant, non minus quam suam ipsius domum, curabat." Geldenhouwer, *Collectanea*, 230, and Geldenhouwer, *Vita clarissimi*, A5r.

25. On Tunstall, his ambassadorial mission to the Netherlands, and his friendship with Erasmus, see Bietenholz, *Contemporaries of Erasmus*, 3:349–54, with prior literature, and also Sturge, *Cuthbert Tunstal*, 31–56.

26. "Ego ex Selandia cum meis vix salvus redeo, usque adeo tetro et plane pestilenti coeli illius infestatus odore, ut multorum dierum inedia nondum febrem accendentem omnino depulerim." Erasmus, *Opus epistolarum*, 1:86, no. 663 (Bruges, 14 September 1517). The translations of passages from this letter are all taken or adapted from *The Collected Works of Erasmus*, 5:120–24, no. 663. The pestilence to which Tunstall refers was the malaria that infested the province of Zeeland during these years.

27. "Stygem arbitror non longe illinc abesse, ea est aquarum nigritudo atque amarulentia." Erasmus, *Opus epistolarum*, 1:86.

28. "Si fastidium oppidi levare obambulatione velis (id quod interim factitare consuevi), via ipsa, imbre conspersa vel levi, tenacius omni visco pedem moratur." Ibid. 1:86–87. Unlike Tunstall, as the chronicler Laurent Vital reports, Prince Charles greatly enjoyed taking promenades with his courtiers during his stay on Walcheren, particularly along the shores of Westhoven, where he strolled day and night listening with pleasure to the singing birds. See Vital, *Collection des voyages*, 3:42–43.

29. "Et nisi aggeres arcerent, marinae beluae in comessantes atque invicem propinantes incolas irrumperent. Ad haec incommoda vitanda praesidium unicum esse aiunt totas haurire congios; remedium certe mihi gravius omni morbo. Nosti enim quam facile in eo genere certaminis herbam porrigo." Erasmus, *Opus epistolarum*, 1:87. Tunstall's association between the inundated land of the Low Countries and the excessive drinking of its inhabitants is a common trope in writing about the region, especially among foreigners, as in an elegy by the German humanist Conrad Celtis, published already in 1502. Celtis writes of the

Netherlandish *populus*: "cavis habitant qui litora terris, / Suspensos dubio per freta saeva metu; / Nec cuiquam mirum, madeant quod nocte dieque, / Quandoquidem mediis hic habitatur aquis." Celtis plays upon the double meaning of the Latin word *madeant*, which can mean both "to be wet" and "to be intoxicated." See Celtis, *Quattuor libri amorum*, 73, lines 99–102.

30. Prior to the sixteenth century, there are only a few examples of works in this genre written by Netherlandish writers in praise of particular provinces or towns, for which see Ijsewijn, "The Coming of Humanism to the Low Countries," 209–11; Slits, *Het Latijnse stededicht*, 243–44; and Herbenus, *De Trajecto instaurato*.

31. For Erasmus's *Auris Batava* and critical notes, see *Opera omnia*, 2.8:36–45, 4.6:35. On the impact of Erasmus's adage and its reverberations in the writings of subsequent Netherlandish humanists, see Mout, "'Het Bataafse oor.'"

32. See Erasmus, *Opus epistolarum*, 1:97, no. 675, for the Netherlandish humanist's witty retort to Tunstall: "Plurimum tibi debet nostra Selandia, quam tua illa tam graphica ὑποτυπώσει nobilitasti: sed tamen hoc illi debes, quod te vel semivivum remiserit." Given Erasmus's international renown and professed ambivalence about his native land, he may have been able to stomach Tunstall's remarks more easily than some of his humanist compatriots in the Netherlands, whose ambit was smaller and whose local pride was consequently far more earnest. See Wesseling, "Are the Dutch Uncivilized?"; Poelhekke, "The Nameless Homeland of Erasmus"; and Huizinga, "Erasmus über Vaterland und Nationen."

33. See the apt comment in Guicciardini, *Descrittione*, 17: "Magno dico adunque, infinita e superba essere la faccia dell'Oceano, ma spaventosa, horribile e piena di pericolo quando egli sdegna e gonfia: vedrailo muovere con tanta furia e tempesta che talvolta le campagne e i paesi interi sommerge e cuopre. In questa provincia, dalle bande sue, specialmente di Silanda, ha fatti più volte, sì come più avanti a' luoghi suoi, si dice particularmente danni gravissimi." On maritime trade in Zeeland, see Unger, "Middelburg als handelsstad"; Sigmond, *Nederlandse zeehavens*, 19–31, 236–37; Parmentier, "Een maritiem-economische schets."

34. On the history of Deventer's map of Zeeland (first created c. 1549) in the context of his larger cartographical projects in the Netherlands, see van Deventer, *De kaarten van de nederlandsche provinciën*, 8, no. 5; Karrow, *Mapmakers of the Sixteenth Century*, 142–58, esp. 150; and Blonk-van der Wijst, *Zelandia comitatus*, 46–53, 123–34, nos. 1–2. For a biographical overview, see van 't Hoff, *Jacob van Deventer*.

35. Denucé, *Catalogue des manuscrits*, 239–41, no. 406; van Beylen, "Zelandiae descriptio"; Galera, *Antoon*

van den Wijngaerde, 198–99; Bos and Bosch, *Landschapsatlas van Walcheren*, 76–97. On the history of fifteenth- and sixteenth-century efforts to dike and secure the island of Walcheren, see Wiersum, "Bijdrage tot de oudste geschiedenis," and de Klerk, "Afwatering en dijkzorg."

36. "Ennosigaeus aquis Zeelandiam bis obruit quae regio cupiet Neptune te dic praesidem." Zovitius, *Ruth*, E5v–E6v.

37. Aurelius, *Batavia*, unpaginated front matter listing works by Aurelius: "Dialogus Vestae et Neptuni super inundatione. carmine Elegiaco." As is clear from Vulcanius, the terminus post quem for the work is 17 February 1496.

38. "Nicasius Mabuese had voor £ 3:13:4 gemaakt '2 patroonen en beworpen vanden oude ende nyeuwe geconcipieerde haven' (1529)." Kesteloo, "De stadsrekeningen," 284; see also Gossart, *Jean Gossart de Maubeuge*, 57. The later Netherlandish artist Jan van Scorel's project to reclaim the land in the region of Zijpe, and his plan to name the polder *Nova Roma*, further exemplify the ways in which sixteenth-century Netherlandish artists were actively and simultaneously engaged with antiquarian pursuits and the physical preservation of their homeland. See Faries, "Jan van Scorel," 277–96.

39. "Nadien datse in Zeelandt noyt voor desen tijdt geen cronijcke op haer selven ghehadt en hebben, overmidts dat in Zeelandt, bysondere by ons ghedactenisse, veel vreemdicheyts ende wonders van inundatien ende hooghe vloeden, ende andersins gheschiet is, waer duere (Godt betert) Zeelandt seer desolaet gheworden is, so is by goede vrienden op my gegheert daer af wat int licht te brengen, ghemerct onse voorouders daer af wat by memorien, ende ons in gheschrifte achtergelaten hebben." Reygersbergh, *Dye cronijcke*, A3r; Reygersbergh and Boxhorn, *Chronik*, 5. This transcription, and all others in the text, are taken from the original 1551 edition. On Boxhorn's augmented edition of Reygersbergh's chronicle, see Esser, "'Concordia res parvae crescunt.'" Reygersbergh's urge to document the history of the region in the face of destruction is evident even earlier in the local literature of Zeeland—for instance, in a 1530 pamphlet that describes the ruin inflicted by flooding that year: *Een nieu ghedichte vander schade die daer nu is gheschiet van die vloet des waters*, 1v–2r: "Int iaer ons heeren M.CCCCC meten / in November den vijfsten dach / datmen in dese landen dits waerhede / met rechte wel onthouwen mach, / wantmen menich mense in rouwen sach / om des waters wille sonder versaghen / dat men oogen wel aenscouwen mach / met rechte machmen wel beclagen . . . O god dits ommer wel claghelijck / datter in zeelant al is ghebuert / die stede van vlissinghe dits waghegelijcs / veel al huysen wech ghevuert." Catalogued in Zijl-

stra, *Den Zeusen Bessem*, no. 8. For documentation of the recurrent floods in the region during these years, see Gottschalk, *Stormvloeden en rivieroverstromingen*.

40. Reygersbergh goes on to praise Maximilian of Burgundy, the Zeeland nobleman to whom the chronicle is dedicated, for his efforts to secure the land with stronger dikes, aligning this kind of physical preservation with historiography itself. See Reygersbergh, *Dye cronijcke*, A3v, and Reygersbergh and Boxhorn, *Chronik*, 6: "Oock hebben wij dese teghenwoordighe cronijcke int licht laten comen, om dat uwe Edelheyt den lande van Zeelandt seer ghetrouwe is, seer neerstich ende voorsichtich wesende, om tselve lant, met Godts hulpen, te bewaren van gront braecselen ende diepten te ondersoecken."

41. "Die gheleghentheyt oft situatie des lants van Zeelandt hoe dattet ten tijden was als den Roomschen Coninck Coninc Willem Grave van Zeelandt / regnerende was ontrent den Jaere duysent twee hondert ende xxx. oft daer ontrent / Aenmerct beminde lese auter tijd present hoe dat Zeeland nu ghelegen is, so suldt sien dat dit voorscreven landt sichtent verandert is." Reygersbergh, *Dye cronijcke*, woodcut inserted between M4v and N1r. On the mapping of waterways in sixteenth-century Holland and Zeeland as an attempt to keep track of this changing landscape, see Bos and Bosch, *Landschapatlas van Walcheren*, 104–5; Groenveld and Huussen, "De zestiende-eeuwse landmeter Jaspar Adriaensz"; and the payment entries in Kesteloo, "De stadsrekeningen," 314, 356, and 369.

42. On the history of the palace of Souburg, see van den Broecke, *Middeleeuwse kastelen van Zeeland*, 28–35; Burger, "Het kasteel van West-Souburg"; and Lantsheer and Nagtglas, *Zelandia illustrata*, 1:694–701.

43. "In patriam reversus, totus exornandae arci suae Suytburgo intentus, inter fabros, architectos, sculptores et pictores versabatur adeo familiariter, ut unus illorum putaretur. Aderant ei et versificatores, qui picturas atque structuras carminibus ornarent, ut utramque picturam et loquentem et tacitam ostentare posset. Excellentes in quavis arte artifices miro favore prosequebatur, domique suae liberaliter alebat. Accersierat sibi magnis expensis pictores et architectos primi nominis, Jacobum Barbarum Venetum et Joannem Malbodium, nostrae aetatis Zeusim et Apellem." Geldenhouwer, *Collectanea*, 235, and Geldenhouwer, *Vita clarissimi*, A7v.

44. Geldenhouwer, *De Zelandiae situ*, G3r–G4r; reprinted in Scriverius, *Batavia illustrata*, 138–41.

45. "Ager fertilis qui longe diligentiori cura colitur quam Hollandicus. Triticum enim Zelandicum Hollandico et purius et candidius est. Oppida, praetoria, templa ut Hollandis magnifica. Zelandis ferme ii mores, is cultus qui et Hollandis. Zelandus lingua nonnihil citatiore quam Hollandus est. Si portuum commoditatem, si mercimoniorum copiam et abundantiam, si navium numerum spectes, Zelandia Hollandia longe superior est. Zelandi bituminosas terrae glebas effodiunt, iisque ignem fovent. Ex cineribus sal coquunt candidissimum atque acerrimum. Advehitur etiam ex Britannia minori et Lusitania satis ingens copia quod Zelandi excoquunt et repurgant quo utuntur vicini Belgae Germanique superi . . . Habet haec nostra aetate Zelandia viros eruditione claros mihique non ignotos." Geldenhouwer follows the last statement with a list of "the famous men of erudition" in his acquaintance. Geldenhouwer, *De Zelandiae situ*, G3r–G3v.

46. "Wallchriam a Gallia denominari mutata g in duplex v persuasit mihi vir princeps Philippus Burgundus, oceani praefectus, qui et hoc anno in Westcappella marmor repperit Herculis nomine vetustissimis inscriptum literis, quare et Herculem aut ibi aliquando appulisse, aut Zelandiam Herculi sacram fuisse asserere nititur. Quod a vero (meo iudicio) non longe abest." Ibid., G3v.

47. The inscription reads: "Herculi / Magusano / M[arcus] priminis / tertius / V.S.L.M." Hercules Magusanus, a conflation of the Roman hero with an indigenous deity, was the most important god worshipped by the ancient inhabitants of the Low Countries. On Hercules Magusanus and the presence of the god's cult in Zeeland, see Burger, *De Romeinen in Zeeland*, esp. 43–45; Roymans and Derks, "Het heiligdom te Empel," esp. 32–35; and Roymans, *Ethnic Identity and Imperial Power*, 235–50.

48. The church at Westkapelle burned down in May 1831, and thereafter the recovered Hercules stone was given to the provincial collection of antiquities, now part of the Zeeuws Museum in Middelburg; see Lantsheer and Nagtglas, *Zelandia illustrata*, 1:635–36. It cannot be ascertained from the sources exactly where within the church the stone was erected or how soon after its discovery the object was put on display, but according to the 1569 chronicle of Becanus (*Origines Antwerpianae*, 154), it was fixed to a wall in the baptistry ("Est hactenus in eo lapide, qui in baptisterio muro infixus cernitur apud Westcapelanos"). See also Reygersbergh and Boxhorn, *Chronik*, 287; Smallegange, *Nieuwe cronyk*, 78–82, 628–29; Gargon, *Walchersche arkadia*, 185–90; and Tirion, *Tegenwoordige staat der Vereenigde Nederlanden*, 215–17.

49. See the late fifteenth-century Netherlandish chronicle of Johannis a Leydis, *Rerum Belgicarum chronici*, 30–31: "Venit itaque sanctus Archiepiscopus Willibrordus in Zelandiam, ad quandam insulam Walachriam nomine, in qua antiquissimum et paganorum prophanitate celeberrimum idolum Mercurii colebatur." The account of Leydis

is derived from Alcuin's c. 796 *Vita sancti Willibrordi*, chap. 14. See also Baart, *Westkapelle*, 13–18. A historical map showing Zeeland during the time of Willibrord's sojourn—rediscovered at Egmond Abbey in 1536, and described as a sketch of that old island of Zeeland done after life ("vivam adumbrationem veteris illius insulae Zelandiae")—attests to the sixteenth-century interest in the province's early Christian history; Lantsheer and Nagtglas, *Zelandia illustrata*, 1:12–13.

50. See chap. 3.

51. "Mijn here d'amirael self metter hant / Halp eenen Hercules maken in sijn huys, / Omdatti reysen soude na Zeelant / Voerbi Sobborch, so na der Sluys. Hi sach wreedelijck, hi scheen confuys, / Met sijnder cudzen, vrom van ghelate; / Hi was so wel ghedaen, 't was een abuys, / In alle sijn leden houdende mate." Pleij, *De sneeuwpoppen van 1511*, 25–26, and 361, lines 125–132.

52. See Scheller, "Jan Gossaerts Triomfwagen." See also Weidema and Koopstra, *Jan Gossart*, 14–15, no. 6, and 17, no. 9.

53. "In currus lateribus effigiati genii nudi, inventione et arte mirifica Joannis Malbodii, pictoris clarissimi: ac nostri saeculi Apellis. Is quicquid in vexillis, curru, armis, insignibus, militaribus signis erat artis pulchritudinisve invenerat, adhortante et subinde iuvante eum unico patrono meo Philippo Burgundo, maris praefecto, qui hac in re (ut in omni) ingenio supra humanum est." Geldenhouwer, *Collectanea*, 209–10, and Geldenhouwer, *Pompa exequiarum*, 3v.

54. "Legimus et in prophanis literis, qua exequiarum pompa populus Romanus divorum Caesaris dictatoris et Octavii Augusti corpora cremaverit, reliquias collegerit, in mausoleis condiderit. Quare celsitudo tua, ne a piis maiorum degeneraret institutis, magnifico apparatu et instrumento, funeralia Catholici Hispaniarum regis Ferdonandi, avi sui materni celebravit." Geldenhouwer, *Collectanea*, 205, and Geldenhouwer, *Pompa exequiarum*, 1v.

55. "Eiusmodi res est, quae ob barbara vocabula et longum ordinem vix Latine scribi possit." Geldenhouwer, *Collectanea*, 214, and Geldenhouwer, *Pompa exequiarum*, 5v.

56. An alternate vernacular account of the funeral written by Rémy du Puys, *Les exeques et pompe funerale* (1516), esp. c1r–c2r, also describes the "antiquitez poeticques" of the chariot but mentions neither Gossart nor Philip by name.

57. "Magnifico heroi Philippo Burgundo, oceani praefecto, Gerardus Noviomagus." Geldenhouwer, *Collectanea*, 175, and Geldenhouwer, *Satyrae octo*, G1v.

58. "Exprimit oceani fluctus ventosque furentes / Regna tridentiferi Neptuni et Tethyos aulam." Geldenhouwer, *Collectanea*, 176, and Geldenhouwer, *Satyrae octo*, G2r.

59. Virgil, *Aeneid*, 1.124–56. On the recurrence of the *Quos ego* motif in literature and art, see Brower, "Visual and Verbal Translation of Myth."

60. "Olim Parrhasius, Zeusis, praeclarus Apelles, / pictores, verae meruere insignia laudis, / grati principibus, laudati carmine vatum, / temporis at nostri pictores, clare Philippe, / dignis muneribus quia donas, artis honorem, / Paucis versiculis tibi scripsimus." Geldenhouwer, *Collectanea*, 176, and Geldenhouwer, *Satyrae octo*, G2r.

61. For the association of Philip with Neptune, and even the suggestion of a possible disguised portrait, see Bergmans et al., *Le siècle de Bruegel*, 101–2, no. 107, with reference to the portrait of Philip of Burgundy in the *Recueil d'Arras*, as illustrated in Châtelet, *Visages d'Autan*, 275, no. 17-1; Sterk, *Philips van Bourgondië*, 117–18; Sicking, "La découverte de Neptune"; Sicking, *Neptune and the Netherlands*, 100–101; Schrader, "Gossaert's *Neptune and Amphitrite*"; Schrader, "Gossart's Mythological Nudes." Despite the arguments of these scholars, the association between Philip and Neptune in Gossart's painting is ultimately less explicit than other instances in which admirals were associated with the sea god, such as the Italian admiral Andrea Doria, who developed a far more systematic and political iconography around himself as an embodiment of Virgil's Neptune; see Boccardo, *Andrea Doria e le arti*, 105–18; Davidson, "The *Navigatione d'Enea* Tapestries"; Strehlke and Cropper, *Pontormo, Bronzino, and the Medici*, 139–41, no. 41. It has been asserted further that Geldenhouwer's Latin epithets for the admiral ("maris praefectus" and "oceani praefectus") echo Flavio Biondo's reference to Neptune in his *De Roma Triumphante Libri Decem*, 10v, but Geldenhouwer's Latin is really just a rendering of his title from the Dutch and French, as seen in any number of contemporary documents—for instance, Fruin, *De leenregisters van bewesten Schelde*, passim. The Latin epithet appears subsequently in reference to the later Burgundian admirals Adolph of Burgundy, in Erasmus, *Opus epistolarum*, 3:339–40, no. 846 (Antwerp, 24 May 1518), and Maximilian of Burgundy (1540–58), as in Ewe, *Schiffe auf Siegeln*, 218, no. 233, and Sicking, *Neptune and the Netherlands*, xvi–xvii, pl. 22. A locus classicus is also to be found in Plutarch's *Life of Alexander*, 22, with reference to the admiral of Alexander the Great ("Philoxenus mari praefectus").

62. "Monseigneur philippe bastart de bourgoingne feust largement dammeret et en jeu enclin a disrober." Vienna, Staatsarchiv, *Der Orden vom Goldenen Vlies, Register der Kapitelsitzungen*, II, 8 (1491–1531), 22r. Sterk, *Philips van Bourgondië*, 33, cites what is only a paraphrase of the original document from de Reiffenberg, *Histoire de l'Ordre*, 302.

63. On jokes in mythological paintings, see Barolsky, *Infinite Jest*, 158–82.

64. "Een groot taeffereel van een naict vroutken mit een pijl in de hant genoempt Cupido overdect mit een gardijnken blau ende geluwe." Sterk, *Philips van Bourgondië*, 227, IXv.

65. On the danger of granting "primary heuristic value" to the patron when interpreting artworks made in the courtly realm, see the insightful remarks in Campbell, *Cabinet of Eros*, 3–4.

66. In particular, see Hyginus, *Astronomica*, 2.17, based on Eratosthenes, *Catasterismi*, 31, and Eustathios, *Commentarii ad Homeri Odysseam*, 3.91; For additional sources, see Kaempf-Dimitriadou, "Amphitrite," 1.1:724–25, and Roscher, *Ausführliches Lexikon*, 1:318–21.

67. Pausanias, in the *Description of Greece* (2.1.7), tells that the ancient Greek temple at Corinth included statues of Amphitrite and Neptune standing on a chariot accompanied by Palaemon on a dolphin, Tritons, Nereids, and the goddess Venus as an infant. The ancient temple at Tenos also featured monumental statues of the couple surrounded by sea creatures. See Étienne and Braun, *Ténos I*, 271–86. Even on coins from Tenos, the diminutive depiction of the sea gods standing in their temple includes two abutting dolphins; Étienne, *Ténos II*, 249–50, no. 402, pl. XXIV. For a general overview of the iconography of Amphitrite in antiquity, see Kaempf-Dimitraidou, "Amphitrite," 1.1:725–35 and 1.2:576–92, with illustrations. As pointed out by Kaempf-Dimitraidou (734–35), Amphitrite was almost always depicted in consort with her host of oceanic creatures beginning in the later Hellenistic period and continuing in Roman art. The representative Roman example illustrated here is a mosaic from ancient Cirta, AD 315–25. Cartari's illustration (*Le imagini de i dei*, 250) is based directly on Pausanias's description of the temple at Corinth mentioned above, as is clear from Cartari's summary description (249): "Vedeuasi anco buona parte della compagnia di Nettuno in un suo tempio nel paese di Corinto, come recita Pausania, percioche egli con Anfitrite sua moglie stava su un carro, ove era anco Palemone fanciullo appoggiato ad un Delfino: Quattro cavalli tiravano il carro, et erano loro à lato duo Tritoni." For English translation, see Cartari, *Vincenzo Cartari's "Images of the Gods"*, 197. The prior, 1556, edition of Cartari's work includes neither this passage nor an illustration of the couple.

68. Bull, "Jan Gossaert and Jacopo Ripanda." Ripanda's Neptune and Amphitrite appear in the Palazzo dei Conservatori in Rome in a historical fresco of the Battle of the Aegadian Islands, a battle fought during the First Punic War.

69. Silver, "*Figure nude, historie e poesie*," 11, suggests this reference to triumph, as does Sterk, *Philips van Bourgondië*, 117–18, but the laurel crowns might also have been understood to associate god and goddess with the arts through the model of Apollo.

70. "Te sors aequa manet, tecum omne habitabit in aevum / fortuna, et pleno copia larga sinu, / mercibus ipse adero assiduis, Neptunnus amicis / fortunabit aquis, prospera semper eris, / haec deus." Cornelius Grapheus, "Antverpia loquitur," in *De nomine florentissimae civitatis Antverpiensis*, A3r.

71. Härting, *Frans Francken II*, 97–113, 310–16, nos. 276–98. For notable examples by other artists working in Antwerp and beyond, see the engraving by Jan Saenredam after Hendrik Goltzius, *Neptune and Amphitrite*, c. 1594, in Hollstein, *Dutch and Flemish Etchings, Engravings, and Woodcuts*, 33:58; the engraving by Jacob Matham after Bartholomeus Spranger, *The Triumph of Neptune*, c. 1611–14, in Widerkehr, *The New Hollstein*, 2:180; a painting by Abraham Bloemaert, *Triumph of Neptune and Amphitrite*, c. 1630–35 (Hartford, Wadsworth Atheneum, inv. no. 1964.223), in Roethlisberger, *Abraham Bloemaert*, 1:299, no. 457 (fig. 634), as well as 278, no. 423 (fig. 593), and 328, no. 514 (fig. 699); and a painting by Jacob Jordaens, *Neptune and Amphitrite*, 1644 (Antwerp, Rubenshuis, inv. no. S3.94), in d'Hulst, *Jacob Jordaens*, 220, fig. 178. For additional examples and discussion, see Bosque, *Mythologie et maniérisme*, 274–80; Reid, *The Oxford Guide to Classical Mythology*, 1:95–97; and especially Balis, "De stroom en de zee."

72. For an early sixteenth-century example, see Grapheus, *Divi Caroli imperatori*, which commences with a plea for Aeolus to calm the winds, as in the opening lines of book 1 of the *Aeneid*, followed by a summons to the gods of the sea to smooth the waves and make way for Charles V to safely reach the port of Antwerp (A2v): "Te quoque cunctarum Genitor ter maxime rerum / Oceane, et te Amphitrite, et te maxime Nereu, / grandeve o Nereu, vos aequoreae quoque Nymphae, / compello, et sacris supplex per carmina votis / vos vos obtestor, (si quid pia carmina possunt) / sternite inaequaleis fluctus, hiemesque, procellasque / arcete instanteis, atque aequor reddite planum, sit tutus."

73. "Formosa Antverpia, eius maritus Scaldis." Grapheus, *De seer wonderlijcke schoone triumphelijke incompst*, G4v. The anonymous author of *De blijde ende heerlijcke incomste van mijn-heer Fransois van Vranckrijck*, 44–47, also places a female personification of Antwerp alongside Neptune. A tableau shown during Antwerp's 1561 Landjuweel, *Spelen van sinne*, H4r–H4v, pairs Antwerp and the river Schelde, who is seated atop a dog (hond) personifying the Honte, i.e., the Westerschelde. On the Landjuweel, see Vandommele, *Als in een spiegel*.

74. "In dierste facie boven de Elevatie sachmen hooge in de locht vier groote statuen oft gesneden beelden, elcke van xii voeten. Te wetene, het beelt van Oceanus Britannicus datis der Engelscher zee, het beelt van Britannia dat is England, ende de beelden van twee Tritones diemen heet Zeeridderen.

Oceanus was als een maect man met eenen langen witten baerde hebbende op sijn hooft eenen crans van mosselschelpen ende zeelesch houdende in de hant eenen grooten langen gouden drijtackegen scepter sittende in een seere groote wijde gouden zeeschelpe. Britannia in gelickenisse van eender Engelsche vrouwen in witte cleederen sittende bi den Oceanum . . . En sy was daeromme in witte cleederen gecleet om dat Engelant van ouden tijden geheeten is geweest Albion, dat is Witlant, also genoempt vander witten stenen die men heet albastren die daer vele sijn." Grapheus, *De seer wonderlijcke schoone triumphelijke incompst*, K1v–K2r. Again, it should be pointed out that although the text identifies the female figure as Britannia on the basis of her white garment, this attribute is legible only in the specific context of the accompanying description and the dedication of the arch as a whole to England.

75. "Sobre el mismo quadro y colunas caya el frontispicio hecho en punta, y su cumbre o acroteria redonda, sobre la qual estava sentada una estatua de mugger grande encima de un delphin dorado, con una ancora dorada enla una mano, y enla otra un circulo tambien dorado: representava la grandiose d'el mar Amphitrite mugger d'el dios Neptuno, o la muy rica y maritima ciudad de Genova." Calvete de Estrella, *El felicissimo viaje*, 230. See also Bussels, *Spectacle, Rhetoric and Power*, 48.

76. See Barthes, "Myth Today," for a discussion of myth in relation to semiology, and the ways in which mythical concepts by nature lend themselves to appropriation in the contemporary political and historical moment. In a similar manner, Loh, *Titian Remade*, 85–128, has recently employed the concept of "allegory" to discuss the ways in which Padovanino's c. 1614–20 *Triumph* (Bergamo, Accademia Carrara) is a painting that builds on the myth of Peleus and Thetis to make a larger statement about art and artistic emulation in the Venetian seicento. The notion of employing the essential form of the myth of Neptune and Amphitrite as a means to create an allegory about the interrelation of land and sea was already suggested by Julius Meyer long ago in his discussion of Peter Paul Rubens's *Neptune and Amphitrite* (formerly Berlin, Staatliche Museen, Gemäldegalerie). See Meyer, "'Neptun und Amphitrite' von Rubens," esp. 119–23. For further evidence of the inherent ambiguity of marine subjects, see the case of Bloemaert's triumphal paintings, Roethlisberger, *Abraham Bloemaert* (as in n. 71); and the debate surrounding the subject of Nicolas Poussin's c. 1635–36 painting in the Philadelphia Museum of Art (inv. no. 1932-1-1), as discussed in Levey, "Poussin's 'Neptune and Amphitrite' at Philadelphia," and Thomas, "Poussin's Philadelphia Marine Painting."

77. "Huic preterea dicit Albericus uxorem fuisse nomine Amphitritem, et amplissimam, sed ex pluribus mulieribus, prolem." Boccaccio, *Genealogie deorum gentilium*, 10.1.

78. See Étienne and Braun, *Ténos I*, 181–84, with the cult at Tenos as the sole instance in which Amphitrite was honored in any notable fashion, and even then only in the latter centuries of the cult's history.

79. Zanker and Ewald, *Mit Mythen Leben*, 117–28, 341–43.

80. "Nec bracchia longo / margine terrarum porrexerat Amphitrite." Ovid, *Metamorphoses*, 1.13–14. The same is the case for all references to Amphitrite in Homer, *Odyssey*, 3.91, 5.422, 12.60, 12.97.

81. "Haec cum aqua sit, dicitur uxor Neptuni, cum is sit spiritus, uti dicebam, per universam aquae molem diffusus, et tanquam anima ipsius aquae elementi: est enim Amphitrite corpus et materia humoris omnis, qui vel circa terram est, vel intra terram ipsam includitur." Translation taken from Conti, *Natali Conti's Mythologiae*, 1:147. A similar characterization of Amphitrite is to be found already in Fulgentius, *Fulgentius the Mythographer*, 51.1.4, and in Giraldi, *De deis gentium*, 227.

82. Cole, *Cellini and the Principles of Sculpture*, 15–42; Zorach, *Blood, Milk, Ink, Gold*, 95–96; Prater, *Cellinis Salzfass für Franz I*, 35–36.

83. "Messer Luigi, sopra questo, apposito di questo sale, disse molte mirabil cose; messer Gabbriello Cesano ancora lui in questo proposito disse cose bellissime. Il Cardinale, molto beigno ascoltatore e saddisfatto oltramodo delli disegni, che con parole aveano fatto questi dua gran virtuosi, voltosi a me disse: Benvenuto mio, il disegno di messer Luigi e quello di messer Gabbriello mi piacciono tanto, che io non saprei qual mi tòrre l'un de' dua; però a te rimetto, che l'hai a mettere in opera. Allora io dissi: . . . Monsignor reverendissimo mio patrone, sarà mia opera e mia invenzione; perché molte cose son belle da dire, che faccendole poi non s'accompagnano bene in opera. E voltomi a que' dua gran virtuosi, dissi: Voi avete ditto e io farò." Cellini, *Opere di Benvenuto Cellini*, 373.

84. "Messer Gabbriello aveva disegnato che io facessi una Amfitrite moglie di Nettuno, insieme con di quei Tritoni di Nettunno e molte altre cose assai belle da dire, ma non da fare. Io feci una forma ovata . . . e sopra detta forma, sicondo che mostra il Mare abbracciarsi con la Terra, feci dua figure grande più d'un palmo assai bene, le quale stavano a sedere entrando colle gambe l'una nell'altra, sì come si vede certi rami di mare lunghi che entran nella terra." Ibid., 374, and translation largely derived from Cole, *Cellini and the Principles of Sculpture*, 22.

85. It is interesting to note that Cellini's object was later classified under other names; a 1560 inventory of the French royal collection, for instance, deems it a depiction of Triton and Thetis. See Lacroix,

"Inventaire des joyaux," 342, no. 107 ("ung triton d'or, avec une Tetis servant de sallière"). See also Cole, *Cellini and the Principles of Sculpture*, 40–42.

86. See above, and also Étienne and Braun, *Ténos I*, 182–84, for a summary discussion of the cults located in the Greek islands of the Cyclades, including the temple on the island of Delos referred to in Virgil, *Aeneid*, 3.73–74. Among the textual sources, Pausanias's *Description of Greece* is particularly important. Although Pausanias was printed for the first time only in 1516 by Aldus Manutius in Venice, his work did circulate in manuscript form. See Kristeller et al., *Catalogus translationum et commentariorum*, 2:215–20, 225–33. Erasmus reports consulting manuscripts of Pausanias and several other Greek writers during the preparation of his *Adages* (1507–8) in Venice; Erasmus, *Opera omnia*, 2.3:22–24, no. 2.1.1. However, attempts to link the architecture of Gossart's painting to one specific ancient temple prove unconvincing. See Heringuez, "L'architecture antique," 118, and Bergmans et al., *Le siècle de Bruegel*, 102, who suggest a link to the Temple of Erechtheion at Athens. Herzog, "Tradition and Innovation," 34–35, suggests that the model was the Temple of Zeus at Olympia, based on a reading of Pausanias. Strangely enough, Herzog omits any mention of the Temple of Neptune at Corinth.

87. Stratenus and Boey, *Venus Zeelanda*. See also Smeesters, "La *Venus Zelanda*."

88. The title page of *Venus Zelanda* is not signed, and little about Dirck Maire's printer's shop is known, but perhaps the engraver was among those who worked for Dirck's father; see Breugelmans, *Fac et spera*, 30–35, 741. The harbor town depicted in the background of the title page may loosely resemble Goes, Stratenus's hometown. See the image of Goes in the *Speculum Zeelandiae* (1660), illustrated in Gittenberger and Weiss, *Zeeland in oude kaarten*, 95.

89. "Dat flammas lethale gelu, medioque calescens / Frigore Mattiaci Venus incunabula ponti / Et Patrias agnoscit aquas, gelidoque fluento / Protrudit geniale caput." Boey, "Venus orta mari," in Cats et al., *Faces augustae*, 291. Already in the sixteenth century, writers such as Hadrianus Junius and Abraham Ortelius had identified the ancient tribe of the "Mattiaci" with Zeeland. Interestingly, in 1637 Boey also published a treatise praising the towns of Zeeland (*Urbium Zelandiae comitatum*), which continued in the literary tradition that Geldenhouwer had begun a century earlier.

90. "Est haec omnium Selandiae insularum amoenissima. Sylvas habet locis aliquot, hortos quoque in quibus est quicquid natura produxit herbarum esculentarum, pomaria passim amplissima. Hic mensibus vernis omnes avium genus subsilire, circumvolitare, colludere, deliciari videas. Hic vel studere, vel obambulare, vel cum amiculo confabulari, vel cibum capere, vel cum sodalibus lusitare summa est voluptas." Barlandus, *Opusculum*, 55v–56. Reprinted in Scriverius, *Batavia illustrata*, 141–42. See also Daxhelet, *Adrien Barlandus*, 106–9, and Wesseling, "In Praise of Brabant."

91. See Hollstein, *Dutch and Flemish Etchings, Engravings, and Woodcuts*, 3:11. The Netherlandish artist Cornelius Massys also made an engraving (c. 1539–43) after Vellert's design, for which see Van der Stock, *Cornelis Matsys*, 30, no. 31. Further attestation of the slippage between Venus and Amphitrite is provided by Philips Galle's engraving of Amphitrite from his *Nimpharum Oceanitudum, Ephydridum Potamidum, Naiadum, Lynadumque Icones*, published in Antwerp in 1587. Galle essentially uses Vellert's design for Amphitrite, replacing the torch in her hand with a trident evocative of her husband, Neptune. See Sellink, *Philips Galle, Part III*, 134, 138, no. 431.

92. The most important ancient sources were Caesar, *De bello gallico*, 4.10, Pliny the Elder, *Historia naturalis*, 4.101, and Tacitus, *Germania* 29. For discussion of these sources, see Teitler, "Romeinen en Bataven."

93. See the 1508 letter of Luigi Marliano to Jerome Busleyden (*Jerome de Busleyden*, 381, no. 48): "Mirum est, quicquid beata haec insula parit tam pulchrum est, ut matre Venere editum putetur."

94. "Ad arctum oculos flecte. Vides ne illic apud Belgas Bathavorum nationem oceano germanico finitimam . . . Video certe venturam annis labentibus aetatem. Que valida ventorum tempestate dirutis undique omnibus illis a stirpe arboribus. Umbriferum quod cernis nemus terram fertilitate frugum felicem. Nec non multo auro lacteque exuberantem efficiet. Ubi etiam urbs quaedam tuta munitionibus praesidioque firmata valido surget. Structurisque domorum super tuoso luxu exedificatarum facile sibi palmam vendicans. Cui certe urbi (quod in illa diversabor) Delphorum nomen indam a priscis olim Delphis tracto vocabulo. Cuius homines quem video fore natura cordatos prudentesque nulla morum pravitate degentes. Mansuetos. Tractabiles. Ad studia atque disciplinas facile animos applicantes." Nerdenus, *Inter Apollinem et Mercurium dialogus*, B4r–B4v. Apollo goes on to describe Delft itself as a city surrounded on all sides by glassy waters and with two magnificent temples (i.e., the Nieuwe Kerk and the Oude Kerk) rising up at its center (C1r): "Vides ne iam . . . qualiter o Mercuri stagnalibus undique vitreisque circumcingat undis civitas: quaeque magnifica due ille templorum eminentie structura consurgant?" In Apollo's description, the layout of the city and its canals serves as a kind of microcosm for Batavia as a whole. Catalogued in Knuttel, *Catalogus van de pamfletten-verzameling*, 1:5, no. 16.

95. More, *Libellus*. More's description of the island loosely evokes the geography of Britain, although Utopia is nonetheless understood to be located in the New World. See Goodey, "Mapping 'Utopia.'"

96. Geldenhouwer was directly involved in seeing More's work published and even wrote a laudatory poem for the original edition, but he evinced particular concern for the illustration of the island, a woodcut plausibly attributed to Ambrosius Holbein, which he had sent to Erasmus for approval prior to the final printing. See *Tentoonstelling Dirk Martens*, 192–93, no. A 273a–c, 278, no. M 136, and Erasmus, *Opus epistolarum*, 2:379–81, no. 487 (12 November 1516): "Insulae ipsius figuram a quodam egregio pictore effictam Paludanus noster tibi ostendet; si quid mutatum velis, scribes aut figurae annotabis."

97. On Geldenhouwer's particular understanding of Batavia, see Bejczy, "Drie humanisten en een mythe," with critical reference to Tilmans, *Historiography and Humanism*, esp. 211–62. See also Noordzij, *Gelre*, 297–301. Geldenhouwer wrote his letter on Zeeland in direct response to that of an Italian visitor to the Low Countries named Crisostomo Colonna, who had simply assumed that Batavia was equivalent to the province of Holland. On Colonna, see Lamattina, *Crisostomo Colonna*, with an edition of his letter (74–79). That Geldenhouwer disagreed with Colonna's view is implicit in his emphasis on Zeeland's affinity with (if not superiority to) Holland in every respect, from its customs to its language and culture. Geldenhouwer's colleague Martin Dorp also saw that Geldenhouwer's letter was published together with that of the Italian and wrote an introduction to Colonna's letter making clear that the debate over Batavia was the explicit concern of the exchange.

98. On the map of Batavia commissioned by Geldenhouwer, which does not survive, see Huussen, "Willem Hendricxz. Croock," esp. 35, and van der Heijden, "De Bataven in de cartographie," 115–16. Geldenhouwer describes the map in a letter to fellow humanist Frans Cranevelt. See Cranevelt, *Literae virorum eruditorum*, 71–72, no. 27 (Souburg, 28 November 1522): "Bathavorum insulam Guilielmus Crocius, egregious pictor et cosmographus, mihi depinxit, ab arce Lobeta in Oceanum mare . . . hanc brevi videbis et gaudebis."

99. Geldenhouwer, in his first published treatise to directly address the question of Batavia, attempts a concordance of the comments of Pliny the Elder and Caesar, noting that both describe the ancient Netherlands as a collection of islands. See Geldenhouwer, *Historische werken*, 40, and Geldenhouwer, *Lucubratiuncula*, A3r: "Iam videamus an Caesari consonet Plynius. Caesar Rhenum dicit, ubi Oceano appropinquat, multas ingenteisque insulas efficere. Plynius multas insula enumerat, quae inter

100. "Reliquum est, ut nunc de nostrae insularis Bataviae felicitate, quae inter duo Rheni brachia sita est, perpauca dicamus. Haec gemina Rheni ostia Plinius Helinum vocat et Flevum. Illud prope Walachriam, extremam Rheni et Salandiae insulam, Oceanum petit." Aurelius, *Batavia*, 48.

101. Geldenhouwer had promised his friend Sebastian of Zierikzee to write a longer history of Zeeland, but never seems to have carried it out. Dorp et al., *Dialogus*, G4r: "si tibi caeterisque amicis placere cognovero, propediem videbis de Zelandia nostra longe cumulatiora." However, several of his early sixteenth-century colleagues did take up the subject, and their conclusions were eventually compiled and summarized by Reygersbergh, *Dye cronijcke*, B1r; Reygersbergh and Boxhorn, *Chronik*, 8: "soo hebben wij, ter begeerte van sommighe goede vrienden ende liefhebbers der vreemder geschiedenissen, uyt vele diversche gheleerder mannen gheschriften uyt Zeelandt te samen vergadert ende int corte by een cronijckswijs ghevoeght tgeene dat wij in haer boecken ofte scriften ghevonden hebben. Als inde boecken oft gescriften van M. Pauwels a Mitelburgo, D. Cornelius Batthus, Joannes Beecker Borssalus, Hugo Bruys, Hadrianus Cordatus, Hadrianus Barlandus, ende meer andere die geschreven hebben van die antiquiteyt ende ouderdom des lants van Zeelandt." None of these writings on Zeeland, besides the short description by Barlandus, has survived in the original, but the sheer number of contemporary authors who devoted themselves to the subject is remarkable in itself. On these authors (excepting Hugo Bruys, who is completely undocumented), see Meertens, *Letterkundig leven*, 31–32, 40–41, 51–52, and Bietenholz, *Contemporaries of Erasmus*, 1:95–96 (Adrianus Barlandus), 1:100 (Cornelis Batt), 1:115–16 (Jan Becker of Borsele), 1:338–39 (Hadrianus Cordatus), 3:57–59 (Paul of Middelburg).

102. Dijkstra and Ketelaar, *Brittenburg*, esp. 10–15; Bloemers and de Weerd, "Van Brittenburg naar Lugdunum."

103. See Aalbers et al., *Heren van stand*, 58–60, and the anonymous manuscript chronicle of the Wassenaer family in The Hague, Koninklijke Bibliotheek, hs. 131, G 31, fol. 4: "heer Jan van Wassenaer, ridder, baenroedse, dede uuijtermaten veel grote blawe ende andere duijsteren tegelen ende ander vreemde dinghen uut dit fundament van den huijse een uut die mueren tot verde in die duijen uutgraven ende soudet achtervolcht hebben om te ondersoecken waer dese structueren vollent zouden hebben."

104. Published by Christopher Plantin in the 1581 edition of Guicciardini's *Descrittione*, 344–45, along with Guicciardini's description of Brittenburg (346). See also Meurer, "Abraham Ortelius' Con-

cept and Map of 'Germania,'" and on Ortelius's antiquarian interests more generally, Meganck, "Erudite Eyes," esp. 19–35.

105. Suetonius, *De vita Caesarum, Caligula*, 46.

106. "His ambagibus nostri Annales primordia suae gentis repetunt, inter vera et falsa versantes. Alii quoque sunt defendentes novam esse terram, e mari emersisse; et, qui contra tradant, ab aevo diuturno luisse, nulli licet diu cultam mortalium. In hac re laborantibus succurrendum esse puto. Priores adferunt nihil praeter opinionis vanitatem: quos ego si ad maris nativum littus ablegem ut conchas legant, an non scopulos arenarios in admiratione habebunt insulam tutantes adversus pelagum, et sua se pontum sede teneri? Posteriores, novitatem urbium nobis obiectant, cur non ita diu Bataviam mortales habitasse: sed hoc uno responso abeant, priscum Germanis fuisse morem nescire urbes, tantum vicos et pagos, quamquam nemo Batavodu-rum non antiquissimam esse civitatem, audebit ire inficias." Snoy, *De rebus Batavicis*, 20. Snoy's con-scious recollection of Suetonius's story is clear from his use of the phrase "conchas legant," which de-rives from Suetonius's original "conchas legerent." Note that Snoy's treatise was not published until the seventeenth century but may still have been known in manuscript form by Geldenhouwer and his other close associates. The actual presence of conch shells on the shores of sixteenth-century Zeeland seems unlikely, but archaeological finds at a fifteenth-century site near Ostende in Flanders have uncovered an exotic conch specimen seem-ingly imported from Spain or the West African coast. See Pieters, "Een 15de-eeuwse sector van het verdwenen vissersdorp," 227, 229, fig. 17. I am grateful to Jos Koldeweij for bringing this reference on the conch to my attention.

CHAPTER 3
LINEAGE

1. Foucault, "Nietzsche, Genealogy, History," esp. 145–48, and Foucault, *The Archaeology of Knowl-edge*, esp. 13–14.

2. For provocative discussion of this idea, see Stewart, *On Longing*.

3. Sterk, *Philips van Bourgondië*, 29–34.

4. "Philippus enim a puero nunquam institutus ad professionem Ecclesiasticam, plus se armis quam literis exercuerat." Heda, *Historia episcoporum Trajectensium*, 416.

5. "Dum ita domi, relicta aula, semotus procul ab omnis ambitione sibi vivere incipit, Carolus rex, magnum avunculum honorare volens, onerat maxime, quod ut aliquanto altius repetam res ipsa postulat." Geldenhouwer, *Collectanea*, 236, and Geldenhouwer, *Vita clarissimi*, A8r. See also

Reiffenberg, *Histoire de l'Ordre*, 327–30, 338, 341–43, 345, 353.

6. For an overview of the early history of the order, see Cockshaw and van den Bergen-Pantens, *L'Ordre de la Toison d'or*, with prior literature.

7. Reiffenberg, *Histoire de l'Ordre*, 333.

8. Ibid., 348. On the chapter meeting held in Barce-lona and the series of coats of arms still hanging in the choir of the cathedral, see Casas, "Arte y simbología en el capítulo Barcelonés."

9. Vienna, Staatsarchiv, *Der Orden vom Goldenen Vlies, Register der Kapitelsitzungen*, Urkunde 142.

10. "In plateis passim acclamatum: 'Vivat dominus Philippus, frater Davidis, optimi praesulis, vivat diu, vivat feliciter!'" Geldenhouwer, *Epistola Gerardi Noviomagi de triumphali ingressu illustris-simi principis Philippi de Burgundia*, in *Collectanea*, 221. For further discussion of the treatise and full translation of its text, see Vermeir, "Erasmus and the Joyous Entry."

11. For the biography of David of Burgundy, see Zilverberg, *David van Bourgondië*.

12. "Quid, cum Traiecti iam lectus episcopus esses, / Erexisti animum subito et rerum humanarum / Corde relegasti curas, cui deditus esses / Officio certus, contemplistique; fugacis / Molle voluptatis studium: non optio solum / Nec probat Alciden, etiam tibi blanda libido / Astitit omneferens placidum exclusoque labore / Obtulit illecebras et dulcis amabile luxus / Commendavit opus, tibi soli vivere iussit / Extra animi curas." *In laudem rever-endissimi*, B2r–B2v. See also Knuttel, *Catalogus van de pamfletten-verzameling*, 1:5, no. 14. The eulogy is a remarkable example of literary appropriation, as it is taken almost verbatim from von Hutten, *In laudem reverendissimi*, edited in von Hutten, *Ulrichi Hutteni equitis*, 3:397, lines 1190–99. This passage is identical in the two treatises with the exception of "cum Saxonicus" (line 1190) in the original, replaced by "cum Traiecti" in the Deventer pamphlet.

13. "Triplex onus humeris sustines: patris exemplum ac fratris, tum horum temporum fata (quid enim aliud dicam?) nescio quomodo ad bellum pertra-hentia." Erasmus, *The Collected Works of Erasmus*, 27:292; Erasmus, *Opera omnia*, 4.2:59–60, lines 10–22. See also the letter from Erasmus to Gelden-houwer in *Collectanea*, 217–18.

14. "In primis vero veterem Dorestati arcem novis aedificiis commodiorem fecit; picturis, sculpturis, figulinisque talibus exornavit, quales vix ipsam Italiam habere crediderim." Geldenhouwer, *Collec-tanea*, 240; Geldenhouwer, *Vita clarissimi*, B2r–B2v.

15. See the various references in Sterk, *Philips van Bourgondië*, 231–33, 235. Two of the splendid vest-ments that David commissioned, a cope and dal-matic, are housed today in the Catharijneconvent, Utrecht, a testament to the care with which Philip

and his successors preserved them. See Defoer and Wüstefeld, *L'art en Hollande au temps de David et Philippe*, 16–17, 100–101, no. 39, and on David of Burgundy's broader artistic patronage, Zilverberg, *David van Bourgondië*, 101–14.

16. For series of painted portraits in the Netherlands predating Philip's project at Wijk bij Duurstede, see van Anrooij, *De Haarlemse gravenportretten*. There are precedents for individual portrait busts in the Low Countries in two silver busts of Charles the Bold commissioned and presented as votive gifts to local cults, for which see van der Velden, *The Donor's Image*, 178–83, 323–34, doc. 75.

17. See Kohl, "Talking Heads," 12–13; Lugli, *Guido Mazzoni*; Verdon, "Guido Mazzoni in Francia"; Verdon, "The Art of Guido Mazzoni," 146–47, 345–47, no. 18; Galvin and Lindley, "Pietro Torrigiani's Portrait Bust"; Darr, "New Documents for Pietro Torrigiani"; Darr, "Pietro Torrigiani and His Sculpture"; and for two early sixteenth-century examples produced in France, see Bresc-Bautier et al., *France 1500*, 205–6, no. 89. For the development of terracotta sculpture in Italy, see Boucher, "Italian Renaissance Terracotta."

18. Weihrauch, "Studien zur süddeutschen Bronzeplastik," 203–13; *Ausstellung Maximilian I*, 161, no. 594; Silver, *Marketing Maximilian*, 77–78; Michel and Sternath, *Emperor Maximilian I*, 366–67, nos. 121a–b, with additional literature.

19. *Ausstellung Maximilian I*, 161, no. 595; Marti, *Charles the Bold*, 357–58, nos. 172–74; Michel and Sternath, *Emperor Maximilian I*, 176–79, nos. 26–28, with additional references.

20. "La représentation de feu Mons(r) de Savoie, que Dieu pardoint, fete de mabre blanc, de la main de M(e) Conrat . . . La representacion de Madame, fete de mesme main et mabre que la precedente . . . Item, la representacion de la soeur de roy d'Angleterre, fete de terre cuyte." Michelant, "Inventaire," 58. On the busts of Margaret and Philibert, and the representation of the Tudor family at Margaret's court, see Eichberger, *Leben mit Kunst*, esp. 37–38, 163–66, 174. The marble busts were in Margaret's library as early as 29 July 1517 when they are described in the journal of the Italian visitor Antonio de Beatis (*Die Reise des Kardinals Luigi*, 115). For an English translation, see Beatis, *The Travel Journal*, 93. The busts from the Mechelen palace do not survive, but for a handful of extant busts attributed to Conrad Meit, one of them a marble bust "all' antica," see Eikelmann, *Conrat Meit*, 104–7, no. 10, and 110–17, nos. 12–13.

21. "Joannes Malboldius adornavit hic aulam in arce, qua nullam credo esse pro sui magnitudine in orbe terrarum pulchriorem, si picturam videas, si spirantes veterum Augustorum statuas inspicias. Ad quam videndem a Brugis huc venires, quanto magis a Noviomago, id est itineris vix unius diei!

Princeps Nassavius ea de causa nuper huc ex Hollandia venit, et multi alii nobiles et principes viri." Ijsewijn and Tournoy, "Litterae ad Craneveldium Balduinianae," 17–20, no. 5, esp. 19 (16 April 1520). The letter is also partially reproduced in Weidema and Koopstra, *Jan Gossart*, 18 no. 10, but the commentary provided is based on a partial mistranslation of the passage.

22. "In 't cleyn geschilderde saelken / VI. veertien gebacken hoofften van eerden, en geschildert, boven in de muer gezet in gaetkens." Matthaeus, *Veteris aevi analecta*, 343.

23. "Bevonden in 'tcleyn geschilderde saelken / Derthien gebacken aensichten staende in gaetkens in de muer. Noch d'aensicht van bisscop Philips al van eerde gemaict . . . Een gebacken hoeft nae de figuer van Carondelet ende is gesonden mijnen heere van Parlermen tot zijnder instantie." Sterk, *Philips van Bourgondië*, 234, fol. XIIIIv. For discussion, see ibid., 130, 297–300n16.

24. "In mijns Genadigen Heeren Oratorie" as "Onses Genadigen Heeren aensicht uyt eerden gebacken mit een fluwelen bonet daer op." Matthaeus, *Veteris aevi analecta*, 338. The 1580 inventory of the later bishop of Utrecht Frederik Schenck van Tautenburg describes fourteen busts of emperors, kings, and famous figures ("veertien geschilderde troonjens van dyversche keyseren, coninghen ende andere groote personagien"). See Dodt, *Archief*, 2:258.

25. "Anno 1518. Accitus ad exornandam arcem Dorestatum Claudius Carnotensis insignis plastes." Matthaeus, *Veteris aevi analecta*, 299. Beyond this reference, we have no documentation of Claude de Chartres or his activities as an artist in the Netherlands. See also Eikelmann, *Conrat Meit*, 63n156, and 252, no. 69.

26. See Hanzer, "Zur Büste eines Jungen Mannes," and Eikelmann, *Conrat Meit*, 32–34, 62–63, 252–53, no. 69. There are also two busts in the Harvard Art Museums dated c. 1510–50 and attributed variously to Michel Colombe and Conrad Meit (inv. nos. 1981.188 and 1981.189), on which technical analysis has revealed significant traces of polychromy. For the bust of Charles V now in the Gruuthusemuseum, Bruges (inv. no. O.4.XXI), see Martens, *Bruges et la Renaissance*, 221, no. 232, with prior literature.

27. An interesting parallel to Philip's series, albeit in an entirely different context, is the series of portrait busts on the exterior of the fifteenth-century Palazzo Spannocchi in Siena, which aligns Roman emperors with the portrait of the palace owner Ambrogio Spannocchi himself. See Carl, "Die Büsten." For discussion of some other near contemporary series produced across Europe, see Lindley, "Playing Check-Mate"; Cacciotti, "La tradizione degli 'Uomini Illustri'"; and Trunk, "Römische Kaiserbildnisse."

28. "Aliter apud maiores in atriis haec erant, quae spectarentur . . . cera vultus singulis disponebantur armariis, ut essent imagines, quae comitarentur gentilicia funera, semperque defuncto aliquo totus aderat familiae eius qui umquam fuerat populus." Pliny the Elder, *Historia naturalis*, 35.2.6–7. With slight adaptations, I have used the Loeb translation by Harris Rackham (Cambridge, 1952), 265.

29. "Uno Hercule con Dehyanira nudi di bona statura." For Beatis, *Die Reise des Kardinals Luigi*, 116. For translation of the full passage, see Beatis, *The Travel Journal*, 94.

30. "Ce son poi alcune tavole de diverse bizzerrie, dove se contrafanno mari, aeri, boschi, campagne et molte altre cose, tali che escono da una cozza marina, altri che cacano grue, donne et homini et bianchi et negri de diversi acti et modi, ucelli, animali de ogni sorte et con molta naturalità, cose tanto piacevole et fantastiche che ad quelli che non ne hanno cognitione in nullo modo se li potriano ben descrivere." Beatis, *Die Reise des Kardinals Luigi*, 116. See the discussion of this passage especially in Steppe, *Jheronimus Bosch*, 8–12; Koerner, "Bosch's Equipment," esp. 41–45; Falkenburg, *The Land of Unlikeness*, 18–19.

31. On Beatis's admiration for northern representations of nudes, especially those of Gossart and van Eyck, see Lehmann, "Mit Haut und Haaren," 59–61.

32. "Ung autre grand tableau d'ung géant et une géante." Drossaers and Scheurleer, *Inventarissen*, 27.

33. Ainsworth, *Jan Gossart's Renaissance*, 221–24, no. 31, with prior literature. Drossaers and Scheurleer, *Inventarissen*, 27n3, refute the earlier supposition put forth by Gombrich, "The Earliest Description of Bosch's Garden of Delight," 404, that the two *Hercules and Deiania* paintings were one and the same. It is also important to note that an auction held in Amsterdam in May 1709 mentions a *Hercules and Deianira* by Gossart, but whether this reference was to the surviving picture in Birmingham, to Henry's lost painting, or yet another version cannot be verified. The Birmingham painting is documented with certainty only as of 1800. For the Amsterdam auction, which also included Lucas van Leyden's *The Dance around the Golden Calf* and several other mythological works, see Cromhout and Loskart, *Catalogus*, A3v, no. 140: "Hercule en Dianiere, van Mabuse," as mentioned by Filedt Kok, *De dans om het Gouden Kalf*, 51–52.

34. Henry also commissioned at least one portrait from Gossart. See Ainsworth, *Jan Gossart's Renaissance*, 265–67, no. 48, and ibid., 296–98, no. 61a–b. See also Staring, "Vraagstukken der Oranje-Iconographie."

35. According to Ainsworth, *Jan Gossart's Renaissance*, 221, these inscriptions are indeed original. This emphatic specificity of subject is far from standard in Renaissance mythological images. By contrast, Gossart's German contemporary Lucas Cranach received a commission from Albrecht von Preussen in 1517 simply for a painting of Hercules squeezing another man to death ("Hercules, der einen nackenden Kerl zu Tod drückt"), without any reference to the combatant's identity. See Koepplin and Falk, *Lukas Cranach*, 2:611–12, nos. 523–26, and general discussion in Foister, "Cranachs Mythologien."

36. Ainsworth, *Jan Gossart's Renaissance*, 422–23, no. 118.

37. Ibid., 304, fig. 247, with prior literature. The painting is inscribed with Gossart's name and the date "1523" but stylistically cannot be attributed to his hand.

38. Orenstein, "Gossart and Printmaking," 105–6.

39. Ainsworth, *Jan Gossart's Renaissance*, 417–18, no. 116. Nadine Orenstein attributes this etching tentatively to Gossart, suggesting that the plate may have been left unfinished at his death and then completed by a later artist, particularly as regards the heads of the figures. For Geldenhouwer's 1522 letter to Cranevelt requesting a recipe for etching fluid on Gossart's behalf, see Weidema and Koopsta, *Jan Gossart*, 25–26, no. 18, and also Stijnman, *Engraving and Etching 1400–2000*, 55–56.

40. Hollstein, *Dutch and Flemish Etchings, Engravings, and Woodcuts*, 4:132, no. 117. On Claesz., see also Jacobowitz and Stepanek, *The Prints of Lucas van Leyden*, 252–53.

41. Bull, "Jan Gossaert and Jacopo Ripanda," 94.

42. Ainsworth, *Jan Gossart's Renaissance*, 310–12, no. 65.

43. Steinberg, "Michelangelo's Florentine *Pietà*."

44. Among sources for the myth available in the sixteenth-century Netherlands were Ovid, *Metamorphoses*, 9.1–272; Boccaccio, *Genealogie deorum gentilium*, 9.17; Boccaccio, "De mulieribus claris," in *Tutte le opere*, 10:24. The *Ovide moralisé* was another important vernacular source, which in the case of the myth of Hercules and Deianira remains fairly close to Ovid's original. See *Ovide moralisé*, 9:1–867.

45. "Ut erat, pharetraque gravis spolioque leonis . . . 'quandoquidem coepi, superentur flumina' dixit, / nec dubitat nec, qua sit elementissimus amnis, / querit, et obsequio deferri spernit aquarum." Ovid, *Metamorphoses*, 9.113–17. The *Ovide moralisé* (9:380–83) includes the same essential details: "Si saut au gué sans atendue, / Sans metre jus son vestement. Parmi s'en vait legierement, / Sans querre l'aiue plus paisible."

46. Verdon, *Italian Primitives*, 26–27, no. 16; Wright, *The Pollaiuolo Brothers*, 98–102.

47. Wright, *The Pollaiuolo Brothers*, 102.

48. Philostratus, *Imagines*, 16. Later paintings of Hercules and Deianira also depict the scene that Philostratus described. See, for instance, Guido

Reni, *Nessus and Deianira* (National Gallery, Prague, inv. no. O 104), and David Vinckboons, *Hercules, Deianira and Nessus* (Vienna, Kunsthistorischesmuseum, Vienna, inv. no. GG 9101). Pliny the Elder also refers to a painting of Hercules and Deianira by the ancient painter Artemon but does not indicate any specifics about its composition. See *Historia naturalis*, 35.40.139.

49. See Maurice Merleau-Ponty's formulation of the body as chiasmus, at the intersection of the visible and the tangible, in *The Visible and the Invisible*, 130–55. For a related and compelling discussion of the empathetic response elicited by viewing Gossart's bodies, see Kavaler, "Gossart's Bodies and Empathy."

50. For a recent summary of literature and interpretations of grisaille painting in the Netherlands, see Borchert, "Color Lapidum."

51. Widerkehr, *The New Hollstein*, 2:61, no. 174. For Goltzius's original drawing of the composition, dating to 1582, see Stech et al., *'Nach dem Leben und aus der Phantasie'*, 38–39, no. 10b.

52. "Post luctam Alcid[a]e cum Naupact[a]eo Acheloo, / Post fraudem Nessi; post Learneamq[ue] sagittam, / Iam satus Alcmena complexu Deianiran / L[a]etus habet, thalamoq[ue] fovens grata oscula figit."

53. Ainsworth, *Jan Gossart's Renaissance*, 221.

54. "In imaginem Herculis, Cupidinem tergo gestantis, ac prope succumbentis oneri. / Ante quibus coelum fuerat leve pondus, iisdem / Nunc gravis est humeris sarcina, parvus Amor." Secundus, *Epigrammatum*, 64–66.

55. On Hercules sarcophagi, see Koch and Sichtermann, *Römische Sarkophage*, 148–49; Robert, *Einzelmythen*, 115–18, 143–46; Giuliano, *Museo Nazionale Romano*, 1.8:543–47, no. XI.3; Jongste, *The Twelve Labours of Hercules*, esp. 122–24, K.6, fig. 7, for the *Savelli Sarcophagus*. For documentation of the monument in Rome at the time of Gossart's 1509 visit, see Albertini, *Opusculum*, 29. For a drawing by the slightly later Netherlandish artist Lambert Lombard after the *Savelli Sarcophagus*, see Denhaene, *Lambert Lombard*, 364–65, no. 16. For further discussion of Lombard, see the epilogue to this book.

56. Robert, *Einzelmythen*, 115–18; Jongste, *The Twelve Labours of Hercules*, passim.

57. Already in 1412 one of the letters in the *Heroides* was adapted in Dutch by Dirc Potter as *Der minnen loep* and read in the poetic circle around Albrecht van Beieren. See van Marion, *Heldinnenbrieven*, 45–59. For the popularity of the *Heroides* at French courts, see also Scheller, "L'Union des Princes," 240–42, and White, *Renaissance Postscripts*. The humanist Jean Lemaire de Belges used the *Heroides* as a model for his *Epistres de l'Amant vert*, dedicated to his patron Margaret of Austria, who had a copy of Ovid's original in her library.

See Fontaine, "Olivier de la Marche and Jean Lemaire de Belges," 224–25.

58. "Respice vindicibus pacatum viribus orbem, / qua latam Nereus caerulus ambit humum. / se tibi pax terrae, tibi se tuta aequora debent; / inplesti meritis solis utramque domum. / quod te laturam est, caelum prius ipse tulisti; / Hercule supposito sidera fulsit Atlans. / quid nisi notitia est misero quaesita pudori, / si cumulus stupri facta priora notat?" Ovid, *Heroides*, 9.13–20.

59. The strong side profile of Hercules in the woodcut is uncharacteristic of Gossart, who favored the dimensionality of three-quarter poses. However, the visage here is very similar to portraits of Charles V dating after 1530, suggesting the intervention of another artist who has endowed Gossart's subtle composition with a far more concrete meaning. For the connection to Charles V, see Ainsworth, *Jan Gossart's Renaissance*, 422–23, no. 118, with prior literature.

60. On the origins of Charles's *devise*, see Rosenthal, "The Invention of the Columnar Device," and Rosenthal, "Plus Ultra, Non Plus Ultra."

61. "Daer na den Datum der feesten melodiues / Ende doen de nieu Devise ghepresen. / Twee pilaren int zee op een rootse gheresen. / Men mocht noyt lesen sulck een wesen. / Tsamen ghestrict met eender croonen / Niet so scoone men macht wel verscoonen." Smeken, *Gedicht op de feesten*, 13. The sails of the ship in which Charles set off for Spain in September 1517 were also decorated with this *devise*. See Vital, *Collection des voyages*, 3:57: "en ses voilles plusiers belles painctures . . . le tout entre les deux coulonnes de Hercules que le Roy porte en sa devise avec son mot, qui est *Plus oultre*, escripte en rolleaux qui accolloient les dictes coulonne."

62. "Verum ut te his parem ostendas, oportet: virtuteque tua tantam orbis molem novus Hercules et Atlas sustineas, teque ipsum et magnitudinem cognoscas tuam." Marliani, *In comitiis Ordinis Aurei Velleris*, 149. It may not be by chance that the image of Hercules bearing the globe of Atlas appears prominently in Gossart's *Hercules and Deianira*. This subject became a standard element of Charles's iconography—for instance, in the background of Hermanus Posthumus's 1536 *Landscape with Roman Ruins* (Liechtenstein Museum, Vienna inv. no. GE740a). See Dacos, "L'Anonyme A de Berlin," and Rubinstein, "*Tempus Edax Rerum*."

63. See the introduction to Lefèvre, *Le recoeil des histoires*, on the history of the text and its numerous manuscript copies. For examples of these manuscripts, see Dogaer and Debae, *De librije van Filips de Goede*, 113–14, nos. 169–71. See also Tanner, *The Last Descendant of Aeneas*, esp. 58–59.

64. During the 1468 marriage celebration of Charles the Bold to Margaret of York, a presentation of the twelve labors of Hercules reveals how force-

fully Lefèvre's narrative impacted the Burgundian courtly imagination. See de la Marche, *Mémoires*, 3:143–47. For additional discussion, see Jung, *Hercule dans la littérature française*.

65. "Herculés . . . souvent se trouvoit avecquez Deyanira en gracieuses devises." Lefèvre, *Le recoeil des histoires*, 360–61.

66. "Comme elle pensoit a Herculés et Herculés a elle, nouvelles vindrent illec que Achelous venoit assegier la cité par terre et par mer . . . leurs espris furent traversés en tell façon que Herculés laissa a regarder Deyanira et la damoiselle laissa a penser a Herculés." Ibid., 361.

67. This tapestry set with the *Wedding of Hercules and Deianira* (inv. no. 35.79.2), dated 1513, is preserved in the Metropolitan Museum of Art, New York. One such series is documented as having been made for Henry VIII, another for Margaret of Austria. Campbell, *Tapestry in the Renaissance*, 136, 140; Rorimer, "A Gift of Four Tapestries"; Soil, *Les tapisseries de Tournai*, 41, 258, 398–99. See also Bulst, "Das Olympische Turnier," 206, for the popularity in Italy of tapestry series based on Lefèvre's text.

68. Koninkijke Bibliotheek, The Hague, KB 78D 48. The manuscript was originally owned by Philip of Cleves and bought by Henry upon Philip's death in 1528. See Korteweg, *Boeken van Oranje-Nassau*, 33, 37.

69. Willem Heda, *Genethliacum*, Universiteit Utrecht, Utrecht, MS 774. On Heda and his genealogy of Maximilian, see also van der Horst, "Willem Heda," and van Langendonck, "Het Karbonkelhuis van kanunnik Willem Heda," 102–4.

70. "In finibus quoque Cimbrorum quos zelandiam provinciam tuam inhabitas se constat nostra aetate saxum ingens visitur cum effigie Herculea, sub scriptum deo Herculi sacrum." Heda, *Genethliacum*, 19r.

71. On the Hercules altar discovered by Philip of Burgundy, see chap. 2.

72. Tacitus, *Germania*, 34.1–3. Naturally, Tacitus was also employed in making similar arguments at the German Renaissance court of Maximilian of Austria. See on this point Leitch, "The Wild Man, Charlemagne and the German Body"; Leitch, *Mapping Ethnography*, 37–62; Braungart, "Mythos und Herrschaft"; and Crossley, "A Return to the Forest."

73. See Heda, *Historia episcoporum Trajectensium*, 197–99, for his historical study of Utrecht and local antiquities. On the general ancient history and archaeological finds in the Utrecht area, see Bloemers, "Utrecht en de archeologie van de Romeinse tijd," and Hessing, "De Romeinen in Utrecht."

74. For discussion of this phenomenon in Renaissance art and literature, see Wood, *Forgery, Replica, Fiction*; Nagel and Wood, *Anachronic Renaissance*, esp. 241–99; Grafton, *Forgers and Critics*; and Rothstein,

"Etymology, Genealogy, and the Immutability of Origins."

75. "Imp. Caes. L. Septimus Severus Aug. et M. Antoninus Caes. Coh. Vol. armamentarium vetustate conlapsum restituerunt sub Val. Pudente leg. Aug. pr. pr. curante Caecil. Batoe prae. Gens Batavorum amici et fratres Romani Imperii." Geldenhouwer, *Historia Batavica*, 4r, and Geldenhouwer, *Historische werken*, 62, and 160n43.

76. "Epitheta Batavorum. Feroces, Truces, Animosi, Fortissimi, Veteres militiae magistri. Populi virtute praecipui. Fidelissimi. Statura proceri. Nobilissimi. Socii Imperii Romani. A primevo aevo laudis et gloriae populus, laudis & gloriae cupidi quondam duces Germaniae atque Galliae in bello quod gerebant contra Romanos. Audacissimi, immetuentissimi, victoriosi. Veteres multorum bellorum victores: Validissimi artus exercitus Tributorum expertes, Galli pro libertate, Germani ob praedam. Batavi pro gloria ad proelia instigabantur ut scribit Tacitus libro vigesimo." Geldenhouwer, in Dorp et al., *Dialogus*, F3r.

77. "Viros ac mulieres educat formosissimos . . . Viri fortes ac staturosi et ad bellorum subeunda pericula ut promptissimi ita et aptissimi." Geldenhouwer, *Lucubratiuncula*, A3v, and Geldenhouwer, *Historische werken*, 42.

78. Geldenhouwer, *Historia Batavica*, title page. On the woodcut, see van de Waal, *Drie eeuwen vaderlandsche geschied-uitbeelding*, 1:157–63, who was the first to recognize that the print constituted a reuse rather than an original illustration. See also van der Coelen, "De Bataven in de beeldende kunst," esp. 145–46; Noordzij, *Gelre*, 299, fig. 22, and my forthcoming article, "Batavia, the New World."

79. Only in the later sixteenth century did an iconography for representing Batavian history emerge, culminating in the cycle created for the seventeenth-century town hall of Amsterdam to which Rembrandt famously contributed. See van der Coelen, "De Bataven in de beeldende kunst," 144–87, with prior literature, and also Mark Morford, "'Theatrum Hodiernae Vitae.'"

80. On the cult of Hercules in Batavia, see Roymans, "De constructie van een Bataafse identiteit," and Roymans, *Ethnic Identity and Imperial Power*, 235–50.

81. "Les Princes de haute emprise dudit temps estoient surnommez Hercules, dont, comme tesmoigne Cornelius Tacitus, les Germains pour memoire perpetuelle de luy, quand ilz marchoient en bataille, chantoient en leur langage aucunes chansons et dictiers terribles et merveilleux de luy." Lemaire de Belges, *Les illustrations de Gaule*, 379.

82. See Geldenhouwer, *Historia Batavica*, 23v–25v, for the translated excerpts from Lemaire de Belges.

83. "In Zelandia quoque, non procul a Middelburgo, in pago quae vulgo Westcapellam nominant,

olim cultus est, quod clare indicant vetustatis monumenta, quae in templo eius loci adservantur." Geldenhouwer, *Historia Batavica*, 25v.

84. "Haec epigrammata, habentur Lovanii in bibliotheca professorum liberalium artium antiquissimo libello, in quo etiam habetur ludus Senecae, Graecis versibus, et sententiis additis, quem doctor utriusque juris Craneveldius et ego legeramus, priusquam in Germania formis excuderetur." Geldenhouwer, *Collectanea*, 127. In the last line, Geldenhouwer refers to the fact that Seneca's *Ludus* was published by Froben in 1515, thus providing a terminus post quem for the discovery in the Leuven library. The dates during which Geldenhouwer was a student at Leuven are uncertain, but he was already corresponding adeptly with fellow humanists in 1504 and published his first written work in 1514. See Prinsen, *Gerardus Geldenhauer*, 17–19.

85. "Ille ego Pannoniis quondam notissimus oris, / Inter mille viros primus fortisque Batavos, / Hadriano potui qui iudice vasta profundi / Aequora Danubii cunctis tranare sub armis / Emissumque arcu, dum pendet in aere telum / Ac redit, ex alia fixi fregique sagitta, / Quem neque Romanus potuit neque barbarus unquam / Non iaculo miles, non arcu vincere Parthus. / Hic situs, hic memori saxo mea facta sacravi. / Viderit an ne aliquis post me mea gesta sequetur. / Exemplo mihi sum, primus qui talia gessi." Geldenhouwer, *Lucubratiuncula*, A4r; Geldenhouwer, *Historia Batavica*, A1v; and Geldenhouwer, *Historische werken*, 60. On the history of this epitaph, see van Lieburg, "Hungary and the Batavian Myth"; Speidel, "Swimming the Danube under Hadrian's Eyes"; Roos, "Soranus: een Bataaf in Romeinse krijgsdienst."

86. Tacitus, *Historiae*, 4.12; Tacitus, *Annales*, 2.8; Tacitus, *Germania*, 3; and Piccolomini, *I commentarii*, 2:44–46: "Insula Rheni duci paret, quam Batavi quondam incoluerant, viri bellicosi atque adeo robusti ut armati Rhenum tranarent."

87. Aurelius, *De cronycke*.

88. "De oude roomsche croniken ende gesten die vanden historiographen als cornelius tacitus, suetonius, ende orosius bescreven zijn houden in ende begripen dat boven alle natien van duytslant die bataviers oft hollanders mitten sinen altijt die starckste mannen vroom van wapen ende snel clouck wacker." Ibid., 12.

89. Ibid., 92. See also Tilmans, *Historiography and Humanism*, 98. The inscription on the tile, one of several found at the ancient site of Roomburg near Leiden, reads: "Ex[ercitus] Ger[manici] inf[erioris]." Ancient Latin sources refer to the Low Countries under the name Lower Germany ("Germania inferioris").

90. Ibid., 235.

91. "Inter prandendum quaestiones variae proponebantur, ex poëtis, ex historiis, ex sacris literis. Historias

veterum fere omnes gallice legerat memoriaeque commendarat. Praeterea, me praelectore, historicos Latinos, quotquot extant, attentissime audierat." Geldenhouwer, *Collectanea*, 241–42; Geldenhouwer, *Vita clarissimi*, B3r.

92. Ijsewijn and Tournoy, "Litterae ad Craneveldium Balduinianae," 20–23, no. 6.

93. "In't garderobbe daerbij . . . twee groete taefferelen mit naicte figueren van mannen; noch een lang taeffereel mit drie naicte luyden." Sterk, *Philips van Bourgondië*, 248, fol. XXVIv.

94. Aurelius even employed the metaphor of fierce combat to characterize his literary pursuits, concluding his treatise on Batavian history with an epigram titled "Aurelius ad suam Bataviam" in which he describes the writing of history as a battle from which he now casts off his helmet so that he may rejoice with friends. Aurelius, *Batavia*, 78: "Dulce solum natale Vale. Tua praelia gessi, / Nunc galeam abiicio. Quisquis amicus, ovet."

95. Geldenhouwer, *Historia Batavica*, 4v; Geldenhouwer, *Historische werken*, 64: "Vetustissima inter Batavos nobilitas est heroum Herculaneorum, qui genus ab Hercule Alemanno, totius olim Germaniae rege, ducere asseruntur. Ab his originem trahit Gelriorum dux Carolus, comites Egmondani, Florentius, comes Burensis, principes etiam ab Hocklem, ab Aspera et multi alii minori nominis." Aurelius, *Batavia*, 16: "His modo Wassenarii heroës absolute imperant, ex Claudio Civile et Cereale trahentes originem."

96. For an overview of the war with Guelders, see Tracy, *Holland under Habsburg Rule*, 64–89.

97. "Nostrae decus Bataviae." Aurelius, *Batavia*, 91.

98. Schrader, "Gossart's Mythological Nudes," makes the most vehement case for the purely erotic reading of Gossart's paintings, arguing against those who have emphasized more moralizing readings, including Silver, "*Figure nude, historie e poesie*," and Veldman, "Die Moralische Funktion," 381–84.

99. "Twee costelicke taeffereelkens van de boelscap wel gedaen mit een custodie daer d'een in hoirt." Sterk, *Philips van Bourgondië*, 264, fol. XXXVIv.

100. See discussion in chap. 2.

101. Ainsworth, *Jan Gossart's Renaissance*, 222.

102. For general discussion of numismatic interest in the Renaissance, see Stahl, *The Rebirth of Antiquity*, and Cunnally, *Images of the Illustrious*.

103. "Eerst XCIX oude penningen van antiquiteyten laetende meest zilver ende versilvert te weren; noch elve oude penningen van coper oick van antiquiteyt." Sterk, *Philips van Bourgondië*, 230, fol. XII. The Utrecht region, in which Philip's Wijk bij Duurstede palace was located, has yielded significant numismatic finds, and it is quite plausible that his collection stemmed from the area.

104. See More, *The Complete Works*, 3.2:264–65; Schroe-

der, "Jerome de Busleyden and Thomas More"; and Herbrüggen, *Morus ad Craneveldium*, 103.

105. On the general history of Renaissance medals, see Scher, *The Currency of Fame*; Scher, *Perspectives on the Renaissance Medal*; Pfisterer, *Lysippus und seine Freunde*; and Cupperi et al., *Wettstreit in Erz*.

106. On portrait medals in the early sixteenth-century Netherlands, see Pollard, *Renaissance Medals*, 759–61, and on the medals of Adrian VI and Erasmus specifically, ibid., 762–64, nos. 766–67, with prior literature. On Adrian's medal, and his complex views on ancient art, see also Reiss, "Adrian VI," 339–59, esp. 351.

107. Sterk, *Philips van Bourgondië*, 141–42, figs. 48–49.

108. For Secundus's production of medals, see Goossens, "Janus Secundus als medailleur," and Wellens-de Donder, *Medailleurs en numismaten*, 39–49.

109. "Ut autem videas an aliquid profecerim, mitto tibi effigiem Archiepiscopi Panormitani, proximis hisce diebus a me sculptam. Rogo, sincere iudices." Secundus, *Itineraria*, 326–28, no. 5.

110. Ibid., 328.

111. For Meit's career, see Eikelmann, *Conrat Meit*, passim.

112. Weidema and Koopstra, *Jan Gossart*, 28–31, nos. 21–22.

113. "Inter inferos Germanos hisce diebus clarebat . . . sculptorum: Chunradus Vermaciensis Germanus in familia dominae Margaritae etc." Geldenhouwer, *Collectanea*, 72–73.

114. Kunsthistorisches Museum, Kunstkammer, Vienna, inv. no. KK 9888 and KK 9889. Eikelmann, *Conrat Meit*, 80–83, no. 4, and Eichberger, *Leben mit Kunst*, 305–7.

115. Eikelmann, *Conrat Meit*, 76–79, no. 3, and, on the properties of alabaster, Lipińska, *Moving Sculptures*, esp. 29–30, and Lipińska, "Alabastrum, id est, corpus hominis," 100–106.

116. Eikelmann, *Conrat Meit*, 72–75, no. 2.

117. Chap. 1, n. 104; Eichberger, *Leben mit Kunst*, 312; and Michelant, "Inventaire," 95: "Item, ung jeune homme nuz, de metal, bien ancien, pourtant le harnast d'ung homme, à ung baston, ayant un bacinet sur sa teste."

118. Ainsworth, "Gossart in His Artistic Milieu," in *Jan Gossart's Renaissance*, 16–19; and Ainsworth, *Jan Gossart's Trip to Rome*.

119. Ainsworth, *Jan Gossart's Renaissance*, 224–26, no. 32, with prior literature.

120. On the general theme of *Weibermacht* ("the power of women") in specific relation to Margaret's court and artistic commissions, see especially Bleyerveld, "Powerful Women, Foolish Men," and also Eichberger, "Playing Games."

121. See discussion in Eichberger, *Leben mit Kunst*, 109–12, 298–301, and Eichberger, "Hoofse hobby's."

122. "Deux personnaiges de Adam et Eve nuz, de leton dorez, bien faiz." Michelant, "Inventaire," 110.

123. For important discussion of the relation between

Gossart's paintings and the medium of sculpture, see Ainsworth, *Jan Gossart's Trip to Rome*.

124. "Item, ung beau tableau auquel est painct ung homme et une femme nuz, estant les pieds en l'eaue; le premier bort de mabre, le second doré et en bas ung escripteau, donné par Monsigneur d'Utrecht." See Michelant, "Inventaire," 110, and Weidema and Koopstra, *Jan Gossart*, 31–32, no. 23.

125. Ainsworth, *Jan Gossart's Renaissance*, 226–29, no. 33.

126. "Nate effrons homines superos que lacessere suet[us] non matri parcis: parcito, ne pereas."

127. Barlandus, *Complures Luciani dialogi*. See also Daxhelet, *Adrien Barlandus*, 37–38.

128. "Veneris et Cupidinis," in Barlandus, *Complures Luciani Dialogi*, B5v–B7v. Schrader, "Gossart's Mythological Nudes," 64, suggests that Gossart's painting should be related to Martin Dorp's *Dialogus* among Venus, Cupid, and Hercules with which Geldenhouwer's *Letter on Zeeland* was published in 1514 (see chap. 2), but she goes too far in denying the didactic function of such dialogues and treats the text solely as a celebration of erotic behavior.

129. "Aderant ei et versificatores, qui picturas atque structuras carminibus ornarent, ut utramque picturam et loquentem et tacitam ostentare posset." Geldenhouwer, *Collectanea*, 235, and Geldenhouwer, *Vita clarissimi*, A7v.

130. Lee, "Ut Pictura Poesis"; Spencer, "Ut Rhetorica Pictura"; Baxandall, *Giotto and the Orators*, passim; and Müller Hofstede, "'Ut Pictura Poesis.'"

131. "Een groote bedde, dat gevonden was van salige bisscop Fredericx tijden, loquitur," and "Een taeffel gebloemt mit cassidoinen, loquitur." Sterk, *Philips van Bourgondië*, 237, XVIIb.

132. See Busleyden, *Jerome de Busleyden,* 244–52, esp. 250–51, and Foncke, "Aantekeningen betreffende Hieronymus van Busleyden." Thomas More, in his poem *Ad Buslidianum de aedibus magnificis Mechliniae*, also praises the epigrams in Busleyden's mansion as verses even Virgil would envy: "disticha quodque notant opus, at quae disticha vellet, / Si non composuit, composuisse Maro." See More, *The Complete Works*, 3.2:264–65.

133. Erasmus, *The Collected Works of Erasmus*, 39:171–243.

134. See Schlüter, *Niet alleen*, 66–67.

135. The apparent original of this composition is in the Kunsthistorisches Museum, Vienna, inv. no. 942, but illustrated here is one of two other surviving versions, for which see Ainsworth, *Jan Gossart's Renaissance*, 173–79, no. 17a–c.

CHAPTER 4
LEGACY

1. See chap. 1, n. 90.

2. See chap. 3, n. 21.

3. For discussion of the Reformation debate over

images, see von Campenhausen, "Die Bilderfrage," and Koerner, *Reformation of the Image*. There is extensive literature on the impact of the Reformation on German artists in the early sixteenth century, particularly those who were engaged with antique models and classical subjects, but for a few recent studies, see Price, *Albrecht Dürer's Renaissance*, esp. 225–75; Weber am Bach, *Hans Baldung Grien*; Werner, Eusterschulte, and Heydenreich, *Lukas Cranach der Jüngere*, passim; Marx, "Wandering Objects, Migrating Artists," 178–203. For an overview of the history of iconoclasm in the later sixteenth-century Low Countries, with prior literature, see Jonckheere, *Antwerp Art after Iconoclasm*, esp. 7–27.

4. Ainsworth, *Jan Gossart's Renaissance*, 232–35, no. 35, with summary and reference to previous literature.

5. As first discussed in Panofsky, "Der gefesselte Eros."

6. See Settis, "Danae verso il 1495," for several examples.

7. See most importantly, Sluijter, "Emulating Sensual Beauty," and also Olbrich, "Jan Gossaerts Münchner 'Danae.'"

8. Ilchman, *Titian, Tintoretto, Veronese*, 178–83; Santore, "Danaë: The Renaissance Courtesan's Alter Ego"; Zapperi, "Alessandro Farnese"; and Goffen, *Titian's Women*, 215–42. A notable exception to the use of coins is the *Danaë* composition by Perino del Vaga for the palace of Andrea Doria in Genoa, which shows the gold shower as rain but then also includes a depiction of Jupiter in the flesh, embracing Danaë on her bed. See Davidson, "The Furti di Giove," and Parma, *Perino del Vaga*, 242–46, no. 125. Other rare examples of the depiction of Jupiter's shower as rain can be found in Jean-Jacques Boissard's 1556 illustrations of Ovid's *Metamorphoses* (Berlin, Kupferstichkabinett, fol. 28v), and in an undated engraving after Frans Floris by Frans Menton (Amsterdam, Rijksprentenkabinet, RP-P-OB-68.203).

9. Leeflang and Luijten, *Hendrick Goltzius*, 284–86, no. 103; Nichols, *The Paintings of Hendrick Goltzius*, 136–40, A-33, pl. 5.

10. Terence, *Eunuchus*, 3.5, lines 580–606. On the knowledge and pedagogical application of Terence's plays in the Netherlands, see Alphen, *Nederlandse Terentius-vertalingen*, as well as the excerpts of model phrases from Terence compiled in Grapheus, *Terentianae phraseos flosculi*, and Grapheus, *Latinissimae colloquiorum formulae*, including the letter written by Geldenhouwer in the latter edition (A1v–A2r) exhorting the use of Terence in schools. See also the 1530 Terence commentary of Hadrianus Barlandus discussed below.

11. St. Augustine, *De Civitate dei contra Paganos*, 18.13.

12. "Et in tabulis magis capit oculos nostros Iupiter per impluvium illapsus in gremium Danaës, quam Gabriel sacrae virgini nuntians coelestem conceptum: vehementius delectat raptus ab aquila Ganymedes, quam Christus ascendens in coelum." Erasmus, *Opera omnia*, 1.2:647, lines 13–16. Translation adapted from Erasmus, *The Collected Works of Erasmus*, 28:396.

13. Erasmus and Amstelredamus, *Carmen bucolicum*, B2r–B7r; for Erasmus's original poem, see Erasmus, *The Collected Works of Erasmus*, 85:234–243, no. 102.

14. "In picturam Danaës. / Si lusit Danaën sub imagine Iupiter auri, / Auri, quae spectas, disce timere dolos." Grudius, Marius, and Secundus, *Poemata et effigies*, 92.

15. "Vel Paphiae Veneris canit is cum Marte nefandos / Concubitus, fucos vel canit ille Iovis, / Ut rutili stillas gremio per tecta metalli / Emittat Danaes, damna pudicitiae / Splendida facta ducum (Veneres discedite molles) / Hic Iudoce vides, Martia facta simul." Daxhelet, *Adrien Barlandus*, 101.

16. "Hic docemur, quantam cladem moribus asserant amorum picturae, quales tamen hodie plures videmus, in domibus divitum et aulicorum, quam de Christi potentibus factis." Barlandus, *P. Terentii sex comoediae*, V2v.

17. Sluijter, "Emulating Sensual Beauty," 16, and Ainsworth, *Jan Gossart's Renaissance*, 235, who follows the outlines of Sluijter's argument.

18. A view descended from Clark, *The Nude*, 308–47.

19. See especially Nagel, "Experiments in Art and Reform"; Nagel, *The Controversy of Renaissance*; Burke, "Sex and Spirituality in 1500s Rome"; Barkan, *The Gods Made Flesh*, 183–84, 191; and the canonical study by Steinberg, *The Sexuality of Christ*.

20. Ainsworth, *Jan Gossart's Renaissance*, 170–73, no. 16.

21. For excellent discussion of Marian images in the Reformation, see Weber am Bach, *Hans Baldung Grien*, and esp. 17, 152, pl. IV, for an explicit copy after Gossart's *Virgin and Child* by Baldung. For the parallel tensions between pagan and Christian subjects in the works of both Gossart and Baldung, see also Muller, "Hans Baldung Grien et Jan Gossaert."

22. Ullmann, "Karlstadts Schrift"; Visser, *Luther's geschriften in de Nederlanden*, 1–27, 42–45, no. 13; and Kronenberg, "Uitgaven van Luther." For lists of banned Lutheran books and burnings of the same, see Fredericq, *Corpus documentorum inquisitionis*, 4:76–77, no. 49, and see ibid., 5:4, no. 391, for the edict issued by Charles V on 24 September 1525 ("Gebieden ende statueren voert, dat alle die boucken van Martinus Luther, Pomerani, Carlostadii, Melancton, Ecolompadii, Fransisci Lamberti, Jone ende andere inden heyliger scriften mit Luther gevoelende, mitsgaders alle die boucken, die sonder tytel geprent zijn, ghebrocht zullen worden in een openbaer plaetse ende aldaer tot polvere verbrant").

23. Fredericq, *Corpus documentorum inquisitionis*, 4:338–39, no. 280, 356–57, no. 307, 372–73, no. 330, 393, no. 360.

24. Führer, *Religionspolitik Kaiser Karls V*, 176–209; Duke, "The 'Inquisition'"; Duke, *Reformation and Revolt*, 1–59; Goosens, *Les inquisitions modernes*, 47–77; Templin, *Pre-Reformation Religious Dissent*; Spruyt, "De Delfts-Haagse kring"; Veldman, "Protestantism and the Arts." On the well-documented trial of Geldenhouwer's colleague Cornelius Grapheus, see Cramer and Pijper, *Bibliotheca Reformatoria Neerlandica*, 6:4–9; Fredericq, *Corpus documentorum inquisitionis*, 4:88, no. 64, 105–10, no. 74; Prims, *Antwerpiensia*, 165–90.

25. Fredericq, *Corpus documentorum inquisitionis*, 5:233–35, no. 612; Decavele, "Vroege Reformatorische bedrijvigheid," and, for useful summary, Galand, *The Bernard van Orley Group*, 67–70.

26. Geldenhouwer, *Collectanea*, 78–82. See also Prinsen, *Gerardus Geldenhauer*, 64–97, and Cranevelt, *Literae virorum eruditorum*, 545–48, no. 209.

27. "Tandem post mortem Optimi Praesuli, patrui tui, visum est mihi operae precium ipsam Saxoniam, Mysiamque adire; illosque doctores, qui ab Evangelio stare videbantur, videre ac audire, id quod et ipse patruus tuus non semel suaserat." Cranevelt, *Literae virorum eruditorum*, 546.

28. Meertens, *Letterkundig leven*, 155–56.

29. Ainsworth, *Jan Gossart's Renaissance*, 160–64, no. 12. See Schaefer, "Gossaert's Vienna *Saint Luke Painting*"; Olds, "Jan Gossart's 'St. Luke Painting the Virgin'"; Boeckl, "The Legend of St. Luke the Painter"; Verstegen, "Between Presence and Perspective," 518.

30. See chap. 1.

31. For interesting discussion of artifice and creative identity in Titian's painting of *Danaë*, see Pardo, "Artifice as Seduction in Titian," and Goffen, *Titian's Women*, 215–42.

32. On the association between rotund buildings and both Vesta and the Virgin Mary, see Tavernor, *On Alberti*, 150–51, 241n136.

33. As discussed by Kavaler, "Gossart as Architect," 35–36. See also Heringuez, "Bramante's Architecture," 229–36, and Kik, "Bramante in the North," for Bramante's *Tempietto* in Rome as a possible model for the design of Danaë's tower and for the importance of Bramante's transmission to the north through the 1481 engraving by Bernardo Prevedari.

34. "Si numquam Danaen habuisset aenea turris, non esset Danae de Iove facta parens." Ovid, *Amores*, 2.19, lines 28–29. See also ibid., 3.4, lines 21–26, and Horace, *Odes*, 3.16, lines 1–6, for expressions of the same sentiment.

35. For discussion of the association between pregnancy and pictorial space, see Leonhard, "Vermeer's Pregnant Women."

36. Gauricus, *De sculptura seu statuaria*, and Gauricus, *De sculptura (1504)*. Grapheus's edition is dedicated to Jan II Carondelet, one of Gossart's most important patrons (chap. 1).

37. "Hanc vero triplicem speciendi rationem a pictore (quisquis ille fuerit) animadvertimus perbelle semel adservatam: ita enim is Danaem composuerat, ut si prospiceres avaram ipsam puellam stupescentem videres, sin suspiceres, Iovem iam iam e nubibus descensurum impluvio putares, sin vero despiceres, proximas regiones aurea conspersas grandine mirarere." Gauricus, *De sculptura seu statuaria*, E6v, and Gauricus, *De sculptura (1504)*, 189–91.

38. Ainsworth, *Jan Gossart's Renaissance*, 234.

39. As suggested by Sluijter, "Emulating Sensual Beauty," 11–12, based on a prior proposal in reference to Correggio's *Danaë* by Zapperi, "Alessandro Farnese," 165. For Sluijter, the similarities between the two paintings pointed to a common origin in an ancient gem or coin, yet Correggio's *Danaë*, unlike Gossart's, is situated on a bed and is in a much more reclined position. On Philip's coin collection, see chap. 3, n. 103.

40. Green, "The Sources," with extensive prior literature. For the English translation, which was first published in 1540 during the reign of King Henry VIII, see Rösslin, *The Birth of Mankind*.

41. De Jong, "Den Roseghaert," and Lie, "Women's Medicine in Middle Dutch," 462–63.

42. Talvacchia, *Taking Positions*, 27.

43. See Colonna, *Hypnerotomachia Poliphili*, 169. For comment on Gossart's potential knowledge of this text, see Kavaler, "Gossart as Architect," 35.

44. Pinkus, "The Eye and the Womb."

45. Sterk, *Philips van Bourgondië*, 86–88; Geldenhouwer, *Collectanea*, 246–47; Geldenhouwer, *Vita clarissimi*, B5v–6v.

46. "Optimo praesuli, clementissimo principi Philippo a Burgundia, boni Philippi Burgundiae ducis filio, episcopo Ultrajectino, patrono B[eatae] M[emoriae] Joannes Malbodius et Gerardus Noviomagus P[onendum] C[uraverunt] / Pacis amatoris cernis bellique periti, / Quisquis ades tumulum hic, mens super astra manet. / Iniustos hostes vix dum paciencia victrix / Vicerat et morti cedere iussus obit. / Collapsas arces reparavit divite cultu, / Praelia quod gessit, non sua culpa fuit. / Perfidus haec civis conflavit, perfidus auxit / Consul, dum patriae consulit excidium." Geldenhouwer, *Collectanea*, 248; Geldenhouwer, *Vita clarissimi*, B6v–B7r. This text is also reproduced, though not fully transcribed, in Weidema and Koopstra, *Jan Gossart*, 47–48, no. 34.

47. Ainsworth, *Jan Gossart's Renaissance*, 395–98, no. 108.

48. See the discussion by Stijn Alsteens in ibid., 396–7.

49. The tombs for Margaret of Austria's funerary chapel at Brou, completed 1531, are executed primarily in the flamboyant Gothic mode, with the exception of a few putti carved by Conrad Meit (see chap. 1, nn. 44 and 82). The earliest surviving examples of Netherlandish tombs that intregrate significant

classicizing ornament are those of Engelbrecht II of Nassau and his wife in Breda (begun c. 1526) and of Guillaume de Cröy, the latter sculpted by Jean Mone circa 1528. See Kavaler, "Being the Count of Nassau," and Wezel, *De Onze-Lieve-Vrouwekerk*, 178–82.

50. "Noch een schoon groot taeffereel wesende de Historie van Hercules gemaeckt zoo onder daerop geschreven stont by Johannes Malbodius int Jaer XV hondert dertich." Denucé, *De Antwerpsche 'konstkamers'*, 12. Michaeli's inventory itself is dated to 1585.

51. "Ung grand tableau de deuz personnaiges nudz de Mars et Vénus, cloz de feuillet, venant de feu monseigneur d'Utrecht; ung autre grand tableau de paincture d'une belle fille qui se désabille, venant de feu monseigneur d'Utrecht." Finot, *Inventaire sommaire*, 432.

52. "Die Danaa mit einem guldenen regen vom Joan Mabusen." Zimmermann, "Das Inventar der Prager Schatz- und Kunstkammer," XLII, no. 1015.

53. Wauters, "Jean Gossaert en Adolphe de Bourgogne"; Meertens, *Letterkundig leven*, 35–36; Sicking, *Neptune and the Netherlands*, 94–102; Bietenholz, *Contemporaries of Erasmus*, 1:223–24, with additional literature. For background of Adolph's mother and family line, see also Kooperberg, "Anna van Borssele."

54. On the history of Sandenberg, see Ermerins, *Eenige Zeeuwsche oudheden*, 163–212. On Wijngaerde's panorama, see chap. 2.

55. See Blom, "Versekert en bewaert."

56. "Mabuse heeft onder ander oock gheschildert een Mary-beeldt terwijlen hy was in dienst van den Marquijs van der Veren, wesende de tronie ghedaen nae de Huysbrouw van den Marquijs, en t'kindeken quam nae haer kindt: dit stuck was soo uytnemende aerdigh en soo sujver gheschildert dat alles wat men anders van hem siet daer by rouw gelijckt te wesen." Van Mander, *Lives*, 1:160–63, fols. 225v–226r, esp. 160, fol. 225v.

57. Ainsworth, *Jan Gossart's Renaissance*, 238–40, no. 37. For additional discussion of disguised portraits depicting Burgundian noblewomen as saints, see Howell Jolly, *Picturing the "Pregnant" Magdalene*, 113–15.

58. Inscribed on the obverse: "Adolphus Burgundia dominus de Beveren admiraldus maris anno MDXXXII," and on the reverse: "Quo deus hoc fausto nos sidere ducet eundem est." See van Mieris, *Histori der Nederlandsche vorsten*, 360.

59. The plaque measures an impressive 108 × 65 cm and likely dates around the year of Adolph's death in 1540. Its creator is unknown, and it is likely not displayed in its original location within the church, as the interior has been heavily renovated.

60. See Sicking and Fagel, "In het kielzog van Columbus," and Sicking and Fagel, "In the Wake of Columbus."

61. On these featherwork objects, see chap. 1.

62. See Snoy, *De rebus Batavicis*, 2v–4. For Jan Becker, see Bietenholz, *Contemporaries of Erasmus*, 1:115–16, and Ijsewijn et al., "Litterae ad Cranveldium Balduinianae," 55–58, no. 108, esp. 57 for Becker's own letter to Cranevelt from 1522 complaining of life in the service of Adolph and his wife.

63. Meertens, *Letterkundig leven*, 97–98.

64. Erasmus, *De recta Latini Graecique sermonis pronuntiatione*.

65. Barlandus, *Carolus Burgundus*, in *Hollandiae Comitum Historia et Icones*, 96, dedicated to "Illustri Veriensium principi Adolpho s[alutem] d[icit] Hadrianus Barlandus" and first published in 1520. On Charles the Bold's marriage festivities, Barlandus writes (105): "Nihil ad hanc magnificentiam egregius alioqui Antonii et Cleopatrae apparatus. Nihil Heliogabali sexcenta strutionum capita una coena apposita. Ut semel finiam, quicquid de dubiis ac pollucibilibus loquitur coenis antiquitas, hac Burgundia inferius est." See also Daxhelet, *Adrien Barlandus*, 104–6, 281–82, no. 36.

66. Unger, "Middelburg als handelsstad," 63.

67. For Pratensis's biography, see Nagtglas, *Levensberichten van Zeeuwen*, 2:435–36; Fokker and de Man, *Levensberichten van Zeeuwsche medici*, 130–31; de Vos, "Jason Pratensis"; Meertens, *Letterkundig leven*, 39; Banga, *De geschiedenis van de geneeskunde*, 32–39; van Hoorn, "Levinus Lemnius," 74–80; van Hoorn, "Zierikzeese medici," 51–54; and Lindeboom, *Dutch Medical Biography*, 1567–68. For an apothecary's recipe written by Pratensis and recorded in a sixteenth-century manuscript, see van Hoorn, "Vijf eeuwen pharmacie in Zierikzee," 5–6.

68. Pratensis, *De tuenda sanitate*. See also Vervliet, *Post-Incunabula and Their Publishers*, 44–45.

69. On Erasmus's interest in the medium of print as a vehicle for portraiture, see especially Hayum, "Dürer's Portrait of Erasmus," and Jardine, *Erasmus, Man of Letters*, 48–53. To my knowledge the only other early sixteenth-century Netherlandish humanist whose portrait appeared in print, prior to that of Pratensis, was Alardus Amstelredamus's woodcut portrait in his treatise *Ritus edendi paschalis agni* (Amsterdam: Dodo Petrus, 1523). I am currently preparing a separate article on Alardus's portrait entitled "After-Images of Erasmus: Albrecht Dürer and the Humanist Portrait in the Early Sixteenth-Century Netherlands." Another woodcut portrait of the Ghent physician and mathematician Robertus Gropretius was also published the same year (1538) as Pratensis's portrait on the title page of his treatise *Regimen Sanitatis*. See Vervliet, *Post-Incunabula and Their Publishers*, 142–143.

70. "Adolphus a Burgundia princeps meus, non raro, cum suae spontis est, eruditos aliquot mensae suae adhibet, quis cum, aut amoenioris aliquid philosophiae, aut etiam alterius disciplinae quadam cum

illecebra et blande disserit, ubi iam expletis sumus, et naturae quantum sit satis, dedimus." Pratensis, *De tuenda sanitate*, 80v.

71. Erasmus, *The Collected Works of Erasmus*, 39:171–243, and Schlüter, *Niet alleen*, passim.

72. See chap. 3, n. 91.

73. "Devant disner, il fait bon parler à luy, mais l'après disner, il n'y a pas d'ordre." Baelde, "Edellieden en juristen," 40.

74. Pratensis, *De tuenda sanitate*, a2r–a4r.

75. Ibid., a3v: "Annae pientissimae matris raras et stupendas virtutes . . . Arbor bona bonos fructus gignit," and 48v–49r: "Ab annis aliquot generosa atque inclyta domina, domina mea Anna Beveriensis, articulari morbo laboravit, ac saepicule gravibus tormentis cruciabatur . . . sed habeo praesens paratumque remedium."

76. "Quiquis Nestoreos annos, laetamque senectam / vivere vult, relegat quattuor hosce libros, / quos Medicus scripsit non aspernandus Jason, / quo sibi non temere magnus Apollo placet." Hadrianus Cordatus, in Pratensis, *De tuenda sanitate*, a4r.

77. Geldenhouwer, *Satyrae octo*. Geldenhouwer also refers to a "Jason himnidicus medicus" in his 1514 *De Zelandiae situ*, G3v.

78. Geldenhouwer, *Satyrae octo*, G1v–G2r.

79. Pratensis, *Sylva carminum adolescentiae*. His poem "Gratulatio in adventu G. N. amici non vulgaris," found in the *Sylva* (D2v–D3r), is also likely addressed to Geldenhouwer ("G[erardus] N[oviomagus]").

80. For the Muses in Zierikzee, see Pratensis, *Sylva carminum adolescentiae*, D6r. For the poem on Venus, see ibid., D5r: "*Venus baltheo succincta. / Tolle oculos, dea sum, ne stes spectator, inuret / Te meus ardenti baltheus igniculo.*" The latter poem calls to mind small bronze sculptures of Venus with a girdle like the c. 1500 example preserved in the Historisches Museum, Basel, on which see Mensger, *Jan Gossaert*, 187–88.

81. "Cum Dius Adolphus a Burgundia, dominus Beveriensis, Verianus etc. dissipatos aggeres in Duvelandia adversus vortices, et insanos fluctus rabidi maris restauraret, huius celsitudini piscatores de Brouwershavene (quae civitas ad domini quoque ditionem pertinet) Xiphiam obtulerunt captum in Brittanico mari. Cuius effigiem clarissimus heros expressam ligno, in ambulacro arcis suae Sandenburgensis aspectandam suspendi curavit." Pratensis, *De tuenda sanitate*, 98r.

82. On this flood, see the 1530 pamphlet *Die vloet des waters* (chap. 2, n. 39).

83. "So hadden die visschers van Brouwershavene eenen seer vreemden visch gevangen hebbende eenen muyl als een sweert, daer die oude historie schrijvers als Plinius . . . ende meer andere af ge-screven hebben, die genoemt wort een sweert visch wiens ghedaente hangende is ter Veere opt huys

van Sandenburch alsmen aldaer noch opten dacht van heden sien mach." Reygersbergh, *Dye cronijcke*, U2r; Reygersbergh and Boxhorn, *Chronik*, 444. For Pratensis's poem honoring Reygersbergh's chronicle, see the introduction to this book.

84. For the continuation of this theme into the seventeenth-century Netherlands, see de Jong, *Nature and Art*.

85. Pliny the Elder, *Historia naturalis*, 32.2; and Pratensis, *De tuenda sanitate*, 98r.

86. I am very grateful to Orlanda Lie and Monica Green for discussing Pratensis with me and for affirming the exceptional originality of his gynecological treatises, which remain completely unstudied. For excellent background on male writing on gynecology in the Renaissance, see Green's *Making Women's Medicine Masculine*, esp. 246–73. Green lists only one of Pratensis's treatises in her appendix of printed gynecological treatises from the period (347, no. 15).

87. "Ferunt enim Celtis Rheni accolis in consuetudine fuisse ut eorum soboles mox cum exiret in lucum, imposita clypeo collocaretur in gurgite Rheni." Pratensis, *De uteris*, H4r. See also Ortelius, *Aurei saeculi imago*, "Infantia."

88. Pratensis, *De uteris*, G3r–G4r (subsection entitled "Adversus lutheranos"). This aside might call to mind Albrecht Dürer's famous lament over Martin Luther's imprisonment (albeit expressing the opposite of Pratensis's view), which appears in the midst of his diary entries from May 1521. For the lament, see Dürer, *Schriftlicher Nachlass*, 1:170–72, lines 1–132; Seebass, "Dürers Stellung in der Reformatorischen Bewegung"; and the forthcoming article by Jeroen Stumpel that will cast doubt on Dürer's authorship of the passage.

89. "Atqui locus non est declamationi, et plus satis parergis datum, ad pensum opera recurrit: prius tamen meliorem mentem Lutheranis apprecatus, qui continentiae vota etiam asobriis, ac per aetatem sapientibus emissa, contemnere docent, ac rescindi posse nulla interveniente superiorem authoritate. Hinc illa pulcherrima discipulorum ad magistros, subditorum ad praelatos, monachorum ad priores harmonia dissolvitur, et concentus ille unanimum fratrum distractis studiis, in stridores, in factiones, et in bellicos tumultus evadit. Et concutit hoc pestilenti dogmate tanquam violentissimi arietis impulsu Christianae reipublicae monarchia." Pratensis, *De uteris*, G3r–G3v.

90. "Egone ineptus, qui lapidem verbero et in deploratos iam destomachor? Satis satis in hos detonuerunt Pontifex, Caesar, et totius orbis Christiani clarissima Gymnasia. Cum id mecum reputo, prae gaudio quantus sum exilio, quod Zyricea nostra semper immunis atque exors tam contaminatae factiosis exstiterit, quanquam conati sint alii hanc luem castis ingeniis inseminare, et item alii innoxios hic

gravare invidia. Diis ipsis nunquam pro meritis gratias agemus, quorum beneficiis nos servatos agnoscimus. Tam illex malum ut quos semel inescarit, difficillime resolvant; tanto quidem pestilentius quanto pellacius arridet." Ibid., G4r.

91. Rooze-Stouthamer, *Hervorming in Zeeland*, 45–76; Meertens, *Letterkundig leven*, 156; Scheffer, *Geschiedenis der kerkhervorming*, 502–17.

92. "Certat cum primis fertilitate locis. / Aeris innocui tanta est clementia, passim / Arborei foetus ut genus omne ferat, / Si cupis ingenium gentis novisse, docebis." Pratensis, in Reygersbergh, *Dye cronijcke*, A4r.

93. "Mirantur plerique in maritimis oris eaque parte Zelandiae, qua a praeterlabente fluvio Scaldia denominatur, tam speciosas immensasque lauros frondescere . . . in civitate Zirizaea telluris beneficio in eam proceritatem assurgat, ut duarum decempedarum altitudinem superet, densa circa radicem fronde, multisque emergentibus stolonibus seu fruticibus." Lemnius, *Occulta naturae miracula*, 305–6. Note that the first edition of Lemnius's *Occulta* (1559) does not include the relevant chapters on the history and natural properties of Zeeland.

94. "Macte Jason . . . nos tibi debebimus omnes, qui mariti bonarum uxorum boni amatores sumus, qui filiis nostris etiam nondum natis tam sapienter prospexeris. Iam tibi non solum tua Cornelia, sed et Zelandia tot cantabit libenter: Non meus auratum vellus convexit Jason, clarior ex Medico pulvere surgit honos. Bene vale, et hunc tuum partum tolle, ut multis partubus prosit aliis." Zagarus, in Pratensis, *De uteris*, final verso (unpaginated).

95. A manuscript of Zagarus's legal writing is preserved in the Koninklijke Bibliotheek, Brussel, MS 3344–3448 titled "Lex lecta intellecta," but is primarily a digest of other authors. For Zagarus's biography, see Bietenholz, *Contemporaries of Erasmus*, 3:467; de Vos, "De Latijnse school te Zierikzee"; van Rhijn, "Wilhelmus Sagarus"; van Rhijn, "Wilhelmus Sagarus en Adrianus Barlandus"; and Meertens, *Letterkundig leven*, 38. For a letter on pedagogy from Barlandus to Zagarus, his former teacher, see Daxhelet, *Adrien Barlandus*, 300–307, no. 53. For a letter from Zagarus to Cranevelt about a book he had entrusted to the care of Geldenhouwer, demonstrating that Zagarus and the latter were acquainted, see Ijsewijn, "Litterae ad Craneveldium Balduinianae," 25–26, no. 95. Geldenhouwer also refers to Zagarus as "adulescens litterarum studiosissimus," in his 1514 *De Zelandiae situ*, G4r. For Zovitius's homage to Zagarus, see Zovitius, *Ruth*, A2v–A4v: "M. Guilielmo Zagaro urbis Ziriceae pensionario, ut aiunt, literarumque iurisque consultissimus Iacobus Zovitius Driescharus s[alutem] d[icit]" Zovitius also dedicated a play to Pratensis, praising him as a most learned and talented doctor to the lord of Veere ("doctissimo simul et expertissimo D. M. Jasoni a Pratis Illustrissimi Principis

Veriensis Medico"). See Zovitius, *Didascalus*, A2v–A3r, and Zovitius, *Didascalus: een geleerd en grappig stuk*, 32–33.

96. "Hunc tam praeclarum animi impetum in eo excitarat vir egregie doctus et humanus Michaël Zagrius reipublicae Middelburgensi in Zelandia Belgica ab actis, ubi tum Lombardus forte degebat. Is cum ad officinam summus graphices amator de more venisset: soloecismum forte commissum in inscriptione ad Didus Reginae Carthaginis effigiem apposita Lombardo indicarat, et priscorum artificum doctrinam ex historia naturali Plinii ad caelum laudibus extulerat . . . His Lombardus incredibili cum voluptate auditis, statim sese addiscendis Graecae et Latinae linguae principiis dare coepit." Lampsonius, *Lamberti Lombardi*, 6–7. A modern but inaccurate edition of the Latin text is to be found in Vasari, *Lo Zibaldone*, 209–24, and, for a French translation, see Hubaux and Puraye, "Dominique Lampson, Lamberti Lombardi."

97. For an overview of Pliny's impact, see Blake McHam, *Pliny and the Artistic Culture of the Italian Renaissance*.

98. "Per organa sensuum imagines, et figuras corporum extrinsecus obiectorum suscipit." Pratensis, *De cerebri morbis*, 296. For background on the text and wide circulation of Ficino's writings on this subject, see Ficino, *Three Books on Life*. A copy of Pratensis's *De cerebri morbis* is recorded in the personal library of the Brussels doctor Joris van Zelle, whose portrait by Bernard van Orley is preserved in the Musée des Beaux Arts, Brussels. See Indestege, "Boekbanden," 161.

99. Alberti, *L'architettura*, 805 (IX, iv). See discussion in Musacchio, *The Art and Ritual of Childbirth*, 125–39; Park and Daston, "Unnatural Conceptions"; Park, "Impressed Images: Reproducing Wonders," 262–63; Daston and Park, *Wonders and the Order of Nature*; and Spinks, *Monstrous Births*.

100. "Circa thoros igitur geniales, in quibus dulcissima Veneris palaestra exercetur ac mutuis officiis in generationem bellissimi coniuges concertant, imagines (quantum ars aemulari queat) venustatis eximiae appingantur, ut haustus decor descendat in uterum." Pratensis, *De uteris*, G1r–G1v.

101. "De picturis, quam sint procacia libidinis irritamenta, neminem fugit. Loquacissimae existunt, et earum tacitus sermo saepe descendit altius, acrioraque spicula in medullas usque promittit, quam aliud quicquam. Nota est fabula de iuvene, qui in statua Veneris suae intemperantiae notas reliquit. Tyberius quoque cubiculum habuisse dicitur descriptum picturis (quas Elephantidis libri designabant) lascivioribus. Et in literis proditum est, adhinniuisse equos equae depictae. Igitur ut modis omnibus genitura quaeratur, quae nisi per maris foeminaeque complexum coit, absurdum non putamus, quoad Christiana religio suffert, et

patitur ipsa probitatis ratio, haec et quae conferre creduntur alia, uti in subsidium advocentur." Pratensis, *Liber de arcenda sterilitate*, L4r.

102. Pliny the Elder, *Historia naturalis*, 35.95–96.

103. Pseudo-Lucien, *Erotes*, 16.

104. Suetonius, *Tiberius*, 43.2. Pratensis mentioned Tiberius already in *De uteris* as well, G1v: "Tyberius cubiculum instruxisse dicitur aeditis picturis (quae Elephantidis libri designabant)," but is not explicit in calling the images lascivious.

105. "Videlicet si per aures corrumpimur, ut habet sententia Menandri, non minus nos per oculos corrumpi censendum est, tam enim hac ad animum penetratur quam illac. Eam tu curam domum tuam transfer, ut omnia sint spurcitiae et obscenitati obstructa." Vives, *De officio mariti*, 146, first published in 1529. The translation is taken from ibid., 147.

106. "Quemadmodum non decet in familia audiri sermonem lascivum, ita nec tabulas haberi convenit impudicas. Loquax enim res est tacita pictura et sensim irrepit in animos hominum . . . Et quae non iudicares tutum ad tuendam filiarum filiorumque pudiciam intueri si fierent, quur ea nunquam pateris abesse a conspectu liberorum? Nota est fabula de iuvene qui in statua Veneris suae intemperantiae notas reliquit." Erasmus, *Opera omnia*, 5.6:206–7. Translation from Erasmus, *The Collected Works of Erasmus*, 69:384. See also Weiler, "Erasmus als kunstcriticus."

107. The recent study by Colantuono, *The Renaissance Science of Procreation*, is perhaps too extreme in taking procreation as the primary motivation for the mythological paintings it discusses.

EPILOGUE

1. "Mabuse n'a eu qu'un élève, qui est moi. Je n'en ai pas eu, et je suis vieux! Tu as assez d'intelligence pour deviner le reste, par ce que je te laisse entrevoir." Balzac, *La comédie humaine*, 10:421.

2. Ainsworth, "Gossart in His Artistic Milieu," 22–25; Ainsworth and Vandivere, "*Judith with the Head of Holofernes*."

3. The first section of Balzac's novella "Maître Frenhofer" was published on 31 July 1831, followed by "Catherine Lescault" on 7 August. On the history of the novella, see Balzac, *La comédie humaine*, 10:1401–9. On the journal *L'Artiste*, see Damiron, "La revue L'Artiste," and Edwards, "La revue *L'Artiste* (1831–1904)."

4. "Mabuse seul possédait le secret de donner de la vie aux figures." Balzac, *La comédie humaine*, 10:421.

5. Apart from the 1801 *Notices des tableaux*, no attributions to Gossart appear in the *Notices* from the years 1804, 1810, 1814, or 1837. For the auction records, see Peronnet and Fredericksen, *Répertoire des tableaux vendus*, 480. On the market for Dutch and

Flemish paintings in this period, see also Michel, "French Collectors."

6. For the auction catalogues listing works in Balzac's collection, see *Catalogue des objets d'art* and *Catalogue des Tableaux anciens . . . appartenant à Madam Veuve Honoré de Balzac* (Paris, 1882). For his inventory, which includes paintings attributed to Van Dyck, Adrien Brouwer, Paul Bril, and Paul Rubens, as well as copies or works in the style of Frans van Mieris and Ruisdael, see Balzac, *Lettres de Balzac à Madame Hanska*, 2:1019–51 ("Inventaire dressé par Balzac du mobilier de son hôtel de la rue Fortunée"). See additional discussion in Adhémar, "Balzac et la peinture"; Laubriet, *Un catéchisme esthétique*; Bonard, *La peinture*; Goetz, "Frenhofer et les maîtres"; Boyer and Boyer-Peigné, *Balzac et la peinture*; Wettlaufer, *Pen vs. Paintbrush*; and Knight, *Balzac and the Model of Painting*.

7. See Yeazell, *Art of the Everyday*, 58–90.

8. "Oh! il y a un chef-d'oeuvre d'Holbein! J'ai regretté de ne pas avoir votre main à presser en regardant ce tableau! La *Madone* de Raphaël, on s'y attend; mais le tableau d'Holbein, c'est cet imprévu qui saisit." Balzac, *Lettres de Balzac à Madame Hanska*, 1:721 (19 October 1843). Balzac was responding to the copy of Holbein's *Darmstadt Madonna* by Bartholomäus Sarburgh (inv. no. 1892) that until 1871 was displayed as an original work by the master. See *Die Ausgestellten Werken*, 616.

9. On Balzac's contact with Samuel Henry Berthoud and other members of the Dutch and Flemish community in Paris, see Balzac, *Correspondence*, 384, no. 31.66; Fargeaud, *Balzac et la recherche de l'absolu*, 257–81; and Fargeaud, "Dans le sillage des grands romantiques." For Berthoud's own novella about Jan and Hubert van Eyck's coveted secret of oil painting, see "Légende des frères Van-Eyck," and also Gotlieb, "The Painter's Secret," 480–83.

10. Michaud, *Biographie universelle*, 11:24 ("Demabuse, Jean") and 26:15 ("Mabuse, Jean de"). See also Goetz, "Frenhofer et les maîtres," 71–72. Although Balzac did eventually purchase Descamps, *La vie des peintres flamands*, which also includes a biography of Gossart (83–85), he does not seem to have had this book in his library by 1831. I am grateful to Hervé Yon for his insights into Balzac's personal library and for providing me with the payment record for Balzac's purchase from Wagner & Spachmann booksellers of Michaud's *Biographie universelle*.

11. Félibien, *Entretiens sur les vies*, 2:311–12.

12. Lampsonius, *Pictorum aliquot celebrium*. On Lampsonius, see Puraye, *Dominique Lampson*; Sciolla and Volpi, *Da van Eyck a Brueghel*, 7–27; and Meiers, "Portraits in Print." For complete images and texts from the volume, see http://www.courtauld.org.uk/netherlandishcanon/lampsonius/image-tombstone/index.html.

13. "Tuque adeo nostris saeclum dicere, Mabusi, / Versibus ad graphicen erudisse tuum. / Nam quis ad aspectum pigmenta politius alter / Florida Apelleis illineret tabulis? / Arte aliis, esto, tua tempora cede secutis / Peniculi ductor par tibi, rarus erit." Lampsonius *Pictorum aliquot celebrium*, B1r, no. 7.

14. In this view, Lampsonius echoes Albrecht Dürer's earlier estimation of Gossart's famous Middelburg altarpiece, which the German artist had praised more for its painting than for its design (chap. 1, n. 51).

15. Lampsonius, *Lamberti Lombardi*, A1v.

16. For additional discussion of Zagarus, see chap. 4.

17. "Lombardum ante profectionem non eosdem, quos in graphice, progressus habuisse; cum graphicen ipsam a Belgis Urso, et Mabusio, didicisset, quibus ea ars, ut quidem ab hominibus Italis eius peritissimis Michelangelo Bonaroto, et Bacio Bandinello Florentinis, Raphaële Urbinate, Titiano Veneto, aliisque pulchritudinis, et venustatis rerum omnium aspectabilium imitationem exercebatur, ignota fuisse iure dici potest, propterea quod illorum opera iis laudibus carebant, quae graphicen oculis, atque animis elegantiorum hominum commendant." Lampsonius, *Lamberti Lombardi*, 10.

18. Van Mander, *Lives*, 1:160, fol. 225v.

19. See commentary on fols. 225r44, 225v23–24, and 225v38 in ibid., 3:145, 149, 152. Van Mander uses the adjectives *suyver* and *net* to highlight the singular qualities of both artists' works.

20. "Geschilderde doeken van fijn weefsel, zoals aan kindjes op Mariafiguren, zou men daarentegen nergens beter kunnen zoeken noch vinden dan bij Mabuse, dunkt mij, ongelogen." Van Mander, *Den grondt*, 2:237.

21. "Hy gaet en neemt schoon wit Papier laetter eenen schoonen tabbaert van maken dien hy met schoon Damast-bloemen en fraey werck verciert." Van Mander, *Lives*, 1:160–63, fols. 225v–226. In van Mander's life of Gossart's contemporary Lucas van Leyden, he tells another story of Gossart showing up to an artist's banquet dressed in a resplendent costume of gold and behaving haughtily toward Lucas and all the other guests. See ibid., 1:115–17, fol. 214r–214v.

22. Sallentin, *L'improvisateur français*, 262 (under the entry "Damas"). See also the reference to the anecdote in Chaudon, *Dictionnaire universel*, 10:445–46.

23. Van Mander, *Lives*, 1:160, fol. 225v.

24. Michaud, *Biographie universelle*, 26:15. Balzac, *La comédie humaine*, 10:423: "Mon pauvre maître s'y est surpassé; mais il manquait encore un peu de vérité, s'il se lève et va venir à nous. Mais l'air, le ciel, le vent que nous respirons, voyons et sentons, n'y sont pas. Puis il n'y a encore là qu'un homme! Or le seul homme qui soit immédiatement sorti des mains de Dieu, devait avoir quelque chose de divin qui manque. Mabuse le disait lui-même quand il n'était pas ivre." In evacuating Eve from the picture, Balzac seems to transform the lone mortal Adam in Mabuse's painting into a figuration of Frenhofer himself, struggling to create a female counterpart in his fraught masterwork.

25. On Scorel, see Faries and Helmus, *Centraal Museum Utrecht*, esp. 23–42, 167–69, with prior literature.

26. Van Mander, *Lives*, 1:195–96, fols. 234r–234v ("den Lanteeren-drager en Straet-maker onser Consten in den Nederlanden gheheeten").

27. Ibid., 1:199, fol. 235r.

28. On the essential point that works like those by Lampsonius and van Mander convey truth even through fiction, see Barolsky, *Why Mona Lisa Smiles*, and Barolsky, "Fear of Fiction."

29. See Kemp and Kemp, "Lambert Lombards antiquarische Theorie und Praxis," and Wouk, "Reclaiming the Antiquities of Gaul"; Faries, *Jan van Scorel*; and Faries and Helmus, *Centraal Museum Utrecht*, esp. 170–73 for the painting *The Dying Cleopatra* (Rijksmuseum, Amsterdam, inv. no. 31305) tenuously attributed to Scorel. See also Wouk, "Lambert Suavius," on the c. 1535 painting *Hercules and Cacus* from Lambert Suavius's circle for a rare surviving example of a large-scale mythological painting by a Netherlandish artist—outside Gossart's own oeuvre—dating to the earlier part of the sixteenth century.

30. See Wouk, "Reclaiming the Antiquities of Gaul," esp. 48–49, with prior literature.

31. Cambridge, Fitzwilliam Museum, inv. no. 103, signed and dated 1553. See Filedt Kok, Halsema-Kubes, and Kloek, *Kunst voor de beeldenstorm*, 267–68, no. 148, and for Heemskerck's c. 1553 *St. Luke Painting the Virgin* (Museé des Beaux-Arts de Rennes, Rennes, inv. no. 801.1.6), in which he situates a sculpture courtyard based on Rome's Cassa Sassi in the background, affirming his belief that classical models should be central to artistic practice in the Netherlands. See ibid., 264–66, no. 146, and Bartsch and Seiler, *Rom zeichnen*.

32. On Heemskerck's humanist contacts, see Veldman, *Maarten van Heemskerck*. For penetrating analysis of Heemskerck's diverse sources, see van Tuinen, "The Struggle for Salvation," esp. 149–55.

33. See Jonckheere, "Nudity on the Market," and Jonckheere, *Willem Key*, with additional literature.

34. See Meganck, "Erudite Eyes."

35. For an important overview of Coxcie's career, see Jonckheere, *Michiel Coxcie*. On the copies after early Netherlandish masters, see Suykerbuyk, "Coxcie's Copies," and Tudela, "Michiel Coxcie, Court Painter."

36. Kotková, *The National Gallery in Prague*, 58, no. 25, with prior literature.

37. Jonckheere, *Michiel Coxcie*, 135.

BIBLIOGRAPHY

Aalbers, J., et al. *Heren van stand: Van Wassenaer 1200–2000: achthonderd jaar Nederlandse adelsgeschiedenis*. The Hague: Stichting Hollandse Historische Reeks, 2000.

Adhémar, Jean. "Balzac et la peinture." *Revue des Sciences Humaines* 70 (1953): 149–62.

Agricola, Rudolph. *Letters*. Edited and translated by Adrie van der Laan and Fokke Akkerman. Assen: Koninklijke van Gorcum, 2002.

Ainsworth, Maryan W. "Introduction: Jan Gossart, the 'Apelles of Our Age.'" In *Man, Myth, and Sensual Pleasures: Jan Gossart's Renaissance: The Complete Works*, edited by Maryan W. Ainsworth, 3–7. New York: Metropolitan Museum of Art, 2010.

———. *Jan Gossart's Trip to Rome and His Route to Paragone*. The Hague: Netherlands Institute for Art History, 2014.

———, ed. *Man, Myth, and Sensual Pleasures: Jan Gossart's Renaissance: The Complete Works*. New York: Metropolitan Museum of Art, 2010.

———. "Observations concerning Gossart's Working Methods." In *Man, Myth, and Sensual Pleasures: Jan Gossart's Renaissance: The Complete Works*, edited by Maryan W. Ainsworth, 69–87. New York: Metropolitan Museum of Art, 2010.

———. "The Painter Gossart in His Artistic Milieu." In *Man, Myth, and Sensual Pleasures: Jan Gossart's Renaissance: The Complete Works*, edited by Maryan W. Ainsworth, 9–29. New York: Metropolitan Museum of Art, 2010.

Ainsworth, Maryan W., and Abbie Vandivere. "*Judith with the Head of Holofernes*: Jan Cornelisz Vermeyen's Earliest Signed Painting." *Journal of Historians of Netherlandish Art* 6.2 (2014): http://jhna.org/index.php/past-issues/vol-62-2014/300-judith-with-the-head-of-holofernes.

Alberti, Leon Battista. *L'architettura (de re aedificatoria)*. Edited by Giovanni Orlandi. Milan: Edizioni il Polifilo, 1966.

———. *On Painting and On Sculpture*. Edited and translated by Cecil Grayson. London: Phaidon, 1972.

Albertini, Francisci. *Opusculum de mirabilibus novae urbis Romae*. Edited by August Schmarsow. Heilbronn: Verlag von Gebr. Henninger, 1886.

Alphen, P.J.M. *Nederlandse Terentius-vertalingen in de 16e en 17e eeuw*. Tilburg: Drukkerij Henri Bergmans N. V., 1954.

Alsteens, Stijn. "Jan Gossart as Draftsman." In *Man, Myth, and Sensual Pleasures: Jan Gossart's Renaissance: The Complete Works*, edited by Maryan

W. Ainsworth, 89–103. New York: Metropolitan Museum of Art, 2010.

Van Anrooij, Wim, ed. *De Haarlemse gravenportretten: Hollandse geschiedenis in woord en beeld*. Hilversum: Verloren, 1997.

Aurelius, Cornelius. *Batavia sive de antiquo veroque eius insulae quam Rhenus in Hollandia facit situ, descriptione et laudibus*. Edited by Bonaventura Vulcanius. Antwerp: apud Christophorum Plantinum, 1586.

———. *De cronycke van Hollandt, Zeelandt ende Vrieslant*. Leiden: Jan Seversz, 1517.

Die Ausgestellten Werken. Dresden: Gemäldegalerie Alte Meister, 2005.

Ausstellung Maximilian I. Innsbruck. Innsbruck: Land Tirol, 1969.

Baart, K. *Westkapelle, hare bevolking, Westkapelsche dijk*. Middelburg: J. C. & W. Altorffer, 1889.

Baelde, Michel. "Edellieden en juristen in het centrale bestuur der zestiende-eeuwse Nederlanden (1531–1578)." *Tijdschrift voor Geschiedenis* 80 (1967): 39–51.

Balis, Arnout. "De stroom en de zee. De iconografie van Scaldis en Neptunus in de Antwerpse kunst." *Tijdschrift voor geschiedenis* 123.4 (2010): 504–19.

Balzac, Honoré de. *La comédie humaine*. Edited by Pierre-Georges Castex. 12 vols. Paris: Gallimard, 1976–81.

———. *Correspondance*. Vol. 1, *1809–1835*. Edited by Roger Pierrot and Hervé Yon. Paris: Gallimard, 2006.

———. *Lettres de Balzac à Madame Hanska*. Edited by Roger Pierrot. 2 vols. Paris: Bouquins, 1990.

Banga, J. *De geschiedenis van de geneeskunde en van hare beoefenaren in Nederland, voor en na de stichting der Hoogeschool te Leiden tot aan den dood van Boerhaave, uit de bronnen toegelicht*. Leeuwarden: W. Eekhoff, 1868.

Barkan, Leonard. *The Gods Made Flesh: Metamorphosis and the Pursuit of Paganism*. New Haven, CT: Yale University Press, 1986.

———. *Unearthing the Past: Archaeology and Aesthetics in the Making of Renaissance Culture*. New Haven, CT: Yale University Press, 1999.

Barlandus, Hadrian. *Carolus Burgundus*. In *Hollandiae comitum historia et icones*. Lugduni Batavorum: ex officina Christophori Plantini, 1584.

———. *Complures Luciani dialogi a Desiderio Erasmo Roterodamo viro utriusque linguae doctissimo in Latinum conversi*. Leuven: Theodoricus Martinus, 1512.

———. *Opusculum de insignibus oppidis inferioris Germaniae*. Leuven: apud Petrum Martinum Alostensem, 1524.

Barlandus, Hadrian. *P. Terentii sex comoediae ex diversis antiquis exemplaribus emendatae.* Leuven: ex officina Rutgeri Rescii, 1530.

Barolsky, Paul. "Fear of Fiction: The Fun of Reading Vasari." In *Reading Vasari,* edited by Anne B. Barriault et al., 31–35. London: Philip Wilson Publishers, 2005.

———. *Infinite Jest: Wit and Humor in Italian Renaissance Art.* Columbia: University of Missouri Press, 1978.

———. *Why Mona Lisa Smiles and Other Tales by Vasari.* University Park: Pennsylvania State University Press, 1991.

Barthes, Roland. "Myth Today." In *Mythologies,* translated by A. Lavers, 109–59. New York: Hill and Wang, 1972.

Bartsch, Tatjana, and Peter Seiler, eds. *Rom zeichnen: Maarten van Heemskerck 1532–1536/37.* Berlin: Gebr. Mann Verlag, 2012.

Bass, Marisa. "Batavia, the New World, and the Origins of Man in Jan Mostaert's *Eve and Four Children.*" In *Netherlandish Culture of the Sixteenth Century,* edited by Ethan Matt Kavaler and Anne-Laure van Bruaene. Turnhout: Brepols, forthcoming.

——— . "Jan Gossaert's *Neptune and Amphitrite* Reconsidered." *Simiolus* 35.1 (2011): 61–83.

———. "*Man, Myth and Sensual Pleasures: Jan Gossart's Renaissance,* Maryan Ainsworth et al." *Historians of Netherlandish Art Newsletter and Review of Books* 28 (2011): 26–27.

Baxandall, Michael. "Bartholomaeus Facius on Painting: A Fifteenth-Century Manuscript of *De viris illustribus.*" *Journal of the Warburg and Courtauld Institutes* 27 (1964): 90–107.

———. *Giotto and the Orators: Humanist Observers of Painting in Italy and the Discovery of Pictorial Composition, 1350–1450.* Oxford: Clarendon Press, 1971.

Beatis, Antonio de. *Die Reise des Kardinals Luigi d'Aragona durch Deutschland, die Niederlande, Frankreich und Uberitalien, 1517–1518.* Edited and translated by Ludwig Pastor. Freiburg im Bresigau: Herderysche Berlagshandlung, 1905.

———. *The Travel Journal of Antonio de Beatis: Germany, Switzerland, the Low Countries, France and Italy, 1517–1518.* Edited by J. R. Hale. Translated by J. R. Hale and J.M.A. Lindon. London: The Hakluyt Society, 1979.

Becanus, Joannes Goropius. *Origines Antwerpianae, sive, Cimmeriorum Becceselana novem libros complexa.* Antwerp: ex officina Christophori Plantini, 1569.

Bejczy, István. "Drie humanisten en een mythe: de betekenis van Erasmus, Aurelius en Geldenhouwer voor de Bataafse kwestie." *Tijdschrift voor Geschiedenis* 109 (1996): 467–84.

Belozerskaya, Marina. *Rethinking the Renaissance: Burgundian Arts across Europe.* Cambridge: Cambridge University Press, 2002.

Belting, Hans. *Likeness and Presence: A History of the Image before the Era of Art.* Translated by Edmund Jephcott. Chicago: University of Chicago Press, 1994.

Benesch, Otto. *The Art of the Renaissance in Northern Europe: Its Relation to the Contemporary Spiritual and Intellectual Movements.* Cambridge, MA: Harvard University Press, 1945.

Bergmans, S., et al. *Le siècle de Bruegel: la peinture en Belgique au XVIe siècle.* Brussels: Musées Royaux des Beaux-Arts de Belgique, 1963.

Berthoud, Samuel Henry. "Légende des frères Van-Eyck." *L'Artiste* 2.1 (1839): 24–27.

Van Beylen, J. "Zelandiae descriptio: een merkwaardige tekening van het eiland Walcheren en de visserij op de Noordzee in de 16e eeuw." *Marine Academie van België: Mededelingen* 10 (1956–1957): 81–114.

Bierende, Edgar. *Lucas Cranach d. Ä. und der deutsche Humanismus: Tafelmalerei im Kontext von Rhetorik, Chroniken und Fürstenspiegeln.* Munich: Deutscher Kunstverlag, 2002.

Bietenholz, Peter G. *Contemporaries of Erasmus: A Biographical Register of the Renaissance and Reformation.* Vols. 1–3. Toronto: University of Toronto Press, 1995.

Biondo, Flavio. *De Roma triumphante libri decem.* Venice: per Bernardinum Vercellensem, 1501.

Blacksberg, Leslie Ann. "The Paintings of the Godhead by Jan van Eyck and Gerard David: A Study of Influence and Effect." In *Le dessin sous-jacent dans la peinture, Colloque VIII, 8–10 septembre 1989,* edited by H. Verougstraete-Marcq and R. van Schoute, 57–66. Louvain-la-Neuve: Collège Érasme, 1991.

Blake McHam, Sarah. *Pliny and the Artistic Culture of the Italian Renaissance: The Legacy of the Natural History.* New Haven, CT: Yale University Press, 2013.

Bleyerveld, Yvonne. "Powerful Women, Foolish Men: The Popularity of the 'Power of Women' Topos in Art." In *Women of Distinction: Margaret of York. Margaret of Austria,* edited by Dagmar Eichberger, 167–75. Turnhout: Brepols, 2005.

De blijde ende heerlijcke incomste van mijn-heer Fransois van Vranckrijck. Antwerp: Ten huyse van Christoffel Plantijn, 1582.

Bloemers, J.H.F. "Utrecht en de archeologie van de Romeinse tijd." In *Het Romeinse castellum te Utrecht,* edited by L.R.P. Ozinga, T. K. Hoekstra, M. D. de Weerd, and S. L. Wynia, 25–35. Utrecht: Broese Kemink, 1989.

Bloemers, J.H.F., and M. D. de Weerd. "Van Brittenburg naar Lugdunum: opgravingen in de bouwput van de nieuwe uitwateringssluis in Katwijk, 1982." In *De uitwateringssluizen van Katwijk, 1404–1984,* 41–51. Leiden: Hoogheemraadschap van Rijnland, 1984.

Blom, Peter. "Vesekert en bewaerd. De geschiedenis van het archief van de heren van Veere en bronnen voor het onderzoek naar het markizaat Veere." In *Borselen, Bourgondië, Oranje: heren en markiezen*

van Veere en Vlissingen, edited by Peter Blom, Peter Hendrikx, and Gerrit van Herwijnen, 173–92. Hilversum: Verloren, 2009.

Blonk-van der Wijst, Dick, and Joan Blonk-van der Wijst. *Zelandia comitatus: geschiedenis en cartobibliografie van de provincie Zeeland tot 1860*. Houten: Hes & De Graaf Publishers, 2010.

Boccaccio, Giovanni. *Genealogie deorum gentilium*. Edited by Vittorio Zaccaria. Milan: Arnoldo Mondadori Editore, 1998.

———. *Tutte le opere di Giovanni Boccaccio*. Vol. 10, *De mulieribus claris*. Edited by Vittore Branca. Milan: Arnoldo Mondadori Editore, 1967.

Boccardo, Piero. *Andrea Doria e le arti*. Rome: Palombi, 1989.

Böckem, Beate. "Jacopo de' Barbari: Ein Apelles am Fürstenhof? Die Allianz von Künstler, Humanist und Herrscher im Alten Reich." In *Apelles am Fürstenhof: Facetten der Hofkunst um 1500 im Alten Reich*, edited by Matthias Müller, Klaus Weschenfelder, Beate Böckem, and Ruth Hansmann, 23–33. Berlin: Lukas Verlag, 2010.

Boeckl, Christine M. "The Legend of St. Luke the Painter: Eastern and Western Iconography." *Wiener Jahrbuch für Kunstgeschichte* 54 (2007): 7–37.

Boey, Cornelis. *Urbium Zelandiae comitatum constituentium et reliquarum encomia*. The Hague: in officina A. Tongerloo, 1637.

Bogaers, J. E. "Maar waar zijn de leeuwen van weleer?" *Westerheem* 21.2 (1977): 59–66.

Bonard, Olivier. *La peinture dans la création balzacienne: invention et vision picturales de "La maison du chat-qui-pelote" au "Père Goriot"*. Geneva: Librairie Droz, 1969.

Borchert, Til-Holger. "Color Lapidum: A Survey of Late Medieval Grisaille." In *Jan van Eyck grisallas*, edited by Til-Holger Borchert, 13–49, 239–53. Madrid: Museo Thyssen-Bornemisza, 2009.

Borggrefe, Heiner. "Anatomie, Erotik, Dissimulation: Nackte Körper von Dürer, Baldung Grien und den Kleinmestern." In *Menschenbilder: Beiträge zur Altdeutschen Kunst*, edited by Andreas Tacke und Stefan Heinz, 33–55. Petersburg: Michael Imhof Verlag, 2011.

———. "Die Bildausstattung des Wittenberger Schlosses: Friedrich der Weise, Albrecht Dürer, und die Entstehung einer mythologisch-höfischen Malerei nach italienischem Vorbild." In *Kunst und Repräsentation: Studien zur europäischen Hofkultur im 16. Jahrhundert*, edited by Heiner Borggrefe and Barbara Uppenkamp, 9–68. Bamberg: Weserrenaissance-Museum Schloß, 2002.

Bos, K., and J. W. Bosch. *Landschapsatlas van Walcheren: inspirede sporen van tijd*. Koudekerke: Bos and Böttcher, 2008.

Bosio, Luciano. *La Tabula Peutingeriana: una descrizione pittorica del mondo antico*. Rimini: Maggioli, 1983.

Bosque, A. de. *Mythologie et maniérisme: Italie, Bavière, Fontainebleau, Prague, Pays-Bas: peinture et dessins*. Paris: A. Michel, 1985.

Boucher, Bruce. "Italian Renaissance Terracotta: Artistic Revival or Technological Innovation?" In *Earth and Fire: Italian Terracotta Sculpture from Dontatello to Canova*, edited by Bruce Boucher, 1–31. New Haven, CT: Yale University Press, 2001.

Boyer, Jean-Pierre, and Elisabeth Boyer-Peigné, eds. *Balzac et la peinture*. Tours: Musée des beaux-arts de Tours, 1999.

Bracciolini, Poggio. *De Balneis prope Thuregum sitis*. In *Bains de Bade au XVe siècle*, translated by Antony Méray. Paris: Isidore Liseux, 1876.

Brandenburgh, Chrystel R., and Wilfried A. M. Hessing. *Matilo—Rodenburg—Roomburg. De Roomburgerpolder: van Romeins castellum tot moderne woonwijk*. Leiden: Primavera Pers, 2005.

Braungart, Georg. "Mythos und Herrschaft: Maximilian I. als Hercules Germanicus." In *Traditionswandel und Traditionsverhalten*, edited by Walter Haug and Burghart Wachinger, 77–95. Tübingen: Niemeyer, 1991.

Bresc-Bautier, Geneviève, et al. *France 1500: entre môyen age et renaissance*. Paris: Editions de la Réunion de musées nationaux, 2010.

Breugelmans, R. *Fac et spera: Joannes Maire, Publisher, Printer and Bookseller in Leiden, 1603–1657: A Bibliography of His Publications*. Leiden: Hes & de Graaf Publishers BV, 2003.

Van den Brink, Peter, and Maximiliaan P. J. Martens, eds. *ExtravagAnt: een kwarteeuw Antwerpse schilderkunst herontdekt, 1500–1530*. Antwerp: Koninklijk Museum voor Schone Kunsten, 2005.

Brinkmann, Bodo, ed. *Cranach die Ältere*. Frankfurt am Main: Städel Museum, 2007.

———, ed. *Witches' Lust and the Fall of Man*. Frankfurt: Städel Museum, 2007.

Van den Broecke, J. *Middeleeuwse kastelen van Zeeland: bijzonderheden over verdwenen burchten en riddershofsteden*. Delft: Elmar b.v., 1978.

Brouwer, Marijke. *De Romeinse tijd in Nederland*. Amsterdam: De Bataafsche Leeuw, 1993.

Brower, R. A. "Visual and Verbal Translation of Myth: Neptune in Virgil, Rubens, Dryden." *Daedalus* 101 (1972): 155–82.

Bruchet, Max. *Marguerite d'Autriche, duchesse de Savoie*. Lille: Imprimerie L. Danel, 1927.

Bull, Duncan. "Jan Gossaert and Jacopo Ripanda on the Capitoline." *Simiolus* 35 (2010): 89–94.

Bulst, Wolfger A. "Das Olympische Turnier des Hercules mit den Amazonen. Flämische Tapiserien am Hofe der Este in Ferrara." In *Italienische Frührenaissance und Nordeuropäisches Mittelalter*, edited by Joachim Poeschke, 203–34. Munich: Hirmer Verlag, 1993.

Burger, J. A. Trimpe. "Het kasteel van West-Souburg." *Zeeuws Tijdschrift* 2 (1972): 251–52.

Burger, J. A. Trimpe. . *De Romeinen in Zeeland: onder de hoede van Nehalennia*. Middelburg: Provincie Zeeland, 1997.

Burke, Jill. "Sex and Spirituality in 1500s Rome: Sebastiano del Piombo's *Martryrdom of Saint Agatha*." *Art Bulletin* 88 (2006): 482–95.

Burke, Peter. *The Renaissance Sense of the Past*. London: Edward Arnold, 1969.

Busleyden, Jerome. *Jerome de Busleyden, Founder of the Louvain Collegium Trilingue; His Life and Writings*. Edited by H. de Vocht. Turnhout: Brepols, 1950.

Bussels, Stijn. *Spectacle, Rhetoric and Power: The Triumphal Entry of Prince Philip of Spain into Antwerp*. Amsterdam: Rodopi, 2012.

Cacciotti, Beatrice. "La tradizione degli 'Uomini Illustri' nella collezione di Don Diego Hurtado de Mendoza ambasciatore tra Venezia e Roma (1539–1553)." *Annali del Dipartimento di Storia. Università degli dtudi di Roma Tor Vergata* 1 (2005): 191–253.

Calvete de Estrella, Juan Christóval. *El felicíssimo viaje del muy alto y muy poderoso principe don Phelippe*. Antwerp: en casa de Martin Nucio, 1552.

Campbell, Lorne. *The Fifteenth Century Netherlandish Schools*. London: National Gallery Publications, 1998.

———. "The Patron of Jan Gossaert's 'Adoration of the Kings' in the National Gallery, London." *Burlington Magazine* 152 (2010): 86–89.

———. *The Sixteenth Century Netherlandish Paintings, with French Paintings before 1600*. London: National Gallery Publications, 2014.

Campbell, Stephen. *The Cabinet of Eros*. New Haven, CT: Yale University Press, 2004.

Campbell, Thomas P. *Tapestry in the Renaissance: Art and Magnificence*. New York: Metropolitan Museum of Art, 2002.

Von Campenhausen, Hans Freiherr. "Die Bilderfrage in der Reformation." *Zeitschrift für Kirchengeschichte* 68 (1957): 96–128.

Carl, Doris. "Die Büsten im Kranzgesims des Palazzo Spannocchi in Siena." *Mitteilungen des Kunsthistorischen Instituts in Florenz* 43 (1999): 628–38.

Cartari, Vincenzo. *Le imagini de i dei de gli antichi*. Venice: appresso Giordano Ziletti, e compagni, 1571.

———. *Vincenzo Cartari's "Images of the Gods of the Ancients": The First Italian Mythography*. Translated by John Mulryan. Tempe, AZ: ACMRS, 2012.

Casas, Rafael Domínguez. "Arte y simbología en el capítulo Barcelonés de la Orden del Toisón de Oro (1519)." In *Liber amicorum Raphaël de Smedt*, edited by Joos vander Auwera, 173–203. Leuven: Peeters, 2001.

Cats, Jacob, et al. *Faces augustae*. Lugduni Batavorum: apud Johannem Elsevirium, 1656.

Cauchies, Jean-Marie. *Philippe le Beau: le dernier duc de Bourgogne*. Turnhout: Brepols, 2003.

Cellini, Benvenuto. *Opere di Benvenuto Cellini*. Edited by Giuseppe Guido Ferrero. Turin: Unione Tipografico, 1971.

Celtis, Conrad. *Quattuor libri amorum secundum quattuor latera Germaniae, Germania generalis*. Edited by F. Pindter. Leipzig: Bibliotheca scriptorum medii recentisque aevorum, 1934.

Certeau, Michel de. *The Writing of History*. Translated by Tom Conley. New York: Columbia University Press, 1988.

Châtelet, Albert. *Visages d'Autan: le Recueil d'Arras*. Lathuile: Editions de Gui, 2007.

Chaudon, L. M., ed. *Dictionnaire universel, historique, critique, et bibliographique*. 20 vols. Paris: De l'Imprimerie de Prudhomme Fils, 1810–12.

Christian, Kathleen Wren. *Empire without End: Antiquities Collections in Renaissance Rome, c. 1350–1527*. New Haven, CT: Yale University Press, 2010.

Clark, Kenneth. *The Nude: A Study in Ideal Form*. Princeton, NJ: Princeton University Press, 1956.

De Clippel, Karolien, Katharina van Cauteren, and Katlijne van der Stighelen, eds. *The Nude and the Norm in the Early Modern Low Countries*. Turnhout: Brepols, 2011.

Cockshaw, Pierre, and Christiane van den Bergen-Pantens, eds. *L'Ordre de la Toison d'or, de Philippe le Bon à Philippe le Beau (1430–1505): idéal ou reflet d'une société?* Turnhout: Brepols, 1996.

Coelen, P. van der, "De Bataven in de beeldende kunst." In *De Bataven: verhalen van een verdwenen volk*, 143–87. Amsterdam: De Bataafsche Leeuw, 2004.

Coenen, Daniel. "Carondelet, Jean II." In *Nouvelle Biographie Nationale*, 2:79–83. Brussels: Académie royale des sciences, des lettres et des beaux-arts de Belgique, 1990.

Colantuono, Anthony. *Titian, Colonna and the Renaissance Science of Procreation: Equicola's Seasons of Desire*. Farnham, UK: Ashgate, 2010.

Cole, Michael W. *Cellini and the Principles of Sculpture*. Cambridge: Cambridge University Press, 2002.

Colonna, Francesco. *Hypnerotomachia Poliphili: The Strife of Love in a Dream*. Translated by Joscelyn Godwin. New York: Thames & Hudson, 2005.

Conti, Natali. *Natali Conti's Mythologiae*. Edited and translated by J. Mulryan and S. Brown. 2 vols. Tempe, AZ: ACMRS, 2006.

Cooper, Richard. *Roman Antiquities in Renaissance France, 1515–65*. Farnham, UK: Ashgate, 2013.

Cramer, S., and J. Pijper, eds. *Bibliotheca Reformatoria Neerlandica*. 10 vols. The Hague: M. Nijhoff, 1903–14.

Cranevelt, Frans van. *Literae virorum eruditorum ad Franciscum Craneveldium 1522–1528: A Collection of Original Letters Edited from the Manuscripts and Illustrated with Notes and Commentaries*. Edited by Henry de Vocht. Leuven: Librairie Universitaire, 1928.

Creizenach, Wilhelm. *Geschichte des Neueren Dramas*. Vol. 2. Halle: Verlag von Max Niemeyer, 1918.

Cromhout, Jacob, and Jasper Loskart. *Catalogus van uitmuntende, konstige en plaisante schilderyen*. Amsterdam: Hendrik en de Wed. van Dirk Boom, 1709.

Crossley, Paul. "The Return to the Forest: Natural Architecture and the German Past in the Age of Dürer." In *Künstlerischer Austausch: Artistic Exchange: Akten des XXVIII. Internationalen Kongresses für Kunstgeschichte Berlin, 15–20. Juli 1992*, edited by Thomas W. Gaehtgens, 2:71–80. Berlin: Akademie Verlag, 1993.

Csordas, Thomas J. "Embodiment as a Paradigm for Anthropology." *Ethos* 18.1 (1990): 5–47.

———. "Introduction: The Body as Representation and Being-in-the-World." In *Embodiment and Experience: The Existential Ground of Culture and Self*, edited by Thomas J. Csordas, 1–24. Cambridge: Cambridge University Press, 1994.

Cunnally, John. *Images of the Illustrious: The Numismatic Presence in the Renaissance.* Princeton, NJ: Princeton University Press, 1999.

Cupperi, Walter, Martin Hirsch, Annette Kranz, and Ulrich Pfisterer, eds. *Wettstreit in Erz: Porträtmedaillen der Deutschen Renaissance.* Berlin: Deutscher Kunstverlag, 2013.

Dacos, Nicole. "L'Anonyme A de Berlin: Hermannus Posthumus." In *Antikenzeichnung und Antikenstudium in Renaissance und Frühbarock: Akten des Internationalen Symposions 8.–10. September 1986 in Coburg*, edited by Richard Harprath and Henning Wrede, 61–80. Mainz am Rhein: Verlag Philipp von Zabern, 1989.

Dall'Oco, Sondra. "Poggio, Baden e il 'de Balneis.'" In *Gli umanisti e le terme*, edited by Paola Andrioli Nemola, Olga Silvana Casale, and Paolo Viti, 147–64. Lecce: Conte Editore, 2004.

Van Dam, Fabiola. "*De consideracie des badens.* De badvoorschriften in *Tregement der Ghesontheyt* (1514), de eerste Nederlandse vertaling van Magninus Mediolanensis '*Regimen Sanitatis* (va. 1335).'" In *Kennis-maken: een bloemlezing uit de middelnederlandse artesliteratuur*, edited by Orlanda S. H. Lie and Lenny M. Veltman, 49–71. Hilversum: Verloren, 2008.

Damiron, Suzanne. "La revue L'Artiste: sa fondation, son époque, ses animateurs." *Gazette des Beaux-Arts* 44 (1954): 191–202, 223–26.

Darr, Alan Philipps. "New Documents for Pietro Torrigiani and Other Early Cinquecento Florentine Sculptors Active in Italy and England." In *Kunst des Cinquecento in der Toskana*, 108–38. Munich: Kunsthistorischen Institut in Florenz, 1992.

———. "Pietro Torrigiani and His Sculpture in Henrician England: Sources and Influences." In *The Anglo-Florentine Renaissance: Art for the Early Tudors*, edited by Cinzia Maria Sicca and Louis A. Waldman, 49–80. New Haven, CT: Yale University Press, 2012.

Daston, Lorraine, and Katharine Park. *Wonders and the Order of Nature, 1150–1750.* New York: Zone Books, 1998.

Davidson, Bernice F. "The *Furti di Giove* Tapestries Designed by Perino del Vaga for Andrea Doria." *Art Bulletin* 70.3 (1988): 424–50.

———. "The *Navigatione d'Enea* Tapestries Designed by Perino del Vaga for Andrea Doria." *Art Bulletin* 72 (1990): 35–50.

Daxhelet, Étienne. *Adrien Barlandus: humaniste Belge, 1486–1538, sa vie, son oeuvre, sa personnalité.* Leuven: Librairie Universitaire, 1938.

Decavele, Johan. "Vroege Reformatorische bedrijvigheid in de grote Nederlandse steden: Claes van der Elst te Brussel, Antwerpen, Amsterdam en Leiden (1524–1528)." *Kerkgeschiedenis* 70 (1990): 13–29.

Defoer, H.L.M., and W.C.M. Wüstefeld. *L'art en Hollande au temps de David et Philippe de Bourgogne: trésors du Musée National het Catharijneconvent à Utrecht.* Paris: Institut néerlandais, 1993.

Denhaene, Godelieve. "Les collections de Philippe de Clèves, le goût pour le nu et la Renaissance aux Pays-Bas." *Bulletin de l'Institut historique belge de Rome* 45 (1975): 309–42.

———, ed. *Lambert Lombard: Renaissanceschilder, Luik 1505/06–1566.* Brussels: Koninklijk Instituut voor het Kunstpatrimonium, 2006.

Denucé, J. *De Antwerpsche 'konstkamers': inventarissen van kunstverzamelingen te Antwerpen in de 16e en 17e eeuwen.* The Hague: Martinus Nijhoff, 1932.

———. *Catalogue des manuscrits: catalogus der handschriften.* Antwerp: Veritas, 1927.

Descamps, Jean-Baptiste. *La vie des peintres flamands, allemands et hollandois.* Paris: Charles-Antoine Jombart, Libraire du Roi, 1753.

Van Deventer, Jacob. *De kaarten van de nederlandsche provinciën in de zestiende eeuw.* The Hague: Martinus Nijhoff, 1941.

Dhanens, Elisabeth. *Hubert and Jan van Eyck.* Antwerp: Mercatorfonds, 1980.

Dijkstra, H., and F. C. Ketelaar, *Brittenburg: raadsels rond een verdronken ruïne.* Bussum: C.A.J. van Dishoeck, 1965.

Dodt, J. J. *Archief voor kerkelijke en wereldsche geschiedenissen inzonderheid van Utrecht.* 7 vols. Utrecht: N. van der Monde, 1839–43.

Dogaer, Georges, and Marguerite Debae. *De librije van Filips de Goede.* Brussels: Koninklijke Bibliotheek, 1967.

Dorp, Martin, et al. *Martini Dorpii sacre theologiae licenciati dialogus, in quo Venus et Cupido omnes adhibent versutias: ut Herculem animi ancipitem in suam militiam invita virtute perpellant.* Leuven: Theoderici Martini Alostensis, 1514.

Drossaers, S.W.A., and Th. H. Lunsingh Scheurleer, eds. *Inventarissen van de inboedels in de verblijven van de Oranjes en daarmee gelijk te stellen stukken, 1567–1795.* The Hague: Martinus Nijhoff, 1974.

Duke, Alastair. "The 'Inquisition' and the Repression of Religious Dissent in the Habsburg Netherlands (1521–1566)." In *L'inquisizione: atti del simposio internazionale, Città del Vaticano, 29–31 ottobre 1998*, 419–43. Città del Vaticano: Biblioteca Apostolica Vaticana, 2003.

Duke, Alastair. *Reformation and Revolt in the Low Countries*. London: Hambledon Press, 1990.

Dunbar, Burton L. *German and Netherlandish Paintings 1450–1600*. Kansas City, MO: The Nelson-Atkins Museum of Art, 2005.

Dürer, Albrecht. *Albrecht Dürer, Vier Bücher von menschlicher Proportion (1528)*. Edited and translated by Berthold Hinz. Berlin: Akademie der Wissenschaften, 2011.

———. *Hierin sind begriffen vier bücher von menschlicher Proportion durch Albrechten Dürer von Nürnberg erfunden und beschriben zu nutz allen denen so zu diser kunst lieb tragen*. Nuremberg: Hieronymus Andreae, 1528.

———. *Schriftlicher Nachlass*. Edited by Hans Rupprich. Vol. 1. Berlin: Deutscher Verein für Kunstwissenschaft, 1956.

Duverger, J. "Jacopo de' Barbari en Jan Gossart bij Filips van Burgondie te Souburg (1515)." In *Mélanges Hulin de Loo*, 142–53. Brussels: Librairie Nationale d'Art et d'Histoire, 1931.

———. "Kopieën van het 'Lam-Gods'-retabel van Hubrecht en Jan van Eyck." *Bulletin des Musées royaux des Beaux-Arts* 3.1 (1954): 51–68.

Van Dyck, L. C. "Jan Gossaerts retabel voor het hoogaltaar van de Abdijkerk te Middelburg." In *De Abdij van Tongerlo: gebundelde historische studies*, 649–54. Averbode: Praemonstratensia Vzw., 1999.

Edwards, Peter J. "La revue *L'Artiste* (1831–1904): notice bibliographique." *Romantism* 67 (1990): 110–18.

Egg, Erich. *Die Hofkirche in Innsbruck: Das Grabdenkmal Kaiser Maximilians I und die Silberne Kapelle*. Innsbruck: Tyrolia Verlag, 1974.

Eichberger, Dagmar. "Hoofse hobby's, over humanisme en mecenaat in de vroege 16de eeuw." *Kunstschrift* 1 (2002): 32–37.

———. *Leben mit Kunst, Wirken durch Kunst: Sammelwesen und Hofkunst unter Margarete von Österreich, Regentin der Niederlande*. Turnhout: Brepols, 2002.

———. "Naturalia and Artefacta: Dürer's Nature Drawings and Early Collecting." In *Dürer and His Culture*, edited by Dagmar Eichberger and Charles Zika, 13–37, 212–16. Cambridge: Cambridge University Press, 1998.

———. "Playing Games: Men, Women and Beasts on the Backgammon Board for King Ferdinand I and Queen Anna of Bohemia and Hungary." In *Women at the Burgundian Court: Presence and Influence*, edited by Dagmar Eichberger, Anne-Marie Legaré, and Wim Hüsken, 123–39. Turnhout: Brepols, 2010.

———. "Stilplurismus und Internationalität am Hofe Margaret von Österreichs (1506–1530)." In *Wege zur Renaissance: Beobachtungen zu den Anfängen neuzeitlicher Kunstauffassung im Rheinland und den Nachbargebieten um 1500*, edited by Norbert Nußbaum, Claudia Euskirchen, and Stephan Hoppe, 261–83. Cologne: SH-Verlag, 2003.

Eikelmann, Renate, ed. *Conrat Meit: Bildhauer der Renaissance*. Munich: Hirmer Verlag, 2006.

Enenkel, Karl. "Autobiografie en etnografie: humanistische reisberichten in de Renaissance." In *Reizen en reizigers in de Renaissance: eigen en vreemd in oude en nieuwe werelden*, edited by Karl Enenkel, Paul van Heck, and Bart Westerweel, 32–43. Amsterdam: Amsterdam University Press, 1998.

Erasmus, Desiderius. *The Collected Works of Erasmus*. 86 vols. Toronto: University of Toronto Press, 1974–.

———. *Opera omnia Desiderii Erasmi Roterodami*. Amsterdam: North Holland Pub. Co., 1969–.

———. *Opus epistolarum Des. Erasmi Roterodami*. Edited by S. Allen. 12 vols. Oxford: in typographeo Clarendoniano, 1906–58.

———. *De recta Latini Graecique sermonis pronuntiatione des Erasmi Roterodami dialogus. Eiusdem dialogus cui titulus, Ciceronianus, sive, de optime genere dicendi*. Basel: apud inclytam Basilaeam in officina Frobeniana, 1528.

Erasmus, Desiderius, and Alardus Amstelredamus. *D. Erasmi Roterdami de vitando pernitioso libidinosoque, aspectu carmen bucolicum*. Leyden: Petrus Balenus excudebat, 1538.

Ermerins, Jacobus. *Eenige Zeeuwsche oudheden*. Middelburg, W. Abrahams, 1786.

Esser, R. "'Concordia res parvae crescunt': Regional Histories and the Dutch Republic in the Seventeenth Century." In *Public Opinion and Changing Identities in the Early Modern Netherlands: Essays in Honour of Alastair Duke*, edited by J. Pollmann and A. Spicer, 239–45. Leiden: Brill, 2007.

Étienne, R. *Ténos II: Tenos et les Cyclades*. Paris: Ecole française d'Athènes, 1990.

Étienne, R., and J.-P. Braun. *Ténos I: le sanctuaire de Poseidon et d'Amphitrite*. Paris: Ecole française d'Athènes, 1986.

Ewe, H. *Schiffe auf Siegeln*. Rostock, VEB Hinstorff Verlag, 1972.

Falkenburg, Reindert. *The Land of Unlikeness: Hieronymus Bosch: "The Garden of Earthly Delights"*. Zwolle: W Books, 2011.

Farbaky, Péter, et al. *Matthias Corvinus, the King: Tradition and Renewal in the Hungarian Royal Court, 1458–1490*. Budapest: Budapest History Museum, 2008.

Farbaky, Péter, and Louis A. Waldman. *Italy and Hungary: Humanism and Art in the Early Renaissance*. Milan: Officina Libraria, 2011.

Fargeaud, Madeleine. *Balzac et la recherche de l'absolu*. Paris: Hachette, 1968.

———. "Dans le sillage des grands romantiques: Samuel-Henry Berthoud." *L'Année balzacienne* (1962): 213–43.

Faries, Molly A. "Jan van Scorel, His Style and Its Historical Context." Ph.D. diss., Bryn Mawr College, 1972.

Faries, Molly, and Liesbeth M. Helmus. *Catalogue of Paintings: 1363–1600: Centraal Museum Utrecht*. Utrecht: Centraal Museum, 2011.

Félibien, André. *Entretiens sur les vies et sur les ouvrages des plus excellens peintres anciens et modernes*. 2 vols. Paris: Denys Mariette, 1696.

Ferrari, Simone. *Jacopo de' Barbari: un protagonist del rinascimento tra Venezia e Dürer*. Milan: B. Mondadori, 2006.

Ficino, Marsilio. *Three Books on Life*. Edited and translated by Carol V. Kaske and John R. Clark. Binghamton: Center for Medieval and Early Renaissance Texts and Studies, State University of New York at Binghamton, 1989.

Filedt Kok, Jan Piet. *De dans om het gouden kalf van Lucas van Leyden*. Amsterdam: Nieuw Amsterdam; Rijksmuseum, 2008.

Filedt Kok, Jan Piet, W. Halsema-Kubes, and W. Th. Kloek, eds. *Kunst voor de beeldenstorm*. Amsterdam: Rijksmuseum, 1986.

Finot, Jules. *Inventaire sommaire des archives départementales antérieres à 1790. Nord: archives civiles, série B*. Vol. 8. Lille: Imprimerie de L. Danel, 1895.

Fiorenza, Giancarlo. *Dosso Dossi: Paintings of Myth, Magic and the Antique*. University Park: Pennsylvania State University Press, 2008.

Foister, Susan. "Cranachs Mythologien. Quellen und Originalität." In *Lucas Cranach: Glaube, Mytholgie und Moderne*, edited by Werner Schade, 116–29. Hamburg: Bucerius Kunst Forum, 2003.

Fokker, Adr. A., and J. C. de Man. *Levensberichten van Zeeuwsche medici*. Middelburg: Zeeuwsch Genootschap der Wetenschap, 1901.

Foncke, Elza. "Aantekeningen betreffende Hieronymus van Busleyden, zijn paleis te Mechelen, de kollekties en de muurschilderingen aldaar vorhanden." *Gentsche Bijdragen tot de Kunstgeschiedenis* 5 (1938): 177–220.

Fontaine, Marie Madeleine. "Antiquaires et rites funéraires." In *Les funérailles à la Renaissance: XIIie colloque international de la Société française d'étude du seizième siècle, Bar-le-Duc, 2–5 décembre 1999*, edited by Jean Balsamo, 329–55. Geneva: Droz, 2002.

———. "Olivier de la Marche and Jean Lemaire de Belges." In *Women of Distinction: Margaret of York. Margaret of Austria*, edited by Dagmar Eichberger, 221–29. Turnhout: Brepols, 2005.

Foucault, Michel. *The Archaeology of Knowledge and the Discourse on Language*. Translated by A. M. Sheridam Smith. New York: Pantheon Books, 1972.

———. "Nietzsche, Genealogy, History." In *Language, Counter-Memory, Practice: Selected Essays and Interviews*, edited and translated by Donald F. Bouchard, 139–64. Ithaca, NY: Cornell University Press, 1977.

Fredericq, P., ed. *Corpus documentorum inquisitionis haereticae pravitatis Neerlandicae: verzameling van stukken betreffende de pauselijke en bisschoppelijke inquisitie in de Nederlanden*. 5 vols. Ghent: J. Vuylsteke, 1889–1902.

Friedländer, Max. J. *Early Netherlandish Painting*, 12 vols. Leiden: A. W. Sijthoff, 1967–76.

Fruin, R. *De leenregisters van bewesten Schelde, 1470–1535*. The Hague: M. Nijhoff, 1911.

Fühner, Jochen A. *Die Kirchen- und die Antireformatorische Religionspolitik Kaiser Karls V. in den Siebzehn Provinzen der Niederlande, 1515–1555*. Leiden: Brill, 2004.

Fulgentius. *Fulgentius the Mythographer*. Translated by Leslie George Whitbread. Columbus: Ohio State University Press, 1971.

Furlotti, Barbara, and Guido Rebecchini. *The Art of Mantua: Power and Patronage in the Renaissance*. Translated by A. Lawrence Jenkens. Los Angeles: J. Paul Getty Museum, 2008.

Galand, Alexandre. *The Bernard van Orley Group*. Vol. 6 of *The Flemish Primitives*. Brussels: Royal Museums of Fine Arts of Belgium, 2013.

Galera, M. *Antoon van den Wijngaerde, pintor de ciudades y de hechos de armas en la Europa del quinientos: cartobibliografía razonada de los dibujos y grabados*. Madrid: Fundación Carlos de Amberes, 1998.

Galvin, Carol, and Phillip Lindley. "Pietro Torrigiani's Portrait Bust of King Henry VII." *Burlington Magazine*, no. 1029 (1988): 892–902.

Gargon, M. *Walchersche arkadia, waar in oorspronk, heerlijkheden, ambachten, etc., van Walcheren nagespoord en opgehelder zijn*. Leiden: Samuel Luchtmans, 1746.

Gauricus, Pomponius. *De sculptura (1504)*. Edited and translated by André Chastel and Robert Klein. Geneva: Libraire Droz, 1969.

———. *Pomponii Gaurici Neapolitani, viri undecunque doctissimi, de sculptura seu statuaria*. Antwerp: apud Joannem Grapheum, 1528.

Geldenhouwer, Gerard. *Collectanea van Gerardus Geldenhauer Noviomagus*. Edited by J. Prinsen. Amsterdam: J. Müller, 1901.

———. *De Zelandiae situ*. In Martin Dorp et al., *Martini Dorpii sacre theologiae licenciati dialogus, in quo Venus et Cupido omnes adhibent versutias: ut Herculem animi ancipitem in suam militiam invita virtute perpellant*. Leuven: Theoderici Martini Alostensis, 1514.

———. *Gerard Geldenhouwer van Nijmegen (1482–1542): Historische werken: Lucubratiuncula de Batavorum insula, Historia Batavica, Germaniae inferioris historiae, Germanicorum historiarum illustratio*. Edited and translated by István Bejczy, Saskia Stegeman, and Michiel Verweij. Hilversum: Verloren, 1998.

———. *Historia Batavica, cum appendice de vetustissima nobilitate, regibus, ac gestis Germanorum*. Argentorati: apud Chr. Aegen., 1530.

———. *Lucubratiuncula Gerardi Noviomagi de Batavorum insula*. Antwerp: per Michaelem Hillenium, 1520.

Geldenhouwer, Gerard. *Pompa exequiarum Catholici Hispaniarum regis Ferdonandi*. Leuven: in aedibus Theodorici Martini Alustensis, 1516.

———. *Satyrae octo ad verae religionis cultores*. Leuven: Theodoricus Martinus Alustensis, 1515.

———. *Vita clarissimi principis, Philippi a Burgundia*. Strasbourg: apud Christianum Aegenolphum, 1529.

Van Genderen, A. J. van den Hoven. "Willem Heda (ca. 1460–1525), kroniekschrijver, kanunnik en humanist." In *Utrechtse biografieën: levensbeschrijvingen van bekende en onbekende Utrechters*, edited by J. Aalberts, 63–68. Amsterdam: Boom, 1995.

Giraldi, Lilio Gregorio. *De deis gentium, 1548*. New York: Garland, 1976.

Gittenberger, F., and H. Weiss. *Zeeland in oude kaarten*. Tielt: Lannoo, 1983.

Giuliano, Antonio, ed. *Museo Nazionale Romano: Le sculture*. Rome: De Luca Editore, 1979.

Goetz, Adrien. "Frenhofer et les maîtres d'autrefois." *L'Année balzacienne* 15 (1994): 69–89.

Goffen, Rona. *Titian's Women*. New Haven, CT: Yale University Press, 1997.

Gombrich, Ernst H. "The Earliest Description of Bosch's Garden of Delight." *Journal of the Warburg and Courtauld Institutes* 30 (1967): 403–6.

Goodey, R. "Mapping 'Utopia': A Comment on the Geography of Sir Thomas More." *Geographical Review* 60 (1970): 15–30.

Goosens, Aline. *Les inquisitions modernes dans les Pays-Bas méridionaux, 1520–1633*. Brussels: Editions del'Université de Bruxelles, 1997.

Goossens, Korneel. "Janus Secundus als medailleur." *Jaarboek van het Koninklijk Museum voor Schone Kunsten* (1970): 29–84.

Gossart, Maurice. *Un des peintres peu connus de l'école flamande de transition, Jean Gossart de Maubeuge, sa vie et son oeuvre*. Lille: Editions du Beffroi, 1902–3.

Gotlieb, Marc. "The Painter's Secret: Invention and Rivalry from Vasari to Balzac." *Art Bulletin* 84.3 (2002): 469–90.

Gottschalk, M.K.E. *Stormvloeden en rivieroverstromingen in Nederland*. Vol. 2. Assen: Gorcum, 1971–77.

Grafton, Anthony. *Forgers and Critics: Creativity and Duplicity in Western Scholarship*. Princeton, NJ: Princeton University Press, 1990.

Grapheus, Cornelius. *De nomine florentissimae civitatis Antverpiensis*. Antwerp: Ioannes Grapheus excudebat, 1527.

———. *Divi Caroli imperatori Caesari optimo maximo desyderatissimus ex Hispania in Germaniam reditus*. Antwerp, 1520.

———. *Latinissimae colloquiorum formulae, ex Terentii comoediis selectae, ac in Germanicam linguam versae*. Augustae Vindelicorum, 1532.

———. *De seer wonderlijcke, schoone, triumphelijcke incompst van de hooghmogenden Prince Philips, Prince van Spaignen*. Antwerp: voer Peeter Coecke van Aelst, gesworen printere, by Gillis van Dies, 1549.

———. *Terentianae phraseos flosculi*. Antwerp: Ioannes Grapheus excudebat, 1530.

Green, Monica. *Making Women's Medicine Masculine: The Rise of Male Authority in Pre-modern Gynaecology*. Oxford: Oxford University Press, 2008.

———. "The Sources of Eucharius Rösslin's 'Rosegarden for Pregnant Women and Midwives' (1513)." *Medical History* 53 (2009): 167–92.

Greene, Thomas M. "Resurrecting Rome: The Double Task of the Humanist Imagination." In *Rome in the Renaissance: The City and the Myth. Papers of the Thirteenth Annual Conference of the Center for Medieval and Early Renaissance Studies*, edited by P. A. Ramsey, 41–54. Binghamton, NY: Medieval and Renaissance Texts and Studies, 1982.

Groenveld, S., and A. H. Huussen Jr.. "De zestiende-eeuwse landmeter Jaspar Adriaensz. en zijn kartografisch werk." *Hollandse Studiën* 8 (1975): 131–77.

Gruben, Françoise de. *Les chapitres de la Toison d'Or à l'époque bourguignonne (1430–1477)*. Leuven: Leuven University Press, 1997.

Grudius, Nicolaus, Hadrianus Marius, and Janus Secundus. *Poemata et effigies trium fratrum Belgarum*. Edited by Luschius Antonius Vicentinus and Dominicus Lampsonius Brugensis. Lugduni Batavorum: apud Ludovicum Elsevirium, 1612.

Guérin-Beauvois, Marie, and Jean-Marie Martin, eds. *Bains curatifs et bains hygiéniques en Italie de l'Antiquité au Moyen Âge*. Rome: Ecole française de Rome, 2007.

Guicciardini, Ludovico. *Descrittione di tutti i Paesi Bassi, altrimenti detti Germania Inferiore*. Antwerp: apresso Guglielmo Silvio, Stampatore Regio, 1567.

———. *Descrittione di tutti i Paesi Bassi, altrimenti detti Germania Inferiore*. Antwerp: apresso Christofano Plantino, 1581.

Gumbrecht, Hans Ulrich. *Production of Presence: What Meaning Cannot Convey*. Stanford, CA: Stanford University Press, 2004.

Hamburger, Jeffrey. "Art History Reviews XI: Hans Belting's 'Bild und Kult: Eine Geschichte des Bildes vor dem Zeitalter der Kunst,' 1990." *Burlington Magazine* 153.1294 (January 2011): 40–45.

Hand, John Oliver, Catherine A. Metzger, and Ron Spronk. *Prayers and Portraits: Unfolding the Netherlandish Diptych*. Washington, DC: National Gallery of Art, 2006.

Hanzer, Helene. "Zur Büste eines Jungen Mannes aus polychromierter Terrakotta Conrat Meit zugeschrieben." *Technologische Studien: Kunsthistorisches Museum* 1 (2004): 52–69.

Harbison, Craig. "Miracles Happen: Image and Experience in Jan van Eyck's *Madonna in a Church*." In *Iconography at the Crossroads: Papers from the Colloquium Sponsored by the Index of Christian Art, Princeton University, 23–24 March 1990*, edited by Brendan Cassidy, 157–66. Princeton, NJ: Index of

Christian Art, Department of Art and Archaeology, Princeton University, 1993.

Härting, Ursula. *Frans Francken II*. Freren: Luca Verlag, 1989.

Haskell, Francis. *History and Its Images: Art and the Interpretation of the Past*. New Haven, CT: Yale University Press, 1993.

Hayum, Andrée. "Dürer's Portrait of Erasmus and the Ars Typographorum." *Renaissance Quarterly* 38.4 (1985): 650–87.

Heda, Wilhemus. *Historia episcoporum Trajectensium*. Franequerae: excudebat Rombertus Doyema, 1612.

Van der Heijden, H. "De Bataven in de cartographie van de zestiende tot negentiende eeuw." In *De Bataven: verhalen van een verdwenen volk*, 108–33. Amsterdam: De Bataafsche Leeuw, 2004.

Hendrikman, Lars. "Verknipte interpretatie: Rafaels invloed op het oeuvre van Bernard van Orley heroverwogen." In *Polyptiek: een veeluik van Groninger bijdragen aan de kunstgeschiedenis* Zwolle: Waanders, 2002.

Herbenus, Matthaeus. *Over hersteld Maastricht (De Trajecto instaurato) vertaald naar het handschrift no. 200 van de Gemeentelijke Archiefdienst Maastricht*. Translated by M.G.M.A. van Heyst. Roermond: Stichting Instituut voor Genealogie en Streekgeschiedenis, 1985.

Herbrüggen, Hubertus Schulte, ed. *Morus ad Craneveldium: litterae Balduinianae novae*. Leuven: Leuven University Press, 1997.

Heringuez, Samantha. "L'architecture antique dans le *Neptune et Amphitrite* de Jean Gossart." *Journal de la Renaissance* 6 (2008): 107–18.

———. "Bramante's Architecture in Jan Gossart's Painting." *Dutch Crossing* 35.3 (2011): 229–48.

Herklotz, Ingo. "Arnaldo Momigliano's 'Ancient History and the Antiquarian': A Critical Review." In *Momigliano and Antiquarianism: Foundations of Modern Cultural Sciences*, edited by Peter N. Miller, 127–53. Toronto: University of Toronto Press, 2007.

Herrmann, Frank. "Peel and Solly: Two Nineteenth-Century Art Collectors and Their Sources of Supply." *Journal of the History of Collections* 3.1 (1991): 92–94.

Herzog, Sadja. "Tradition and Innovation in Gossart's Neptune and Amphitrite and Danae." *Bulletin Museum Boymans van Beuningen* 19 (1968): 25–41.

Hessing, W.A.M. "De Romeinen in Utrecht." In *Geschiedenis van de provincie Utrecht*, vol. 1, *tot 1528*, 42–58. Utrecht: Uitgeverij het Spectrum, Stichtse Historische Reeks, 1997.

Hindriks, Sandra. "Der 'vlaemsche Apelles'. Jan van Eycks früher Ruhm und die niederländische 'Renaissance.'" Ph.D. diss., University of Bonn, 2015.

Hoff, B. van 't. *Jacob van Deventer, keizerlijk-koninklijk geograaf*. The Hague: Nijhoff, 1953.

Hollegger, Manfred. "Personality and Reign: The Biography of Emperor Maximilian I." In *Emperor Maximilian I and the Age of Dürer*, edited by Eva Michel and Maria Luise Sternath, 23–35. Vienna: Albertina, 2013.

Hollstein, F.W.H. *Dutch and Flemish Etchings, Engravings, and Woodcuts, ca. 1450–1700*. 72 vols. Amsterdam: Menno Hertzberger, 1949–2010.

Hoogewerff, G. J. *Nederlandsche schilders in Italië in de XVIe eeuw: de geschiedenis van het Romanisme*. Utrecht: A. Oosthoek, 1912.

Van Hoorn, C. M. "Levinus Lemnius, 1505–1568: zestiende-eeuws Zeeuws geneesheer." Ph.D. diss., Vrije Universiteit Amsterdam, 1978.

———. "Vijf eeuwen pharmacie in Zierikzee." *Bulletin van de Kring voor de Geschiedenis van de Pharmacie in de Benelux* 76 (1989): 1–77.

———. "Zierikzeese medici vanaf de veertiende eeuw tot circa 1600." *Archief. Mededelingen van het Koninklijk Zeeuwsch Genootschap der Wetenschappen* (1990): 45–76.

Hoppe, Stephan. "Die Antike des Jan van Eyck. Architektonische Fiktion und Empirie im Umkreis des burgundischen Hofs um 1435." In *Persistenz und Rezeption. Weiterverwendung, Wiederverwendung und Neuinterpretation antiker Werke im Mittelalter*, edited by Dietrich Boschung and Susanne Wittekind, 351–94. Wiesbaden: Reichert Verlag, 2008.

———. "Northern Gothic, Italian Renaissance and Beyond: Toward a Thick Description of Style." In *Le gothique de la Renaissance: actes des quatrième rencontres d'architecture européenne, Paris, 12–16 juin 2007*, edited by Monique Chatenet, 47–64. Paris: Picard, 2011.

———. "Romanik als Antike und die baulichen Folgen. Mutmaßungen zu einem in Vergessenheit geratenen Diskurs." In *Wege zur Renaissance: Beobachtungen zu den Anfängen neuzeitlicher Kunstauffassung im Rheinland und den Nachbargebieten um 1500*, edited by Norbert Nußbaum, Claudia Euskirchen, and Stephan Hoppe, 89–131. Cologne: SH-Verlag, 2003.

Van der Horst, Koert. "Willem Heda and the Edition of His *Historia Episcoporum Ultrajectensium*." *Quaerendo* 33 (2003): 267–68.

Howell Jolly, Penny. *Picturing the "Pregnant" Magdalene in Northern Art, 1430–1550: Addressing and Undressing the Sinner-Saint*. Farnham, UK: Ashgate, 2014.

Hubaux, Jean, and Jean Puraye. "Dominique Lampson, Lamberti Lombardi . . . vita: traduction et notes." *Revue belge d'archologie et d'histoire de l'art* 18 (1949): 53–77.

Huizinga, Johan. *The Autumn of the Middle Ages*. Translated by Rodney J. Payton and Ulrich Mammitzsch. Chicago: University of Chicago Press, 1996.

———. "Erasmus über Vaterland und Nationen." In *Verzamelde Werken*, 9 vols., 6:252–67. Haarlem: H. D. Tjeenk Willink, 1948–53.

———. "The Problem of the Renaissance." In *Men and Ideas: History, the Middle Ages, the Renaissance*,

translated by James S. Holmes and Hans van Marle, 243–87. New York: Harper & Row, 1959.

D'Hulst, R.-A. *Jacob Jordaens*. Ithaca, NY: Cornell University Press, 1982.

Von Hutten, Ulrich. *In laudem reverendissimi Alberthi Archepiscopi Moguntini Ulrichi de Hutten equitis panegyricus*. Tübingen: apud Thomam Anshelmum Badensem, 1515.

———. *Ulrichi Hutteni equitis Germani opera quae reperiri potuerunt omnia*. 5 vols. Eduardus Böcking. Lipsiae: in aedibus Teubnerianis, 1859–70.

Huussen, A. H. "Willem Hendricxz. Croock, Amsterdam stadsfabriekmeester, schilder en kartograaf in de eerste helft van de zestiende eeuw." *Jaarboek van het Genootschap Amstelodamum* 64 (1972): 29–53.

Ijsewijn, Jozef. "The Coming of Humanism to the Low Countries." In *Itinerarium Italicum: The Profile of the Italian Renaissance in the Mirror of Its European Transformations*, edited by Heiko A. Oberman and Thomas A. Brady, 193–301. Leiden: E. J. Brill, 1975.

———. "Martinus Dorpius, Dialogus (ca. 1508?)." In *Charisterium H. de Vocht 1878–1978*, edited by J. Ijsewijn and J. Roegiers, 74–101. Leuven: Leuven University Press, 1979.

Ijsewijn, Jozef, et al. "Litterae ad Cranveldium Balduinianae. A Preliminary Edition. 4. Letters 86–116 (November 1521–June 1522; April 1523; November 1528)." *Humanistica Lovaniensia* 44 (1995): 1–78.

Ijsewijn, Jozef, and Gilbert Tournoy, eds. "Litterae ad Cranveldium Balduinianae: A Preliminary Edition. 1. Letters 1–30 (March 1520–February 1521)." *Humanistica Lovaniensia* 41 (1992): 1–85.

Ilchman, Frederick. *Titian, Tintoretto, Veronese: Rivals in Renaissance Venice*. Boston: Museum of Fine Arts, 2009.

Indestege, Luc. "Boekbanden uit het bezit van de Brusselse dokter Joris van Zelle (1491–1567)." *Bulletin Koninklijke Musea voor Schone Kunsten* (1959): 149–62.

In laudem reverendissimi in Christo patris atque illustrissimi principis ac domini Domini Philippi de Burgundia episcopi Traiectini. Deventer: in officina Jacobi de Breda, 1517.

Jacks, Philip. *The Antiquarian and the Myth of Antiquity: The Origins of Rome in Renaissance Thought*. Cambridge: Cambridge University Press, 1993.

Jacobowitz, Ellen S., and Stephanie Loeb Stepanek. *The Prints of Lucas van Leyden and His Contemporaries*. Washington, DC: National Gallery of Art, 1983.

Jacobs, Lynn F. *Opening Doors: The Early Netherlandish Triptych Reinterpreted*. University Park: Pennsylvania State University Press, 2012.

Jardine, Lisa. *Erasmus, Man of Letters: The Construction of Charisma in Print*. Princeton, NJ: Princeton University Press, 1993.

Jonckheere, Koenraad. *Antwerp Art after Iconoclasm: Experiments in Decorum, 1566–1585*. Brussels: Mercatorfonds, 2012.

———, ed. *Michiel Coxcie 1499–1592 and the Giants of His Age*. London: Harvey Miller Publishers, 2013.

———. "Nudity on the Market: Some Thoughts on the Market and Innovations in Sixteenth-Century Antwerp." In *Aemulatio: Imitation, Emulation and Invention in Netherlandish Art from 1500–1800: Essays in Honor of Eric Jan Sluijter*, edited by Anton W. A. Boschloo et al., 25–36. Zwolle: Waanders, 2011.

———. *Willem Key (1516–1568): Portrait of a Humanist Painter*. Turnhout: Brepols, 2011.

De Jong, Erik. *Nature and Art: Dutch Garden and Landscape Architecture, 1650–1740*. Philadelphia: University of Pennsylvania Press, 2000.

De Jong, Neeltje. "Den Roseghaert vanden bevruchten vrouwen: een middelnederlandse vertaling van der Rosengarten (uit 1513) met toevoegingen van een Antwerpse bewerker." Ph.D. diss., Universiteit Utrecht, 2006.

De Jonge, Krista. "*Anticse wercken*: Architecture in the Antique Manner 1500–1530." In *Unity and Discontinuity: Architectural Relations between the Southern and Northern Low Countries 1530–1700*, edited by Krista de Jonge and Konrad Ottenheym, 21–40. Turnhout: Brepols, 2007.

———. "Estuves et baingneries dans les résidences flamandes des ducs de Bourgogne." *Bulletin Monumental* 159 (2001): 63–76.

———. "Style and Manner in Early Modern Netherlandish Architecture (1450–1600): Contemporary Sources and Historiographical Tradition." In *Stil als Bedeutung: Stil als Bedeutung in der nordalpinen Renaissance*, edited by Stephan Hoppe and Matthias Müller, 264–85. Regensburg: Schnell & Steiner, 2008.

Jongste, Peter F. B. *The Twelve Labours of Hercules on Roman Sarcophagi*. Rome: L'Erma di Bretschneider, 1992.

Jung, Marc René. *Hercule dans la littérature française du XVIe siècle: de l'Hercule courtois a l'Hercule Baroque*. Geneva: Droz, 1966.

Junius, Hadrianus. *Batavia*. Lugduni Batavorum: ex officina Plantiniana, 1588.

Kaempf-Dimitriadou, S. "Amphitrite." In *Lexicon Iconographicum Mythologiae Classicae (LIMC)*, 1:724–25. Zürich: Artemis, 1981–2009.

Karrow, Robert W. *Mapmakers of the Sixteenth Century and Their Maps: Bio-bibliographies of the Cartographers of Abraham Ortelius, 1570: Based on Leo Bagrow's A. Ortelii Catalogus Cartographorum*. Chicago: Speculum Orbis Press, 1993.

Kavaler, Ethan Matt. "Being the Count of Nassau: Refiguring Identity in Space, Time, and Stone." *Nederlands Kunsthistorisch Jaarboek* 46 (1995): 12–51.

———. "Gossart as Architect." In *Man, Myth, and Sensual Pleasures: Jan Gossart's Renaissance: The Complete Works*, edited by Maryan W. Ainsworth, 31–43. New York: Metropolitan Museum of Art, 2010.

———. "Gossart's Bodies and Empathy." *Journal of Historians of Netherlandish Art* 5.2 (2013): http://www .jhna.org/index.php/past-issues/volume-5-issue-2-2013/196-gossarts-bodies-and-empathy.

———. "Gothic as Renaissance: Ornament, Excess, and Identity, circa 1500." In *Renaissance Theory*, edited by James Elkins and Williams Robert, 115–57. New York: Routledge, 2008.

———. "Margaret of Austria, Ornament, and the Court Style of Brou." In *Artists at Court: Image-Making and Identity, 1300–1550*, edited by Stephen J. Campbell, 124–37. Boston: Isabella Stewart Gardner Museum, 2004.

———. *Renaissance Gothic*. New Haven, CT: Yale University Press, 2012.

———. "Renaissance Gothic in the Netherlands: The Uses of Ornament." *Art Bulletin* 82.2 (June 2000): 226–51.

———. "Renaissance Gothic: Pictures of Geometry and Narratives of Ornament." *Art History* 29 (2006): 1–46.

Kemp, Ellen, and Wolfgang Kemp. "Lambert Lombards antiquarische Theorie und Praxis." *Zeitschrift für Kunstgeschichte* 36 (1973): 122–52.

Kesteloo, H. M. "De stadsrekeningen van Middelburg III, 1500–1549." *Archief: vroegere en latere mededeelingen voornamelijk in betrekking tot Zeeland uitgegeven door het Zeeuwsch Genootschap der Wetenschappen* 6 (1888): 20–426.

Kik, Oliver G. "Bramante in the North: Antiquity in the Low Countries (1500–1539)." In *Portraits of the City: Representing Urban Space in Later Medieval and Early Modern Europe*, edited by Katrien Lichtert, Jan Dumolyn, and Maximiliaan P. J. Martens, 97–112. Turnhout: Brepols, 2014.

De Klerk, A. P. "Afwatering en dijkzorg in de periode 1396–1574: een gevecht op twee fronten." In *Duizend jaar Walcheren: over gelanden, heren en geschot, over binnen- en buitenbeheer*, edited by A. Hendrikx et al., 37–52. Middelburg: Koninklijk Zeeuwsch Genootschap der Wetenschappen, 1996.

———. *Het Nederlandse landschap, de dorpen in Zeeland en het water op Walcheren*. Utrecht: Matrijs, 2003.

Knight, Diana. *Balzac and the Model of Painting: Artist Stories in 'La Comédie Humaine'*. Legenda: Research Monographs in French Studies, 2007.

Knuttel, W.P.C. *Catalogus van de pamfletten-verzameling berustende in de Koninklijke Bibliotheek, 1486–1853*. 9 vols. The Hague: Koninklijke Bibliotheek, 1889–1920.

Koch, Guntram, and Hellmut Sichtermann. *Römische Sarkophage*. Munich: C. H. Beck, 1982.

Koepplin, Dieter, and Tilman Falk. *Lukas Cranach: Gemälde, Zeichnungen, Druckgraphik*. 2 vols. Basel; Birkhäuser Verlag, 1976.

Koerner, Joseph Leo. "Bosch's Equipment." In *Things That Talk: Object Lessons from Art and Science*, edited by Lorraine Daston, 27–65. New York: Zone Books, 2004.

———. *The Moment of Self-Portraiture in German Renaissance Art*. Chicago: University of Chicago Press, 1993.

———. *The Reformation of the Image*. Chicago: University of Chicago Press, 2003.

Kohl, Jeanette. "Talking Heads. Reflexionen zu einer Phänomenologie der Büste." In *Kopf / Bild: Die Büste in Mittelalter und Früher Neuzeit*, edited by Jeanette Kohl and Rebecca Müller, 9–30. Munich: Deutscher Kunstverlag, 2007.

Köhler, Wilhelm H. "Die Sammlung Solly, Merkmale und Kennzeichen Ihrer Bilder." In *Frühe Italienische Malerei: Gemäldegalerie Berlin, Katalog der Gemälde*, edited by Miklós Boskovits, translated by Erich Schleier, 185–86. Berlin: Gebr. Mann Verlag, 1988.

König, Eberhard. "Gossaerts Neptun und Amphritite: Eine Eyckische Renaissance." In *'Als Ik Can': Liber Amicorum in Memory of Professor Dr. Maurits Smeyers*, edited by Bert Cardon, Jan van der Stock, and Dominique Vanwijnsberghe, 743–55. Paris: Peeters, 2002.

Kooperberg, L.M.G. "Anna van Borssele, haar geslacht en haar omgeving." *Archief vroegere en latere mededeelingen voornamelijk in betrekking tot Zeeland* (1938): 1–88.

Korteweg, Anne S. *Boeken van Oranje-Nassau: de bibliotheek van de graven van Nassau en prinsen van Oranje in de vijftiende en zestiende eeuw*. The Hague: Koninklijke Bibliotheek, 1998.

Kotková, Olga. *The National Gallery in Prague. Illustrated Summary Catalogue. Netherlandish Painting 1480–1600*. Prague: National Gallery in Prague, 1999.

Kotková, Olga, and Adam Pokorný. "Technological Research into the Painting, *St Luke Drawing the Virgin*, by Jan Gossaert, called Mabuse." *Bulletin of the National Gallery in Prague* 18–19 (2008–9): 31–41.

Kristeller, Paul Oskar, et al. *Catalogus translationum et commentariorum: Mediaeval and Renaissance Latin Translations and Commentaries*. 10 vols. Washington, DC: Catholic University of America Press, 1960–.

Kronenberg, M. E. "Uitgaven van Luther in de Nederlanden, verschenen tot 1541." *Nederlands Archief voor Kerkgeschiedenis* 40 (1954): 1–25.

Lacroix, Paul. "Inventaire des joyaux de la couronne de France." *Revue universelle des arts* 3 (1856): 334–50.

Lamattina, G. *Crisostomo Colonna tra gli umanisti e i reali di Napoli*. Salerno: Dottrinari, 1982.

Lampsonius, Dominicus. *Lamberti Lombardi apud Eburones pictoris celeberrimi vita*. Bruges: H. Goltzius, 1565.

———. *Pictorum aliquot celebrium Germaniae Inferioris effigies*. Antwerp: apud viduam Hieronymi Cock, 1572.

Van Langendonck, Linda. "Het Karbonkelhuis van kanunnik Willem Heda: een renaissance *Primavera* op de Groenplaats in Antwerpen (1520–1522)." In

Vreemd gebouwd: westerse en niet-westerse elementen in onze architectuur, 93–112. Turnhout: Brepols, 2002.

Langereis, Sandra. *Geschiedenis als ambacht. Oudheidkunde in de Gouden Eeuw: Arnoldus Buchelius en Petrus Scriverius*. Hollandse Studiën. Hilversum: Uitgeverij Verloren, 2001.

Lantsheer, M. F., and F. Nagtglas. *Zelandia illustrata: verzameling van kaarten, portretten, platen enz., betreffende de oudheid en geschiedenis van Zeeland*. 2 vols. Middelburg: J. C. & W. Altorffer, 1879.

Laubriet, Pierre. *Un catéchisme esthétique: le Chef-d'oeuvre inconnu de Balzac*. Paris: Didier, 1961.

Lee, Rensselaer W. "Ut Pictura Poesis: The Humanistic Theory of Painting." *Art Bulletin* 22.4 (December 1940): 197–269.

Leeflang, Huigen, and Ger Luijten. *Hendrick Goltzius (1558–1617): Drawings, Prints and Paintings*. Zwolle: Waanders, 2003.

Lefèvre, Raoul. *Le recoeil des histoires de Troyes*. Edited by Marc Aeschbach. Bern: Peter Lang, 1987.

Lehmann, Ann-Sophie. "Mit Haut und Haaren: Jan van Eycks *Adam und Eva*–Tafeln in Gent—Rezeption, Bedeutung und Maltechnik des Aktes in der frühniederländischen Malerei." Ph.D. diss., Universiteit Utrecht, 2004.

Leitch, Stephanie. *Mapping Ethnography in Early Modern Germany: New Worlds in Print Culture*. New York: Palgrave Macmillan, 2010.

———. "The Wild Man, Charlemagne and the German Body." *Art History* 31.3 (June 2008): 283–302.

Lemaire de Belges, Jean. *Des anciennes pompes funeralles*. Edited by Marie Madeleine Fontaine. Paris: Société des Texts Français Modernes, 2001.

———. *Les illustrations de Gaule et singularitez de Troye*. In *Oeuvres de Jean Lemaire de Belges*, edited by J. Stecher, vol. 2. Leuven: Imprimerie Lefever Frères et Soeur, 1882.

Lemerle, Frédérique. *La Renaissance et les antiquités de la Gaule*. Turnhout: Brepols, 2005.

Lemnius, Levinus. *Occulta naturae miracula, ac varia rerum documenta, probabili ratione atque artifici coniectura explicata*. Antwerp: apud Guilielmum Simonem, 1564.

Lems, Els. *Op zoek naar Matilo: sporen van de Romeinen in Leiden*. Leiden: Leids Verleden, 1995.

Leonhard, Karin. "Vermeer's Pregnant Women. On Human Generation and Pictorial Representation." *Art History* 25.3 (2002): 293–318.

Levenson, Jay A. "Jacopo de' Barbari and Northern Art of the Early Sixteenth Century." Ph.D. diss., New York University, 1978.

Levey, Michael. "Poussin's 'Neptune and Amphitrite' at Philadelphia: A Re-identification Rejected." *Journal of the Warburg and Courtauld Institutes* 26.3/4 (1963): 359–60.

Leydis, Johannis a. *Rerum Belgicarum chronici et historici de bellis, urbibus, situ, et moribus gentis antiqui re-*

centioresqve scriptores. Edited by F. Sweertius. Frankfurt: in officina Danielis ac Davidis Aubriorum et Clementis Schleichii, 1620.

Lie, Orlanda S. H. "Women's Medicine in Middle Dutch." In *Science Translated: Latin and Vernacular Translations of Scientific Treatises in Medieval Europe*, edited by Michèle Goyens, Pieter de Leemans, and An Smets, 449–66. Leuven: Leuven University Press, 2008.

Van Lieburg, Fred. "Hungary and the Batavian Myth." *Acta Ethnographica Hungarica* 49 (2004): 151–60.

Lindeboom, G. A. *Dutch Medical Biography: A Biographical Dictionary of Dutch Physicians and Surgeons, 1475–1975*. Amsterdam: Rodopi, 1984.

Lindley, P. G. "Playing Check-Mate with Royal Majesty? Wolsey's Patronage of Italian Renaissance Sculpture." In *Cardinal Wolsey: Church, State and Art*, edited by S. J. Gunn and P. G. Lindley, 261–85. Cambridge: Cambridge University Press, 1991.

Lindquist, Sherry C. M., ed. *The Meanings of Nudity in Medieval Art*. Farnham, UK: Ashgate, 2012.

Lipińska, Aleksandra. "'Alabastrum, id est, corpus hominis': Alabaster in the Low Countries, a Cultural History." In *Meaning in Materials, 1400–1800*, edited by Ann-Sophie Lehmann, Frits Scholten, and H. Perry Chapman. *Nederlands Kunsthistorisch Jaarboek* 62 (2012): 85–115.

———. *Moving Sculptures: Southern Netherlandish Alabasters from the 16th to 17th Centuries in Central and Northern Europe*. Leiden: Brill, 2015.

Loh, Maria. *Titian Remade: Repetition and the Transformation of Early Modern Italian Art*. Los Angeles: Getty Research Institute, 2007.

Luciano, Eleonara, et al. *Antico: The Golden Age of Renaissance Bronzes*. Washington, DC: National Gallery of Art, 2011.

Lugli, Adalgisa. *Guido Mazzoni e la rinascita della terracotta del Quattrocento*. Turin: U. Allemandi, 1991.

Van Mander, Karel. *Den grondt der edel vry schilder-const*. Edited by Hessel Miedema. Utrecht: Haentjens Dekker & Gumbert, 1973.

———. *The Lives of the Illustrious Netherlandish and German Painters*. Edited by Hessel Miedema. 6 vols. Doornspijk: Davaco, 1994–99.

De la Marche, Olivier. *Mémoires d'Olivier de la Marche: maître d'hôtel et capitaine des gardes de Charles le Téméraire*. Edited by H. Beaune and J. d'Arbaumont. 4 vols. Paris: Librairie Renouard, 1883–88.

Van Marion, Olga. *Heldinnenbrieven: Ovidius' "Heroides" in Nederland*. Nijmegen: Uitgeverij Vantilt, 2005.

Marliani, Luigi. *Aloysii Marliani oratio habita in comitiis Ordinis Aurei Velleris serenissimi Caroli Regis Catholici*. Basel, 1517.

———. *In comitiis Ordinis Aurei Velleris*. In *Rerum Germanicarum scriptores varii*, edited by Marquardus Freherus and Burcardo Gotthelffio Struvius. Argentorati: sumptibus Johannis Reinholdi Dulsseckeri, 1717.

Marrow, James H. "Artistic Identity in Early Netherlandish Painting: The Place of Rogier van der Weyden's St. Luke Drawing the Virgin." In *Rogier Van der Weyden, St. Luke Drawing the Virgin: Selected Essays in Context*, edited by Carol J. Purtle, 53–59. Turnhout: Brepols, 1997.

Martens, Maximiliaan P. J., ed. *Bruges et la Renaissance: de Memling à Pourbus: notices*. Bruges: Stedelijke Musea, 1998.

Marti, Susan, et al. *Charles the Bold (1433–1477): Splendour of Burgundy*. Brussels: Mercatorfonds, 2009.

Marx, Barbara. "Wandering Objects, Migrating Artists: The Appropriation of Italian Renaissance Art by German Courts in the Sixteenth Century." In *Cultural Exchange in Early Modern Europe*, vol. 4, *Forging European Identities, 1400–1700*, edited by Herman Roodenburg, 178–226. Cambridge: Cambridge University Press, 2007.

Matthaeus, Antonius. *Veteris aevi analecta seu vetera aliquot monumenta quae hactenus nondum visa*. Lugduni Batavorum: apud Fredericum Haaring, 1698.

Mediolanensis, Magninus. *Tregement der ghesontheyt*. Brussels: Thomas van der Noot, 1514.

Meertens, J. *Letterkundig leven in Zeeland in de zestiende en de eerste helft der zeventiende eeuw*. Amsterdam: N.V. Noord-Hollandsche Uitgevers Maatschappij, 1943.

Meganck, Tine Luk. "Erudite Eyes: Artists and Antiquarians in the Circle of Abraham Ortelius (1527–1598)." Ph.D. diss., Princeton University, 2003.

Meiers, Sarah. "Portraits in Print: Hieronymus Cock, Dominicus Lampsonius, and *Pictorum aliquot celebrium Germaniae Inferioris effigies*." *Zeitschrift für Kunstgeschichte* 69 (2006): 1–16.

Meinhardi, Andreas. *The "Dialogus" of Andreas Meinhardi: A Utopian Description of Wittenberg and Its University, 1508*. Edited and translated by Edgar C. Reinke. Ann Arbor, MI: University Microfilms International, 1976.

Meiss, Millard. "Light as Form and Symbol in Some Fifteenth-Century Paintings." *Art Bulletin* 27.3 (September 1945): 175–81.

Melion, Walter S. *Shaping the Netherlandish Canon: Karel van Mander's "Schilder-Boeck."* Chicago: University of Chicago Press, 1991.

Mensger, Ariane. "Blick zurück nach vorn: Jan Gossaert kopiert Jan van Eyck." In *Porträt-Landschaft-Interieur: Jan van Eycks Rolin-Madonna im ästhetischen Kontext*, edited by Christiane Kruse and Felix Thürlemann, 273–90. Tübingen: Gunter Narr Verlag, 1999.

———. *Jan Gossaert: die Niederländische Kunst zu Beginn der Neuzeit*. Berlin: Reimer, 2002.

———. "Jan Gossaert und der niederländische Stilpluralismus zu Beginn des 16. Jahrhunderts—eine Annäherung." In *Stil als Bedeutung: Stil als Bedeutung in der nordalpinen Renaissance*, edited by Stephan Hoppe and Matthias Müller, 188–211. Regensburg: Schnell & Steiner, 2008.

———. "Jan van Eyck, 'Belgarum Splendor' und der Anfang einer niederländischen Geschichte der Kunst." *Pantheon* 58 (2000): 44–53.

———. "'Nostrae aetatis Apelles': Der niederländische Hofkünstler Jan Gossaert (1478–1532)." In *Apelles am Fürstenhof: Facetten der Hofkunst um 1500 im Alten Reich*, edited by Matthias Müller, Klaus Weschenfelder, Beate Böckem, and Ruth Hansmann, 99–111. Berlin: Lukas Verlag, 2010.

Merleau-Ponty, Maurice. *Phenomenology of Perception*. Translated by Donald A. Landes. New York: Routledge, 2012.

———. *The Visible and the Invisible*. Edited by Claude Lefrot. Translated by Alphonso Lingis. Evanston, IL: Northwestern University Press, 1968.

Meurer, H. "Abraham Ortelius' Concept and Map of 'Germania.'" In *Abraham Ortelius and the First Atlas: Essays Commemorating the Quadricentennial of His Death, 1598–1998*, edited by M. van den Broecke et al., 263–90. 't Goy-Houten: HES, 1998.

Meyer, Julius, "'Neptun und Amphitrite' von Rubens." *Jahrbuch der Königlich Preussischen Kunstsammlungen* 2 (1881): 113–30.

Michaud Frères. *Biographie universelle, ancienne et moderne*. Paris: Chez Michaud Frères, Libraires, 1811–62.

Michel, Edouard. *Catalogue raisonné des peintres du Moyen-Age, de la renaissance et des temps modernes: peintres flamandes du XVe et du XVIe siècle*. Paris: Éditions des Musées Nationaux, 1953.

Michel, Eva, and Maria Luise Sternath, eds. *Emperor Maximilian I and the Age of Dürer*. Vienna: Albertina, 2013.

Michel, Patrick. "French Collectors and the Taste for Flemish Painting during the Eighteenth Century." In *Art Auctions and Dealers: The Dissemination of Netherlandish Art during the Ancien Régime*, edited by Dries Lyna, Filip Vermeylen, and Hans Vlieghe, 127–37. Turnhout: Brepols, 2009.

Michelant, H. "Inventaire des vaisselles, joyaux, tapisseries, peintures, manuscrits, etc. de Marguerite d'Autriche, régente et gouverante des Pays-Bas, dressé en son palais de Malines, le 9 juillet 1523." *Académie Royale des Sciences des Lettres et des Beaux-Arts de Belgique, Bulletin de la Commission Royal d'Histoire* 12 (1871): 33–75, 83–136.

Van Miegroet, Hans J. *Gerard David*. Antwerp: Fonds Mercator, 1989.

Van Mieris, Frans. *Histori der Nederlandsche vorsten, welken, sedert de regeering van Albert, graaf van Holland, tot den dood van Keizer Karel den Vyfden*. Vol. 2. The Hague: Pieter de Hondt, 1733.

Momigliano, Arnaldo. "Ancient History and the Antiquarian." *Journal of the Warburg and Courtauld Institutes* 13 (1950): 285–315.

Montanus, Petrus. *De laudibus Germanorum*. In Gerard Geldenhouwer, *Historia Batavica, cum appendice de vetustissima nobilitate, regibus, ac gestis Germanorum. Rhapsodo Gerardo Nouiomago*. Argentorati: apud Chr. Aegen., 1530.

More, Thomas. *The Complete Works of St. Thomas More*. 15 vols. New Haven, CT: Yale University Press, 1963–97.

———. *Libellus vere aureus nec minus salutaris quam festivus de optimo reip. statu, deque nova insula Utopia*. Leuven: arte Theodorici Martini Alustensis, 1516.

Morford, Mark. "'Theatrum Hodiernae Vitae': Lipsius, Vaenius, and the Rebellion of Civilis." In *Recreating Ancient History: Episodes from the Greek and Roman Past in the Arts and Literature of the Early Modern*, edited by Karl Enenkel, Jan L. de Jong, and Jeanine de Landtsheer, 57–74. Leiden: Brill, 2001.

Mout, M.E.H.N. "'Het Bataafse oor': de lotgevallen van Erasmus' adagium 'Auris Batava' in de Nederlandse geschiedschrijving." *Mededelingen der Koninklijk Nederlandse Akademie van Wetenschappen* 56 (1993): 77–102.

Mulier, E.O.G. Haitsma. "De Bataafse mythe opnieuw bekeken." *Bijdragen en Mededelingen voor de Geschiedenis der Nederlanden* 111 (1996): 344–67.

Muller, Frank, "Hans Baldung Grien et Jan Gossaert entre christianisme et paganisme." In *De l'objet culturel à l'œuvre d'art en Europe: repères de transition*, edited by Frank Muller, 173–97. Geneva: Droz, 2013.

Müller, Jürgen. "Italienverehrung als Italienverachtung. Hans Sebald Behams 'Jungbrunnen' von 1536 und die Italiensche Kunst der Renaissance." In Philine Helas et al., *Bild/Geschichte, Festschrift für Horst Bredekamp*, 309–18. Berlin: Akademie Verlag, 2007.

Müller Hofstede, Justus, "'Ut Pictura Poesis': Rubens und die humanistische Kunsttheorie." *Gentse bijdragen tot de Kunstgeschiedenis* 24 (1976/78): 171–89.

Musacchio, Jacqueline Marie. *The Art and Ritual of Childbirth in Renaissance Italy*. New Haven, CT: Yale University Press, 1999.

Nagel, Alexander. *The Controversy of Renaissance Art*. Chicago: University of Chicago Press, 2011.

———. "Experiments in Art and Reform in Italy in the Early Sixteenth Century." In *The Pontificate of Clement VII: History, Politics, Culture*, edited by Kenneth Gouwens and Sheryl E. Reiss, 385–409. Aldershot, UK: Ashgate, 2005.

Nagel, Alexander, and Christopher Wood. *Anachronic Renaissance*. New York: Zone Books, 2009.

Nagtglas, Frederik. *Levensberichten van Zeeuwen*. 2 vols. Middelburg : J. C. & W. Altorffer, 1890–93.

Négrier, Paul. *Les bains à travers les âges*. Paris: Librairie de la Construction moderne, 1925.

Nerdenus, Lucas. *Luce Nerdeni inter Apollinem et Mercurium dialogus fabulosus de prima civitatis Delphorum apud Hollandos*. Delft, 1517.

Neville, Kristoffer. "The Land of the Goths and Vandals. The Visual Presentation of Gothicism at the Swedish Court, 1550–1700." *Renaissance Studies* 27 (2013): 435–59.

Nevola, Fabrizio. *Siena: Constructing the Renaissance City*. New Haven, CT: Yale University Press, 2007.

Nichols, Lawrence W. *The Paintings of Hendrick Goltzius, 1558–1617: A Monograph and Catalogue Raisonné*. Doornspijk: Davaco Publishers, 2013.

Noordzij, Aart. *Gelre: dynastie, land en identiteit in de late middeleeuwen*. Hilversum: Verloren, 2009.

Notices des tableaux des écoles française et flamande, exposé dans la Grand Galerie, et des tableaux des écoles de Lombardie et de Bologne. Paris: Musée Central des Arts, 1801.

Nuttall, Paula. "Reconsidering the Nude: Northern Tradition and Venetian Innovation." In *The Meanings of Nudity in Medieval Art*, edited by Sherry C. M. Lindquist, 299–318. Farnham, UK: Ashgate, 2012.

Olbrich, Harald. "Jan Gossaerts Münchner 'Danae' von 1527: In der Kunsthistorischen Rede stillgelegte Erotik?" In *Kunst und Sozialgeschichte*, edited by Martin Papenbrock et al., 306–15. Pfaffenweiler: Centauraus-Verlagsgesellschaft, 1995.

Olds, Clifton. "Jan Gossaert's 'St. Luke Painting the Virgin': A Renaissance Artist's Cultural Literacy." *Journal of Aesthetic Education* 24.1 (1990): 89–96.

Olivier, Elyne. "Philippe de Clèves, le goût et les particularismes artistiques d'un noble bourguignon à travers le *Recueil de mandements, d'inventaires et de pieces diverses concernant la succession de Philippe de Clèves*." In *Entre la ville, la noblesse et l'état: Philippe de Clèves (1456–1528), homme politique et bibliophile*, edited by J. Haemers, C. Van Hoorebeeck, and H. Wijsman, 143–59. Turnhout: Brepols, 2007.

Orenstein, Nadine M. "Gossart and Printmaking." In *Man, Myth, and Sensual Pleasures: Jan Gossart's Renaissance: The Complete Works*, edited by Maryan W. Ainsworth, 105–12. New York: Metropolitan Museum of Art, 2010.

Ortelius, Abraham. *Aurei saeculi imago, of Spiegel van de gouden tijd*. Translated by Joost Depuydt and Jeanine de Landtsheer. Wildert: De Carbolineum Pers, 1999.

———. *Aurei saeculi imago, sive Germanorum veterum*. Antwerp: apud Philippum Galleaum, 1596.

Ott, Martin. *Die Entdeckung des Altertums: der Umgang mit Römischen Vergangenheit Süddeutschlands im 16. Jahrhundert*. Kallmünz: Verlag Michael Lassleben, 2002.

Ovid, *Heroides*. Translated by Grant Showerman. Cambridge, MA: Harvard University Press, 1971.

Ovide moralisé: poème du commencement du quatorzième siècle. Edited by Cornelis de Boer, Cornelis, Martina G. de Boer, and Jeannette Th. M. van 't Sant. 5 vols. Amsterdam: J. Müller, 1915–38.

Panofsky, Erwin. "Der gefesselte Eros (zur Genealogie von Rembrandts Danae)." *Oud Holland* 50 (1933): 193–217.

———. *Early Netherlandish Painting: Its Origins and Character*. New York: Harper & Row, 1971.

———. *Renaissance and Renascences in Western Art.* New York: Harper & Row, 1969.

Pardo, Mary. "Artifice as Seduction in Titian." In *Sexuality and Gender in Early Modern Europe*, edited by James Grantham Turner, 55–89. Cambridge: Cambridge University Press, 1993.

Park, Katharine. "Impressed Images: Reproducing Wonders." In *Picturing Science, Producing Art*, edited by Caroline A. Jones and Peter Galison, 254–71. New York: Routledge, 1998.

Park, Katharine, and Lorraine Daston. "Unnatural Conceptions: The Study of Monsters in Sixteenth- and Seventeenth-Century France and England." *Past & Present* 92 (1981): 20–54.

Parma, Elena. *Perino del Vaga: tra Raffaello e Michelangelo.* Milan: Electa, 2001.

Parmentier, J. "Een maritiem-economische schets van de deltahavens, 1400–1800." In *De scheldedelta als verbinding en scheiding tussen noord en zuid, 1500–1800*, edited by M. Ebben and S. Groenveld, 11–26. Maastricht: Shaker Publishing, 2007.

Parshall, Peter. "Graphic Knowledge: Albrecht Dürer and the Imagination." *Art Bulletin* 95.3 (2013): 393–410.

Pauwels, H., H. R. Hoetink, and S. Herzog, eds. *Jan Gossaert genaamd Mabuse.* Rotterdam: Museum Boymans van Beuningen, 1965.

Peronnet, Benjamin, and Burton B. Fredericksen, eds. *Répertoire des tableaux vendus en France au XIXe siècle.* Los Angeles: Provenance Index of the Getty Information Institute, 1998.

Pfisterer, Ulrich. *Lysippus und seine Freunde: Liebesgaben und Gedächtnis im Rom der Renaissance, oder das erste Jahrhundert der Medaille.* Berlin: Akademie Verlag, 2008.

Piccolomini, Silvius. *I commentarii.* Edited by Luigi Totaro. 2 vols. Milan: Adelphi Edizioni, 1984.

Pieters, M. "Een 15de-eeuwse sector van het verdwenen vissersdorp te Raversijde (stad Oostende, prov. West-Vlaanderen." *Archeologie in Vlaanderen: Archaeology in Flanders* 4 (1994): 219–36.

Pinkus, Assaf. "The Eye and the Womb: Viewing the *Schreinmadonna*." *Arte Medievale* 4 (2012): 201–20.

Pleij, Herman. *De sneeuwpoppen van 1511: literatuur en stadscultur tussen middeleeuwen en moderne tijd.* Amsterdam: Meulenhoff, 1988.

Poelhekke, J. J. "The Nameless Homeland of Erasmus." *Acta Historiae Neerlandicae: Studies in the History of the Netherlands* 7 (1974): 54–87.

Polak, M., J. van Doesburg, and P.A.M.M. van Kempen. *Op zoek naar het castellum Matilo en het St. Margaretaklooster te Leiden-Roomburg: het archeologisch onderzoek in 1999–2000.* Amersfoort: Rijksdienst voor het Oudheidkundig Bodemonderzoek, Rapportage Archeologische Monumentenzorg, 2005.

Pollard, John Graham. *Renaissance Medals.* Vol. 2, *France, Germany, The Netherlands, and England.* Princeton, NJ: Princeton University Press, 2007.

Pontano, Giovanni Gioviano. *Baiae.* Translated by Rodney G. Dennis. The I Tatti Renaissance Library. Cambridge, MA: Harvard University Press, 2006.

Pratensis, Jason. *De cerebri morbis.* Basel: per Henrichum Petri, 1549.

———. *De tuenda sanitate.* Antwerp: ex officina Michaelis Hillenii, 1538.

———. *Liber de arcenda sterilitate et progignendis liberis.* Antwerp: apud Michaelem Hillenium, 1531.

———. *Libri duo de uteris.* Antwerp: apud Michaelem Hillenium, 1524.

———. *Sylva carminum adolescentiae.* Antwerp: apud Michaelem Hillenium, 1530.

Prater, Andreas. *Cellinis Salzfass für Franz I.* Stuttgart: F. Steiner Verlag Wiesbaden, 1988.

Preimesberger, Rudolf. "Zu Jan van Eycks Diptychon der Sammlung Thyssen-Bornemisza." *Zeitschrift für Kunstgeschichte* 54 (1991): 459–89.

Price, David Hotchkiss. *Albrecht Dürer's Renaissance: Humanism, Reformation, and the Art of Faith.* Ann Arbor: University of Michigan Press, 2003.

Prims, Floris. *Antwerpiensia: losse bijdragen tot de Antwerpsche geschiedenis.* Antwerp: Drukkerij de Vlijt, 1939.

Prinsen, J. *Gerardus Geldenhauer Noviomagus: bijdrage tot de kennis van zijn leven en werken.* The Hague: Martinus Nijhoff, 1898.

Prontera, Francesco, ed. *Tabula Peutingeriana: le antiche vie del mondo.* Florence: L. S. Olschki, 2003.

Puraye, Jean. *Dominique Lampson: humaniste, 1531–1599.* Bruges: Desclée de Brouwer, 1950.

Purtle, Carol J. *The Marian Paintings of Jan van Eyck.* Princeton, NJ: Princeton University Press, 1982.

———, ed. *Rogier van der Weyden, St. Luke Drawing the Virgin: Selected Essays in Context.* Boston: Museum of Fine Arts Boston, 1997.

Du Puys, Rémy. *Les exeques et pompe funerale.* Leuven: Théodore Martinus Alost, 1516.

Quint, David. *Epic and Empire: Politics and Generic Form from Virgil to Milton.* Princeton, NJ: Princeton University Press, 1993.

Reid, J. D. *The Oxford Guide to Classical Mythology in the Arts, 1300–1990s.* 2 vols. New York: Oxford University Press, 1993.

Reiffenberg, Le Baron de. *Histoire de l'Ordre de la Toison d'Or.* Brussels: Fonderie et Imprimerie Normales, 1830.

Reiss, Sheryl E. "Adrian VI, Clement VII, and Art." In *The Pontificate of Clement VII: History, Politics, Culture*, edited by Kenneth Gouwens and Sheryl E. Reiss, 339–62. Aldershot, UK: Ashgate, 2005.

Reygersbergh, Jan. *Dye cronijcke van Zeelandt.* Antwerp: by die weduwe van Henrick Peetersen, 1551.

Reygersbergh, Jan, and Marcus Zuerius van Boxhorn. *Chronik van Zeelandt, eertijdts beschreven door d'heer Johan Reygersbergen, nu verbetert, ende vermeerdert.* Middelburg: by Zacharias ende Michiel Roman, 1644.

Van Rhijn, M. "Wilhelmus Sagarus." *Nederlandsch Archief voor Kerkgeschiedenis* 30 (1938): 27–30.

———. "Wilhelmus Sagarus en Adrianus Barlandus." *Nederlandsch Archief voor Kerkgeschiedenis* 35 (1946–47): 85–90.

Robert, Carl, ed. *Einzelmythen: Actaeon-Hercules, Die Antiken Sarkophag-Reliefs.* Berlin: G. Grote, 1898.

Roethlisberger, G. *Abraham Bloemaert and His Sons: Paintings and Prints.* 2 vols. Doornspijk: Davaco, 1993.

Roos, A. G. "Soranus: een Bataaf in Romeinse krijgsdienst." *Mededelingen der Koninklijke Nederlandse Akademie van Wetenschappen* 16 (1953): 319–26.

Rooze-Stouthamer, Clasina Martina. *Hervorming in Zeeland (c. 1520–1572).* Goes: De Koperen Tuin, 1996.

Rorimer, James J. "A Gift of Four Tapestries." *Bulletin of the Metropolitan Museum of Art* 30 (1935): 138–41.

Roscher, W. H. *Ausführliches Lexikon der Griechischen und Römischen Mythologie.* 6 vols. Leipzig: B. G. Teubner, 1884–1937.

Rosenthal, Earl. "The Invention of the Columnar Device of Emperor Charles V and the Court of Burgundy in Flanders in 1516." *Journal of the Warburg and Courtauld Institutes* 36 (1973): 198–230.

———. "Plus Ultra, Non Plus Ultra, and the Columnar Device of Emperor Charles V." *Journal of the Warburg and Courtauld Institutes* 34 (1971): 204–28.

Rösslin, Eucharius. *The Birth of Mankind: Otherwise Named, the Woman's Book.* Edited by Elaine Hobby. Farnham, UK: Ashgate, 2009.

Rothstein, Marian. "Etymology, Genealogy, and the Immutability of Origins." *Renaissance Quarterly* 43 (1990): 332–47.

Röver-Kann, Anne. *Albrecht Dürer: Das Frauenbad von 1496.* Bremen: H. M. Hauschild GmbH, 2001.

Rowland, Ingrid D. *The Scarith of Scornello: A Tale of Renaissance Forgery.* Chicago: University of Chicago Press, 2004.

Roymans, Nico. *Ethnic Identity and Imperial Power: The Batavians in the Early Roman Empire.* Amsterdam: Amsterdam University Press, 2004.

———. "Hercules en de constructie van een Bataafse identiteit in de context van het Romeinse Rijk." In *De Bataven: verhalen van een verdwenen volk,* 300–315, 331–32. Amsterdam: De Bataafsche Leeuw, 2004.

Roymans, Nico, and T. Derks. "Het heiligdom te Empel: algemene beschouwingen." In *De tempel van Empel: een Hercules-heiligdom in het woongebied van de Bataven,* 10–38. Den Bosch: Stichting Brabantse Regionale Geschiedbeoefening, 1994.

Rubinstein, R. O. "*Tempus Edax Rerum*: A Newly Discovered Painting by Hermannus Posthumus." *Burlington Magazine* 127 (1985): 425–33.

Sallentin, Louis. *L'improvisateur français.* Paris: Goujon, 1804.

Sander, Jochen. "Anmerkungen zu Jan Gossaert." In *Tributes in Honor of James H. Marrow: Studies in Painting and Manuscript Illumination of the Late Middle Ages and Northern Renaissance,* edited by Jeffrey E. Hamburger and Anne S. Korteweg, 421–30. London: Harvey Miller, 2006.

Santore, Cathy. "Danaë: The Renaissance Courtesan's Alter Ego." *Zeitschrift für Kunstgeschichte* 54 (1991): 412–27.

Schaefer, Jan Owens. "Gossaert's Vienna *Saint Luke Painting* as an Early Reply to Protestant Iconoclasts." *Source: Notes in the History of Art* 12.1 (1992): 31–37.

Scheffer, J. G. de Hoop. *Geschiedenis der kerkhervorming in Nederland van haar ontstaan tot 1531.* Amsterdam: G. L. Funke, 1873.

Scheller, Robert W. "Jan Gossaerts Triomfwagen." In *Essays in Northern European Art Presented to Egbert Haverkamp-Begemann on His Sixtieth Birthday,* edited by A.-M. Logan, 228–36. Doornspijk: Davaco, 1983.

———. "L'Union des Princes: Louis XII, His Allies and the Venetian Campaign 1509." *Simiolus* 27.4 (1999): 195–242.

Scher, Stephen K. *The Currency of Fame: Portrait Medals of the Renaissance.* New York: Harry N. Abrams, 1994.

———, ed. *Perspectives on the Renaissance Medal.* New York: Garland Publishing, 2000.

Schlüter, Lucy L. E. *Niet alleen: een kunsthistorisch-ethische plaatsbepaling van tuin en huis in het "Convivium Religiosum" van Erasmus.* Amsterdam: Amsterdam University Press, 1995.

Schoch, Rainer, Matthias Menda, and Anna Scherbaum. *Albrecht Dürer: Das druckgraphische Werk.* 3 vols. Munich: Prestel, 2001.

Schöffer, I. "The Batavian Myth during the Sixteenth and Seventeenth Centuries." In *Britain and the Netherlands,* vol. 5, *Some Political Mythologies. Papers Delivered to the Fifth Anglo-Dutch Historical Conference,* edited by J. S. Bromley and E. H. Kossmann, 78–101. The Hague: Martinus Nijhoff, 1975.

Schrader, Stephanie. "Drawing for Diplomacy: Gossart's Sojourn in Rome." In *Man, Myth, and Sensual Pleasures: Jan Gossart's Renaissance: The Complete Works,* edited by Maryan W. Ainsworth, 45–55. New York: Metropolitan Museum of Art, 2010.

———. "Gossaert's *Neptune and Amphitrite* and the Body of the Patron." *Nederlands Kunsthistorisch Jaarboek* 58 (2008): 40–57.

———. "Gossart's Mythological Nudes and the Shaping of Philip of Burgundy's Erotic Identity." In *Man, Myth, and Sensual Pleasures: Jan Gossart's Renaissance: The Complete Works,* edited by Maryan W. Ainsworth, 57–67. New York: Metropolitan Museum of Art, 2010.

———. "Jan Gossaert's Art of Imitation: Fashioning Identity at the Burgundian Court," Ph.D. diss., University of California, Santa Barbara, 2006.

Schroeder, Karl G. "Jerome de Busleyden and Thomas More." *Moreana* 32.121 (1995): 3–10.

Sciolla, Gianni Carlo, and Caterina Volpi. *Da van Eyck a Brueghel: scritti sulle arti di Domenico Lampsonio*. Turin: Utet, 2001.

Scriverius, Petrus. *Batavia illustrata seu de Batavorum insula, Hollandia, Zelandia, Frisia, Territorio Traiectensi et Gelria*. Lugdunum Batavorum: apud Ludovicum Elzevirium, 1609.

Secundus, Janus. *Epigrammatum liber unus; epistolarum libri duo*. Vol. 3 of *Oeuvres Complètes*. Edited by Roland Guillot. Translated by Daniel Delas and Jean-Claude Ternaux. Paris: Honoré Champion Éditeur, 2007.

———. *Itineraria (carnets de voyage); correspondance*. Vol. 5 of *Oeuvres Complètes*. Edited and translated by Roland Guillot. Paris: Honoré Champion Éditeur, 2007.

Seebass, Gottfried. "Dürers Stellung in der Reformatorischen Bewegung." In *Albrecht Dürers Umwelt. Festschrift zum 500. Geburtstag*, edited by Gerhard Hirschmann and Fritz Schnelbögl, 101–31. Nuremberg: Verein für Geschichte der Stadt Nürnberg, 1971.

Segard, Achille. *Jean Gossart dit Mabuse*. Brussels; Paris: G. van Oest, 1923.

Seidel, Linda. "Nudity as Natural Garment: Seeing through Adam and Eve's Skin." In *The Meanings of Nudity in Medieval Art*, edited by Sherry C. M. Lindquist, 207–30. Farnham: Ashgate, 2012.

Sellink, Manfred, ed. *Philips Galle*. Part 3. The New Hollstein: Dutch and Flemish Etchings, Engravings and Woodcuts, 1450–1700. Rotterdam: South & Vision Publishers, 2001.

Settis, Salvatore. "Danae verso il 1495." *I Tatti Studies: Essays in the Renaissance* 1 (1985): 207–37.

Shelton, Anthony Alan. "Cabinets of Transgression: Renaissance Collections and the Incorporation of the New World." In *The Cultures of Collecting*, edited by John Elsner and Roger Cardinal, 177–203, 288–91. London: Reaktion Books, 1994.

Sicking, Louis. "La découverte de Neptune: representations maritimes des souverains et amiraux des Pays-Bas (XVe–XVIe siècles)." In *Publication du centre européen d'études bourguignonnes*, edited by J.-M. Cauchies, 132–34. Neuchâtel, 1997.

———. *Neptune and the Netherlands: State, Economy, and War at Sea in the Renaissance*. Leiden: E. J. Brill, 2004.

Sicking, Louis, and Raymond Fagel. "In het kielzog van Columbus. De heer van Veere en de Nieuwe Wereld, 1517–1527." *Bijdragen en Mededelingen Betreffende de Geschiedenis der Nederlanden* 114 (1999): 313–27.

———. "In the Wake of Columbus: The First Expedition Attempted from the Netherlands to the New World, 1517–1527." *Terrae Incognitae* 34 (2002): 34–45.

Sigmond, J. *Nederlandse zeehavens tussen 1500–1800*. Amsterdam: Bataafse Leeuw, 1989.

Silver, Larry. "*Figure nude, historie e poesie*: Jan Gossaert and the Renaissance Nude in the Netherlands." *Nederlands Kunsthistorisch Jaarboek* 37 (1986): 1–40.

———. "Fountain and Source: A Rediscovered Eyckian Icon." *Pantheon* 41.2 (1983): 95–104.

———. "The 'Gothic' Gossaert: Native and Traditional Elements in a Mabuse Madonna." *Pantheon* 45 (1987): 58–69.

———. *Marketing Maximilian: The Visual Ideology of a Holy Roman Emperor*. Princeton, NJ: Princeton University Press, 2008.

———. *The Paintings of Quinten Massys with Catalogue Raisonné*. Montclair: Allanheld & Schram, 1984.

Slits, F. T. *Het Latijnse stededicht: oorsprong en ontwikkeling tot in de zeventiende eeuw*. Amsterdam: Thesis Publishers, 1990.

Sluijter, Eric Jan. "Emulating Sensual Beauty: Representations of Danaë from Gossaert to Rembrandt." *Simiolus* 27 (1999): 5–45.

Smallegange, Mattheus. *Nieuwe cronyk van Zeeland*. Middelburg: Joannes Meertens, 1696.

Smeesters, Aline. "La *Venus Zelanda* de Petrus Stratenus et Cornelius Boyus (1641)." In *'Petite patrie': l'image de la region natale chez les écrivains de la Renaissance. Actes du colloque de Dijon, mars 2012*, edited by Sylvie Laigneau-Fontaine, 171–86. Geneva: Librairie Droz, 2013.

Smeken, Jan. *Gedicht op de feesten ter eere van het Gulden Vlies te Brussel in 1516*. Edited by Gilbert Degroote. Antwerp: De Sikkel, 1946.

Snoy, Reinier. *De rebus Batavicis libri XIII*. Edited by Jacobus Brassica. Frankfurt: in officina Danielis ac Davidis Aubriorum & Clementis Schleichij, 1620.

Soil, Eugène. *Les tapisseries de Tournai: les tapisseres et les hautelisseurs de cette ville*. Tournai: H. & L. Casterman, 1891.

Soly, Hugo, and Johan van de Wiele. *Carolus: Keizer Karel V 1500–1558*. Ghent: Kunsthal De Sint-Pietersabdij Gent, 2000.

Speidel, Michael P. "Swimming the Danube under Hadrian's Eyes: A Feat of the Emperor's Batavi Horse Guard." *Ancient Society* 22 (1991): 277–82.

Spelen van sinne. Antwerp: M. Willem Silvius, 1562.

Spencer, John R. "Ut Rhetorica Pictura: A Study in Quattrocento Theory of Painting." *Journal of the Warburg and Courtauld Institutes* 20 (1957): 26–44.

Spinks, Jennifer. *Monstrous Births and Visual Culture in Sixteenth-Century Germany*. London: Pickering & Chatto, 2009.

Spruyt, B. J. "De Delfts-Haagse kring (ca. 1520–ca. 1525). Evangelisch humanisme in het vroeg zestiende-eeuwse Delft en den Haag." In *Heidenen, papen, libertijnen en fijnen: artikelen over de kerkgeschiedenis van het zuidwestelijk gedeelte van Zuid-Holland van de voorchristelijke tijd tot heden*, edited by J. C. Okkema, 107–19. Delft: Eburon, 1994.

Stahl, Alan M., ed. *The Rebirth of Antiquity: Numismatics, Archaeology, and Classical Studies in the Culture*

of the Renaissance. Princeton, NJ: Princeton University Press, 2009.

Staring, A. "Vraagstukken der Oranje-Iconographie." *Oud Holland* 67 (1952): 144–56.

Stech, Annette, et al. *'Nach dem Leben und aus der Phantasie': Niederländische Zeichnungen vom 15. bis 18. Jahrhundert aus dem Städelschen Kunstinstitut.* Frankfurt am Main: Städelsches Kunstinstitut und Städtische Galerie, 2000.

Stechow, Wolfgang. *Northern Renaissance Art 1400–1600: Sources and Documents.* Evanston, IL: Northwestern University Press, 1966.

Steinberg, Leo. "Michelangelo's Florentine *Pietà*: The Missing Leg." *Art Bulletin* 50.4 (December 1968): 343–53.

———. *The Sexuality of Christ in Renaissance Art and in Modern Oblivion.* Chicago: University of Chicago Press, 1983.

Stenhouse, William. *Reading Inscriptions and Writing Ancient History in the Late Renaissance.* London: Institute of Classical Studies, 2005.

Steppe, Jan. *Jheronimus Bosch: bijdragen bij gelegenheid van de herdenkingstentoonstelling te 's-Hertogenbosch 1967.* Den Bosch: Hieronymus Bosch Exhibition Foundation, 1967.

Sterk, Jos. *Philips van Bourgondië (1465–1524): bisschop van Utrecht als protagonist van de Renaissance, zijn leven en maecenaat.* Zutphen: Walberg Pers, 1980.

Stewart, Susan. *On Longing: Narratives of the Miniature, the Gigantic, the Souvenir, the Collection.* Durham, NC: Duke University Press, 1993.

Stijnman, Ad. *Engraving and Etching 1400–2000: A History of the Development of Manual Intaglio Printmaking Processes.* London: Archetype Publications, 2012.

Van der Stock, Jan. *Cornelis Matsys, 1510/11–1556/57: oeuvre graphique.* Brussels: Koninklijke Bibliotheek Albert I, 1985.

Stoichita, Victor. *The Pygmalion Effect from Ovid to Hitchcock.* Translated by Alison Anderson. Chicago: University of Chicago Press, 2008.

Stratenus, Petrus, and Cornelis Boey. *Venus Zeelanda et alia eius poëmata.* The Hague: ex officina Theodori Maire, 1641.

Strehlke, Carl Brandon, and Elizabeth Cropper. *Pontormo, Bronzino, and the Medici: The Transformation of the Renaissance Portrait in Florence.* Philadelphia: Philadelphia Museum of Art, 2004.

Sturge, Charles. *Cuthbert Tunstal: Churchman, Scholar, Statesman, Administrator.* London: Longmans, 1938.

Suykerbuyk, Ruben. "Coxcie's Copies of Old Masters: An Addition and an Analysis." *Simiolus* 37.1 (2013–14): 5–24.

Swinkels, Louis, ed. *De Bataven: verhalen van een verdwenen volk.* Amsterdam: De Bataafse Leeuw, 2004.

Tafur, Pero. *Travels and Adventures, 1435–1439.* Edited and translated by Malcolm Letts. London: George Routledge & Sons, 1926.

Talvacchia, Bette. *Taking Positions: On the Erotic in Renaissance Culture.* Princeton, NJ: Princeton University Press, 1998.

Tanner, Marie. *The Last Descendant of Aeneas: The Hapsburgs and the Mythic Image of the Emperor.* New Haven, CT: Yale University Press, 1993.

Tavernor, Robert. *On Alberti and the Art of Building.* New Haven, CT: Yale University Press, 1998.

Teitler, H. "Romeinen en Bataven: de literaire bronnen." In *De Bataven: verhalen van een verdwenen volk,* 20–36. Amsterdam: De Bataafsche Leeuw, 2004.

Templin, J. Alton. *Pre-Reformation Religious Dissent in the Netherlands, 1518–1530.* Landam, MD: University Press of America, 2006.

Tentoonstelling Dirk Martens, 1473–1973. Aalst: Stadsbestuur, 1973.

Thomas, Troy. "Poussin's Philadelphia Marine Painting: New Evidence for the *Neptune and Amphitrite* Theory." *Aurora* 10 (2009): 40–76.

Tilmans, Karin. *Historiography and Humanism in Holland in the Age of Erasmus: Aurelius and the Divisiekroniek of 1517.* Nieuwkoop: De Graaf Publishers, 1992.

Tirion, Isaak. *Tegenwoordige staat der Vereenigde Nederlanden: behelzende eene beschryving van Zeeland.* Amsterdam: Isaak Tirion, 1761.

La Toscana illustrata nella sua storia. Livorno: per Anton Santini e Compagni, 1755.

Tracy, James D. *Holland under Habsburg Rule, 1506–1566.* Berkeley: University of California Press, 1990.

Trunk, Markus. "Römische Kaiserbildnisse als panegyrisches Programm im Spanien des 16. Jhs." In *300 Jahre 'Thesaurus Brandenburgicus': Archäologie, Antikensammlungen und Antikisierende Residenzausstattungen im Barock.* Edited by Henning Wrede and Max Kunze, 463–86. Munich: Biering & Brinkmann, 2006.

Tuchen, Birgit. *Öffentliche Badhäuser in Deutschland und der Schweiz im Mittelalter und der frühen Neuzeit.* Petersberg: Imhof, 2003.

Tudela, Almudena Perez de. "Michiel Coxcie, Court Painter." In *Michiel Coxcie 1499–1592 and the Giants of His Age,* edited by Koenraad Jonckheere, 100–115. London: Harvey Miller Publishers, 2013.

Van Tuinen, Ilona. "The Struggle for Salvation: A Reconstruction and Interpretation of Maarten van Heemskerck's *Strong Men.*" *Simiolus* 36.3/4 (2012): 142–62.

Ullmann, Ernst. "Karlstadts Schrift 'Von Abthuung der Bylder', ihre Entstehung und ihre Folgen." In *Crise de l'image religieuse: de Nicée II à Vatican II,* edited by Olivier Christin and Dario Gamboni, 111–19. Paris: Éditions de la Maison des sciences de l'homme, 2000.

Unger, W. S. "Middelburg als handelsstad (XIIIe tot XVIe eeuw)." *Archief: vroegere en latere mededeelingen voornamelijk in betrekking tot Zeeland uitgegeven door het Zeeuwsch Genootschap der Wetenschappen* (1935): 1–177.

Van Vaernewijck, Marcus. *Den spieghel der Nederland-scher audtheyt*. Ghent: Gheeraert van Salencon, 1568.

Vandenbroeck, Paul. "Amerindian Art and Ornamental Objects in Royal Collections. Brussels, Mechelen, Duurstede, 1520–1530." In *America, Bride of the Sun: 500 Years Latin America and the Low Countries*, 99–120. Ghent: Ministry of the Flemish Community, Administration of External Relations, 1991.

Vandommele, Jeroen. *Als in een spiegel: vrede, kennis en gemeenschap op het Antwerpse Landjuweel van 1561*. Hilversum: Verloren, 2011.

Vasari, Giorgio. *Le vite de' più eccellenti pittori, scultori ed architettori*. Edited by Gaetano Milanesi. 9 vols. Florence: G. C. Sansoni, 1878–85.

———. *Lo Zibaldone di Giorgio Vasari*. Edited by Alessandro del Vita. Rome: Istituto d'archeologia e storia dell'arte, 1938.

Van der Velden, Hugo. "Diptych Altarpieces and the Principle of Dextrality." In *Essays in Context: Unfolding the Netherlandish Diptych*, edited by John Oliver Hand and Ron Spronk, 125–55. Cambridge, MA: Harvard University Press, 2006.

———. *The Donor's Image: Gerard Loyet and the Votive Portraits of Charles the Bold*. Translated by Beverly Jackson. Turnhout: Brepols, 2000.

Veldman, Ilja M. *Maarten van Heemskerck and Dutch Humanism in the Sixteenth Century*. Amsterdam: Meulenhoff, 1977.

———. "Die Moralische Funktion von Renaissance-Themen in der bildenden Kunst der Niederlande." In *Imperium Romanum—Irregulare Corpus—Teutscher Reichs-Staat: Das Alte Reich im Verständnis der Zeitgenossen und der Historiographie*, edited by Matthias Schnettger, 381–403. Mainz: Verlag Philipp von Zabern, 2002.

———. "Protestantism and the Arts: Sixteenth- and Seventeenth-Century Netherlands." In *Seeing beyond the Word: Visual Arts and the Calvinist Tradition*, edited by Paul Corby Finney, 398–403. Grand Rapids, MI: William B. Eerdmans Publishing Company, 1999.

Verdon, Timothy. "The Art of Guido Mazzoni." Ph.D. diss., New York University, 1978.

———. "Guido Mazzoni in Francia: nuovi contributi." *Mitteilungen des Kunsthistorischen Institutes in Florenz* 34 (1990): 139–64.

———. *Italian Primitives: The Case History of a Collection and Its Conservation*. New Haven, CT: Yale University Art Gallery, 1972.

Vermeir, Maarten. "Erasmus and the Joyous Entry." *Erasmus Studies* 34 (2014): 144–53.

Verstegen, Ian. "Between Presence and Perspective: The Portrait-in-a-Picture in Early Modern Painting." *Zeitschrift Für Kunstgeschichte* 71 (2008): 513–26.

Vervliet, Hendrik D. L., ed. *Post-Incunabula and Their Publishers in the Low Countries*. The Hague: Martinus Nijhoff, 1978.

Vine, Angus. *In Defiance of Time: Antiquarian Writing in Early Modern England*. Oxford: Oxford University Press, 2010.

Visser, C.Ch.G. *Luther's geschriften in de Nederlanden tot 1546*. Assen: Van Gorcum & Comp., 1969.

Vital, Laurent. *Relation du premier voyage de Charles-Quint en Espagne*. In *Collection des voyages des souverains des Pays-Bas*. Edited by L.-P. Gachard and C. Piot. Vol. 3. Brussels: F. Hayez, 1881.

Vives, Juan Luis. *De officio mariti*. Edited and translated by C. Fantazzi. Selected Works of J. L. Vives. Leiden: Brill, 2006.

De Vocht, Henry. *History of the Foundation and the Rise of the Collegium Trilingue Lovaniense 1517–1550*. 4 vols. Louvain: Bibliothèque de l'Université, 1951–55.

———, ed. *Monumenta Humanistica Lovaniensia: Texts and Studies about Louvain Humanists in the First Half of the XVIth Century: Erasmus-Vives-Dorpius-Clenardus-Goes-Moringus*. Leuven: Librairie Universitaire, 1934.

De Vos, Dirk. *Stedelijk Museum voor Schone Kunsten (Groeningemuseum Brugge)*. Brussels: Nationaal Centrum voor Navorsingen over de Vlaamse Primitieven, 1981.

De Vos, P. D. "Jason Pratensis, een vermaard 16e eeuwsch geneeskundige." *Zierikzeesche Nieuwsbode* (4 May 1934).

———. "De Latijnse school te Zierikzee en hare rectoren van de eerste helft der XVIe eeuw tot 1800." *De Nederlandsche Leeuw* (1899): 3–25.

Waagen, G. F. *Verzeichniss der Gemälde-Sammlung des Königlichen Museums zu Berlin*. Berlin: Druckerei der Königlichen Akademie der Wissenschaften, 1832.

Waal, Henri van de. *Drie eeuwen vaderlandsche geschied-uitbeelding, 1400–1800: een iconologische studie*. 2 vols. The Hague: Martinus Nijhoff, 1952.

Wauters, A. J. "Une ambassade flamande chez le Pape Jules II en 1508." *La Revue de Belgique* (1904): 5–32.

———. "Jean Gossaert en Adolphe de Bourgogne." *La Revue de Belgique* (1903): 1–23.

Weale, W. H. James. *Exposition des Primitifs Flamands et d'art ancien, Bruges*. Bruges, 1902.

———. *Hubert and John van Eyck: Their Life and Work*. London: John Lane Company, 1908.

Weber am Bach, Sibylle. *Hans Baldung Grien (1484–1545): Marienbilder in der Reformation*. Regensburg: Schnell & Steiner, 2006.

Weidema, Sytske, and Anna Koopstra. *Jan Gossart: The Documentary Evidence*. Turnhout: Brepols, 2012.

Weihrauch, Hans. "Studien zur süddeutschen Bronze-plastik." *Münchner Jahrbuch der bildenden Kunst* 3–4 (1952–53): 199–215.

Weiler, A. G. "Erasmus als kunstcriticus in de geest van de Moderne Devotie." In *Geen povere schoonheid: laat-middeleeuwse kunst in verband met de Moderne Devotie*, edited by Kees Veelenturf, 315–41. Nijmegen: Uitgeverij Valkhof Pers, 2000.

Weiss, Roberto. *The Renaissance Discovery of Classical Antiquity*. Oxford: Basil Blackwell, 1969.

Weisz, Ernst. *Jan Gossart gen. Mabuse: Sein Leben und Seine Werke*. Parchim in Mecklenburg: Hermann Freises Verlag, 1913.

Wellens-de Donder, Liliane. *Medailleurs en numismaten van de Renaissance in de Nederlanden*. Brussels: Koninklijke Bibliotheek, 1959.

Werner, Elke, Anne Eusterschulte, and Gunnar Heydenreich, eds. *Lukas Cranach der Jüngere und die Reformation der Bilder*. Munich: Hirmer, 2015.

Wesseling, Ari. "Are the Dutch Uncivilized? Erasmus on the Batavians and His National Identity." *Erasmus of Rotterdam Society* 13 (1993): 68–102.

———. "In Praise of Brabant, Holland, and the Habsburg Expansion: Barlandus' Survey of the Low Countries (1524)." In *Myricae: Essays on Neo-Latin Literature in Memory of Jozef Ijsewijn*, edited by D. Sacré and G. Tournoy, 229–47. Leuven: Leuven University Press, 2000.

Wettlaufer, Alexandra K. *Pen vs. Paintbrush: Girodet, Balzac and the Myth of Pygmalion in Postrevolutionary France*. New York: Palgrave, 2001.

Wezel, Gerard van, et al. *De Onze-Lieve-Vrouwekerk en de grafkapel voor Oranje-Nassau te Breda*. Zwolle: Waanders Uitgevers, 2003.

White, Paul. *Renaissance Postscripts: Responding to Ovid's "Heroides" in Sixteenth-Century France*. Columbus: Ohio State University Press, 2009.

Widerkehr, Léna. *The New Hollstein, Dutch and Flemish Etchings, Engravings and Woodcuts, 1450–1700, Jacob Matham*. Edited by Huigen Leeflang. 3 vols. Ouderkerk aan den Ijssel: Sound & Vision, 2007.

Wiersum, E. "Bijdrage tot de oudste geschiedenis van den polder Walcheren." *Archief: vroegere en latere mededeelingen voornamelijk in betrekking tot Zeeland uitgegeven door het Zeeuwsch Genootschap der Wetenschappen* (1907): 1–30.

Wijsman, Hanno. "Northern Renaissance? Burgundy and Netherlandish Art in Fifteenth-Century Europe." In *Renaissance? Perceptions of Continuity and Discontinuity in Europe, c.1300–c.1550*, edited by Alex Lee, Pierre Péporté, and Harry Schnitker, 269–88. Leiden: Brill, 2010.

Winzinger, Franz. *Albrecht Altdorfer: Die Gemälde: Tafelbilder, Miniaturen, Wandbilder, Bildhauerarbeiten, Werkstatt und Umkreis*. Munich: Hirmer, 1975.

Wolfegg, Christoph Graf zu Waldburg. *Venus and Mars: The World of the Medieval Housebook*. Translated by Almuth Seebohm. Munich: Prestel, 1998.

Wolfthal, Diane. *In and out of the Marital Bed: Seeing Sex in Renaissance Europe*. New Haven, CT: Yale University Press, 2010.

Wood, Christopher S. *Forgery, Replica, Fiction: Temporalities of German Renaissance Art*. Chicago: University of Chicago Press, 2008.

———. "Indoor-Outdoor: the Studio around 1500." In *Inventions of the Studio: Renaissance to Romanticism*, edited by Michael Cole and Mary Pardo, 36–72. Chapel Hill: University of North Carolina Press, 2005.

———. "Maximilian I as Archeologist." *Renaissance Quarterly* 57 (2005): 1128–74.

Wouk, Edward H. "Lambert Suavius." In *The Bernard and Mary Berenson Collection of European Paintings at I Tatti*, edited by Carl Brandon Strehlke and Machtelt Brüggen Israëls, 582–86. Milan: Officina Libraria, 2015.

———. "Reclaiming the Antiquities of Gaul: Lambert Lombard and the History of Northern Art." *Simiolus* 36 (2012): 35–65.

Wright, Alison. *The Pollaiuolo Brothers: The Arts of Florence and Rome*. New Haven, CT: Yale University Press, 2005.

Yeazell, Ruth Bernard. *Art of the Everyday: Dutch Painting and the Realist Novel*. Princeton, NJ: Princeton University Press, 2008.

Zanker, Paul, and Björn Christian Ewald. *Mit Mythen Leben: Die Bilderwelt der Römischen Sarkophage*. Munich: Hirmer, 2004.

Zapperi, Roberto. "Alessandro Farnese, Giovanni della Casa and Titian's Danae in Naples." *Journal of the Warburg and Courtauld Institutes* 54 (1991): 153–71.

Zerner, Henri. *Renaissance Art in France: The Invention of Classicism*. Paris: Éditions Flammarion, 2003.

Zijlstra, W. C. *Den Zeusen Bessem: catalogus van de Nederlandse pamfletten (alsmede de niet-Zeeuwse plakkaten en ordonnanties) tot en met 1795, aanwezig in de Zeeuwse Bibliotheek*. Middelburg: Zeeuwse bibliotheek, 1994.

Zilverberg, S.B.J. *David van Bourgondië, Bisschop van Terwaan en van Utrecht (1427–1496)*. Groningen: Wolters, 1951.

Zimmermann, Heinrich. "Das Inventar der Prager Schatz- und Kunstkammer vom 6. Dezember 1621, nach Akten des K. und K. Reichsfinanzarchivs in Wien." *Jahrbuch der Kunsthistorischen Sammlungen des Allerhöchsten Kaiserhauses* 25.2. Quellen (1905): XIII–LXXV.

Zorach, Rebecca. *Blood, Milk, Ink, Gold: Abundance and Excess in the French Renaissance*. Chicago: University of Chicago Press, 2005.

Zovitius, Jacobus. *Didascalus*. Cologne: apud Ioannem Gymnicum, 1541.

———. *Didascalus: een geleerd en grappig stuk over de leraar uit 1540*. Edited by Egbert Vloeimans. Amersfoort: Florivallis, 2009.

———. *Ruth, authore Iacobo Zovitio Driescharo, Ludi Hoochstratani Hypodidascalo*. Antwerp: apud Michaelem Hillenium, 1533.

INDEX

Note: Bold page numbers indicate figures.

Adam and Eve: in Balzac's *The Unknown Masterpiece*, 150; in Dürer's *Adam and Eve*, 10, 11, 15, 51; in van Eyck's *Ghent Altarpiece*, 14, 15, 51, 81; in JG's *Adam and Eve* (c. 1525), 15, 16; in JG's *Adam and Eve* (c. 1520–25), 86; JG's lost representation of dwarfs as, 16; in illustration for Geldenhouwer's *Batavian History*, 97; in Meit's *Adam and Eve*, 104, **105**

Adolph of Burgundy, 103, 116, 122; as admiral of Netherlands, 132; and artistic commissions, 137; and commission of swordfish sculpture, 137; and conversations on art, 135–36, 137–38; copper plaque commemorating heart of, 133, 178n59; court of, 134–36, 137–38; death of, 178n59; and JG, 132–33; and JG's *Danaë*, 132; and JG's mythological pictures, 143; and van Mander, 150; as patron, 132–33, 136, 137–38, 143; and Philip of Burgundy, 132, 143; portrait medal of, 103, 133–34, **134**, 137; and Pratensis, 135–36, 137, 143; and Sandenberg palace, 132, 137, 138; and Souburg palace, 132; and voyage of discovery, 134

Adrian VI, Pope, 103

Aeneas, 40

Agricola, Rudolph, 40, 115

alabaster, 104, **106**

Alberti, Leon Battista, 8; *On Architecture*, 14, 141; *On Painting*, 7, 14

Amphitrite, 46, 59, 61–62, 64, 65–66, 67, 165n67

Amstelredamus, Alardus, 118–19, 178n69

Antico, 155n5

antiquarianism, 2, 40, 102, 151; and Geldenhouwer, 38, 40, 42, 56–57, 70–71; and JG, 4, 36, 45–46, 71, 124, 146, 156; and JG's approach to van Eyck's legacy, 36; and JG's *Neptune and Zeelandia*, 45–46, 71; and Maximilian of Austria, 43; and medals, 104, 133; and Netherlandish humanists, 40; of Philip of Burgundy, 57, 80, 130, 138; in Rome, 48

antiquities: collectible, 76, 103; JG's drawings of, 3, 12, 48, **48**, **49**, **50**, 56; and JG's *St. Luke Drawing the Virgin* (c. 1515), 30; surrogates of, 2, 8, 71, 76, 103, 104

antiquity, 75, 105; and Dürer, 10; and van Eyck's *Ghent Altarpiece*, 36; and Geldenhouwer, 95, 97; geography of, 115; and JG's *Danaë*, 116, 120, 129; JG's embodiment of, 8, 10, 45, 51, 73, 151; and JG's *Neptune and Zeelandia*, 70, 72, 73; and JG's

St. Luke Drawing the Virgin (c. 1515), 28; and Heemskerck, 152; and Herbenus, 41; local/Netherlandish, 4, 21, 36, 38, 40–43, 72, 80, 95, 97, 151, 152; and Neptune and Amphitrite, 59; and Philip of Burgundy, 22, 56–57, 76, 100, 136; and portrait busts, 77; revival of, 2, 4, 36, 40, 42, 145; and Walcheren, 70; and Zeeland, 52, 56

Antony and Cleopatra, 134

Antwerp, 26, 146; art market in, 152; JG in, 23; and Neptune and Amphitrite, 61–62, 64; personified, 62, 165n73; processional of Philip II into, 62–63

Apelles, 42, 57, 142; *Venus* of, 41

Apollo, 70, 140

Apollodorus, 91

archaeology, 2, 38, 43; and Aurelius, 100, 101; and Brittenburg castle, 71–72, **72**; and conch shells in the Netherlands, 169n106; and Geldenhouwer, 43, 78, 98; and JG's *Neptune and Zeelandia*, 70; and Heda, 95; and Hercules Magusanus altar, 56–57; and Philip of Burgundy, 43, 57

architecture: ancient, 45, 46, 48; and ancient Roman sarcophagi, 91; classical, 104, 120, 125; classicizing, 42; in van Eyck's *The Madonna with Canon van der Paele*, 52; in JG's *Danaë*, 124, 125, 127; JG's drawings of, 48; and JG's *Hercules and Deianira* (c. 1520), woodcut, 83; and JG's *Malvagna Triptych*, 33; and JG's *Neptune and Zeelandia*, 45, 46, 51, 52, 59, 66, 67, 76; and JG's *St. Luke Drawing the Virgin* (c. 1515), 28; and *Hercules Wrestling with Antaeus*, 83; juxtaposition of bodies in, 7; of Michelangelo's Sistine Chapel ceiling, 7; Romanesque, 41, 52

arms and armor: and Batavians, 99, 100; in van Eyck's *Van der Paele Madonna*, 14; and JG's chariot for funeral of Ferdinand of Aragon, 57; JG's drawings of, 12, 48. *See also* chariot

Augustine, St., 118

Augustus, Emperor, 57

Aurelius, Cornelius, 102; on Batavian history, 71, 100–102, 174n94; *Chronicle of Holland, Zeeland, and Friesland (Divisiekroniek)*, 100–101; *Dialogue between Vesta and Neptune on the Subject of Flooding*, 54

Backer, Jacob de, 152

Baden-Baden, baths of, 17

Baldung Grien, Hans, 12, 176n21

Balzac, Honoré de, 152, 181n6, 181nn9–10; *The Unknown Masterpiece*, 145, 146–47, 150

Barbari, Jacopo de', 51

Barlandus, Hadrianus, 68–69, 109, 119–20, 134, 140; *On the Noblemen of Holland*, 119

Batavia: and Geldenhouwer, 95, 97–102, 168n97, 168n99; and JG's *Neptune and Zeelandia*, 73; island of, 70–71, 75; recovery of past of, 145

Batavians, 43, 75, 95, 97–102

bathers: in JG's *Women's Bath*, 17, 19; representation of, 17

bathhouses, 17, 19, 157n32

Beatis, Antonio de, 80–81, 102

Becker, Jan, 41, 42, 134

Bergen, Anna van, 133, 136, 143

Berthoud, Samuel Henry, 147, 181n9

Beveren, St. Martin's Church, 133

Biondo, Flavio, 40–41

birth/birthing, 138; and Danaë in Colonna, 128–29; and JG's *Danaë*, 127–28, 129. *See also* pregnancy/ impregnation

birthing stool, 128, **128**

Blioul, Laurent de, 76

Boccaccio, Giovanni, *Genealogy of the Pagan Gods*, 65

Boechout, Daniel van, Lord of Boelare, 22

Boey, Cornelis, *The Venus of Zeeland* (1641), 67–68; title page, **68**, 69

Boissard, Jean-Jacques, 176n8

Bosch, Hieronymus, *Garden of Earthly Delights*, 80–81, **81**

Bracciolini, Poggio, 17

Bramante, Donato, 30, 177n33

Britannia, 62, 64, 66, 165–66n74

Brittenburg castle, 71–72, **72**, 73

bronze: and busts for Maximilian I, 78; JG's representation of, 28, 111; and local archaeological finds, 43, 104; and Meit's *Mars and Venus* (c. 1515–20), 104, **107**; statuettes, 104, 109, 179n80

Brou, burial chapel of Margaret of Austria, 21, 35, 158n82, 177n49

Bruni, Leonardo, 40–41

Brussels, excavations outside, **42**, 43

bucrania: and JG's design for tomb of Isabella of Austria (c. 1526), 131; and JG's *Hercules and Deianira*, 83; and JG's *Neptune and Zeelandia*, 51

Burgundian court, 21–23, 35, 93; and van Eyck, 26; and JG, 151; local traditions of, 58

Burgundians, 38; ancestry of, 43, 93–94; and Aurelius, 100; and Batavians, 43, 98, 100; and JG's *Portrait of a Nobleman*, 34; and Hercules, 57; and Hercules and Deianira, 94; legacy of, 77; and Low Countries, 146; motto of, 34; patronage of, 80; and Trojan heroes, 75

Busleyden, Jerome van, 103, 111

Bust of Charles V (c. 1520), **79**

busts: ancient, 160n7; in bishop's palace at Wijk bij Duurstede, 88; bronze, 78; of Roman emperors, 78; sculpted, polychromed portrait, 77–80, 88; terracotta, 78, 79

Caligula, Emperor, 72

Carondelet, Jan II, 35, 79, 80, 104, 177n36

Cartari, Vincenzo: *Images of the Gods*, 59, **61**

Cellini, Benvenuto, *Salt Cellar* (1540–44), **64**, 65–66

Celtis, Conrad, 159n86, 161–62n29

chariot: and JG's design for funeral of Ferdinand of Aragon, 57

Charles the Bold, duke of Burgundy, 21, 134, 172–73n64

Charles V, Holy Roman Emperor, 22, 40, 53, 94, 146, 161n28; and Adolph of Burgundy's voyage of discovery, 134; and Aurelius, 100; Bust of (c. 1520), **79**; departure for Spain, 102; and Geldenhouwer, 57; and Grapheus, 165n72; and JG's *Hercules and Deianira*, woodcut (c. 1520), 172n59; and Hercules, 92–93; and van Mander, 150; and Order of the Golden Fleece, 76, 92–93; and Philip of Burgundy, 76; *Plus ultra* devise of, 92–93; and Pratensis, 139; as ruler of Spain, 52, 92

Chartres, Claude de, 79

chastity: and JG's *Danaë*, 118. *See also* virginity

Christian II of Denmark, 22, 122, 131

Claesz, Allaert, *Hercules Holding a Club and Embracing Deianira*, engraving (c. 1520–30), 83, **85**

coins, ancient, 43, 78, 102–3; and Danaë paintings, 118; and JG's *Danaë*, 127; and JG's *Venus and Amor*, 111. *See also* medals

Colombe, Michel, 170n26

Colonna, Crisostomo, 168n97

Colonna, Francesco, *Hypnerotomachia Poliphili*, 128–29

Colosseum, 3, 48, 50, 73, 151–52

conch shell: and JG's *Neptune and Zeelandia*, 46, 58–59, 61, 72–73

Conti, Natale, *Mythologies*, 65

Cordatus, Hadrianus, 136, 140

Correggio, Antonio Allegri da, 116, 155n5; *Danaë* (1530), 125, **126**

Cortés, Hernán, 20

Coukercken, Corneille van, 119

Coxcie, Michel, side wings depicting St. John the Evangelist and St. Matthew (1560–65), 152, **153**

Cozumel, island of, 134

Cranach, Lucas, the Elder, 12, 171n35; *Venus* (1532), **12**

Cranevelt, Frans, 78–80, 100, 103, 115, 140, 171n39

Danaë: in Colonna's *Hypnerotomachia Poliphili*, 128–29; and Erasmus, 118, 119; and Gauricus, 125–26; and Goltzius, 118; and JG's *Danaë*, 116, 118, 124, 125, 126, 127, 129–30; and Immaculate Conception, 118; myth of, 118, 125; in Terence, 118; womb of, 116

David of Burgundy, 77, 130, 169–70n15

Deianira, 100, 171–72n48; in JG's *Hercules and Deianira* (1517), 83, 86, 88, 91; in JG's *Hercules and Deianira* (c. 1520), woodcut, 83; in Lefèvre, 93–94; in Matham's *Hercules and Deianira*, 88; myth of, 86–87

Deventer, Jacob van, *Map of Zeeland* (c. 1570), 53, **53**, **57**, 71

Doria, Andrea, 164n61, 176n8

Dorp, Martin, 41, 42, 56, 168n97

Dossi, Dosso, 155n5

Dürer, Albrecht, 14, 20, 147, 182n14; *Adam and Eve* (1504), **10**, 10–11, 15, 51; and JG's Middelburg altarpiece, 22; and JG's mythological works, 23; and Luther, 179n88; and van Orley, 28

Egmond, house of, 101

Elephantis, 142

Erasmus, Desiderius, 5, 40, 52, 77, 135, 162n32; and Adolf of Burgundy, 134; and Alardus Amstelredamus, 119; *A Batavian Ear*, 53; and Danaë, 118, 119; engraved portrait of, 135; *The Godly Feast*, 111, 136; on images, 142–43; and Lucian, 109; medal for (1519), 103; and paganism, 120; and Philip of Burgundy, 77, 100; and Terence, 118

Este, Cardinal Ippolito d', 65

Estrella, Juan Calvete de, 64

Eyck, Jan van, 3, 20, 26, 158n55; *The Arnolfini Portrait* (1434), 26, **27**, 28; and Balzac, 147; copies and interpretations after, 26; *Ghent Altarpiece* (c. 1425–35), 14–15, **16**, **17**, 36, 51, 81, 124, 152, 158n84; and illusionistic tradition, 124; lost painting of woman at her bath, 16–17, 26; *Madonna in the Church* (c. 1425), **31**, 31–33; *The Madonna of Chancellor Rolin* (1435), 28; *The Madonna with Canon van der Paele* (1436), 14, **15**, 35, 52; and van Mander, 148; and Netherlandish antiquity, 43; painterly technique of, 28; and reflective surfaces, 14

Eyckian revival, 26–37, 145

Fazio, Bartolomeo, 17

featherwork, 20, 134

Ferdinand of Aragon, 57

Ficino, Marsilio, 141

flamboyant Gothic. *See* Gothic architecture/ornament, flamboyant

Floris, Frans, 146, 150, 152

forgery, 75, 95

Francken, Frans, the Younger, 61–62; *The Triumph of Neptune and Amphitrite*, **62**

Frederick of Baden, 111

Frederick the Wise, 2

Frenhofer, Master (Balzac character), 146–47

Galen, 138

Gauricus, Pomponius, *On Sculpture*, 125–26, 156–57n15

Geldenhouwer, Gerard, 42–43, 48, 159n86, 174n84

and archaeology, 43, 98

and Aurelius, 54

and de' Barbari, 51

and Barlandus, 69, 109, 120

and Batavia, 95, 97–102, 168n97, 168n99

and Batavian isle, 71

and Batavians, 97–102

and Cranevelt, 100

and JG, 38, 40, 42, 57, 78, 79, 80, 115

on JG as Apelles, 42, 57

on JG's drawings for Philip of Burgundy, 49–50

and JG's *Neptune and Zeelandia*, 46, 58, 66

and Italy, 77

journey to Wittenberg, 122

and Lemaire de Belges, 97

and local antiquity, 95, 97

as Lutheran, 50, 122, 161n15

at Marburg Lutheran university, 122

and Meit, 104

and More, 71, 168n96

and Philip of Burgundy, 38, 57, 136

on Philip of Burgundy as bishop, 77

and Philip of Burgundy as Neptune, 58

on Philip of Burgundy's court, 136

and Philip of Burgundy's death, 122

and Philip of Burgundy's funerary monument, 130

and Philip of Burgundy's reading and conversations, 100–101, 136

in Philip of Burgundy's service, 56

and Pratensis, 136

and Reformation, 122

and Rome, 38, 40, 50

and Sebastian of Zierikzee, 168n101

and Snoy, 72, 134

on Walcheren's ancient history, 70

and Zagarus, 140, 180n95

Works: *Batavian History*, 95, 97–100; *Eight Satires*, 58, 136; on funeral of King Ferdinand of Aragon, 57–58; *Historica Batavica (Batavian History)*, *Epitaph on Soranus the Batavian*, 99, **99**; *Historica Batavica (Batavian History)* (Title Page) (1530), **98**; Latin epithets for Philip of Burgundy, 164n61; *A Letter on Zeeland* (1514), 56, 68–69, 70, 71, 97, 168n97; letter to Adolph of Burgundy, 122; letter to Frans Cranevelt (1520), 78–80, 81, 115; *Lucubration on the Batavian Isle*, 97; on Philip of Burgundy's inauguration as bishop, 77; poem honoring Philip of Burgundy as patron, 58, 136; unrealized history of early sixteenth-century Netherlands, 104; *Vita* (biography) of Philip of Burgundy, 46–47, 49–50, 51, 52, 55, 109, 111

genealogy, 75, 76, 94, 98, 101

Gens Batavorum inscription, 95, **97**

Geraardsbergen, St. Adrian's Abbey, chapel of Our Lady, 22

geschied-uitbeelding, 2

Goes, Hugo van der, 30

Golden Fleece, 140. *See also* Order of the Golden Fleece

Goltzius, Hendrick, 124; *Hercules and Deianira*, 88, **89**; *The Sleeping Danaë Being Prepared to Receive Jupiter* (1603), 118, **119**

Gossart, Jan (Mabuse), 2

 and Brotherhood of Our Lady in Middelburg, 161n23

 career at court, 21–23, 26

 circle and milieu of, 4, 20, 22–23, 26, 35, 42, 68, 69, 122, 148

 death of, 146

 legacy of, 146–52

 van Mander's biography of, 133, 148–50

 portrait of, **144–45**, 147–48, **149**

 return from Italy, 3, 52

 travel to Italy, 3, 4, 11, 12, 21, 23, 41, 46, 56, 58, 59, 91

 Works: *Adam and Eve* (1510), 10–11, **11**; *Adam and Eve* (c. 1525), **6–7**, 15–16, **18**; *Adam and Eve* (c. 1520–25), 86, **86**; *Adam and Eve*, as dwarfs (lost painting), 16; *Adoration of the Kings* (c. 1510–15), 22, **25**, 30–31, 51; *Apollo Citharoedus of the Casa Sassi* (1509), 48, **49**, 107; *Carondelet Diptych* (1517), **34**, 34–35, 147; chariot for funeral of King Ferdinand of Aragon, 57; and choir screen for Utrecht Cathedral, 22; *Danaë* (1527), 116–18, **117**, 124, 125, 126–28, **127**, 129–30, 131–32, 136, 138, 142, 143; *Doria-Pamphilj Diptych* (1510–15), **32**, 32–33; drawings of antiquities, 3, 12, 48, **48**, **49**, **50**, 56; drawings of antiquities for Philip of Burgundy, 49–51; experiments with etching, 83; *Hercules and Deianira* (1517), 59, 76, 81, **82**, 83–84, 86, 88–89, **90**, 91–92, 93, 94, 100, 102–3, 105, 107, 111, 136, 171n33; *Hercules and Deianira* (lost, Henry of Nassau's collection), 80, 81, 83, 102, 171n33; *Hercules and Deianira* (c. 1520–30) etching (attributed to Jan Gossart), 83, **85**; *Hercules and Deianira* (c. 1520) woodcut, 83, **84**, 92; *Hercules of the Forum Boarium* (c. 1509), 48, **50**; Hercules painting (lost, listed in Michaeli's Antwerp inventory), 131; *Hermaphroditus and Salmacis* (c. 1517), **74–75**, 105, 107, **108**, 109, 136; *Malvagna Triptych* (1513–15), 33, **33**, 51, 102; Middelburg Abbey altarpiece (lost), 22, 182n14; *Neptune and Zeelandia* (also known as *Neptune and Amphitrite*) (1516), **44–45**, 45–46, **47**, 50, 51, 56, 58–61, **66**, 66–73, 76, 77, 81, 83, 86, 132, 140, 143, 164n61; Philip of Burgundy's funerary monument, 130, 131; and Philip of Burgundy's portrait busts, 78, 79; and Philip of Burgundy's Souberg palace, 55–56; and Philip of Burgundy's Wijk bij Duurstede palace, 78, 79, 80; portrait of Anna van Bergen, 133, 137, 143; *Portrait of a Nobleman* (c. 1528–30), **24**, 34, 148; *Portrait of Jan II Carondelet* (c. 1525/30), **36**; and restoration of paintings for Margaret of Austria, 22; *St. Luke Drawing the Virgin* (c. 1515) (Mechelen altarpiece) (Prague), 28, **29**, 30, 118, 122, 152, 158n67; *St. Luke Drawing the Virgin* (1520–22) (Vienna), **114–15**, 122, **123**, 124, 125; *Study sheet with Spinario* (c. 1509), 12, **13**, 14, 48; *The Three Children of Christian II of Denmark* (1526), 22, **23**; tomb of Isabella of Austria, design for (c. 1526), 131, **131**; *Venus* (1521), 8, **9**, 10, 11–12, 14, 15, 16, 17, 19, 20, 21, 33, 102, 109, 136; *Venus and Amor* (1521), 109, **110**, 111, 113, 136; *View of the Colosseum Seen from the West* (c. 1509), 3, 48, **48**, 50–51, 73; *Virgin and Child* (c. 1527) (London), 111, **112**, 113, 126; *Virgin and Child* (c. 1527) (Prado), 120, **121**; *Virgin Mary, Christ Blessing, and St. John the Baptist (Deesis)* (1525–30), 35–36, **37**, 124, 152; *Women's Bath* (c. 1520–25), 17, 19, **20**

Gossart, Nicasius, 54

Gothic architecture: and van Eyck's *Madonna in the Church*, 31–32

Gothic architecture/ornament, flamboyant, 4; and JG's *Danaë*, 125; and JG's *Deesis*, 35, 124; and JG's *Malvagna Triptych*, 33; and JG's *St. Luke Drawing the Virgin* (c. 1515), 30

Grapheus, Cornelius, 61, 62, 122, 156–57n15, 165n72; *De seer wonderlijcke . . . incompst* (1549), **63**

Grudius, Nicolaus, 119

Guelders, rebellion in, 101–2, 130

Guevara, Diego de, 158n60

Guicciardini, Ludovico: *Descrittione di tutti i Paesi Bassi* (1581), 72, **72**; on JG, 3, 7, 148

Hadrian, Emperor, 98; bust of, 48

Heda, Willem, 26, 46, 158n54; and archaeology, 95; art collection of, 26; biography of Philip of Burgundy, 14, 76; *Genethliacum*, 94–95, 98; *Genethliacum*, title page, **96**; and house on Groenplaats in Antwerp, 14; and library inventory, 14

Heemskerck, Maarten van, 151–52; *Self-Portrait in Rome with the Colosseum* (1553), **151**, 151–52

Heliogabolus, Emperor, 134

Hemessen, Jan Sanders van, 146

Hendrik (son of Adolph of Burgundy), 134

Henry of Nassau, Count, Lord of Breda, 26; and Batavians, 102; and JG, 171n34; and JG's *Hercules and Deiania* (lost painting), 80, 81, 83, 102, 171n33; and JG's *Hercules and Deianira* (1517), 103; and Guelders rebellion, 101–2; inventory of, 81, 132; and Lefèvre's *Compendium*, 94; and Order of the Golden Fleece, 92; palace in Brussels, 80–81; and Philip of Burgundy, 81; and Janus Secundus,

104; and portrait busts at Wijk bij Duurstede, 78, 80

Herbenus, Matthaeus, *On Maastricht Restored*, 40–41

Hercules: and Antaeus, 89, 91; and Atlas, 89, 91; and Batavians, 97, 102; and Burgundian house, 57; and Charles V, 92–93; and Deianira (representations of not by JG), 87, 171–72n48; in Goltzius, 88; in JG's *Hercules and Deianira* (1517), 83, 86, 88, 89, 91; in JG's *Hercules and Deianira* (c. 1520), woodcut, 83, 172n59; and JG's *Virgin and Child*, 113; in Heda's *Genethliacum*, 95; and Hydra, 89, 91; labors of, 89, 91–92, 93, 101, 151, 172–73n64; in Lefèvre, 93–94, 95; and Lemaire de Belges, 97; and love and war, 88–89, 91–92; and Low Countries, 94; and Margaret of Austria's nude statuette, 105; in Matham's *Hercules and Deianira*, 88; myth of, 86–87; and Nessus, 87, 88; and Netherlands, 95; and Philip of Burgundy, 101; and Soranus, 100; and Straits of Gibraltar, 92, 95; and virtue vs. vice, 77; as world ruler, 92

Hercules and Deianira, from Raoul Lefèvre, *Compendium* (1470s), **94**

Hercules Magusanus: altar dedicated to, 56–57, **57**, 67, 70, 71, 95, 163nn47–48

Hercules sarcophagi, 91

Hercules Wrestling with Antaeus (1523), after Jan Gossart, 83, **85**

Hermaphroditus: and JG's *Hermaphroditus and Salmacis*, 107

historia: Alberti on, 7

Holbein, Ambrosius, *The Island of Utopia* (1516), woodcut, **70**

Holbein, Hans, 147

iconoclasm, 116, 120, 122, 175–76n3

Immaculate Conception, 32, 118, 124

inventories: of Heda, 14; of Henry of Nassau, 132; of Margaret of Austria, 104, 109, 132; of Michaeli, 131; of Philip of Burgundy, 20, 102, 103, 111; of Philip of Cleves, 131, 132; of Prague Kunstkammer, 131

Isabella of Austria, 22, 131

Italy: JG's travel and experience in, 3–4, 21, 41, 46–47, 56, 58, 59; Lombard's travel to, 148; and Netherlandish artists after JG, 151; Netherlands as rival to, 38, 40–41; Philip of Burgundy's ambassadorial mission to, 21, 46–47. *See also* Rome

Jan II, of Wassenaer, 72

jetons (*rekenpenningen*), 103

Julius Caesar, 41, 57, 70; bust of, 48

Julius II, Pope, 46–47, 48, 49

Karlstadt, Andreas, 120, 122

Key, Willem, 152

Lampsonius, Dominicus: on JG, 147–48, 150–51, 182n14; *Lamberti Lombardi apud Eburones pictoris celeberrimi vita*, portrait of Lambert Lombard (1565), **149**; on Lambert Lombard, 140; *Pictorum aliquot celebrium Germaniae Inferioris effigies*, portrait of Jan Gossart (1572), **144–45**, **149**

Laocoön, sculpture of, 49

laus patriae, 52–53

Lefèvre, Raoul, *Compendium of Trojan Histories*, 93–94, **94**, 95, 172–73n64

Leiden: excavations outside, 43; Roman inscription near, 95

Lemaire de Belges, Jean, 43; *Illustrations of Gaul and Singularities of Troy*, 97

Lemnius, Levinius, 140

Leo X, Pope, 76

Leyden, Lucas van, 146, 171n33, 182n21

local antiquity. *See* antiquity; Netherlandish antiquity

Lombard, Lambert, 140, 148, 150–51

Lucian, dialogue between Venus and Cupid, 109

Luke, St., 28, 30; Eastern Orthodox version of legend of, 122, 124; and JG's *St. Luke Drawing the Virgin* (c. 1515), 28, 30; as patron saint of Netherlandish artists, 122

Luther, Martin, 116, 120, 122, 179n88

Lutheranism, 122, 138–40, 161n15

Maastricht, antiquity of, 40–41

Mabuse (Balzac character), 146–47

Mander, Karel van, 137; biography of JG, 133, 148–50; *Lives of the Illustrious Netherlandish and German Painters*, 3, 148–50

Mantegna, Andrea, 155n5

Marck, Érard de la, 151

Margaret of Austria, 16, 22, 136; and Adolph of Burgundy's voyage of discovery, 134; and ambassadorial mission to Italy, 21; burial chapel of in Brou, 21, 35, 158n82, 177–78n49; and van Eyck's *Arnolfini Portrait*, 28; and JG, 104; and JG's *Hermaphroditus and Salmacis*, 107, 109, 115; and JG's lost painting with dwarfs as Adam and Eve, 16; and JG's mythological works, 26; inventory of, 104, 109, 132; and Lemaire de Belges, 97; library of at Mechelen, 78; marble portrait bust of, 78, 104; mother-in-law of, 21; and van Orley, 122; small metal nude youth in collection of, 104–5

Margaret of York, 134, 172–73n64

Marliani, Luigi, 92–93

Mary of Burgundy, 21

Mary of Hungary, 136, 146

Mary Tudor, 78

Masaccio, *Trinity*, 7

Massys, Quentin, 26, 32; medal for Erasmus (1519), 103; *The Moneylender and His Wife* (1514), 26, **27**

Matham, Jacob, after Hendrick Goltzius, *Hercules and Deianira* (c. 1590) engraving, 88, **89**

Maubeuge, 146

Maximilian I, Holy Roman Emperor, 21–22, 43; bronze busts of, 78, 80; and Heda's *Genethliacum*, 94, 95, 98; imperial lineage of, 78; tomb of, 78, 80

Maximilian of Burgundy, 22, 136, 163n40

Mazzoni, Guido, 78

medals, 76, 102; and JG's *Venus and Amor*, 111; portrait, 103–4; portrait medal of Adolph of Burgundy, 133–34, **134**; portrait medal of Adrian VI, 103. *See also* coins

Medici, Lorenzo de', 160n7

Mediolanensis, Magninus, *Tregement der ghesontheyt* (1514), 17, **19**

Meinhardi, Andreas, 2

Meit, Conrad, 78, 104–5, 170n26; *Adam and Eve* (1510), 104, **105**, 109; *Judith with the Head of Holofernes* (c. 1525–28), 104; *Mars and Venus* (c. 1515–20), 104, 105, **107**

Michaeli, Ipolito, 131

Michaud, Louis Gabriel, *Universal Biography*, 147, 150

Michelangelo, Sistine Chapel ceiling, 7

Middelburg, Premonstratensian Abbey of, 22

mirrors and reflections: in van Eyck, 14, 17, 26; in JG's *Venus*, 8, 10, 14; in JG's *Women's Bath*, 19; and Massys, 26; and Narcissus, 8

Modi, I, 128, **129**

Montanus, Petrus, *Adage in Praise of the Germans*, 40

More, Thomas, 103, 168nn95–96; *Utopia*, 70, 71

Muskat, Jörg, 78

mythological works, 22; and Adolph of Burgundy, 138, 143; and antique collectibles, 76; and Beatis, 80–81; and bodies, 7; and Burgundian court, 21, 23; and Christian and ancient history, 113; *Danaë* as JG's last extant, 116, 131; and van Eyck's compositions, 28, 42; after JG, 146, 151–52; and JG after Philip of Burgundy's death, 115, 116, 131; JG's dramatic intervention of, 14; and JG's *Hercules and Deianira* (1517), 83, 84, 102; and JG's native milieu, 41–42; and JG's *Neptune and Zeelandia*, 73; and JG's Netherlandish colleagues, 81; and JG's trip to Rome, 3; JG's turn to, 41; and Heemskerck, 151, 152; as *historie* with nude figures, 7; as independent genre, 2; interpretation of, 111, 120, 124; and Italian models, 41, 45, 58; and Meinhardi, 2; and Meit, 104, 105; and portrait busts, 78; and small figural sculptures, 104; social setting for discussion of, 100–101, 136, 137–38; as surrogate ancient monuments, 2; as surrogates for collectible antiquities, 76, 103; and *Venus and Amor* (1521), 109, 111

Narcissus, myth of, 8, 10, 14, 15

Neptune, 65; and Amphitrite, 59, 61, 64; ancient

Greek sanctuaries of, 65; and Antwerp, 61–62, 64; in Boccaccio, 65; and Cellini, 65–66; and Estrella, 64; and Geldenhouwer's poem on art of painting, 58; in JG's *Neptune and Zeelandia*, 46, 58–59, 61, 66–67, 69, 71, 73; and Philip of Burgundy, 58, 67, 164n61; in Ripanda, 59, 61

Neptune and Amphitrite (315–25) (ancient Cirta, mosaic), **60**

Netherlandish antiquity, 4, 36, 41–42, 43, 71, 100

"New World," 20, 21, 134

Nijmegen (Noviomagi), antiquity of, 38, 40, 42

Northern Renaissance, 4, 156n20

Order of the Golden Fleece, 21, 26, 92–93; and Philip of Burgundy, 58, 76, 77, 92; and portrait medal of Adolph of Burgundy, 133

Orley, Bernard van, 28, 122; *Haneton Triptych* of, 158n61

Ortelius, Abraham, 72, 152, 159n86; *Aurei saeculi imago* (Infancy) (1596), engraving, 138, **139**

Ovid, 87, 138; *Amores*, 125; *Heroides*, 91; *Metamorphoses*, 8, 65

paragone, 109

past, ancient/local, 2, 8, 40, 100; and Agricola, 115; and JG, 80, 105, 146, 150; and genealogy, 75; and JG's *Carondelet Diptych*, 35; and JG's *Hercules and Deianira* (1517), 88; and JG's *Neptune and Zeelandia*, 46, 67, 70, 73; and JG's *View of the Colosseum Seen from the West*, 50; and JG's *Virgin and Child*, 113; humanists' restoration and revival of, 41–42; and Meit, 105; possession of as tangible reality, 105; and Reygersbergh, 55

patrons: Adolph of Burgundy as, 132–33, 143; and JG, 2, 8, 14, 20–23, 26, 41–43; and JG's *Danaë*, 116, 124; and JG's mythological nudes, 23; humanist biographical descriptions of, 50, 100–101, 136; Philip of Burgundy as, 3, 14, 20, 21, 115, 130, 145; and pursuit of ancient past, 38; urban, 26

Pausanias, *Description of Greece*, 165n67, 167n86

perspective: Alberti on, 7; and Gauricus, 125–26; and JG's *Danaë*, 126–27; and JG's *St. Luke Drawing the Virgin* (c. 1515), 30

Peutinger, Conrad, 38, 159n86

Philibert of Savoy, 21; marble portrait busts of, 78, 104

Philip II of Spain, 62–63, 146

Philip of Burgundy, 3, 21, 22, 152; as admiral, 52, 58, 76; and Adolph of Burgundy, 132, 134, 143; ambassadorial mission of, 46–47; amorous proclivities of, 58; and ancient history, 100; ancient lineage of, 57; and ancient past, 76; antiquarian endeavors of, 130; and antiquity, 22, 56–57; and archaeology, 43; and Batavians, 101; as bishop of Utrecht, 76–77, 103, 105, 132; bishop's palace of at

Wijk bij Duurstede, 59, 76, 77, 78, 79, 88, 100–101, 102, 103, 111, 130; Burgundian lineage of, 76; and Charles V, 76; and collectible antiquities, 103; conversations about art with, 100–101, 136, 138; court of, 58, 76, 136; death of, 115, 116, 122, 130, 132; epitaph for, 130; and Eyckian tradition, 51–52; and funeral of King Ferdinand of Aragon, 58; funerary monument for, 130, 131; and Geldenhouwer, 38, 56, 57, 58, 77, 100, 122, 130, 136, 164n61; Geldenhouwer's biography of, 46–47, 49–50, 51, 52, 55, 109, 111; Geldenhouwer's Latin epithets for, 164n61; and Geldenhouwer's poem on art of painting, 58, 136; and JG, 3, 46, 56, 115; and JG's *Danaë*, 127; JG's drawings for, 49–51; and JG's *Hercules and Deianira* (1517), 103; and JG's *Hermaphroditus and Salmacis*, 105, 107, 109, 115; JG's mythological work after death of, 131; and JG's mythological works, 23, 26; and JG's *Neptune and Zeelandia*, 46, 58–59, 67, 71, 73; as guardian of Zeeland's shores, 52, 67; and Guelders rebellion, 101, 130; Heda's biography of, 14, 46, 76; helmet in collection of, 14; and Henry of Nassau, 81; and Hercules, 101; and Hercules Magusanus altar, 56–57, 71, 95, 97, 98; and Hercules snowman, 57; intellectual pursuits of, 136; and inventory of bishop's palace at Wijk bij Duurstede, 102, 103, 111; and jetons (*rekenpenningen*), 103; legacy of, 143; letter to Laurent de Blioul of April 5, 1520, 76; and Maximilian of Burgundy, 22; and motto *A plus sera*, 46; and Neptune, 58, 67, 164n61; and Neptune and Amphitrite myth, 59; and New World objects, 20; numismatic collection of, 103; and occupations of war and peace, 130; and Order of the Golden Fleece, 58, 76, 77, 92; painting and drawing by, 46; and painting of nude Venus and Cupid, 59; palace of at Souburg/West-Souburg (Walcheren), 55–56, 67, 73, 81, 109, 130, 132, 138; palace of at Wijk bij Duurstede, 59, 76–78, 88, 100–103, 111, 130; as patron, 14, 20, 58, 73, 115, 130, 145; and sacred monuments of antiquity, 49; and sculpted portrait busts, 77–80; terracotta bust of, 79; and travel to Italy, 21, 23, 56, 58, 59, 73; triumphal entry into Utrecht in May 1517, 76–77; and Zeeland, 52, 55

Philip of Cleves, Lord of Ravenstein, 26, 157n34, 160n7; inventory of, 131, 132

Philip the Fair, 21, 22

Philip the Good, Duke of Burgundy, 21, 26, 76, 77, 93, 158n55

Philostratus, 171–72n48

Plautus, 56; *The Pot of Gold*, 41

Pliny the Elder, 70, 137, 142, 171–72n48; *Natural History*, 80, 140

Plus ultra devise (1519), 92–93, **93**

Pollaiuolo, Antonio, *Hercules, Nessus and Deianira* (c. 1470), **87**, 87–88

portrait busts, 76, 77–80, 104, 170nn26–27

Portrait medal, of Adolph of Burgundy, 103, 133–34, **134**, 137

Pourbus, Frans, II, 146

Poussin, Nicolas, 146, 147

Prague Kunstkammer, inventory of, 131

Pratensis, Jason, 1–2, 5, 135, 148
 and Adolph of Burgundy, 143
 and Anna van Bergen, 143
 dedicatory poem for *Reygersbergh's Chronicle of Zeeland*, 1, 137, 140
 and JG's *Danaë*, 136
 How to Prevent Sterility, 141–42
 and Luther, 179n88
 On Diseases of the Mind, 141
 On Maintaining Good Health (1538), 135, 136, 137; title page, **135**
 On the Womb, 138–40, 141
 An Orchard of Songs of Youth, 137
 "Venus Armed with a Girdle," 137

Praxiteles, 142

pregnancy/impregnation, 138, 141; and JG's *Danaë*, 125. *See also* birth/birthing; womb

Preussen, Albrecht von, 171n35

putti: and Conrad Meit, 177n49; and JG's *Danaë*, 126; and JG's design for tomb of Isabella of Austria (c. 1526), 131; and JG's *St. Luke Drawing the Virgin* (1520–22), 122, 124; and JG's *Virgin and Child*, 113

Pygmalion, myth of, 8, 10, 15

Raimondi, Marcantonio, *A Nude Couple Embracing*, from *I Modi* (c. 1510–20), **129**

Raphael, *Sistine Madonna*, 147

reflections. *See* mirrors and reflections

Reformation, 111, 120, 138, 143; and condemnations of images, 143; and JG's *Danaë*, 116; and JG's *St. Luke Drawing the Virgin* (1520–22), 124; in Low Countries, 115–16; and mythological images, 146; and Pratensis, 139; and representation of classical nudes, 120

Reygersbergh, Jan: *The Chronicle of Zeeland*, 1, 55, 137, 140; *Map of Zeeland (c. 1230)*, from *Dye cronijcke van Zeelandt* (*The Chronicle of Zeeland*) (1551), woodcut, **x–1**, 55

Ripanda, Jacopo, *Battaglia navale, Sala di Annibale* (1505–7), 59, 61, **61**

Romanesque architecture, 41, 52

Romanists, 3–4

Rome: antiquarian endeavor in, 48, 49; architectural monuments of, 3; Catholic corruption in, 50; claim to Roman past and intellectual legacy of,

Rome: antiquarian endeavor in (*continued*)
2; and Geldenhouwer, 38, 40, 50; JG's drawings
of antiquities in, 3, 49–51, 56; and JG's *Neptune
and Zeelandia*, 51; and JG's *St. Luke Drawing the
Virgin* (c. 1515), 30; JG's travel to, 3, 46, 59, 91;
and Herbenus, 41; Philip of Burgundy's travel to,
73. *See also* Italy

Roomburg: coins and bronze lions from, 43; inscrip-
tion found at, **97**; statue of Minerva from, 43, 104

Rösslin, Eucharius: *Den Roseghaert vanden Bevruchten
Vrouwen* (1528), woodcut, 128; *Der swangern Frauwen
und Hebamen Rosegarten* (1513), woodcut, 127–28, **128**

Sandenberg palace, 132, 137, 138

Savelli Sarcophagus, 91, **92**

Scheldt River (personified), 62

Schreinmadonna, 129

Scorel, Jan van, 103–4, 150–51, 162n38

sculpture: ancient, 3, 19, 20, 48; enlivened, 15; and
van Eyck, 15; JG's drawings of ancient Roman, 48;
and JG's *Hermaphroditus and Salmacis*, 109; and
JG's *Venus*, 10; and Meit, 78, 104–5; and Nether-
landish altarpieces, 88; Netherlandish funerary,
131; painted, 15; and Philip of Burgundy, 46, 77;
portraits, 77–80; and Pygmalion, 8; Roman, 3;
Schreinmadonna, 129; small-scale nudes, 76, 104–5

Sebastian of Zierikzee, 168n101

Secundus, Janus, 91; letter of 1533 to Jan van Scorel,
103–4; portrait medals of, 103–4

Sellaer, Vincent, 152

Siena, Palazzo Spannocchi, 170n27

Smeken, Jan, 57, 164n51, 172n61

Snoy, Reinier, 72, 134, 169n106

Solly, Edward, 160n1

Soranus the Batavian, 98–100, **99**

Soranus of Ephesus, 141

Souburg palace. *See under* Philip of Burgundy

Spinario (statue in Palazzo dei Conservatori), 12, 19.
See also under Gossart, Jan, Works

spolium, 91

Stratenus, Petrus, *The Venus of Zeeland* (1641), 67–68;
title page, **68**, 69

Suetonius, 72, 80, 169n106

Tabula Peutingeriana (c. 1200), 38, **39**, 159n86

Tacitus, Cornelius, 43, 70, 95, 97, 99, 100

Tafur, Pero, 17

tapestries, 21, 26, 28, 94

temples: ancient Greek, 59, 66; and JG's *Neptune and
Zeelandia*, 66, 67, 69

Tenos, 59

Terence, *The Eunuch*, 118, 119, 124

Tiberius, Emperor, 142, 181n104

Tintoretto, 118, 124

Titian, 116, 118, 124, 146

Torrigiani, Pietro, 78

trident: and JG's *Neptune and Zeelandia*, 61, 73

Tritons, 59, 62

Triumphal Arch of the English Nation, 62, **63**, 64

Trojan heroes/ancient Troy, 75, 93, 97

Tunstall, Cuthbert, 52–53, 102, 161nn28–29, 162n32

University of Leuven, 40

Urceo, Antonio, 41

ut pictura poesis, 109, 111

Utrecht, antiquities found near, 95

Utrecht Cathedral, choir screen, 22

Vaernewijck, Marcus van, *Mirror of Netherlandish
Antiquity*, 15, 36

Vaga, Perino del, *Danaë*, 176n8

Vasari, Giorgio, *Lives of the Artists*, 3, 148, 155n8

Vatican, 50; Belvedere courtyard in, 49

Veere, 53, 132, **132**, 134

Vellert, Dirck, 146; *Venus Sailing in a Shell* (1524)
(engraving), 69, **69**

Venus: of Apelles, 41; and Batavian isle, 70; in JG's
Venus (1521), 8, 10, 11, 15, 17, 19, 21, 109; in JG's
Venus and Amor, 109, 111; and Pygmalion, 8;
on Roman sarcophagi, 65; sports of, 141; at her
toilette, 17; and Zeeland, 69

Venus of Zeeland, 68

Vermeyen, Jan Cornelisz., 146; *Portrait of Jan II
Carondelet* (c. 1525/30), attributed to, **36**; *St.
Donatian* (c. 1525/30), attributed to, 35, **36**

Virgil, *Aeneid*, 40, 58, 165n72

Virgin and Child (c. 1522), copy after Jan Gossart, 133,
133, 136

virginity, and Gossart's *Danaë*, 125. *See also* chastity

Virgin Mary: as ecclesiastical mother, 32, 33; in van
Eyck, 14, 32; and JG's *Carondelet Diptych*, 35; and
JG's *Danaë*, 118; JG's depictions of, 23, 150; and JG's
Malvagna Triptych, 33; in JG's *St. Luke Drawing the
Virgin* (c. 1515), 28, 30, 118; in JG's *St. Luke Drawing
the Virgin* (1520–22), 122, 124, 125; in JG's *Virgin and
Child* (1527) (London), 113; in JG's *Virgin and Child*
(c. 1527) (Prado), 120; Immaculate Conception of, 32,
124; and legend of St. Luke, 122; and *Schreinmadonna*
sculptures, 129; vision of, 122; womb of, 129

Vitruvius, *On Architecture*, 51

Vives, Juan Luis, *On the Office of Marriage*, 142

Waal, Henri van de, 2

Walcheren, 53, 55–57, **57**, 67, 73; and Adolph of Bur-
gundy, 132; ancient history of, 70; and Batavian
territory, 71; and Hercules Magusanus altar,
55–57, 71, 98

Wassenaer, house of, 101

Wedding of Hercules and Deianira, Tournai Workshop
(c. 1513), tapestry, **94**

Westkapelle, church at, 56, 98, 163n48

Weyden, Rogier van der, 3; *Lamentation*, 152; *St. Luke Drawing the Virgin* (c. 1435–40), 28, **30**

Wijk bij Duurstede: church of St. John the Baptist, 130

Wijk bij Duurstede palace, 76; and Geldenhouwer's correspondence with Cranevelt, 79; inventory of, 102, 103, 111; paintings of nude men in combat at, 100–101; renovation of, 77, 130; terracotta busts at, 78, 88; Venus and Cupid painting in, 59

Wijngaerde, Anton van den, *Panorama of Walcheren* (1550), 53, **54**, 132, **132**

Willibrord, St., 56, 163–64n49

womb: and JG's *Danaë*, 116, 125, 127, 129, 143; and imagination, 141–42; and Pratensis, 141; of Virgin Mary, 129. *See also* birth/birthing; pregnancy/impregnation

Zagarus, Willem, 140, 148, 180n95

Zeeland, 1, 22, 52–58; and Adolph of Burgundy, 132, 134; ancient cult worship in, 56; and Batavian isle, 71; flooding in, 71; and Geldenhouwer, 56; geography of, 56, 71; JG's home in, 46, 52; and JG's *Neptune and Zeelandia*, 67, 69, 73; history of, 52, 56–57, 70, 71; and humanists, 56; and Lemnius, 140; as *locus amoenus*, 68–69; and Netherlandish trade and diplomacy, 52, 56; and ocean, 53, 54–55; personification of, 67–68; Philip's duties as admiral in, 52; and Pratensis, 139–40; Reformation in, 139–40, 143

Zeelandia (goddess), 46; in JG's *Neptune and Zeelandia*, 59, 61, 66–67, 69, 71

Zierikzee, 54, 139, 140

Zovitius, Jacob, 53–54, **54**, 140

ILLUSTRATION CREDITS